INTO THE DARK

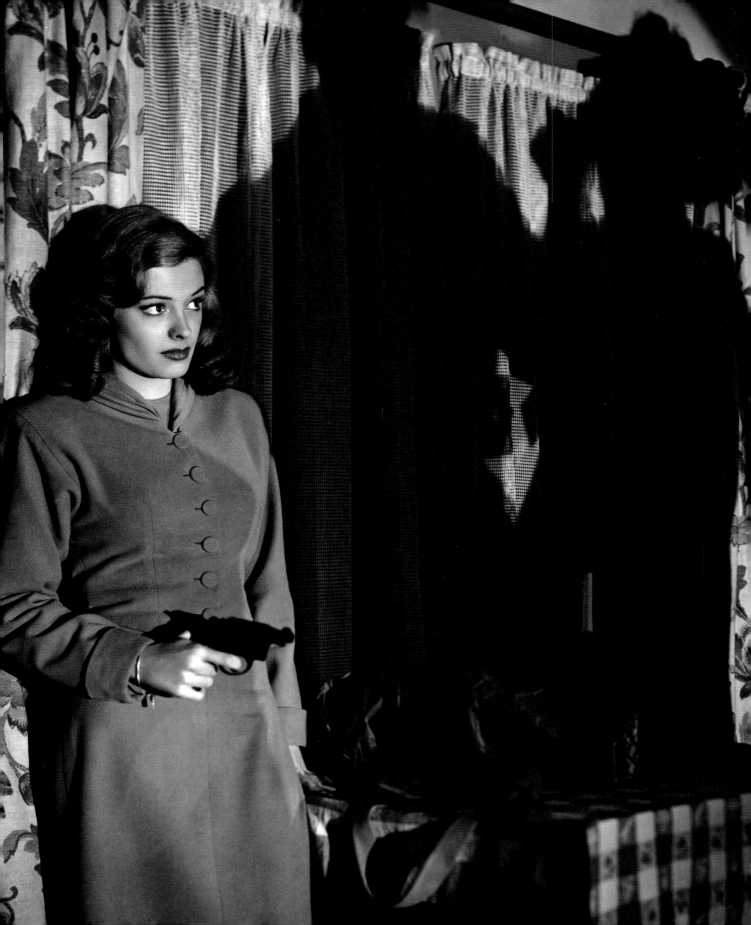

INTO THE DARK

THE HIDDEN WORLD
OF FILM NOIR, 1941-1950

———

MARK A. VIEIRA
FOREWORD BY EDDIE MULLER

RUNNING PRESS
PHILADELPHIA · LONDON

And to Dorothy Chambless and Ben Carbonetto.

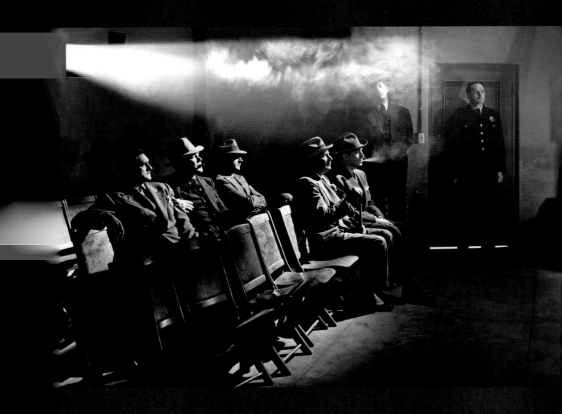

© 2016 by Mark A. Vieira

Published by Running Press,
A Member of the Perseus Books Group

Printed in China

Books published by Running Press are available at
special discounts for bulk purchases in the United
States by corporations, institutions, and other organiza-
tions. For more information, please contact the Special
Markets Department at the Perseus Books Group,
2300 Chestnut Street, Suite 200, Philadelphia, PA
19103, or call (800) 810-4145, ext. 5000, or
e-mail special.markets@perseusbooks.com

ISBN 978-0-7624-5523-2
Library of Congress Control Number: 2

E-book ISBN 978-0-7624-5806-6

9 8 7 6 5 4 3 2
Digit on the right indicates the number

Designed by Jason Kayser
Edited by Cindy De La Hoz
Typography: Minion and Verlag

Running Press Book Publishers
2300 Chestnut Street
Philadelphia, PA 19103-4371

Visit us on the web!
www.runningpress.com

er as
t in Jacques
t of

n Mowbray
ture in a
Bruce Hum-
ake Up

wford
e film noir
n Negule-
que.
y Eugene

CONTENTS

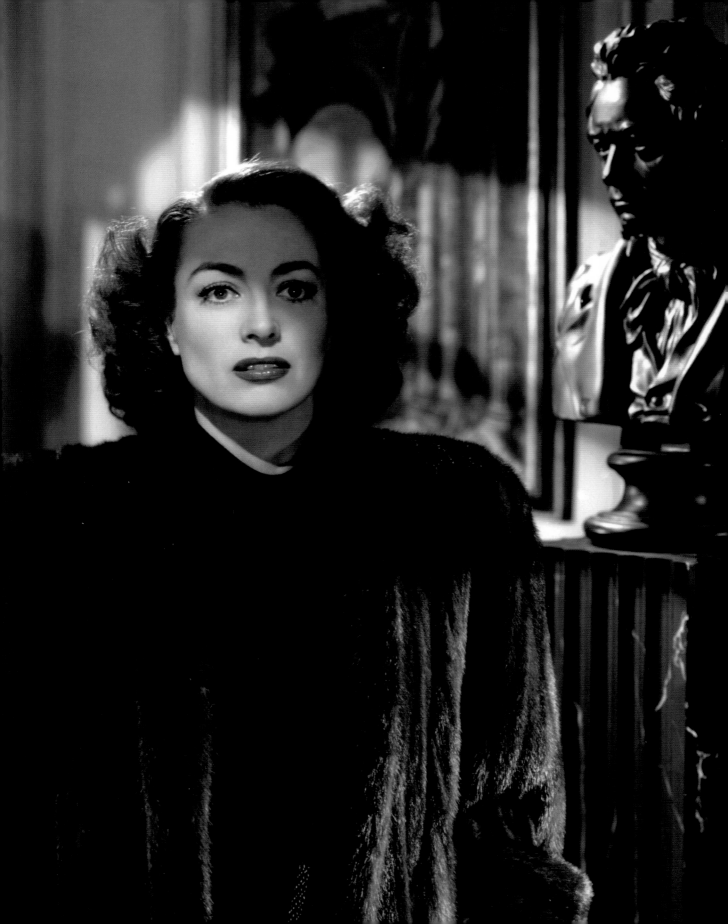

FOREWORD
BY EDDIE MULLER

Back in 1997, when I was researching my first book on noir, *Dark City: The Lost World of Film Noir*, the most invaluable reference works I found were industry trade journals from the 1940s, magazines such as *Motion Picture Herald*, *Exhibitor's Trade Journal*, and *Moving Picture World*. They gave an insiders' perspective on how a rapidly developing artistic movement—spreading through Hollywood like an ominous and nameless black tide—was actually being sold to theater operators throughout America.

In those pages I first learned that *films noir*—a scholarly appellation that wouldn't be applied for another twenty or so years—were originally labeled by the folks who produced them, "crime thrillers" and "murder dramas." The tags weren't applied indiscriminately: "crime thrillers" typically involved professional cops and robbers (think *Kiss of Death*, *The Asphalt Jungle*, *The Big Heat*) while "murder dramas" usually dealt with guilty or innocent amateurs in over their heads (*Double Indemnity*, *The Postman Always Rings Twice*, anything written by Cornell Woolrich).

It's this practical side of Hollywood history, and especially noir, that's gotten short shrift among the literally hundreds of volumes dedicated to exploring and analyzing what I contend was Hollywood's only truly organic artistic movement. Hollywood's version of film noir was born of a particular place and time; it was a perfect storm of artistic foment, economic upheaval, and political backstabbing. Plenty has been written about that. Less explored is the role the worker bees of the business—agents, publicists, exhibitors, critics—had on the movement's rise and fall.

With *Into the Dark*, Mark Vieira goes a long way toward balancing the scales, providing a "You Are There" chronology of events, detailing how the emergence of this new strain of cinema was—like all art movements—simultaneously embraced and attacked by the mainstream. He's culled some wonderful archival snippets as illuminating signposts along the route: excerpts from Bosley Crowther's and Philip Scheuer's reviews of *Citizen Kane* both read as if they're reviewing a film noir, long before the movement started to

coalesce. Orson Welles's influence on the development of "noir style" has never been more pithily depicted. (I'm especially pleased to see Phil Scheuer, one-time critic for the *Los Angeles Times*, acknowledged for his insightful and spot-on reportage of 1940s crime films and their significance to both the industry and culture. He was Johnny-on-the-Spot when his East Coast colleague Crowther, pontificating from his lofty perch at the "Paper of Record," was oblivious to it all.

Mostly it's fun to flip through these pages and sense the thrill this amazing array of film artists—including Vieira's beloved stills photographers—experienced producing the sexy and sinister style that would become known as *noir*. The book reminded me of many conversations I had with actresses I'd profiled in *Dark City Dames: The Wicked Women of Film Noir*—none of whom knew the slightest thing about "film noir" but could vividly recall every detail of their work on *Out of the Past, Force of Evil, The Prowler, Detour, The Set-Up*, and *Nightmare Alley*—all classic examples of the form.

But it was Claire Trevor—the Grande Dame of Film Noir—who put film theory versus film reality into the sharpest perspective, when I sought details about her starring role in one of the definitive noir films, *Raw Deal*: "Honey," she sighed, "I made so many of those pictures I can't tell one from the other. But I'll bet my bottom dollar I was the bad girl."

—EDDIE MULLER

Eddie Muller is known internationally as "The Czar of Noir," both for his books on the subject and his work rescuing and restoring at-risk films as founder and president of the Film Noir Foundation. He is producer and host of the annual Noir City Film Festival in San Francisco, the largest retrospective of classic film noir in the world, which has satellite festivals in numerous U.S. cities. A familiar face on Turner Classic Movies, Muller was programmer and host of TCM's 2015 "Summer of Darkness," a nine-night festival of classic noir. He has lectured on the subject for the Smithsonian Institute, the Museum of Modern Art, France's Institut Lumière and Cinematheque Française, among many other prestigious venues. He is coauthor of the national bestseller *Tab Hunter Confidential* and his crime novel, *The Distance*, was named Best First Novel by the Private Eye Writers of America.

PREFACE

WHAT IS FILM NOIR? Does anyone know? The definition of this genre differs from one scholar to the next. No one agrees on essential noir titles. Some say that 1940's *Stranger on the Third Floor* was the first film noir; others that 1942's *Street of Chance* was the first. When I finally saw these films, the former looked like a horror film; the latter like a mystery. *The Maltese Falcon* is often cited as the first film noir, but I saw little relation to textbook noir such as *Out of the Past*. I had read that a noir protagonist had to be alienated, obsessed, or doomed, yet none of these words describe Humphrey Bogart in that film, and certainly not Dick Powell in *Murder, My Sweet*, the accepted kickoff of the noir cycle. What are the criteria? What is the history of the genre? These are questions I had to answer when I set out to write a book on film noir. As

I began my research, I was overwhelmed. There are 150 books on the subject. This might be encouraging to a researcher, but not to a writer. With so many books on the market, I could not do "just another film noir book." I had to do something different, something that would challenge the conventional wisdom.

I've always been fascinated by the technical excellence of 1940s filmmaking, so I decided on a pictorial history of the big-studio melodramas that characterized the film noir product of those years. A pictorial history would not be enough, however; I wanted to lead the reader into the '40s. Researching archival documents, I read letters, conference transcripts, and interviews that explained the true genesis of film noir. I chose to let those documents tell that story. The result is *Into the Dark: The Hidden World of Film Noir, 1941–1950*.

This book tells the story of film noir in its own voice. Filmmakers, journalists, and exhibitors tell how the trend evolved. Unheard voices and unseen images from eighty two films transport you to the '40s. This is time travel, a ticket to the smoky, glamorous world of noir. You enter a story conference with Billy Wilder and Raymond Chandler, visit Clifton Webb on the set of *Laura*, and watch *Mildred Pierce* with a preview audience. *Into the Dark* is the first book to recreate the environment that spawned film noir.

No book has told how the genre came to be. Some include production histories or interviews with filmmakers, many of which are contradicted by archival documents. A few explore the connection

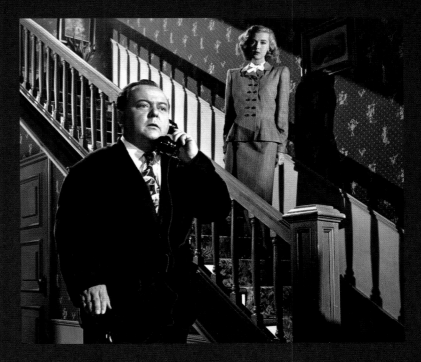

between pulp novelists and noir screen-writers. Not one studies the genre in the context of the movie business, the book-to-screen gauntlet that makes or breaks a project. Not one delves into the production hierarchy and protocol of the industry as it was recorded on in-house documents. Not one establishes a definitive chronology by using nuts-and-bolts research in studio archives and industry press. Most of these books are subjective, proposing film theory and advancing analysis that has nothing to do with the time and place in which the film was made. You can say that a certain movie is a "seminal film noir" and that it was the "progenitor of the genre." But how was the film regarded in 1944? By the industry? By the press? By audiences? Was there an acknowledgment of a trend? These are questions that must be answered in order to write a history of the genre. I have written definitive histories of pre-Code films, horror films, and the production phenomenon of 1939. To do so, I went to the archives. I have done the same for film noir. I have found the words that were pounded out on typewriters in the '40s—what really happened, told by people who were there, as it was happening.

Writing a book on pre-Code films was a straightforward proposition. They were made in a clearly demarcated period, from March 1930 to July 1934. This is not true of film noir. Even its title is ambiguous. In 1946 the French critic Nino Frank was pondering a new type of Hollywood film. At the time, of course, every American film was new to the French. They had been deprived of Hollywood product by the Vichy government since 1940. When the occupation ended and France could once more view Hollywood movies, Frank and his confreres saw that Hollywood was making something new. It was not a melodrama, a mystery, or a detective film, though it had elements of all three. It was distinguished by darkness. Its imagery, its characters' motives, and its world view were dark. Before this, the typical Hollywood film had been relentlessly optimistic. Its happy ending offered an escape to a

John Sturges's *Shadowed* has both the title and look of film noir, but it is a comedy.

benevolent universe. This film offered no such escape. Its hero was alienated, obsessed, doomed. He was not saved in the last reel. He often died. Mr. Frank dubbed this genre *film noir*; i.e., *black film*.

The name meant nothing to Hollywood. No one was reading French film criticism in 1946. They were too busy making dark films. In spite of this darkness—or perhaps because of it—these films were suddenly popular. During World War II, Americans had turned to Technicolor musicals and family comedies, giving Hollywood the biggest boom in its history. In 1946 the dark films began to encroach. The fatalism of *The Big Sleep* and *The Killers* was far removed from the positivism of *Blue Skies* and *The Harvey Girls*, but America embraced dark films, calling them "crime," "mystery," or "hardboiled," and they became a studio staple.

Film noir flourished in the '40s, finding subject matter in all levels of society, from disenfranchised vets to exploited athletes and disillusioned public servants. It survived the changes that assailed the studios in 1948: the HUAC hearings, the loss of theaters, and the advent of television. Nineteen fifty saw some of the best film noir entries, but within a year the

trend was losing steam, in part because many of its artists were being blacklisted. By the mid-1950s, the cycle had played itself out, acknowledged as démodé in Robert Aldrich's *Kiss Me Deadly*. By 1960 film noir was a thing of the past. There had been nineteen years of these films, but—unlike westerns, comedies, and musicals—they had no name. That was left to the critical fraternity. It took years.

In the Spring 1972 issue of *Film Comment*, the fledgling film historian Alain Silver wrote a profile of director Robert Aldrich that was titled "Mr. Film Noir Stays at the Table." Indeed, Aldrich had held up a French magazine cover years earlier for an on-set photographer, pointing to the words "Film Noir." But these were hardly mainstream placements. On February 9, 1973, while reviewing Michael Hodges's *Pulp* in the *New York Times*, Roger Greenspun wrote: "You can guess

Above: Dick Powell saved his career by becoming a film noir hero. He is seen here with Claire Trevor in Edward Dmytryk's *Murder, My Sweet*.

Opposite: Robert Montgomery was both a film noir actor and director.

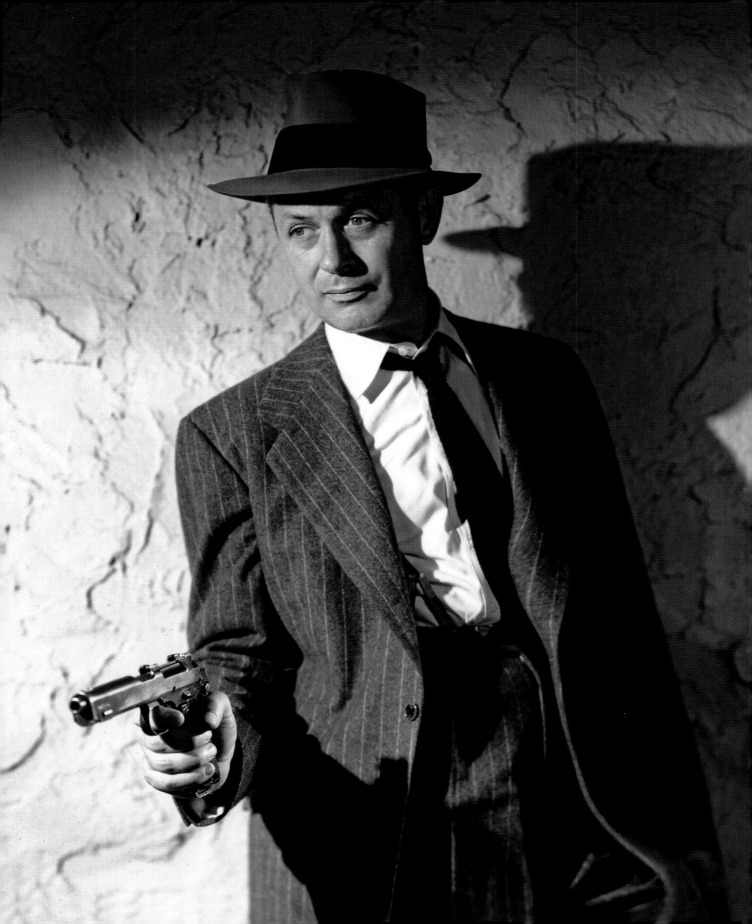

where everything comes from: the cast—Mickey Rooney, Lionel Stander, Lizabeth Scott—partly out of the nineteen thirties and forties; the characters—imitation Humphrey Bogart, James Cagney, and the like—out of those pop-culture objects now made icons; the moods and tensions, out of the collective depths of the film *noir*."

Aha! "The film *noir*."

This was the first time the term had been used in a mainstream American publication. Not coincidentally, the country was enjoying one of its periodic nostalgia crazes. In the early '60s, the culture had gone mad for the Roaring Twenties. In the late '60s, the advent of "camp" had lumped King Kong with Marlene Dietrich, giving the '30s a fresh currency. In the early '70s, on the heels of the hippie era and glitter rock, came a fascination with the floral prints and pompadours of the '40s. On a

deeper level, these were a reaction to the Vietnam War and social unrest. I saw poster shops on Telegraph Avenue in Berkeley displaying huge images of Humphrey Bogart as his films played in repertory theaters down the block. The anti-hero had become a cultural icon. Film noir was ready for re-evaluation.

These films had not gone away. They were everywhere, because every home had a television set. The studios had sold their libraries to television in the late 1950s, so, along with westerns and war movies, "detective movies" were devoured by young Americans as they ate dinner from TV trays. The children who ingested these features grew up hungry for more. They were curious about Dick Powell's Philip Marlowe and Robert Mitchum's Jeff Markham. Surely these films were more than the sum of their parts. By the 1970s, when these Baby Boomers were in college, America was "rediscovering the American cinema," both on college campuses and in repertory theaters. The *Times* had officially named the genre, and films like *Dark Passage* were more than "old flicks." They belonged to a formal genre. They were studied in high schools, colleges, and film schools. Most importantly, they were viewed.

By the late '70s, RKO's sole 35mm copy of Jacques Tourneur's *Out of the*

Left: A 1986 portrait of Jane Greer, whose career was revived by the 1970s rediscovery of 1940s film noir. Photograph by Mark A. Vieira.

Opposite: Robert Mitchum embodies the film noir hero in *Out of the Past*.

Past—a fragile nitrate print—was being shipped hither, thither, and yon for festivals. Its star, a then-forgotten actress named Jane Greer, found a new prominence. One of the first American books on film noir was published in 1979. *The Film Noir Encyclopedia* by James Ursini and Alain Silver set criteria and enumerated titles. Film noir was established.

Part of the satisfaction of writing a film history is learning. As I pored over thousands of articles, letters, and interviews, I saw the genesis of a trend. The *Los Angeles Times* was by 1941 almost a Hollywood trade paper, sharing access to filmmakers with *Variety*, the *Hollywood Reporter*, and the *Motion Picture Herald*. If there was a trend, it would be covered in the *Times*. Thus we can read Edwin Schallert's 1944 report on a new film cycle and his assertion that it began in 1941 with *Citizen Kane* and *The Maltese Falcon*. We read Philip K. Scheuer's 1949 report on how the "hard-boiled cycle" had made roles for women scarce, an injustice addressed by *Sunset Boulevard*, *Beyond the Forest*, and *The Damned Don't Cry*. We read Hedda Hopper's reports on Orson Welles, in which she calls him "Little Orson Annie." Most film noir analyses are seriously short of humor, which is odd. The films—and their reviewers—are often droll. When Holly-

wood legends like Barbara Stanwyck, Lee Garmes, and Orson Welles reminisce about film noir, they are witty and articulate, putting a frame on the flashback.

Do audiences say "Eeeek!" when a murderous character is almost caught? They did in 1944, when *Double Indemnity* grabbed its first audience. We learn from rural theater owners how their patrons responded to these films, with indifference and even hostility. For venom, no one surpassed Bosley Crowther in the *New York Times*. He dismissed nearly every film noir that is now considered a classic. In one review he called Joan Crawford a "ghost wailing for a demon lover beneath a waning moon." Did he attack *Possessed* because he hated Crawford or just because he hated movies? Only the reader can decide.

My fond hope for *Into the Dark* is that it will serve a significant function for anyone who is curious, interested, or even fanatical about '40s film noir. This is the first book to accurately describe the environment that spawned film noir. This environment was not only that of postwar America, with its fumbling adjustment to new roles and new mores. It was the production hierarchy of the Hollywood film studio. If the hard-boiled material written by a screenwriter did not appeal to a producer—and did not

make money—it would never have been filmed. There would never have been a film noir genre.

As you will read, this environment did not altogether appeal to crime-fiction giants. Raymond Chandler's clashes with Billy Wilder almost constitute comic relief. I hope that the dashes of humor contained herein will be refreshing. I hope that the basic questions about each film are answered in the entries, and that the new data I have found will be of value. I credit many more studio photographers than was previously possible. Film noir was their achievement, too, so giving credit to artists like Ned Scott adds one more feature to this book.

I hope that these aspects will enhance your next film noir viewing. I saw my first noir in 1957, when I was seven. If I had known that the working title of *The Locket* was *What Nancy Wanted*, I may have enjoyed the film more. In any case, I am happy to share my knowledge, and grateful to my publisher, Running Press, and to Turner Classic Movies, for the opportunity to do so. I hope that *Into the Dark* will convey the mystery, glamour, and irony that make '40s film noir surpassingly popular.

MARK A. VIEIRA
June 26, 2015

"The wiles of dissembling fate afford us the illusion of freedom, yet in the end always lead us into the same trap."

JEAN COCTEAU

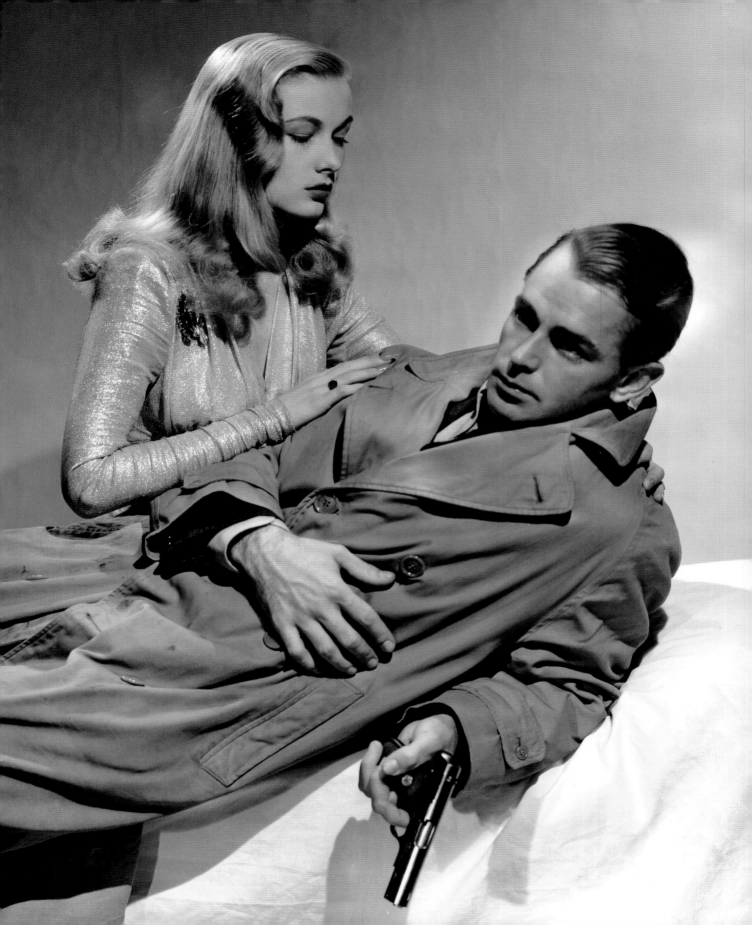

Shadowed

(1941–1943)

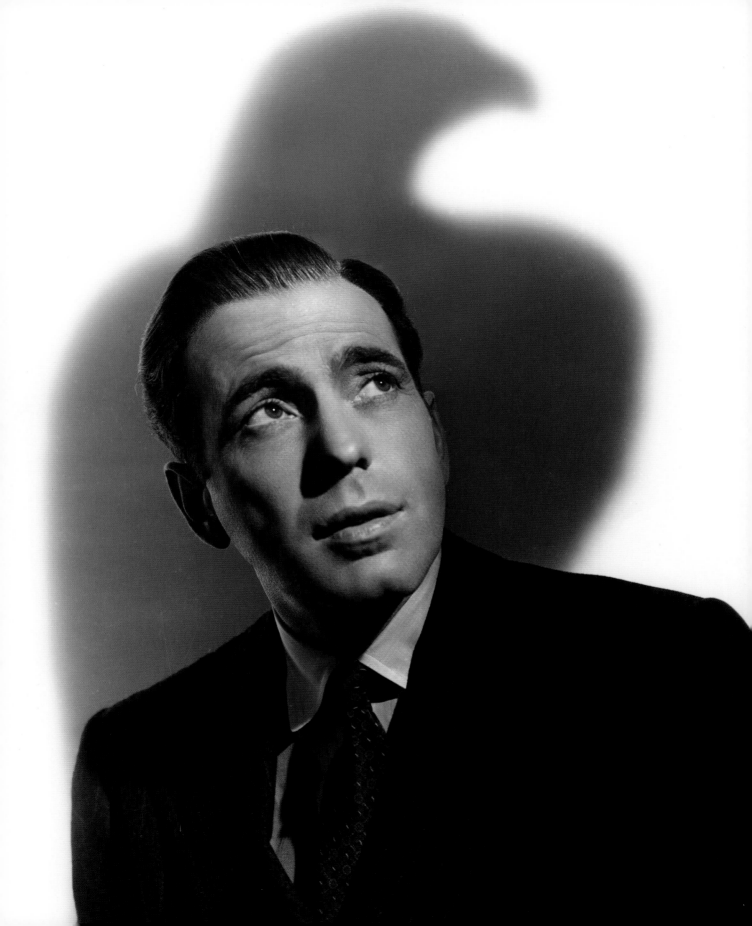

1941

p. 18: Veronica Lake and Alan Ladd became stars in Frank Tuttle's *This Gun for Hire*. Photograph by A. L. ("Whitey") Schafer.

Opposite: Humphrey Bogart posed for poster art to publicize John Huston's *The Maltese Falcon*. Photograph by Scotty Welbourne.

"Reader interest in mystery novels, always high, has recently doubled. Instead of an average printing of 3,500 copies, an edition will run as high as 7,000 and 10,000. The screen, on the other hand, has been notoriously lax in exploring this field of drama. For too long Hollywood has contented itself with the childishly obvious in crime yarns. They have fallen into three groups: the pseudo-horror, clutching exponents like Karloff, Lugosi, and Lorre; the spook comedy, as exemplified by *The Cat and the Canary*; and the detective-crook 'school' of Charlie Chan and the Lone Wolf. The producers have completely ignored the moviegoing equivalent of the public that dotes on the intelligent, well-told mystery novel."

PHILIP K. SCHEUER, *Los Angeles Times*, October 12, 1941

CITIZEN KANE

RKO RADIO PICTURES
RELEASED MAY 1, 1941

Producer-director
ORSON WELLES

Screenwriters
HERMAN J. MANKIEWICZ
ORSON WELLES

Cinematographer
GREGG TOLAND

Unit stills photographer
ALEX KAHLE

Stars
ORSON WELLES
JOSEPH COTTEN
AGNES MOOREHEAD
RUTH WARRICK

A MAGNATE'S DYING WORDS INSPIRE A SEARCH FOR THE TRUTH BEHIND HIS LEGEND.

PRODUCTION QUOTE

"Well, this afternoon at the old Pathé studio, where this town has seen a lot of history made, we'll witness the formal start of *Citizen Kane*, the first picture to be helmed by Orson Welles. I wouldn't miss the christening for the world. 'Little Orson Annie' is occupying the bungalow dressing room which was once used by Gloria Swanson."

HEDDA HOPPER, *Los Angeles Times*, August 1, 1940

Gloria Swanson used this bungalow in 1928 while filming *Queen Kelly*, the film she watches in *Sunset Boulevard*. Coincidentally, Swanson attended the gala premiere of *Citizen Kane*.

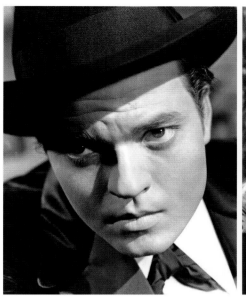
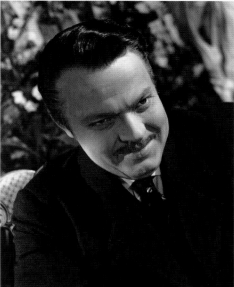
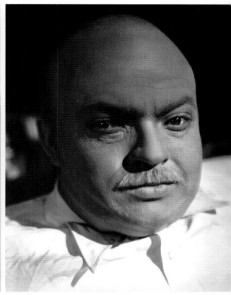

REVIEWS

"*Citizen Kane* is far and away the most surprising and cinematically exciting motion picture to be seen here in many a moon. As a matter of fact, it comes close to being the most sensational film ever made in Hollywood. Mr. Welles has put upon the screen a motion picture that really moves. It is cynical, ironic, sometimes oppressive, and as realistic as a slap."

BOSLEY CROWTHER, *The New York Times*, May 2, 1941

"*Citizen Kane*, the one incomparably fine film of 1941, can be held up as a shining example of almost anything. For instance, it is a great mystery story, one told with mathematical precision. This may have been lost sight of in the excitement over its more controversial aspects."

PHILIP K. SCHEUER, *Los Angeles Times*, October 12, 1941

LETTERS FROM REGIONAL THEATER OWNERS

"Stay away from this. A nightmare. Will drive 'em out of your theater. It may be a classic to you, but it's plumb nuts to your public. Some swell acting and production wasted. Way too extreme."

J. K. BURGESS, Iris Theatre, Velva, North Dakota, *Motion Picture Herald*, January 3, 1942

"Don't try to tell me Orson Welles isn't a genius. Herein he has produced a mighty fine picture. Herewith he has established for me the lowest gross I have ever experienced. I hurt all over."

DANIEL KORMAN, Palace Theatre, Ontario, Canada, *Motion Picture Herald*, February 28, 1942

In *Citizen Kane*, Orson Welles both directed and acted the first film noir antihero. Charles Foster Kane is alienated, obsessed, and doomed. Welles was a twenty-five-year-old émigré from radio when he played the eponymous publisher, aging from twenty to seventy in the course of the story. Photographs by Alex Kahle.

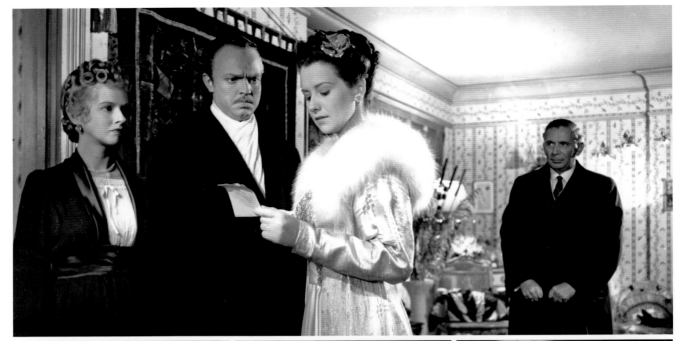

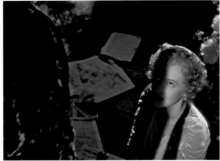

Top: In this shadowy scene from *Citizen Kane* are: (l. to r.) Dorothy Comingore, Orson Welles, Ruth Warrick, and Ray Collins.

Citizen Kane was the vanguard of film noir. The film's visual innovations—deep shadows, unorthodox camera angles, nightmarish montages—would become film noir conventions.

Opposite: In this scene from *Citizen Kane*, Ruth Warrick defies Ray Collins (in silhouette) in order to save herself and her son. Photograph by Alex Kahle.

ARTIST COMMENT

"I had this terrible sense that a film was dead—a piece of film that would just be run through a projection machine. I didn't want that. That is why my films are strongly stated. I can't believe that people won't fall asleep unless my films are theatrical. For myself, unless a film is hallucinatory, unless it becomes that kind of an experience, it doesn't come alive."

ORSON WELLES in Barbara Leaming's *Orson Welles*

THE MALTESE FALCON

WARNER BROS. PICTURES
PREMIERED OCTOBER 18, 1941

Producer
HAL WALLIS

Director-writer
JOHN HUSTON

Source
THE DASHIELL HAMMETT NOVEL

Cinematographer
ARTHUR EDESON

Unit stills photographer
MACK ELLIOTT

Stars
HUMPHREY BOGART
MARY ASTOR
SYDNEY GREENSTREET
PETER LORRE

WHILE INVESTIGATING THE MURDER OF HIS BUSINESS PARTNER, A DETECTIVE IS PULLED INTO A QUEST FOR A FABULOUS WORK OF ART.

PRODUCTION QUOTE

"I know now why most of the camera 'business' I wrote in my scenarios wasn't followed. It couldn't be!"

JOHN HUSTON, *Los Angeles Times*, October 19, 1941

REVIEWS

"John Huston sets the mood in this picture with suspenseful long shots, ceilings on sets to create a feeling of confinement, and extra wide-angle lenses—tricks used by Orson Welles."

BOB HALL, "Dad's Boy," *Hollywood* magazine, August 1942

"Critics have found *The Maltese Falcon* to be the freshest and most original film seen in New York since *Citizen Kane* [which opened the previous May]. It is also the most cynical, depraved, and brilliantly melodramatic. There isn't an honest motive in the entire cast—which is why we accept the characters as real people."

RICHARD GRIFFITH, *Los Angeles Times*, October 14, 1941

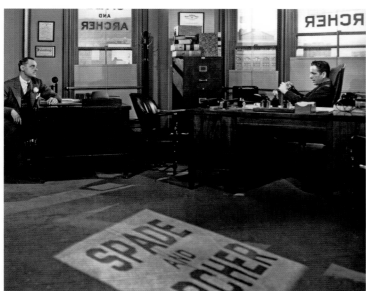

LETTER FROM REGIONAL THEATER OWNER

"The picture is too long and talky. Its title is meaningless. Bogart is miscast. My patrons tell me they like him best as a crook."

E. M. FREIBURGER, Paramount Theatre, Dewey, Oklahoma, *Motion Picture Herald*, January 17, 1942

ARTIST COMMENT

"It was Huston's script, Huston's picture. He had the wit to keep Hammett's book intact. His shooting script was a precise map of what went on. Every shot, camera move, entrance, exit was down on paper, leaving nothing to chance, inspiration, or invention. Of course you don't know you're making history while you're in there making it."

MARY ASTOR, *A Life on Film*

The Maltese Falcon cost $375,000. It grossed $1.7 million.

Above left: *The Maltese Falcon* crystallized the film noir antihero, a slightly tarnished detective who works from a slightly rundown office. We see Jerome Cowan and Humphrey Bogart in their native milieu.

Above right: Lee Patrick plays the detective's secretary, as excited as her boss when the fabled "black bird" arrives.

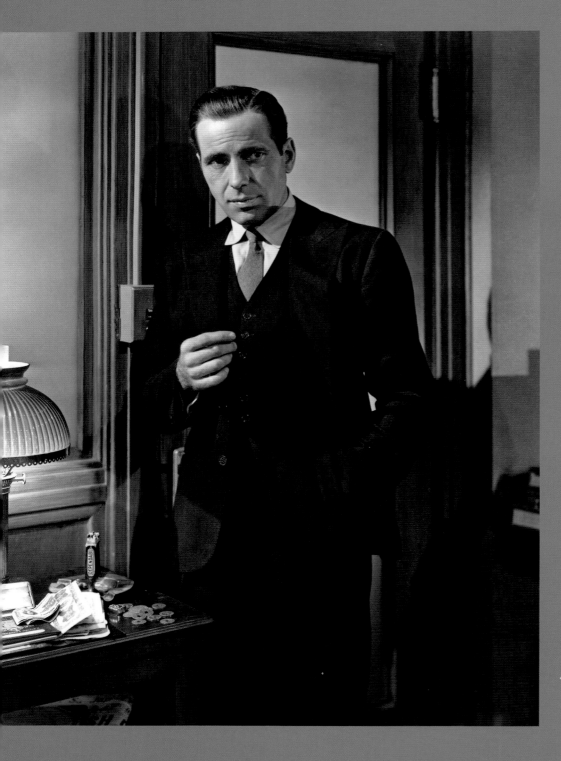

Humphrey Bogart got the role of Sam Spade after George Raft turned it down, telling studio boss Jack Warner that *The Maltese Falcon* was "an unimportant picture." Bogart told *Photoplay*: "All I ask is that Paul Muni and George Raft be given the good roles here. In that way I get to do them eventually." When Raft saw what the film had done for Bogart, he said, "There, but for the grace of me, go I.

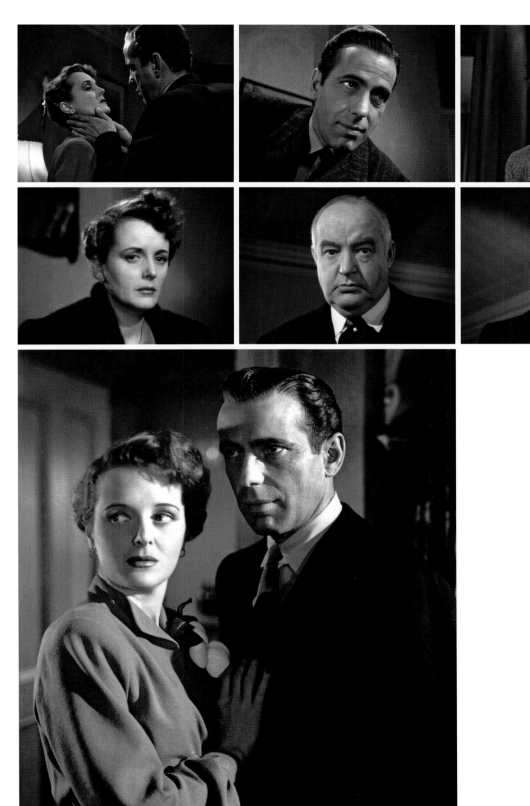

Above: As a film noir protagonist, Bogart was able to menace everyone: Elisha Cook Jr., Mary Astor, Sydney Greenstreet, and Peter Lorre. There had never been a film with so many rotten characters. "There wasn't one decent person in the whole picture," said Cook in 1986. "And look what a film it was."

Left: Mary Astor as Brigid O'Shaughnessy and Humphrey Bogart as Sam Spade in *The Maltese Falcon*.

I WAKE UP SCREAMING

TWENTIETH CENTURY–FOX
RELEASED OCTOBER 18, 1941

Producer
MILTON SPERLING

Director
H. BRUCE ("LUCKY") HUMBERSTONE

Screenwriter
DWIGHT TAYLOR

Source
THE STEVE FISHER NOVEL

Cinematographer
EDWARD CRONJAGER

Stars
BETTY GRABLE
VICTOR MATURE • CAROLE LANDIS
LAIRD CREGAR

WORKING TITLE: *HOT SPOT*

THE MURDER OF A WAITRESS-TURNED-MODEL PITS HER PROMOTER AGAINST A SADISTIC DETECTIVE.

REVIEWS

"Most murder mysteries are Bs regardless of budget, but this one is an exception to the rule. H. Bruce Humberstone has obtained results that are all that may be asked of a murder meller with a romantic strain of more than ordinary strength."

Variety, October 22, 1941

"In spite of the fact that it embodies many perceptible tricks of quality melodrama—flashbacks, sharp photography, menace music, and a water-torture pace—*I Wake Up Screaming* is a pretty obvious who-dunit and a strangely unmoving affair. Incidentally, the picture never does make clear who it is that wakes up screaming."

BOSLEY CROWTHER, *The New York Times*, January 17, 1942

This comment on screaming may refer to the offbeat casting of Betty Grable, who was usually singing—not screaming—for Twentieth Century-Fox.

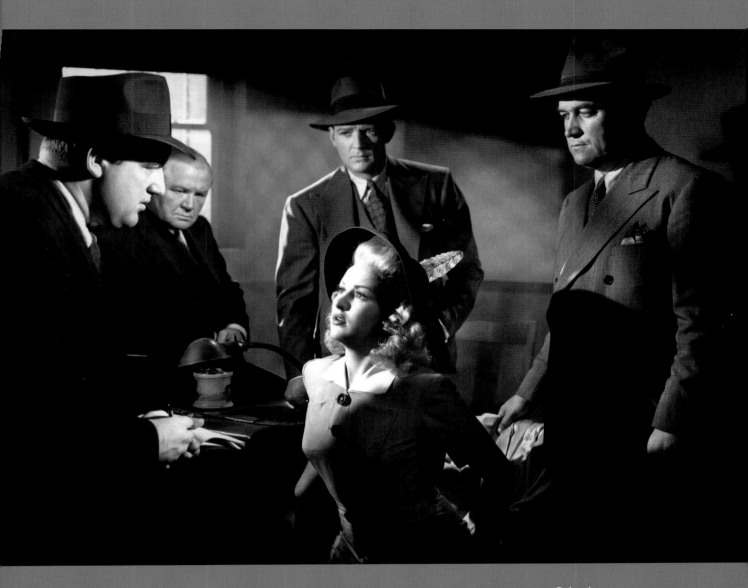

Police lieutenant Cornell (Laird Cregar) grills Betty Grable about the murder of her sister in a scene from H. Bruce Humberstone's *I Wake Up Screaming*.

THE SHANGHAI GESTURE

UNITED ARTISTS
PREMIERED DECEMBER 25, 1941

Producer
ARNOLD PRESSBURGER

Director
JOSEF VON STERNBERG

Screenwriters
GEZA HERCZEG • JULES FURTHMAN
KARL VOLMÖLLER
JOSEF VON STERNBERG

Source
THE JOHN COLTON PLAY

Cinematographers
PAUL IVANO
JOSEF VON STERNBERG

Stars
WALTER HUSTON
GENE TIERNEY
ONA MUNSON • VICTOR MATURE

THE QUEEN OF THE CHINESE UNDERWORLD TRIES TO DESTROY A BRITISH INDUSTRIALIST BY CORRUPTING HIS DAUGHTER.

PRODUCTION QUOTE

"Josef von Sternberg is shooting a scene. 'My children,' Joe says to the hushed mob, 'we're all together in a strange house in Shanghai. It's the gambling hell of Mother Gin Sling. It exists only in my mind. Nothing like it ever existed anywhere. But don't let that cramp you. Try to act like human beings.'"

HEDDA HOPPER, "Looking at Hollywood," *Los Angeles Times*, November 9, 1941

REVIEW

"Yesterday *The Shanghai Gesture* opened before an attendance at Grauman's Chinese Theatre that was bewildered, bored, or impressed, according to individual reaction. This writer confesses to an intermittent combination of all three. When Poppy (Gene Tierney) arrives at the gambling den of Mother Gin Sling (Ona Munson), she says, 'Anything could happen here. Any moment.' The moment is too long delayed. "

PHILIP K. SCHEUER, "*Shanghai Gesture* Bids for Shocker Laurels," *Los Angeles Times*, January 30, 1942

In Joseph von Sternberg's *The Shanghai Gesture*, Ona Munson plays the mysterious Mother Gin Sling. Portrait by Ned Scott.

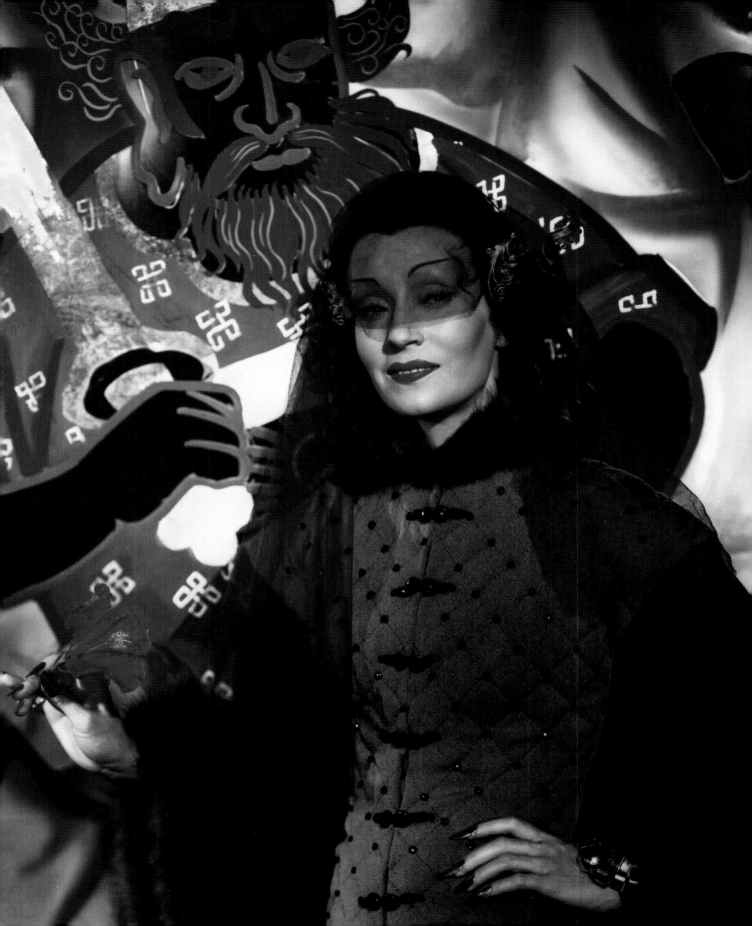

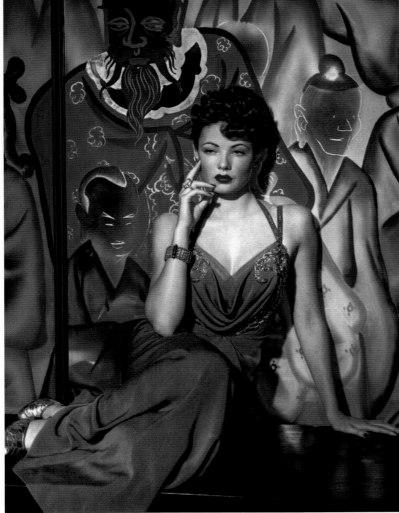

Top: Gene Tierney plays a wealthy young woman who succumbs to the blandishments of the underworld. Portrait by Ned Scott.

Bottom: Mother Gin Sling helps the finishing-school graduate degrade herself.

Opposite: By the end of *The Shanghai Gesture*, Victoria has become Poppy, an opium-addled nymphomaniac.

LETTERS FROM REGIONAL THEATER OWNERS

"Different! Interesting! Pleased all!"

ELINA A. BOLDUC, Majestic Theatre, Conway, New Hampshire, *Motion Picture Herald*, April 4, 1942

"This is the world's worst. More patrons panned this than any picture I have run in seventeen years. I noticed a few fairly good reports on this. There must be a great difference in people within our borders!"

L. V. BERGTOLD, Westby Theatre, Westby, Wisconsin, *Motion Picture Herald*, August 8, 1942

ARTIST COMMENT

"*The Shanghai Gesture* was released to devastating reviews. What had seemed dramatic and crisp on the soundstage struck the critics as hollow and absurd. Years later, in France, strangers would ask me about *The Shanghai Gesture* as if it were a work of art. I learned that the picture was very well regarded."

GENE TIERNEY, *Self-Portrait*

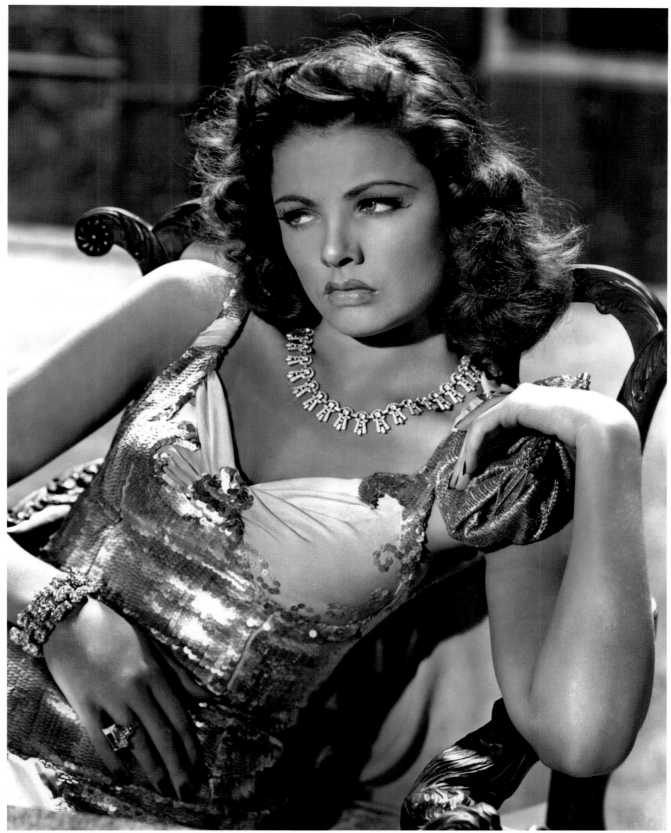

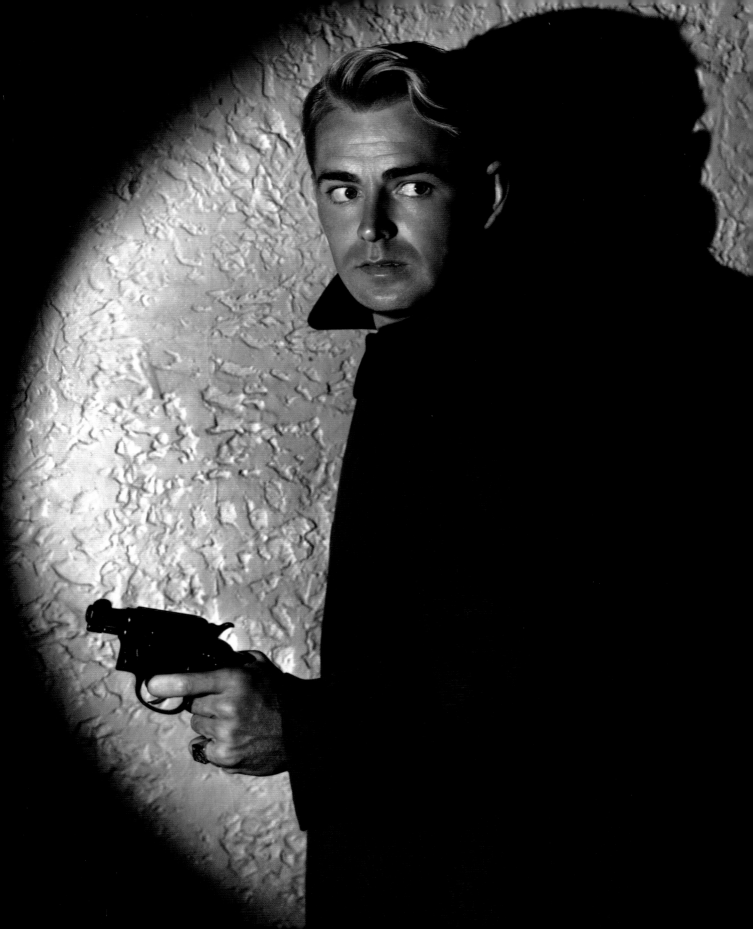

1942-1943

"The shortage of story material
and writers has film companies
seriously ogling the pulp mag scripts
and scripters. It marks the first time
Hollywood has ever initiated a
concerted drive to replenish its
dwindling library of supplies and its
scripter ranks from the twenty-
cents-a-word authors of the weird-
snappy-breezy-argosy-spy-crime-
detective-mag school."

Variety, November 10, 1943

"One shudders to think of
the career which Paramount
must have in mind for
Alan Ladd," wrote Bosley
Crowther in the *New York
Times*. "Obviously, they
have tagged him to be the
toughest monkey loose on
the screen. For not since
Jimmy Cagney massaged
Mae Clarke's face with a
grapefruit has a grim des-
perado gunned his way into
cinema ranks with such vio-
lence." Portrait by A. L.
("Whitey") Schafer.

THIS GUN FOR HIRE

PARAMOUNT PICTURES
RELEASED MAY 13, 1942

Producer
B. G. DeSYLVA

Director
FRANK TUTTLE

Screenwriters
ALBERT MALTZ • W. R. BURNETT
FRANK TUTTLE

Source
THE GRAHAM GREENE NOVEL
A GUN FOR SALE

Cinematographer
JOHN F. SEITZ

Stars
ALAN LADD • VERONICA LAKE
ROBERT PRESTON
LAIRD CREGAR

A HIRED KILLER IS PULLED INTO AN INTRIGUE OF FIFTH COLUMNISTS WHEN HE IS TREATED KINDLY BY A DETECTIVE'S GIRLFRIEND.

REVIEW

"This gangster film with a patriotic twist was tradeshown at the Ambassador Hotel Theatre, to an audience of exhibitors and critics which pronounced it excellent entertainment. Its script is a demonstration of skill and artifice in the maintenance of tension, withholding disclosures only until they mean the most to the picture and indulging in no routine deceptions for the sake of the finale."

WILLIAM R. WEAVER, *Motion Picture Herald*, March 21, 1942

LETTER FROM REGIONAL THEATER OWNER

"Our audience was so hushed during the runoff of this that one might have supposed that they had ceased to exist. They liked it that much."

Palace Theatre, Penacook, New Hampshire, *Motion Picture Herald*, October 17, 1942

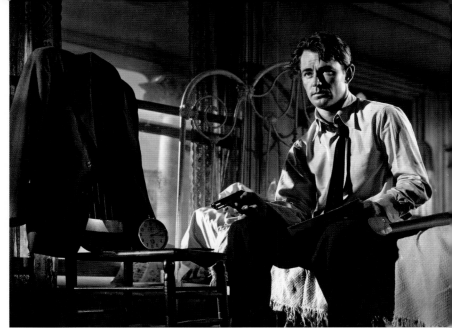

Top: Alan Ladd in a scene from Frank Tuttle's *This Gun for Hire*.

Bottom: In *This Gun for Hire*, Raven (Alan Ladd) treats a little girl (Virita Campbell) with kindness while completing a homicidal assignment.

ARTIST COMMENT

"Sitting there in that theater for the preview, I heard every cough in the house. I saw every head turn. I watched every kid fidget. When anybody got up to go out, my heart flopped to my socks. My heart raced like a P-38's engine. I didn't even know what the picture was about."

ALAN LADD in Kirtley Baskette's "Killer Diller," *Modern Screen*, October 1942

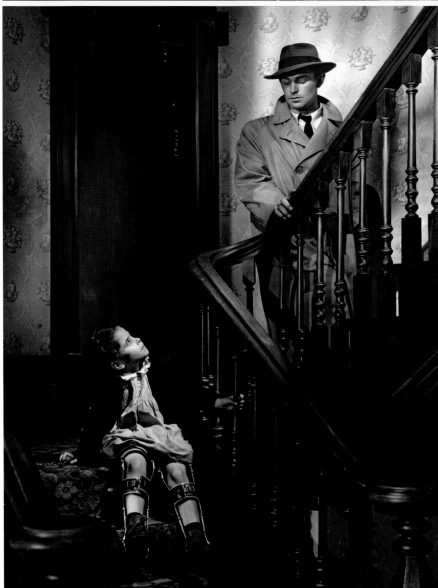

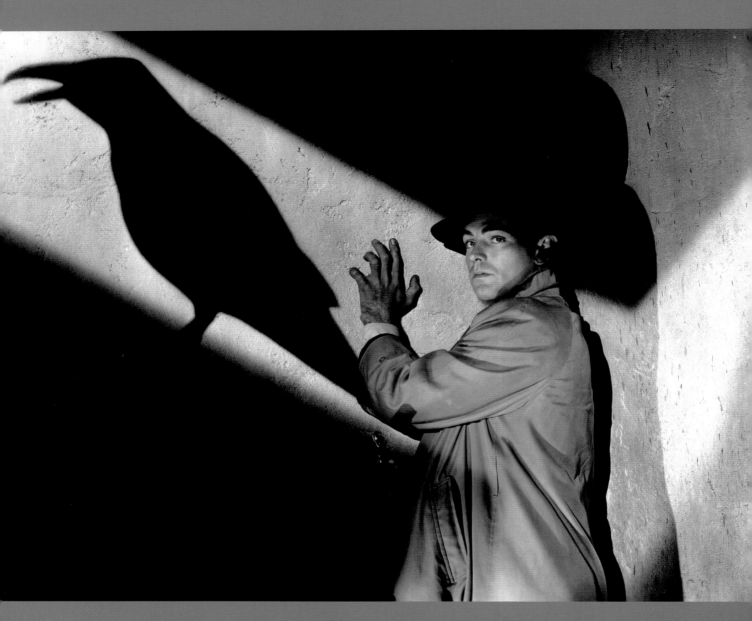

Above: After years as
a dress extra and bit player,
Alan Ladd became a star
by going into the shadows.

Opposite: "Whitey"
Schafer made this poster
art of Veronica Lake and
Alan Ladd to publicize
This Gun for Hire.

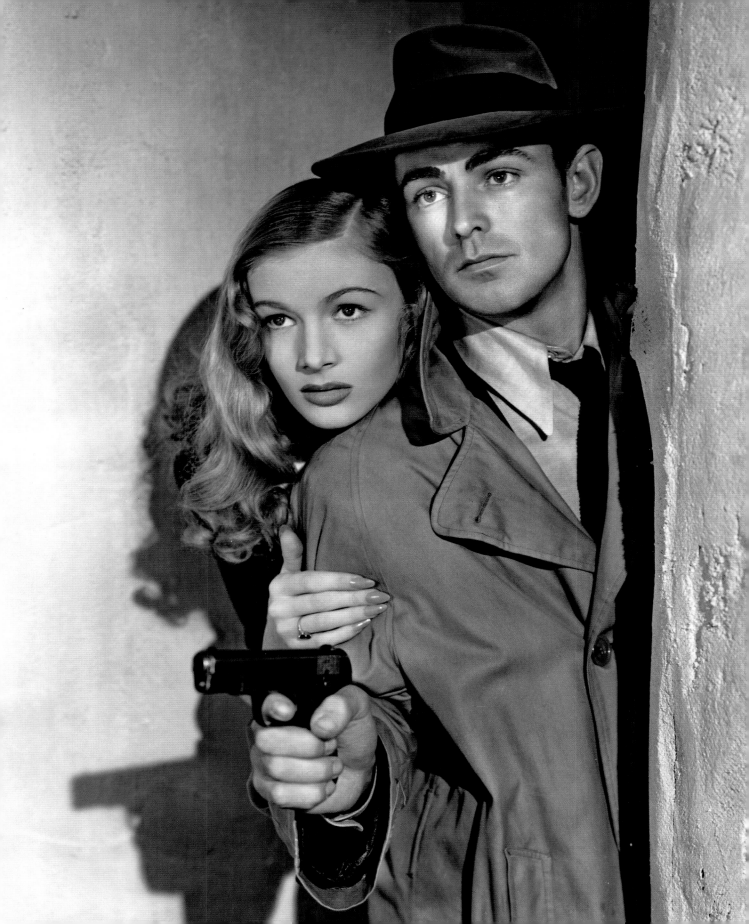

THE GLASS KEY

PARAMOUNT PICTURES
RELEASED OCTOBER 23, 1942

Producer
B. G. DeSYLVA

Director
STUART HEISLER

Screenwriter
JONATHAN LATIMER

Source
THE DASHIELL HAMMETT NOVEL

Cinematographer
THEODOR SPARKUHL

Stars
VERONICA LAKE
ALAN LADD
BRIAN DONLEVY

THE LOYAL ASSISTANT OF A CORRUPT POLITICIAN MUST PROVE THAT HIS REFORMED BOSS DID NOT COMMIT A MURDER.

REVIEW

"When it comes to writing neat mystery thrillers, no one can touch Dashiell Hammett. In case you've forgotten, Paramount's *The Glass Key* will jog your memory. Hammett characters are always audacious. In *The Glass Key* there are some that get over beautifully. Others tend to irritate. Director Stuart Heisler has confused 'hard-boiled' with 'acrimonious.' No one dreams of seeing a Hammett type—man or woman—portrayed as saintly; at the same time, caution must be exercised to keep them from rubbing us the wrong way."

PHILIP K. SCHEUER, *Los Angeles Times*, January 15, 1943

LETTER FROM REGIONAL THEATER OWNER

"Did fair business despite gas rationing, cold weather, and war-depressed minds. Guess it would have taken more than that to keep the women from coming to see Alan Ladd—oh, and what a 'lad'!"

TERRY AXLEY, New Theatre, England, Arkansas, *Motion Picture Herald*, January 30, 1943

Eliot Elisofon made this portrait of Veronica Lake to publicize Stuart Heisler's *The Glass Key*.

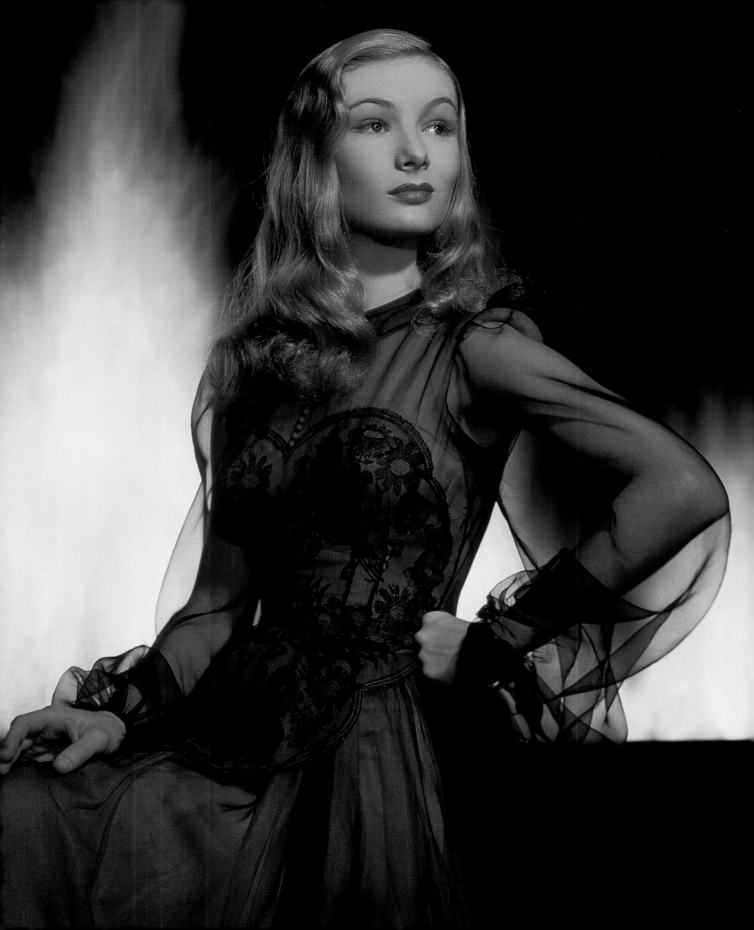

THE SEVENTH VICTIM

**RKO RADIO PICTURES
RELEASED AUGUST 21, 1943**

Producer
VAL LEWTON

Director
MARK ROBSON

Screenwriters
CHARLES O'NEAL
DEWITT BODEEN

Cinematographer
NICHOLAS MUSURACA

Stars
TOM CONWAY
JEAN BROOKS
KIM HUNTER

A NAÏVE YOUNG WOMAN FINDS THAT HER MISSING SISTER HAS BECOME INVOLVED WITH SATANISTS

REVIEW

"Hard-boiled mystery fans will be disappointed that none of the devil-worship society's horrific rites are disclosed, but there are enough thrills and chills to make up. Indeed, at the Hawaii Theatre yesterday, loud screams greeted several creepy sequences."

GRACE KINGSLEY, *Los Angeles Times*, December 24, 1943

LETTER FROM REGIONAL THEATER OWNER

"This is the worst one of this series. It has a terrible ending. Pass it up."

RALPH RASPA, State Theatre, Rivesville, West Virginia, *Motion Picture Herald*, May 13, 1944

ARTIST COMMENTS

"*The Seventh Victim* had a rather sinister quality, of something intangible but horribly real. It had an atmosphere. I think the actors and the director had to believe very strongly in the possibilities of disaster, that something was there. We believed it ourselves. We talked ourselves into believing it."

MARK ROBSON in Charles Higham and Joel Greenberg's *The Celluloid Muse*

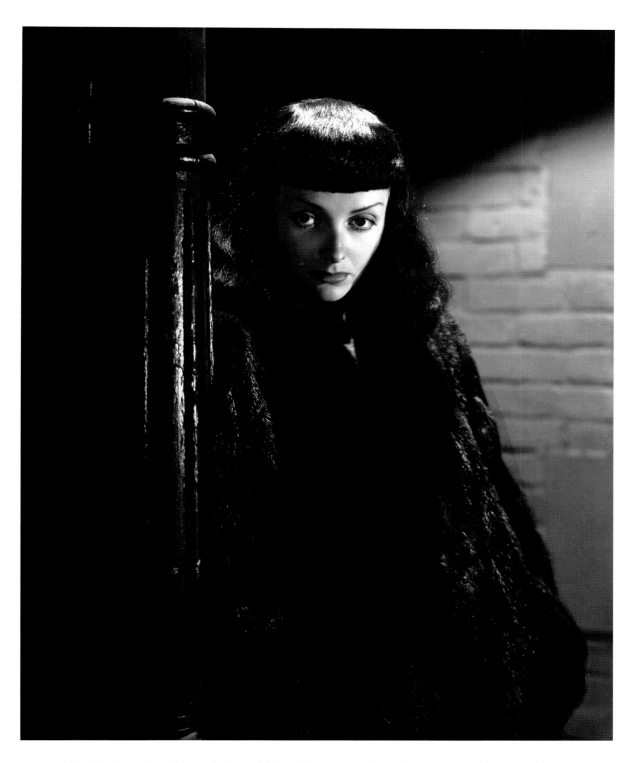

Jean Brooks as Jacqueline in *The Seventh Victim*. "The picture achieved some notoriety after the war," recalled Mark Robson. "They used to bicycle a print of it around London. The directors Carol Reed and Alberto Cavalcanti thought it was an advanced, weird form of filmmaking."

CHAPTER 2

Cynical

(1944–1945)

1944

REPORTS ON THE CRIME STORY CYCLE

"The success of *Phantom Lady*, produced by Joan Harrison, who was schooled in the Hitchcock company, stacks up as a demonstration that the field of upper-bracket chillers is not closed to competition. The market has presented no proof that readiness, even eagerness for million-dollar thrillers is lacking. On the contrary, it has presented evidence, in its acceptance of B-type thrillers so long and loosely utilized for the purpose of filling the secondary spot on a double bill, that the hunger for vicarious excitement is constant and dependable."

"Market Appears Ready for Thriller Films," *Motion Picture Herald*, May 13, 1944

"There is a new honesty in pictures, and it is most strongly evidenced in the crime story. This, I think, is the dominant—and most encouraging—'trend' of 1944. It is the only trend (I dislike the word, but it will have to do) that holds out any hope for the intelligent minority among filmgoers. As a term, 'crime story' must be interpreted loosely. It ranges from the half-world of Martinique in *To Have and Have Not* to the psychological-murder milieu of *Double Indemnity*. Two films in 1941 gave us the first working models for this new honesty in technique: *Citizen Kane* and *The Maltese Falcon*. It has taken three years to reach fruition."

PHILIP K. SCHEUER, "New Honesty Shown in Picture Making," *Los Angeles Times*, December 24, 1944

"Thanks to *Murder, My Sweet*, 1944 may go down in picture history as the year in which Hollywood boosted the crime picture from its accepted state as the old reliable of the B bracket, gave it the gold dust treatment, peddled it nicely, and then saw that gold dust grow into comforting chunks of bullion."

The Hollywood Reporter, March 23, 1945

LOOKING BACK AT FILM NOIR

"A man who makes movies, and, certainly somebody like myself that makes all kinds of movies, works in different styles. As a picture maker, I am not aware of patterns. We're not aware that 'This picture will be in this genre.' It comes naturally, just the way you do your handwriting. You don't do it consciously."

BILLY WILDER in Alain Silver, James Ursini, and Robert Porfirio's *Film Noir Reader 3*

p. 48: A Frank Powolny portrait of Gene Tierney as Ellen in John Stahl's *Leave Her to Heaven*.

Opposite: Claire Trevor is the definitive femme fatale in Edward Dmytryk's *Murder, My Sweet*. Photograph by John Miehle.

PHANTOM LADY

**UNIVERSAL PICTURES
RELEASED FEBRUARY 17, 1944**

Producer
JOAN HARRISON

Director
ROBERT SIODMAK

Screenwriter
BERNARD C. SCHOENFELD

Source
THE WILLIAM IRISH NOVEL

Cinematographer
ELWOOD BREDELL

Stars
FRANCHOT TONE
ELLA RAINES
ELISHA COOK, JR.

AN INNOCENT MAN WILL BE
SAVED FROM EXECUTION IF HE
CAN FIND THE WOMAN WHO
IS HIS ALIBI.

PRODUCTION QUOTE

"Universal has found its 'Phantom
Lady.' Fay Helm will do the role. It's
one of those parts, of course, which
gets into the plum classification,
because a very particular type is
required. A number of actresses were
tested for the assignment, and there is
plenty required of its interpreter.
Phantom Lady is the first feature for
Joan Harrison, lone feminine pro-
ducer of Hollywood."

EDWIN SCHALLERT, *Los Angeles Times*,
September 30, 1943

REVIEW

"Something was bound to happen
when a former Alfred Hitchcock pro-
tégée and a former director of
German horror films were teamed on
the Universal lot—something severe
and unrelenting, drenched in creep-
ing morbidity and gloom. And that
something, which Miss Joan Harrison
and Robert Siodmak have evolved, is
a little item called *Phantom Lady*."

BOSLEY CROWTHER, *The New York Times*,
February 18, 1944

In Robert Siodmak's *Phantom Lady*, Franchot
Tone plays a psychotic architect who intends to
let an innocent friend be executed.

Opposite top: *Phantom Lady* features a knockout jam session. "There is no dialogue," wrote John T. McManus in *PM*, "just the hottest of hot music, one drink of what looks like gin, a madder-than-mad flight on the drums, and, at the end of it, a drummer who's hopped up like a reefer addict."

Opposite bottom: Thomas Gomez plays a patiently methodical detective in *Phantom Lady*.

Above: Woody Bredell's lighting took audiences to a dark place in *Phantom Lady*.

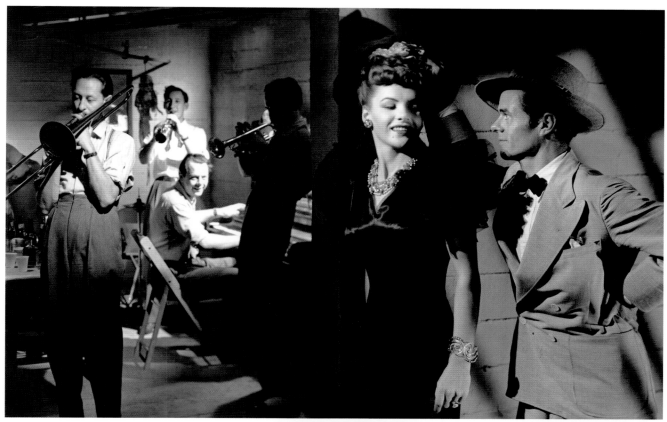

LETTER FROM REGIONAL THEATER OWNER

"A tense, dramatic mystery that proves to be just a fair draw to our small-town patronage."

LEONARD J. LEISE, Rand Theatre, Randolph, Nebraska, *Motion Picture Herald*, June 24, 1944

ARTIST COMMENT

"I was under contract to Universal, and, as is usual in the film city, if you are successful at making a certain type of picture, then you are given more of them to make."

ROBERT SIODMAK in Joseph Greco's *The File on Robert Siodmak, 1941–1951*

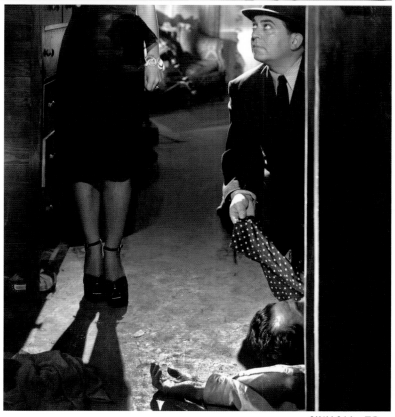

DOUBLE INDEMNITY

**PARAMOUNT PICTURES
RELEASED SEPTEMBER 6, 1944**

Producer
B. G. DeSYLVA

Director
BILLY WILDER

Screenwriters
BILLY WILDER • RAYMOND CHANDLER

Source
THE JAMES M. CAIN NOVEL
IN THE OMNIBUS *THREE OF A KIND*

Cinematographer
JOHN F. SEITZ

Unit stills photographer
ED HENDERSON

Stars
FRED MacMURRAY
BARBARA STANWYCK
EDWARD G. ROBINSON

FOR BOTH LOVE AND MONEY, AN INSURANCE SALESMAN CONSPIRES WITH A CUSTOMER TO MURDER HER HUSBAND.

PRODUCTION QUOTES

"George Raft turned the role down flat. We knew then that we'd have a good picture. He always turns the good ones down."

BILLY WILDER in Philip K. Scheuer's "Film History Made," *Los Angeles Times*, August 6, 1944

Raft refused *High Sierra*, *The Maltese Falcon*, and *Casablanca*.

"James M. Cain and Raymond Chandler each had a hand in the writing of *Double Indemnity*. Cain wrote the novel and Chandler the script. Both happen to be my favorite novelists in the hard-boiled crime field. Cain and Chandler are agreed (although they met but once, at lunch) that the yarn should be treated psychologically. It is Fred MacMurray who dictates the story, or confession. The idea is to make him an understandable murderer and even (if the Hays Office will please look the other way) sympathetic to a degree. The film will be unique, but so are the two men who are conceiving it."

PHILIP K. SCHEUER, "Crime Pair Write Film Whodunit," *Los Angeles Times*, September 12, 1943

"I visited Barbara Stanwyck on the set of her new picture. In it, she schemes to kill one man and shoots another. 'How did you ever get away with that role?' I asked her.

"'Easy,' she answered. 'No objections. The story proves that crime doesn't pay.'

"'But the sweater. The sweater! How did the Hays Office ever let that get by?'

"'What's wrong with it? The picture is very moral. It's anti-crime and anti-sweater. It shows what happens if you fall for a gal who wears a sweater.'"

SIDNEY SKOLSKY, "She Frightened Herself," *New York Evening Post*, August 24, 1943

REVIEW

"*Double Indemnity* has Barbara Stanwyck and Fred MacMurray as a pair of murderers who don't get away with it, but while they are carrying out their nefarious scheme and struggling to keep from being found out, they take their audience with them every step of the tense way. At one point the audience, keyed up to the breaking point, finally let go with a long, drawn out 'Eeeek!' as the guilty pair escaped detection by a hair's breadth."

JANE CORBY, *Brooklyn Daily Eagle*, September 7, 1944

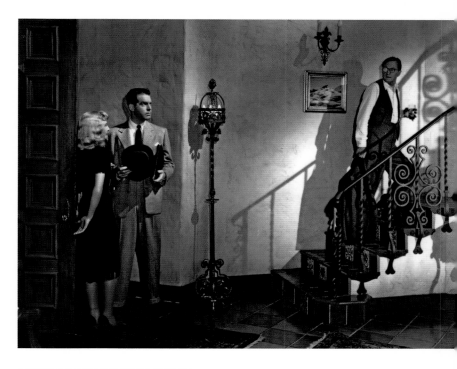

LETTER FROM REGIONAL THEATER OWNER

"Big stars wasted on a gruesome murder subject. Business was way, way off, yet we were charged stiff prices. The indemnity we paid was indeed double."

N. W. HUSTON, Liberty Theatre, Columbus, Kansas, *Motion Picture Herald*, February 25, 1945

ARTIST COMMENTS

"I wanted to do the script with James M. Cain, but he was doing a Western for Twentieth Century-Fox, so Raymond Chandler seemed the best choice. Raymond was a kook, a crazy man, but he had a wonderful flair. It was, incidentally, the first time he had worked on a script, or been inside a studio."

BILLY WILDER in Charles Higham and Joel Greenberg's *The Celluloid Muse*

Stanwyck, MacMurray, and Tom Powers in the "California Spanish" home designed by Hal Pereira for Billy Wilder's *Double Indemnity*.

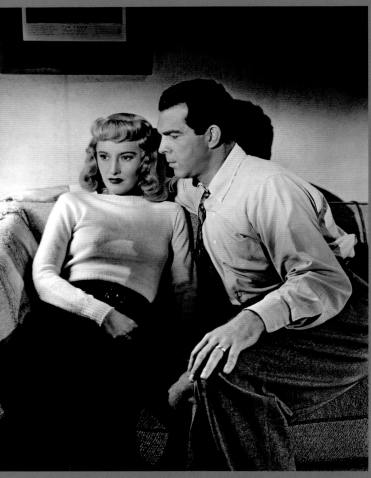

Left: Stanwyck and Mac-Murray conspire in *Double Indemnity*. Lighting by John Seitz, photograph by Ed Henderson.

Right: Phyllis Dietrichson was Stanwyck's first portrayal of a character without a conscience. "Roles in which actresses play evil women sometimes make a deep impression," said Stanwyck later. Portrait by A. L. ("Whitey") Schafer.

Opposite top: Edward G. Robinson was the conscience of *Double Indemnity*. This scene caused audiences to say "Eeeek!"

Opposite bottom: Robinson watching MacMurray go to the gas chamber was the original ending of *Double Indemnity*. For reasons lost to history, Wilder cut this scene.

"I must say Billy Wilder did a terrific job. It's the only picture made from my books that had things in it I wish I had thought of. Wilder's ending was much better than my ending, and his device for letting the guy tell the story by talking to the office dictating machine—I would have done it if I had thought of it."

JAMES M. CAIN in Patrick McGilligan's *Backstory 1*

Double Indemnity cost $927, 262 and grossed $2.5 million.

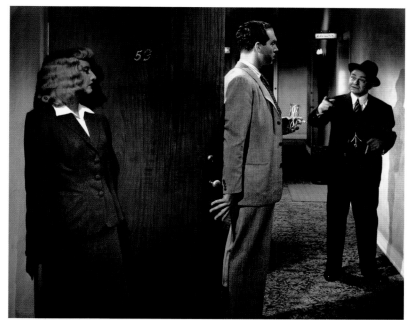

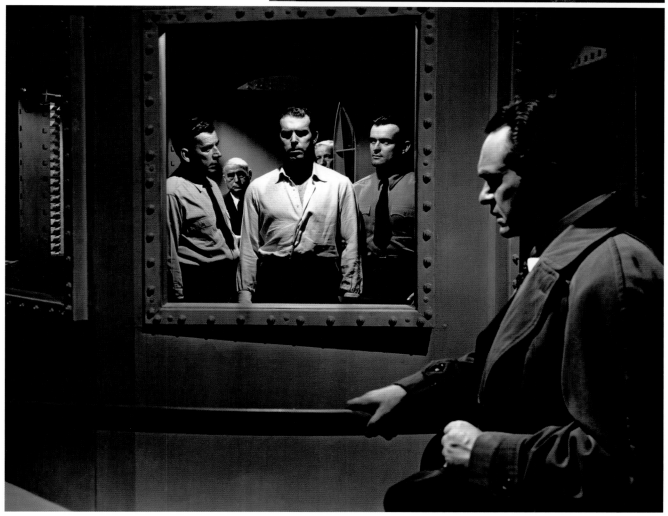

LAURA

TWENTIETH CENTURY–FOX
RELEASED OCTOBER 11, 1944

Producer-director
OTTO PREMINGER

Screenwriters
**JAY DRATLER • SAMUEL HOFFENSTEIN
BETTY REINHARDT**

Source
THE VERA CASPARY NOVEL

Cinematographer
JOSEPH LaSHELLE

Stars
**GENE TIERNEY
DANA ANDREWS • CLIFTON WEBB
VINCENT PRICE**

A DETECTIVE INVESTIGATING A MURDER IS MESMERIZED BY A PORTRAIT OF THE VICTIM.

PRODUCTION QUOTE

"We were on the bathroom set of *Laura*. You never saw a bath like this one, not even in those early DeMille pictures. Clifton Webb is sitting in it. In this picture, he plays the acid-etched role of Waldo Lydecker, a combination of columnists Cholly Knickerbocker and Alex Woollcott. 'If interviewing me in the bath isn't an occasion, I'd like to know what is,' said Clifton. 'I *would* spend my first day before the camera sitting in luke-warm water. Sort of limits me.'

"'Nice little place you've got here,' I said.

"'That's what Dana Andrews says to me when he comes to question me about Laura's murder,' replied Clifton. 'And I love my reply. "It's lavish. I call it home."' Clifton went on to explain the psychology of his role, describing Waldo as 'an original, a sybarite, a species of adder turned out by Sulka and Charvet.'"

HEDDA HOPPER, *Los Angeles Times*, June 4, 1944

The waspish writer and the laconic detective square off; a scene still of Clifton Webb and Dana Andrews from Otto Preminger's *Laura*.

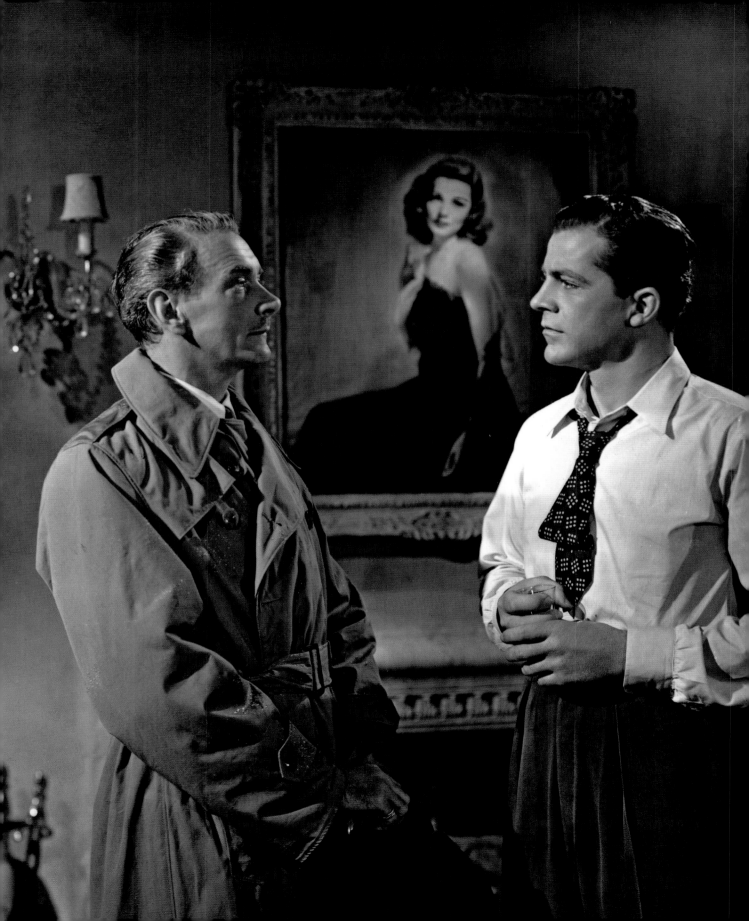

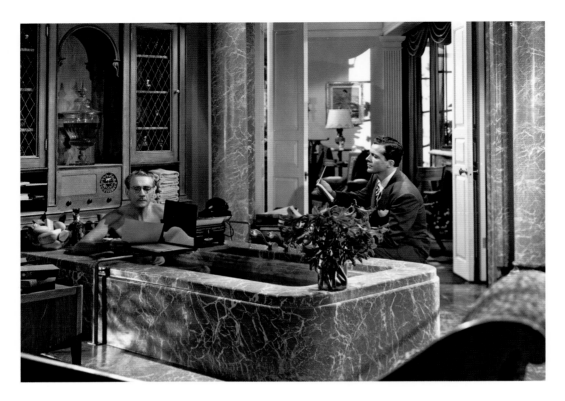

Above: Detective Mark McPherson is forced to question Lydecker in his bathroom.

Opposite: The portrait becomes a focal point for an obsession.

REVIEW

"It is amazing how you are captivated by the individual scenes in *Laura*. There is one that is outstandingly enacted by Andrews, while he is alone in the apartment of the murdered woman. A portrait hanging on the wall reveals the magic that she exerts and is a symbol of this spell. It is action carried out without a single word being spoken, yet it is remarkably compelling. The audience at the Fox Wilshire last night quite evidently fell under the hypnotic influence of the scene, for under ordinary circumstances it would have appeared too protracted. But its force was fully conveyed."

EDWIN SCHALLERT, *Los Angeles Times*, November 17, 1944

LETTER FROM REGIONAL THEATER OWNER

"Picture is very well played, but mysteries are not liked here by the general public. I guess they are making too many now. They are overdoing it, as in the case of the war pictures."

M. W. HUGHES, Colonial Theatre, Astoria, Illinois, *Motion Picture Herald*, May 26, 1945

QUOTE FROM TRADE ARTICLE

"I remember one time when a Jap air raid broke up a screening of *Laura*. My men spent the next thirty minutes in a foxhole discussing the identity of the murderer in the picture—not the Jap planes overhead."

BRIGADIER GENERAL HAYWARD HANSELL in "Target Tokyo Vivid Telling," *Motion Picture Herald*, May 19, 1945

ARTIST COMMENTS

"I liked the script of *Laura*, but after one reading was unenthused about my role. The time on camera was less than one would like. And who wants to play a painting? In truth, only Otto Preminger had absolute faith in the project."

GENE TIERNEY, *Self-Portrait*

"I understand the people in *Laura*. They're all heels, just like my friends in New York."

OTTO PREMINGER in Victoria Price's *Vincent Price: A Daughter's Biography*

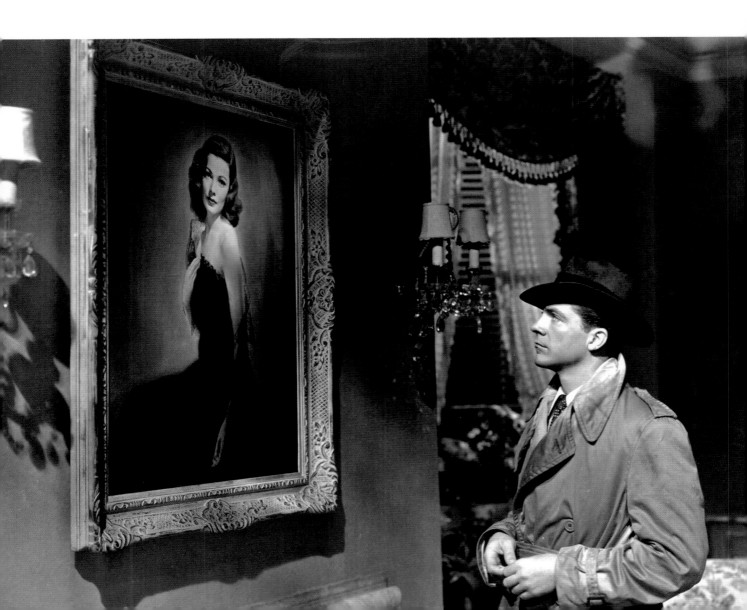

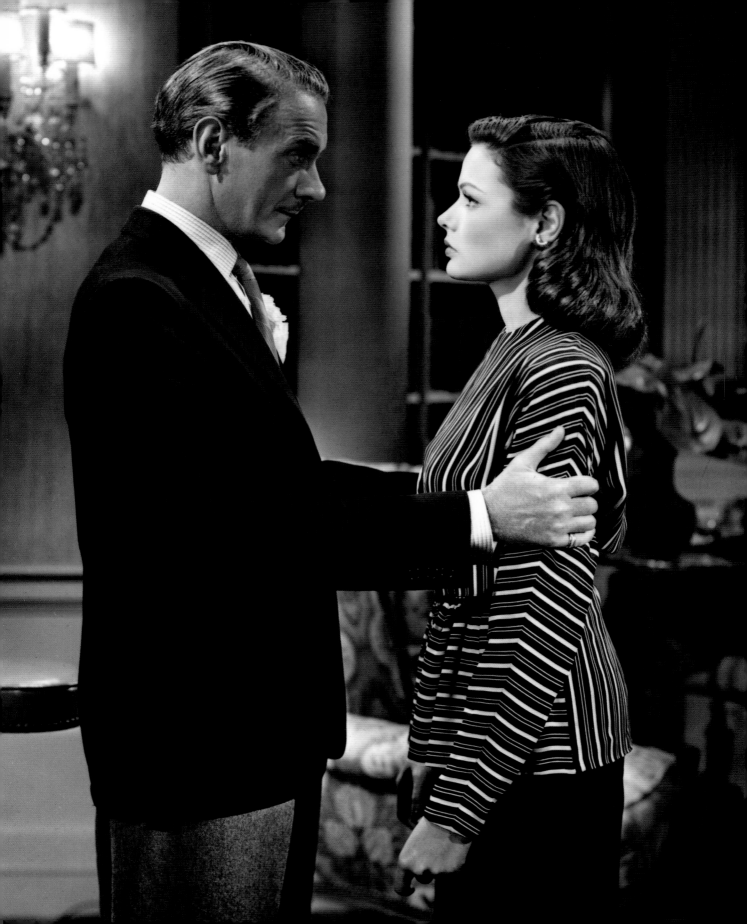

Opposite: *Laura* brought film noir into high society. Clifton Webb portrayed the columnist Waldo Lydecker. Gene Tierney played Laura Hunt, whom Lydecker has raised to stardom in the advertising world.

Right: Lydecker fears that he is losing his protégée.

Bottom: *Laura* was a major hit and advanced many careers. Gene Tierney, Clifton Webb, Dana Andrews, and Vincent Price (seen here) became stars; Otto Preminger became a first-rank director. The film also accelerated the cycle of "mystery thrillers" later known as film noir.

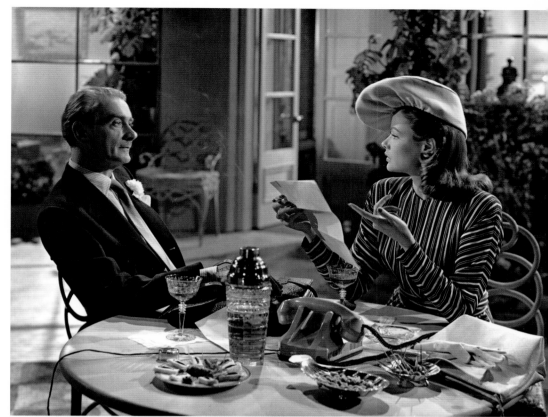

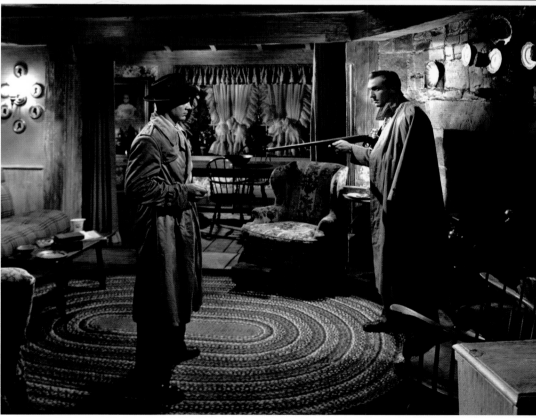

TO HAVE AND HAVE NOT

WARNER BROS. PICTURES
PREMIERED OCTOBER 11, 1944

AN EXPATRIATE AMERICAN FISHERMAN IS PULLED INTO A PARTISAN CONFLICT IN MARTINIQUE WHEN HE FERRIES A SUSPICIOUS CUSTOMER.

PRODUCTION QUOTE

"Lauren Bacall is the minx with the pussy-willow face and poison points. That combination has never failed to make headlines. When I ran into her at Romanoff's, she said, 'Hedda, remember the luncheon Elsa Maxwell gave me on my eighteenth birthday? You said, "Listen, girlie. Don't ever let them put you in a sweet ingénue role. Hold out and you'll make history." Well, I took your advice.'"

HEDDA HOPPER, *Los Angeles Times*, December 5, 1944

Producer
JACK L. WARNER

Director
HOWARD HAWKS

Screenwriters
JULES FURTHMAN • WILLIAM FAULKNER

Source
THE ERNEST HEMINGWAY NOVEL

Cinematographer
SID HICKOX

Unit stills photographer
MAC JULIAN

Stars
HUMPHREY BOGART • LAUREN BACALL
WALTER BRENNAN

REVIEW

"That ultra-aware modernism, 'hep,' is a very handy word to have around for a picture like *To Have and Have Not*. Whatever it may have been as a Hemingway novel, as a film it is now a typically hep Warner Bros. war melodrama, similar in style to *Casablanca*, not quite up to it in meaning, but nevertheless a film which knows all the angles. The 'hepness' of this film is all over it. It is like a rebus of democratic slants and angles. If you look for them, they're in every scene—with Hoagy Carmichael and the girl, singing with a small, hot Negro band; in Bogart's speedboat with Sir Lancelot as his guide to the tuna schools; in Bogart's brushes with the fascist Vichy Gestapo. *To Have and Have Not* has a healthy, democratic flesh tone, and it is not only skin deep."

JOHN T. MCMANUS, "Vichy, Bogart, and a Dame," *PM*, October 12, 1944

LETTER FROM REGIONAL THEATER OWNER

"Another good one from Warners. They all came out to see Miss Bacall on Sunday."

C. H. CAUDELL, V Theatre, Wallace, North Carolina, *Motion Picture Herald*, February 10, 1945

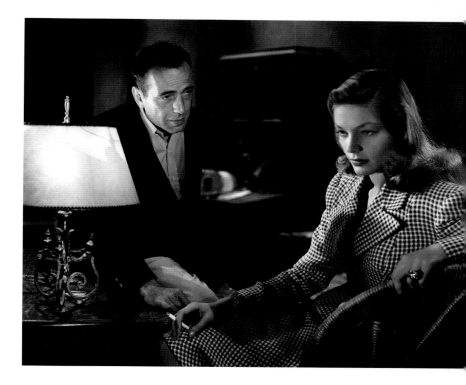

ARTIST COMMENT

"The idea of playing this woman of the world at age nineteen, flirting with the guy, and all this stuff was great fun. But then I was scared to death, because when Howard Hawks would say, 'Quiet on the set,' and the bell would ring, and he'd say 'Action,' there was dead silence. All these people were staring at me. And the camera. It was frightening."

LAUREN BACALL in Mark Cousins's *Scene by Scene: Film Actors and Directors Discuss Their Work*

To Have and Have Not cost $1.55 million and grossed $3.65 million.

"By now," wrote critic John T. McManus, "everybody in America who goes to movies and apparently every American on all the fighting fronts, from Palau to Aachen, is mad about Humphrey Bogart. What will really get them in *To Have and Have Not* is to see their guy tangle with a case-hardened café girl named Lauren Bacall, a blonde, wide-lipped, frankly sexy creature with a voice like the low register of a brass clarinet."

THE WOMAN IN THE WINDOW

CHRISTIE CORPORATION–
INTERNATIONAL PICTURES
DISTRIBUTED BY RKO RADIO PICTURES
RELEASED NOVEMBER 2, 1944

Producer
NUNNALLY JOHNSON

Director
FRITZ LANG

Screenwriter
NUNNALLY JOHNSON

Source
**THE J. H. WALLIS NOVEL
ONCE OFF GUARD**

Cinematographer
MILTON KRASNER

Stars
**EDWARD G. ROBINSON
JOAN BENNETT • DAN DURYEA**

WORKING TITLE: ONCE OFF GUARD

A PORTRAIT IN A GALLERY
WINDOW PULLS A KINDLY
PROFESSOR INTO A NIGHTMARE
OF MURDER AND DECEIT.

REVIEW

"*The Woman in the Window* is a humdinger of a mystery melodrama. Nunnally Johnson has provided a script that is literate, slightly tinged with sophistication and topped off with penetrating satirical thrusts at radio advertising and newsreel coverage of crime stories. The ads have been making quite a to-do about the picture's ending, and rightly so. The ending came as a surprise, sure enough, and we only wish that the code of ethics in matters like this didn't prevent us from revealing the big secret. For this is a trick denouement and it is effected with a brashness which, it is doubtful, even that master melodramatic trickster, Alfred Hitchcock, would attempt."

BOSLEY CROWTHER, *The New York Times*,
January 26, 1945

LETTER FROM REGIONAL THEATER OWNER

"This is an excellent murder mystery which is best enjoyed from the beginning. Not only the direction but also the cast and lighting make it one of the best films of the year. Good business. Everyone enjoyed it."

T. DI LORENZO, New Paltz Theatre,
New Paltz, New York, *Motion Picture Herald*,
February 10, 1945

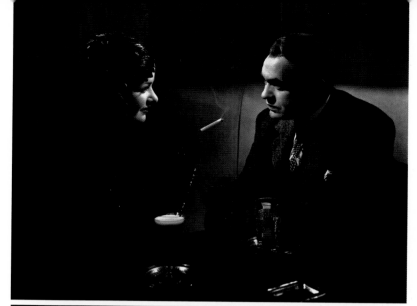

Top: Fritz Lang's *The Woman in the Window* tells the story of a college professor who is entranced by a dreamlike painting. When he meets its subject, his life becomes a nightmare.

Center: *The Woman in the Window* introduced Dan Duryea and Joan Bennett to the world of film noir.

Bottom: Joan Bennett excelled in the role of the apparently sympathetic woman who lures the film noir hero to a predestined demise.

ARTIST COMMENT

"In *The Woman in the Window*, the killing is by chance, without will. The English title of the film, *Once Off Guard*, suggests '*Un moment sans vigilance.*' And during this moment, something happens. The novel's title was not used in America because of the potential confusion with 'Once Off God.'"

FRITZ LANG in Barry Keith Grant's *Fritz Lang: Interviews*

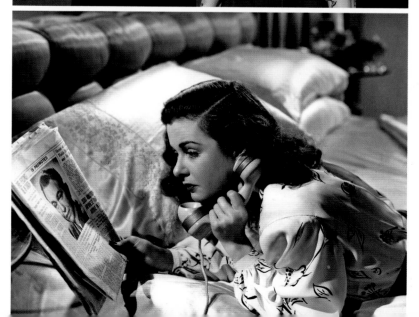

MURDER, MY SWEET

RKO RADIO PICTURES
RELEASED DECEMBER 9, 1944

Producer
ADRIAN SCOTT

Director
EDWARD DMYTRYK

Screenwriter
JOHN PAXTON

Source
**THE RAYMOND CHANDLER NOVEL
FAREWELL, MY LOVELY**

Cinematographer
HARRY J. WILD

Stars
**DICK POWELL
CLAIRE TREVOR • MIKE MAZURKI
ANNE SHIRLEY**

WORKING TITLE: FAREWELL, MY LOVELY

WHEN A PRIVATE DETECTIVE IS HIRED BY A GIANT EX-CON TO FIND A LONG-LOST GIRLFRIEND, TWO CASES MERGE INTO ONE THREATENING MESS.

PRODUCTION QUOTES

"Dick Powell went to work in a new motion picture yesterday which he says will either be 'my best or my last.' The picture is RKO's *Farewell, My Lovely*, in which Dick, once the town's top musical star, plays a private detective. 'It's just what I've been wanting to play for a long time,' said Dick. 'I hope it will do for me what *Night Must Fall* did for Robert Montgomery and what quitting gangster roles did for Jimmy Cagney.'"

ERSKINE JOHNSON, "Dick Powell Without a Song in New Picture," *Elmira Star-Gazette*, June 1, 1944

"This is about the tops in title changes. *Farewell, My Lovely*, which has been exploited so extensively by RKO, is now called *Murder, My Sweet*. The book thrived under the other name."

EDWIN SCHALLERT, *Los Angeles Times*, December 16, 1944

"I can't wait, after playing one of those blonde heels, to get the feel of it off me by changing that platinum back to my own shade of hair color."

CLAIRE TREVOR in Hedda Hopper's "Trevor and Ever," *Los Angeles Times*, April 24, 1948

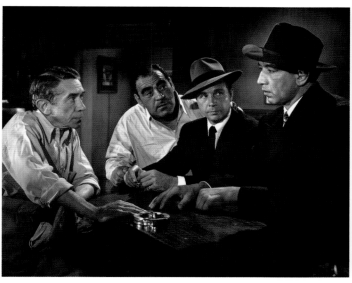

REVIEWS

"Director Edward Dmytryk has made few concessions to the social amenities and has kept his yarn stark and unyielding. In fact, the film gets off to so jet-pulsed a start that it necessarily hits a couple of slow stretches midway as it settles into uniform groove. But interest never flags, and the mystery is never really cleared up until the punchy closing."

Variety, March 14, 1945

"Philip Marlowe is a new type of character for Dick Powell. And while he may lack the steely coldness and cynicism of a Humphrey Bogart, Mr. Powell need not offer any apologies. He has definitely stepped out of the song-and-dance pretty-boy league with this performance."

BOSLEY CROWTHER, The New York Times, March 9, 1945

"Murder, My Sweet transforms Dick Powell from the perennial smirking juvenile to a significant dramatic actor. With really amazing success, Dick sacrifices glamour-boyishness for the near-ugly demeanor of a hard-as-nails detective."

IRENE THIRER, "Dick Powell Totes a Gun!" Brooklyn Daily Eagle, March 10, 1945

LETTER FROM REGIONAL THEATER OWNER

"It is a passable program picture. But I'll dislike running many of these when this easy money era ends, and that is in the offing!"

A. E. HANCOCK, Columbia Theatre, Columbia City, Indiana, Motion Picture Herald, July 28, 1945

Left: The bartender (Ernie Adams), the boss (Dewey Robinson), and detective Philip Marlowe (Dick Powell) listen to Moose Malloy (Mike Mazurki). Moose has hired Marlowe to find the mysterious Velma in Murder, My Sweet.

Right: Marlowe's next client is the effete Lindsay Marriott (Douglas Walton), who needs to buy back a stolen jade necklace.

Opposite: "I don't know anybody by the name of moose!" says Jessie Florian (Esther Howard).

ARTIST COMMENTS

"Dick Powell volunteered to do *Double Indemnity*. He told me, 'I'll do it for nothing.' He knew it would be his way out of those silly things—you know where he was singing smack into Ruby Keeler's face—and he had to get out of those. He came to my office to sell me: 'For Christ's sake, let me play it.' And I told him: 'Well, look, Dick. I can take a comedian and make this picture. But I can't take a singer.' This was before *Murder, My Sweet*. But he was damned good, you know, in *Murder, My Sweet*."

BILLY WILDER in Alain Silver, James Ursini, and Robert Porfirio's *Film Noir Reader 3*

"The producer Adrian Scott and I decided to meet Dick Powell. He was a lot taller [six foot two] and huskier and more masculine than he looked in those Warners musicals. We decided to try him. That was the best thing we ever did."

EDWARD DMYTRYK in Gene D. Phillips's *Creatures of Darkness*

"They released it as *Farewell, My Lovely* in a few theaters, and everybody thought it was a musical because of Dick Powell, so nobody went to see it. That's why we changed the title to *Murder, My Sweet*. Nobody would have any doubt that it *wasn't* a musical."

EDWARD DMYTRYK in Alain Silver, James Ursini, and Robert Porfirio's *Film Noir Reader 3*

"I thought the picture was very well directed by Edward Dmytryk. I had a crush on Dick Powell, but that was when he was going with June Allyson, whom he married not long after. He later became a good friend. I thought he was sensational in *Murder, My Sweet*. To change from a singer in musicals to a dramatic actor was a big jump. It made a whole new career for him."

CLAIRE TREVOR in William M. Drew's *At the Center of the Frame*

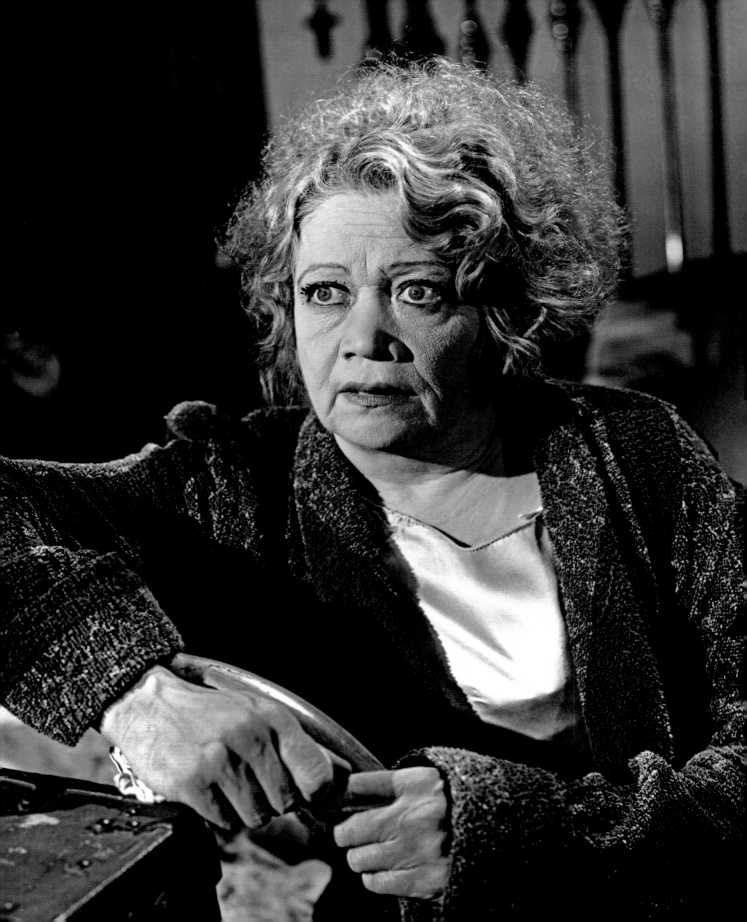

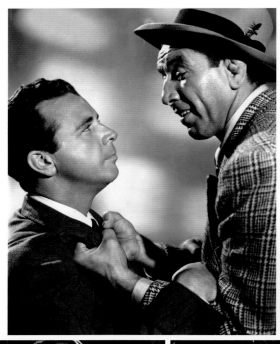

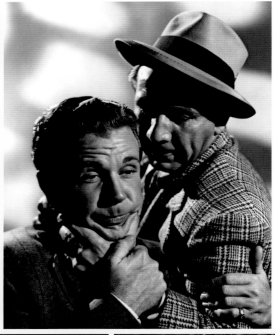

Opposite: Moose Malloy takes Marlowe to visit a quack psychic, Jules Amthor (Otto Kruger). Marlowe is beaten, drugged, and has terrifying hallucinations.

Above: After Marriott is killed, his friend Mrs. Grayle (Claire Trevor), the wife of an eccentric millionaire, agrees to help Marlowe find both the jade and Velma. The climax brings Marlowe to the Grayles' beach house.

Above: Marlowe expounds his solution to the cases.

Opposite: "You know," says Mrs. Grayle, "this will be the first time I've ever killed anyone I knew so little and liked so well."

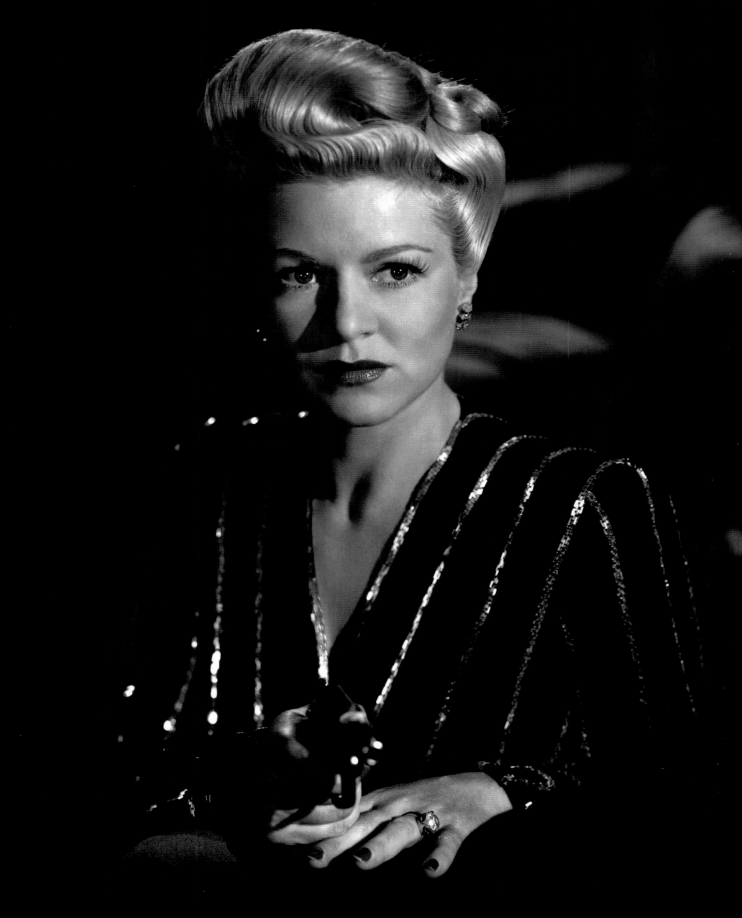

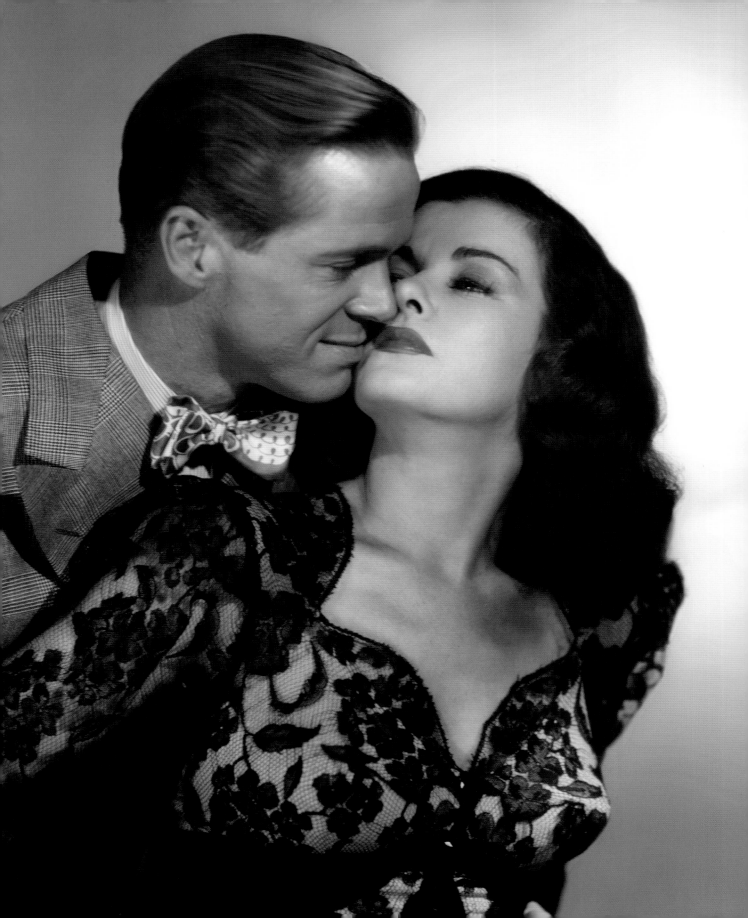

1945

REPORT ON THE CRIME STORY CYCLE

"The modern bad girl is intelligent. She has a mind as well as a body with which to attract men. In the near future we're in for a new series of spectacular shady ladies. Some of Hollywood's nicest girls will play 'em. Rita Hayworth begged and pleaded with her boss Harry Cohn for such a part. Though the Hays Office sees to it that the bad heroines repent before the final fadeout, what fun our actresses, yes, and their audiences, will have before the payoff!"

HEDDA HOPPER, "Sweet-Girl Stars Covet Siren Roles," *Los Angeles Times*, October 21, 1945

LOOKING BACK AT FILM NOIR

"You are a historian of film, and I am not. So you call it 'film noir' if you want. Fine. But when you speak about film noir, why are you interested in lumping people together? I feel very honored to be mentioned in the same breath as Fritz Lang or Alfred Hitchcock; but I don't think we had anything in common."

OTTO PREMINGER in Alain Silver, James Ursini, and Robert Porfirio's *Film Noir Reader 3*

Dan Duryea and Joan Bennett brought sleaziness to film noir in Fritz Lang's *Scarlet Street*. "I felt I needed a bath when *Scarlet Street* ended," wrote Wright Bryan in the *Atlanta Journal*. "The feminine lead has the most completely despicable role since Bette Davis's in *Of Human Bondage*."

MILDRED PIERCE

**WARNER BROS. PICTURES
PREMIERED SEPTEMBER 28, 1945**

Producer
JERRY WALD

Director
MICHAEL CURTIZ

Screenwriter
RANALD MacDOUGALL

Source
THE JAMES M. CAIN NOVEL

Cinematographer
ERNEST HALLER

Stars
**JOAN CRAWFORD
ANN BLYTH • JACK CARSON
EVE ARDEN**

A DIVORCED HOUSEWIFE BECOMES AN AMBITIOUS CAREER WOMAN IN ORDER TO KEEP HER DAUGHTER FROM STRAYING.

PRODUCTION QUOTES

"Zachary Scott has sustained an injury to his sacroiliac, so schedules have been rearranged so that he might spend two days doing his 'corpse' scene and rest his injured spine."

VIRGINIA WILSON, "Mildred Pierce," *Modern Screen*, November 1945

"At a preview of *Mildred Pierce*, something went wrong with the projector lens and Joan Crawford came out with two heads. The audience cheered. But after the mistake was rectified, the audience kept on cheering."

HEDDA HOPPER, "Looking at Hollywood," *Los Angeles Times*, July, 1945

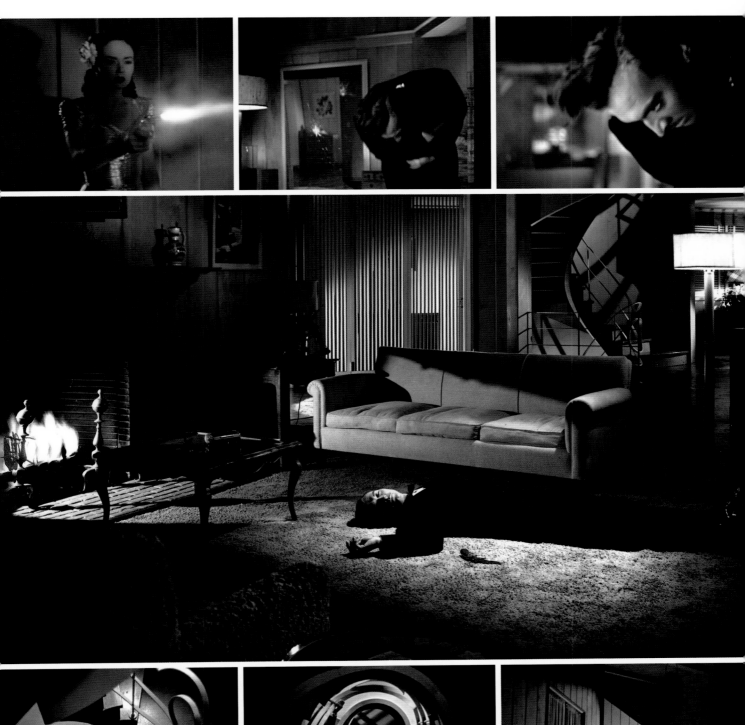

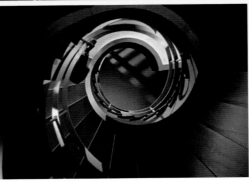
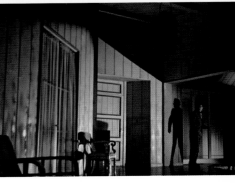

REVIEWS

"Joan Crawford is playing a most troubled lady, and giving a sincere and generally effective characterization of same, in *Mildred Pierce*, which the Warners presented yesterday at the Strand. But somehow all Miss Crawford's gallant suffering left this spectator strangely unmoved. For it does not seem reasonable that a level-headed person like Mildred Pierce, who builds a fabulously successful chain of restaurants on practically nothing, could be completely dominated by a selfish and grasping daughter who spells trouble in capital letters. If you can accept this rather demanding premise—and there were not a few ladies in the Strand who were frequently blotting tears with evident enjoyment—then *Mildred Pierce* is just the tortured drama you've been waiting for."

THOMAS M. PRYOR, *The New York Times*, September 29, 1945

Mildred Pierce is a laggard and somewhat ludicrous movie, and Miss Crawford is self-sacrificial beyond belief. An opening day audience was often moved to laughter."

HOWARD BARNES, *New York Herald Tribune*, September 29, 1945

"To me *Mildred Pierce* presented a commentary on how too many Americans act and think, or would if they had the opportunity. They should be examined in broad daylight so that their actions bring forth from an audience an open expression of disgust—as this picture did when I saw it this week."

MORTON FELDMAN, "From the Readers of the Review of *Mildred Pierce*," *PM*, October 18, 1945

"The chief comment of the critics is that Joan Crawford should have chosen a particularly unsympathetic role for her reappearance after too long an absence from the screen. They think she's terrific but the fact that she chose a straight dramatic role seems to bother the boys. It doesn't bother the ladies, though. They are turning out by the thousands to sit there and sympathize and sob and shudder, and break attendance records at the Wiltern, the Warner Hollywood, and the Warner Downtown."

BILL HENRY, "By the Way," *Los Angeles Times*, October 31, 1945

LETTER FROM REGIONAL THEATER OWNER

"This is a great picture and will certainly keep your audience spellbound."

J. C. BALKCOM, Gray Theatre, Gray, Georgia, *Motion Picture Herald*, January 12, 1946

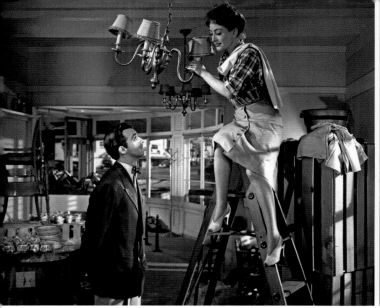
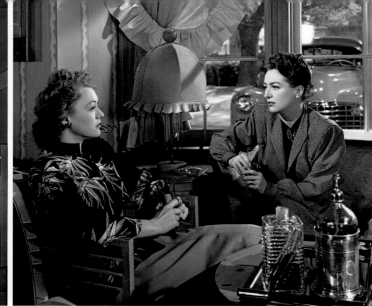

ARTIST COMMENTS

"Warner Bros. had fifty writers under contract, all of us confined in one building that we called the 'Cell Block.' It was a fermenting, creative pudding that made every day interesting. I wrote the *Mildred Pierce* screenplay in about ten weeks, during the actual shooting of the film, and never more than a few days ahead of the camera."

RANALD MACDOUGALL, "Film Writer Hearkens to Television's Siren Song," *Los Angeles Times*, July 9, 1967

"*Mildred Pierce* grossed the studio five million dollars. A happy ending to a big gamble."

JOAN CRAWFORD, *A Portrait of Joan*

Mildred Pierce cost $1.45 million. It grossed $5.63 million.

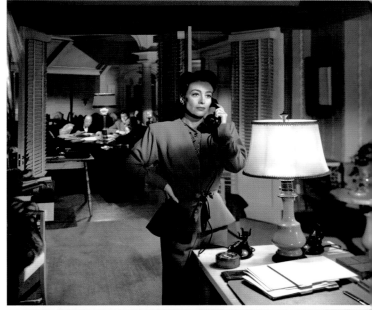

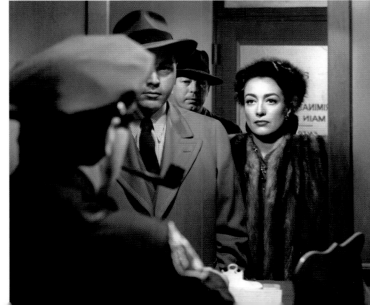

DETOUR

PRODUCERS RELEASING CORPORATION
RELEASED NOVEMBER 7, 1945

Producers
**LEON FROMKESS
MARTIN MOONEY**

Director
EDGAR G. ULMER

Screenwriter
MARTIN GOLDSMITH

Source
**THE GOLDSMITH NOVEL
DETOUR: AN EXTRAORDINARY TALE**

Cinematographer
BENJAMIN H. KLINE

Stars
**ANN SAVAGE
TOM NEAL**

A CROSS-COUNTRY HITCHHIKER
ENDS UP WITH A DEAD MAN'S
CAR AND A BLACKMAILING
PASSENGER.

PRODUCTION QUOTE

"Lew Landers will direct Tom Neal
and Ann Savage in PRC's *Detour*,
based on Martin Goldsmith's novel."

"Showmen's Trade Review," *Motion Picture
Herald*, June 9, 1945

PRC replaced Landers with Edgar
Ulmer, a more "artistic" (and speedy)
director.

REVIEWS

"Venturing far from the familiar
melodramatic pattern, director Edgar
G. Ulmer has turned out an adroit
albeit unpretentious production about
a man who stumbles into a series of
circumstances that seal his doom.
Making no compromise with the
'happy ending' formula, the film has a
number of suspenseful and ironic
moments."

MANDEL HERBSTMAN, "Product Digest,"
Motion Picture Herald, November 10, 1945

"This very poor story has little to
commend it. It tries the unusual by
interspersing dialogue with commen-
tary, and fails. The direction is as poor
as the story. The only bright spot is
Ann Savage's performance, which she
does so well that she leaves a taste of
complete revulsion in the mouth."

P. T., "Detour," *U.K. Monthly Film Bulletin*,
October 1946

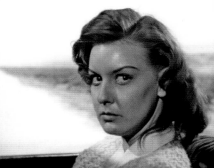

Above: In Edgar G. Ulmer's *Detour*, fate matches a hitchhiking musician (Tom Neal) with a hard-bitten harpy (Ann Savage).

Right: When Fate pulls the strings in a Hollywood hotel room, the string is a telephone cord.

LETTER FROM REGIONAL THEATER OWNER

"PRC continues to surprise us with these little pictures. They have good plots and are well liked in our town."

MRS. M. D. WILLIAMS, Oliver Springs Theatre, Oliver Springs, Tennessee, *Motion Picture Herald*, October 19, 1946

ARTIST COMMENT

"I really am looking for absolution for all the things I had to do for money."

EDGAR G. ULMER in Noah Isenberg's *Edgar G. Ulmer, A Filmmaker at the Margins*

Detour cost $117,000.

THE LOST WEEKEND

PARAMOUNT PICTURES
RELEASED NOVEMBER 16, 1945

Producer-director
BILLY WILDER

Screenwriters
CHARLES BRACKETT
BILLY WILDER

Source
THE CHARLES R. JACKSON NOVEL

Cinematographer
JOHN F. SEITZ

Stars
RAY MILLAND
JANE WYMAN

A NOVELIST STRUGGLES TO AVERT A DEADLY DRINKING BINGE.

PRODUCTION QUOTES

"I'm doing this picture for the hell of it. Hollywood is in a rut. We don't make pictures. We remake 'em. That's what I want to get away from. If the Hays Office suddenly gave us permission to discuss adultery—treat it with tact, I mean—we'd have 1,000 new plots. But, of course, they won't."

BILLY WILDER in Philip K. Scheuer, "Die Cast on Doings of Drunk," *Los Angeles Times*, December 3, 1944

"Prudently deciding that no part of Southern California looks so much like dingy Third Avenue as Third Avenue itself, Billy Wilder chose to make that part of the picture in New York. Thus it was necessary to disguise both the camera apparatus and Ray Milland, who was stubby-bearded, badly mussed, and without makeup. One passing motorist telephoned the Paramount organization in New York to say, 'I just saw Ray Milland dead drunk on Third Avenue. If I were you, I'd try to get hold of him and straighten him out.'"

OLIVER JENSEN, "*Lost Weekend* Hangover," *Life* magazine, March 11, 1946

REVIEWS

"After the preview of *The Lost Weekend*, I heard people criticizing its ending; the transformation in the alcoholic's character was abrupt and unconvincing. But that, according to the producers, was the effect they wished. As the author of the book stated, the man could be saved, but he'd have to save himself. No one, not even the character himself, knew whether he'd be able to stay on the water wagon."

HEDDA HOPPER, *Los Angeles Times*, November 29, 1945

"*The Lost Weekend* will either make you take a drink to forget it, or else quit altogether. I am under the impression from the large opening-day audience that the picture will arouse plenty of popular interest, though the reactions it arouses are bound to be variable. Laughs will doubtless be spurred by some of the more sensational yet pitiful episodes. Some mischievous audience members hissed an incident when a bottle of whiskey was dumped into the wash basin."

EDWIN SCHALLERT, *Los Angeles Times*, November 30, 1945

LETTER FROM REGIONAL THEATER OWNERS

"Did not sell in this situation. Maybe the publicity hurt. Couldn't even get the bar flies out for this."

H. L. Boner, Star Theatre, Guernsey, Wyoming, *Motion Picture Herald*, June 29, 1946

The Lost Weekend cost $1.25 million. It grossed $4.3 million.

Don Birnam (Ray Milland) is confronted by his brother (Philip Terry) and his fiancée (Jane Wyman) after he has tried to hide a bottle of alcohol, in the opening scene of Billy Wilder's *The Lost Weekend*.

ARTIST COMMENTS

"After a month on location in New York the company returned to Hollywood. Now the real work started, the cerebral part, the part where the thought processes become vocal, where the camera comes so close that nothing can be hidden and fakery isn't possible. Thank God for Wilder with his prying, probing, intuitive touch of genius, and Brackett with his kindly calm and sociological insight. There was also Charles Jackson, the author of the book, like a bright, erratic problem child, telling me of the horrors he had been through."

RAY MILLAND, *Wide-Eyed in Babylon*

"Since the Don Birnam character is having the d.t.s, Ray Milland had to look pretty bad. So we made a closeup of him, and I lit it just as harsh as possible and used an orange-yellow filter. As we were looking at the rushes the next day, Ray saw this scene, this closeup, and he shuddered. Charlie Brackett looked at Ray and me and said, 'This is the most eloquent closeup I've ever seen of anybody in my life.'"

Cinematographer John Seitz in Alain Silver, James Ursini, and Robert Porfirio's *Film Noir Reader 3*

Above left: *The Lost Weekend* was the first film to show the inside of a psych ward. In this scene, an inmate named Beetles (Douglas Spencer) is restrained, giving Don Birnam a chance to escape.

"*The Lost Weekend* is truly a chef d'oeuvre of motion-picture art, a shatteringly realistic and morbidly fascinating film," wrote Bosley Crowther in the *New York Times*. "Billy Wilder and Charles Brackett have done such a job with their pens and their cameras as puts all recent 'horror' films to shame."

FALLEN ANGEL

**TWENTIETH CENTURY–FOX
PREMIERED NOVEMBER 7, 1945**

Producer-director
OTTO PREMINGER

Screenwriter
HARRY KLEINER

Source
THE MARTY HOLLAND NOVEL

Cinematographer
JOSEPH LaSHELLE

Stars
**ALICE FAYE
DANA ANDREWS
LINDA DARNELL
CHARLES BICKFORD**

A DRIFTER ROMANCES A SMALL-TOWN WOMAN IN ORDER TO UNDERWRITE HIS AFFAIR WITH A DINER WAITRESS.

PRODUCTION QUOTE

"I became tired of playing those big musicals. But I felt if I could make pictures I'd be proud to show my kids someday, that would be different. I began to feel I'd never find the right role, but along came June Mills in *Fallen Angel*. She's an organist in a small town, a real person, a human, a woman with a heart, not a painted, doll-like dummy."

ALICE FAYE in Hedda Hopper's "Studio Regains Alice Faye," *Los Angeles Times*, November 4, 1945

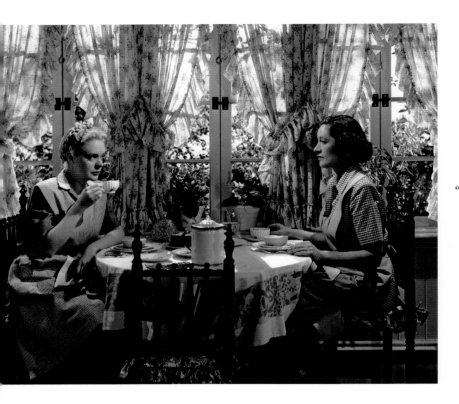

Above: In Otto Pre-
minger's *Fallen Angel*,
June Mills (Alice Faye) and
her sister, Clara (Anne
Revere), live in the sunny
seaside town of Walton,
seemingly worlds away
from the shadows of film
noir.

Opposite, top left: A seedy
diner is the chosen milieu
of Stella (Linda Darnell),
salesman Dave (Bruce
Cabot), drifter Eric (Dana
Andrews), and detective
Mark (Charles Bickford).

Opposite, top right: Eric
decides that the way to get
Stella is to marry June—for
her money.

Opposite, bottom: The
diner's proprietor (Percy
Kilbride) is also pursuing
Stella. Before long, she is
indeed a fallen angel.

REVIEW

"Back in 1944, Twentieth Century-
Fox, Otto Preminger, and Dana
Andrews, among others, combined
story, talent, and scintillating dia-
logue to turn out a taut and superior
murder mystery in *Laura*. The same
auspices cannot be blamed for fol-
lowing a vaguely similar tact with
Fallen Angel. As the frustrated
adventurer, Andrews adds another
tight-lipped portrait to a growing
gallery. Linda Darnell is perfectly
cast as the sultry, single-minded siren,
while Alice Faye, whose lines often
border on the banal, shoulders her
first straight dramatic burden grace-
fully. But for all of its acting wealth,
Fallen Angel falls short of being
a top flight whodunit."

BOSLEY CROWTHER, *The New York Times*,
February 7, 1946

LETTER FROM REGIONAL
THEATER OWNER

"This held the audience throughout its
length without any restlessness, and
there were many favorable comments.
Acting superb and story very good."

B. R. JOHNSON, Roxy Theatre, Nipawin,
Saskatchewan, Canada, *Motion Picture Herald*,
January 26, 1946

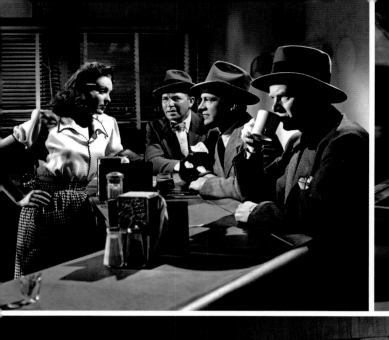

LEAVE HER TO HEAVEN

TWENTIETH CENTURY-FOX
PREMIERED DECEMBER 25, 1945

Producer
WILLIAM A. BACHER

Director
JOHN STAHL

Screenwriter
JO SWERLING

Source
THE BEN AMES WILLIAMS NOVEL

Cinematographer
LEON SHAMROY

Stars
GENE TIERNEY
CORNEL WILDE • VINCENT PRICE
JEANNE CRAIN

WHEN A MAN MARRIES A WOMAN WHO SAYS HE LOOKS LIKE HER DECEASED FATHER, HE FINDS HIMSELF A PRISONER OF HER OBSESSION.

PRODUCTION QUOTE

"I asked Gene Tierney how she felt while she was playing the murderess Ellen. 'Mentally unbalanced,' she flashed. 'I'm naturally a happy person, but such parts are fascinating. In a world of sick human beings, it's a full-time job trying to get inside these people to find out what makes them the way they are.'"

PHILIP K. SCHEUER, "La Tierney Hints Bolt to Comedy," *Los Angeles Times*, February 10, 1946

REVIEW

"Christmas Day was an inauspicious moment to bring in a moody, morbid film which is all about a selfish, jealous, and deceitful dame. Yet such is the unpleasant topic which is pursued to exhausting length in the *Leave Her to Heaven*. The fact is, however, that this picture would be little more congenial at any time, for it is plainly a piece of cheap fiction done up in Technicolor and expensive sets. Miss Tierney's petulant performance of this vixenish character is about as analytical as a piece of pin-up poster art. It is strictly one-dimensional, in the manner of a dot on an I."

BOSLEY CROWTHER, *The New York Times*, December 26, 1945

John Stahl's *Leave Her to Heaven* proved that the evil in a "dark film" could occur in daylight and in Technicolor.

Opposite: The heroine of *Leave Her to Heaven* is so obsessed with her husband that she murders his brother and throws herself down a flight of stairs to end a pregnancy—all to keep anyone from coming between them. Then, when she sees her husband falling for her sister, she kills herself in such a way as to incriminate the innocent girl.

LETTERS FROM REGIONAL THEATER OWNERS

"*Leave Her to Heaven* opened at the Roxy Theatre in New York on Christmas Day. A total of 181,865 persons paid $168,196 during the eight-day period ending New Year's Night, breaking all house records."

"Boom Week," *Motion Picture Herald*, January 5, 1946

"Wow! This picture has the greatest box-office pull of anything I've played here in ten years. It established a new Sunday attendance record and did the biggest two-day business in our history. Thanks a lot for this moneymaker, Mr. Zanuck."

THOMAS DI LORENZO, New Paltz Theatre, New Paltz, New York, *Motion Picture Herald*, March 16, 1946

"A magnificent picture. My audience came out in tears. This is a sign of satisfaction."

KENNETH M. GORHAM, Town Hall Theatre, Middlebury, Vermont, *Motion Picture Herald*, March 30, 1946

ARTIST COMMENT

"I want to tell you that you gave me one of the most memorable evenings I have ever had in the theater. When I saw the expression on your face in the sequence in which you drowned the boy, I thought, '*That* is acting.'"

NOËL COWARD in Gene Tierney's *Self-Portrait*

Leave Her to Heaven grossed $8.2 million.

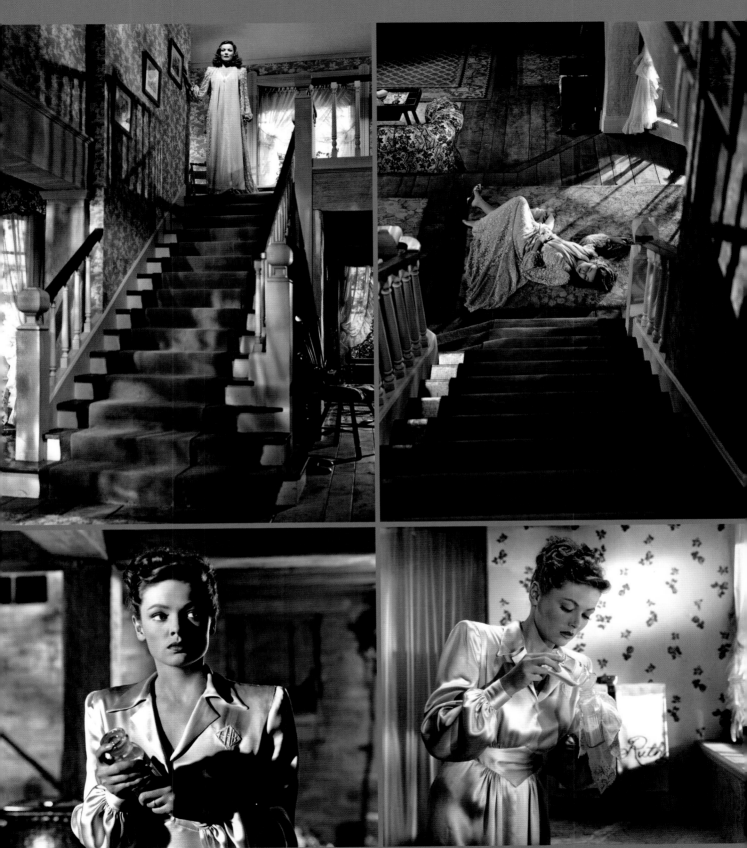

SCARLET STREET

DIANA PRODUCTIONS
DISTRIBUTED BY UNIVERSAL PICTURES
RELEASED DECEMBER 28, 1945

Producer-director
FRITZ LANG

Screenwriter
DUDLEY NICHOLS

Source
THE GEORGES DE LA FOUCHARDIÈRE NOVEL *LA CHIENNE*

Cinematographer
MILTON KRASNER

Stars
EDWARD G. ROBINSON
JOAN BENNETT
DAN DURYEA

WHEN A HENPECKED HUSBAND FINDS SOLACE WITH A SHADY LADY, HER PANDERER FINDS A WAY TO FLEECE HIM.

PRODUCTION QUOTE

"[Supporting player] Charles Kemper wishes that Fritz Lang wouldn't be so realistic. Charley had to do a guzzling scene in *Scarlet Street*. Usually you get only cold tea to guzzle on the screen. But Fritz served real beer, and before the scene was over, they had to send to the commissary for pots of hot coffee."

HEDDA HOPPER, *Los Angeles Times*, September 7, 1945

REVIEWS

"Now that the censors have finished playing around with *Scarlet Street*, the public may decide for itself just how damaging to its morals this picture may be. We're not anxious to prejudice any sinners in advance, but it isn't likely to encourage a life of crime. *Scarlet Street*, despite that title and all the lurid implications of the censors' ban, is a painfully moral picture, making it fearfully plain that the didoes of middle-aged Don Juans are perilous in the extreme."

BOSLEY CROWTHER, *The New York Times*, December 26, 1945

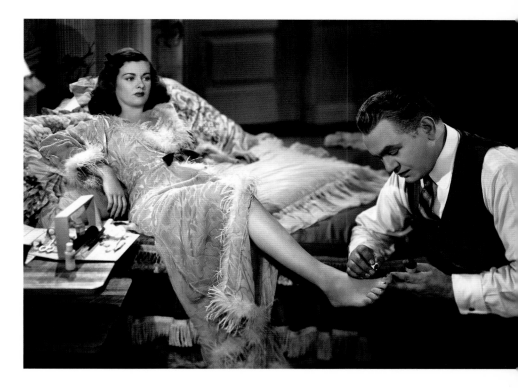

"Our theatre was packed with teenagers who whistled, giggled, and made demonstrations at the most sensational scenes," wrote an outraged patron in Fresno, California (quoted in Brian Kellow, *The Bennetts: An Acting Family*). This scene with Edward G. Robinson may have provoked the derelictions of decorum.

"The advance publicity *Scarlet Street* has received as a result of the censorship bans will cause it to draw crowds, but it will prove a disgrace to the industry. It flouts the principles of objective morality as established by the Production Code."

Harrison's Reports, January 19, 1946

"*Scarlet Street* has been banned in Atlanta, on the grounds that it is 'licentious, profane, obscene, and contrary to the good order of the community.' Christine Smith, city censor, said that the picture was not suitable for public consumption."

"*Scarlet Street* Banned by Atlanta Censor," *Motion Picture Herald*, February 9, 1946

LETTERS FROM REGIONAL THEATER OWNERS

"The less said about this one the better. Words would fail to tell the miserable showing. Our lowest gross to date. The operator [projectionist] said he liked it, but the customers' comments made us hide our heads. No more."

JACK HAMMOND, Hart Theatre, Ferndale, California, *Motion Picture Herald*, August 17, 1946

"We took advantage of this being censored. Publicity of a censored picture is great for a small town, but I can't understand why it was censored. Neither can my patrons. The acting is great, and it teaches a lesson that all Americans should see. We had a packed house."

J. C. BALKCOM, Gray Theatre, Gray, Georgia, *Motion Picture Herald*, January 12, 1946

Left: The paintings that motivated the plot were the work of the renowned John Decker.

Opposite: The tag-team brutality of Joan Bennett and Dan Duryea brought a unique distinction to Fritz Lang's *Scarlet Street*. It was banned by censor boards in Atlanta, Minneapolis, and New York State—even though Joseph Breen and the PCA had passed it.

ARTIST COMMENTS

"I did have a fight with Joe Breen over the 'innocent' man [Dan Duryea] being executed. I pointed out that the character played by Edward G. Robin-son received the greater punishment: he would either live on in complete despair or end his life. This was again a picture about destiny. Fate plays the tricks, but man makes the choice."

FRITZ LANG in Alain Silver, James Ursini, and Robert Porfirio's *Film Noir Reader 3*

"Dan Duryea took his wife to *Scarlet Street*. 'I wanted to get audience reac-tion,' he explains. A pleasant-faced lady sitting in front of them turned to her companion and said, quite loudly, 'Have you ever seen a more repulsive man?'"

LOUIS BERG, "Don't Shoot My Dad!" *Los Angeles Times*, November 10, 1946

Scarlet Street cost $1.2 million. It grossed $2.9 million.

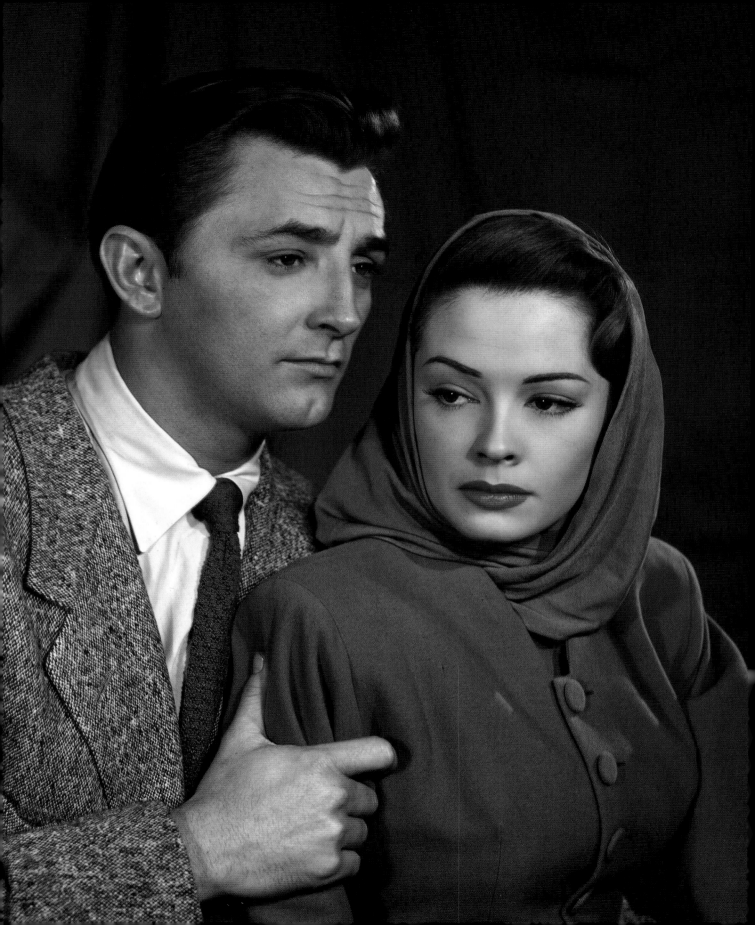

Alienated

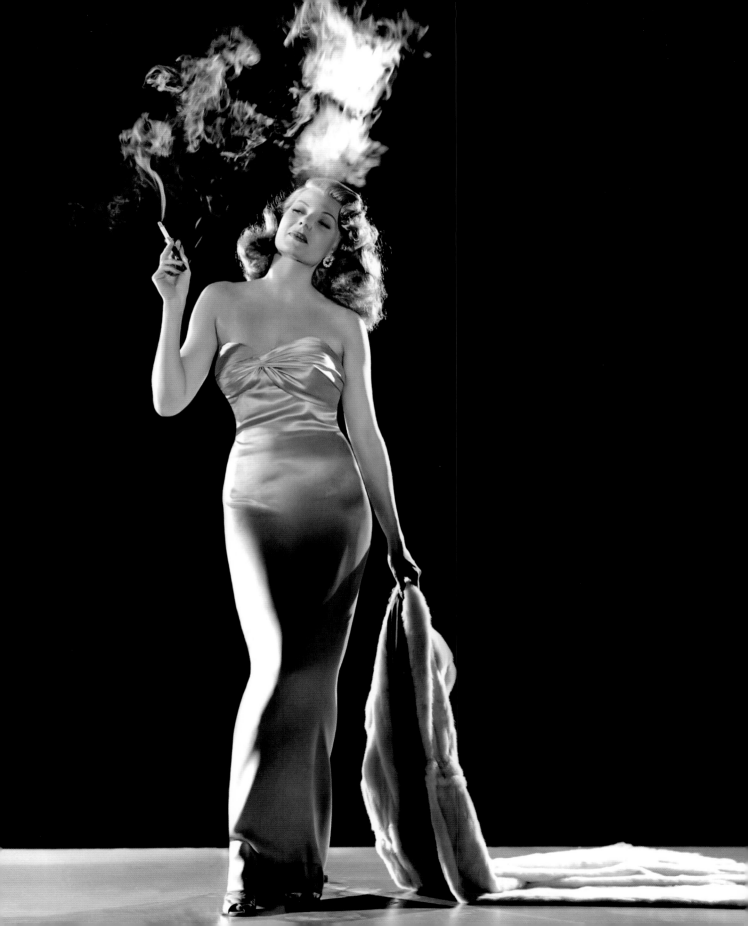

1946

REPORTS ON THE CRIME STORY CYCLE

"Whoever went to the movies with any regularity in 1946 was caught in the midst of Hollywood's profound postwar affection for morbid drama. From January through December, deep shadows, clutching hands, exploding revolvers, sadistic villains, and heroines tormented with deeply rooted diseases of the mind, flashed across the screen in a panting display of psychoneuroses, unsublimated sex, and murder most foul. Apparently delighted to pay good money for having their pants scared off, moviegoers flocked in record numbers to these spectacles."

DONALD MARSHMAN, "Mister See-odd mack,"
Life magazine, August 25, 1947

LOOKING BACK AT FILM NOIR

"Acting? The critics said I acted best with a gun in my hand. And I recently did an interview special, *The Women of Film Noir*, on AMC, with Jane Greer, Marie Windsor, and Coleen Gray. Marie had the best line. She said, 'We didn't call it film noir in our day. We called it B-picture-making.' But those are the movies people remember. Strange, isn't it?"

AUDREY TOTTER in James Bawden's *One on One with Audrey Totter*

p. 98: A portrait of Robert Mitchum and Jane Greer made for *Out of the Past* by Ernest Bachrach.

Opposite: In Charles Vidor's *Gilda*, Rita Hayworth brought music and dance to film noir. Portrait by Robert Coburn.

THE SPIRAL STAIRCASE

RKO RADIO PICTURES
RELEASED FEBRUARY 6, 1946

Producer
DORE SCHARY

Director
ROBERT SIODMAK

Screenwriter
MEL DINELLI

Source
**THE ETHEL LINA WHITE NOVEL
SOME MUST WATCH**

Cinematographer
NICHOLAS MUSURACA

Stars
**DOROTHY MCGUIRE
ETHEL BARRYMORE • GEORGE BRENT
RHONDA FLEMING**

WORKING TITLE: SOME MUST WATCH

A HANDICAPPED GIRL IS TARGETED BY A MAN WHO KILLS "IMPERFECT" WOMEN.

REVIEW

"This is a shocker, plain and simple, and whatever pretentions it has to psychological drama may be considered merely as a concession to a currently popular fancy. It is quite evident by the technique Robert Siodmak has employed to develop and sustain suspense—brooding photography and ominously suggestive settings—that he is at no time striving for narrative subtlety. That Mr. Siodmak and his players, notably Dorothy McGuire, had a packed early-morning house under their spell was evident by the frequent spasms of nervous giggling and the audible, breathless sighs."

BOSLEY CROWTHER, *The New York Times*, February 7, 1946

LETTER FROM REGIONAL THEATER OWNER

"This one caused all the kids to abandon their front seats and beat it to the rear of the theater."

HENRY SPARKS, Sparks Theatre, Cooper, Texas, *Motion Picture Herald*, April 20, 1946

Dorothy McGuire, who cannot speak, watches a silent movie in this scene from Robert Siodmak's *The Spiral Staircase*.

GILDA

COLUMBIA PICTURES
PREMIERED FEBRUARY 14, 1946

Producer
VIRGINIA VAN UPP

Director
CHARLES VIDOR

Screenwriter
MARION PARSONNET
FROM AN ADAPTION BY JO EISINGER

Source
A STORY BY E. A. ELLINGTON

Cinematographer
RUDOLPH MATÉ

Stars
RITA HAYWORTH
GLENN FORD
GEORGE MACREADY

A WORLD-WEARY SINGER INSPIRES A DEADLY RIVALRY BETWEEN A GAMBLER AND HIS EMPLOYER, HER HUSBAND.

PRODUCTION QUOTES

"When Rita Hayworth plays her first bad-girl role in *Gilda* (enacting the part of a lady with a list of telephone numbers as long as your arm), she'll wear twenty-one seductive gowns designed by New York's Jean Louis. The Hays Office can begin polishing its spectacles."

HEDDA HOPPER, "Looking at Hollywood," *Los Angeles Times*, August 22, 1945

"After seeing the preview of *Gilda*, I'd say that Rita Hayworth need not depend on her beauty or dancing for pictures. She displayed real dramatic ability."

HEDDA HOPPER, "Looking at Hollywood," *Los Angeles Times*, March 19, 1946

REVIEWS

"*Gilda* is a slow, opaque, unexciting film. It seems that a fantastic female turns up in a Buenos Aires casino as the wife of the dour proprietor. But it also seems that she was previously the sweetie of a caustic young man. For reasons which are guardedly suggested, she taunts and torments this tough lad—but don't ask us why. She wears gowns of shimmering luster and tosses her tawny hair in glamorous style, but her manner of playing a worldly woman is distinctly five-and-dime. A couple of times she sings song numbers, with little distinction, be it said, and wiggles through a few dances that are nothing short of crude."

BOSLEY CROWTHER, *The New York Times*, March 16, 1946

"Practically all the s.a. habiliments of the femme fatale have been mustered for *Gilda*. When things get trite and frequently farfetched, somehow, at the drop of a shoulder strap, there is always Rita Hayworth to excite the filmgoer."

"Gilda," *Variety*, March 20, 1946

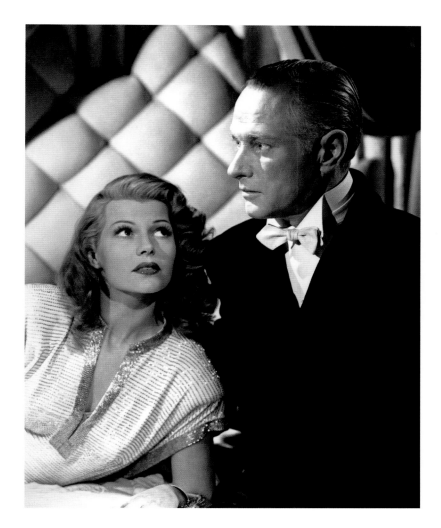

"*Gilda* will undoubtedly class as one of the most fussed-up and fantastic efforts to turn a good girl into a bad girl this year. Audiences are going to have a good time even while they are being kidded about the heroine, and I judge that crowds will go. They were heavy for the evening shows at yesterday's 'premeer.'"

EDWIN SCHALLERT, "Guilt Gilds Lily in *Gilda*, but All the Gilt's Not Gold," *Los Angeles Times*, April 27, 1946

Every scene between Rita Hayworth and George Macready in *Gilda* is charged with tension.

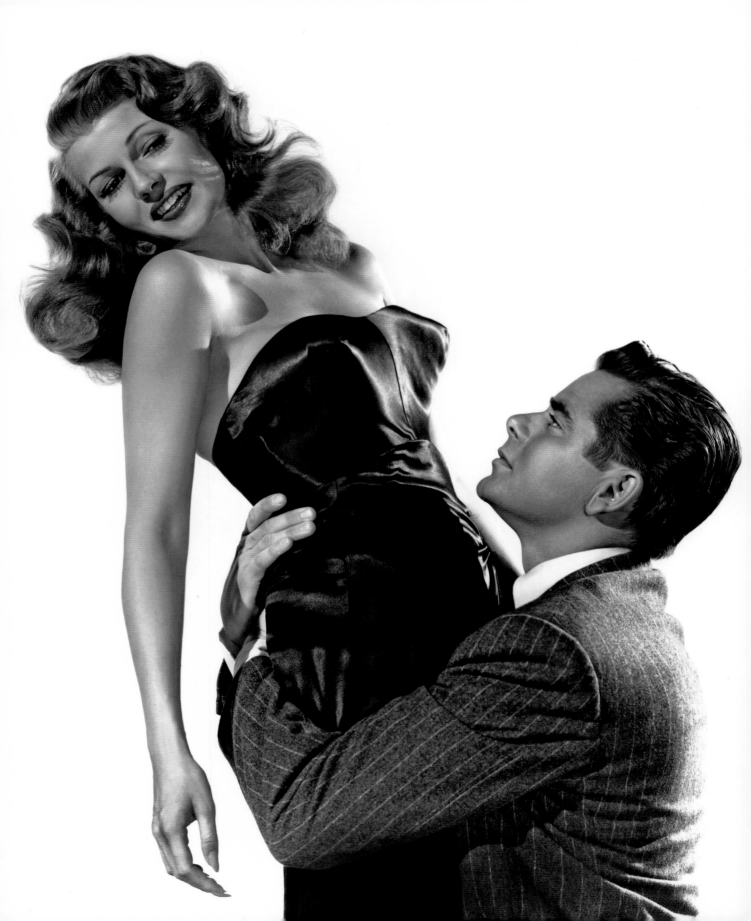

Every scene between Rita Hayworth and Glenn Ford in *Gilda* is charged with erotic tension.

LETTERS FROM REGIONAL THEATER OWNERS

"Good picture, good direction. Hayworth sure is coming up in the world. Give us more like this, Columbia!"

H. L. BONER, Star Theatre, Guernsey, Wyoming, *Motion Picture Herald*, October 26, 1946

"This is the best one to come out of Columbia for some time, but why wasn't it made in Technicolor? The women here are raving about the clothes Miss Hayworth wore and the men are still talking about her."

JIM D. LOFLIN, Ritz Theatre, Prentiss, Mississippi, *Motion Picture Herald*, March 2, 1946

ARTIST COMMENTS

"The black satin dress was not described in the script. It was just supposed to be an evening dress she's wearing with her long hair and a sleeveless ermine coat. I knew she was going to have to do a number when she was wearing it, but it was a very elegant thing, because [choreographer] Jack Cole described it to me, 'Oh, we are going to take the gloves off, and we're going to do *this*.'"

COSTUME DESIGNER JEAN LOUIS in John Kobal's *People Will Talk*

"Jean Louis wanted to know how to dress Rita, and I told him to use John Singer Sargent's painting, *Madame X*, as a model. That black dress! Of all the things I've done with Rita, the 'Put the Blame on Mame' number is the one that pleases me most. Rita was just so wildly suited to do what she was doing."

CHOREOGRAPHER JACK COLE in John Kobal's *People Will Talk*

Gilda grossed $4.8 million.

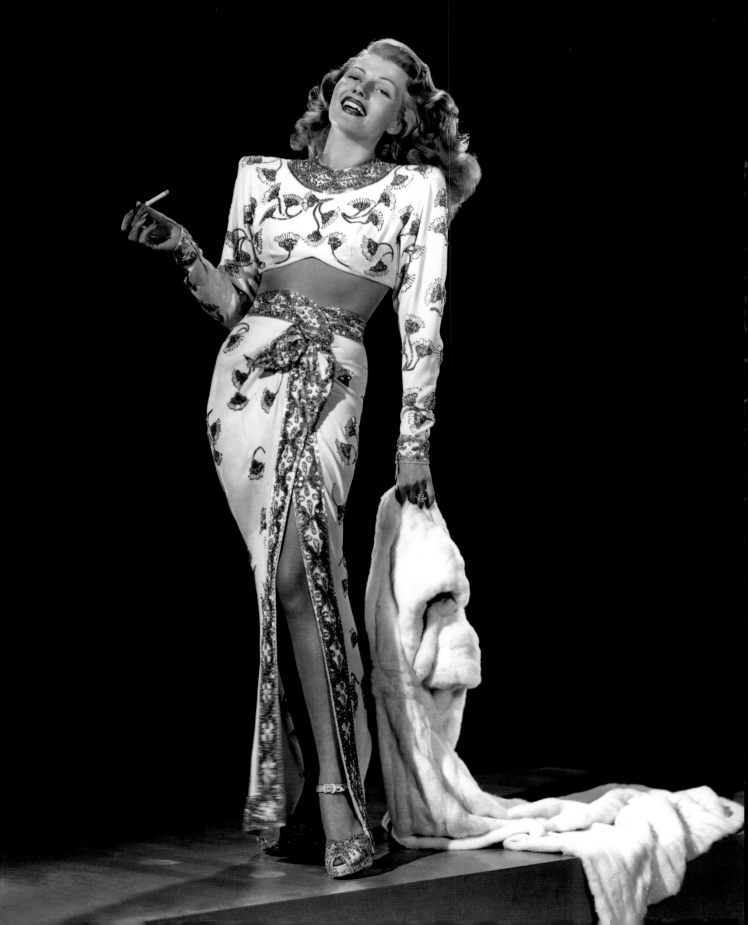

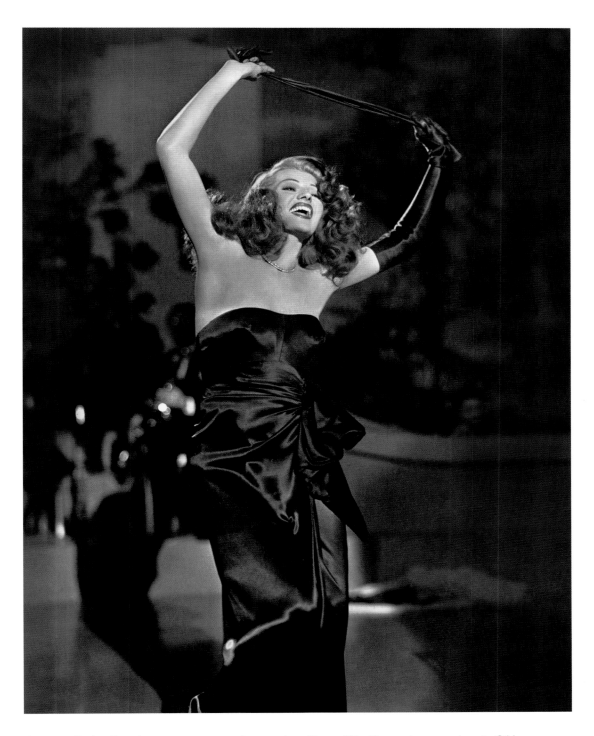

Opposite: Bosley Crowther was more snooty than usual when he reviewed *Gilda*: "Miss Hayworth, in her first straight dramatic role, gives little evidence of a talent that should be commended or encouraged." Portrait by Robert Coburn.

Above: "Rita Hayworth wears a dress in *Gilda* that's more revealing than Norma Shearer's white satin gown in *A Free Soul*," wrote Hedda Hopper. "I didn't think that was possible." Photograph by Ned Scott.

DEADLINE AT DAWN

RKO RADIO PICTURES
RELEASED APRIL 3, 1946

Producers
ADRIAN SCOTT
SID ROGELL

Director
HAROLD CLURMAN

Screenwriter
CLIFFORD ODETS

Source
THE CORNELL WOOLRICH NOVEL

Cinematographer
NICHOLAS MUSURACA

Stars
SUSAN HAYWARD
PAUL LUKAS • BILL WILLIAMS

A DANCE-HALL HOSTESS AND A CAB DRIVER SPEND A NIGHT TRYING TO SAVE A SAILOR FROM A MURDER RAP.

PRODUCTION QUOTE

"Susan Hayward, making *Deadline at Dawn*, looked at the dead girl on the floor and said, 'Poor girl. She drank too much, loved too often, and lived alone.' This was too much for Lola Lane, who was playing the murdered girl. She sat up and said, 'Hey! Is that bad?'"

HEDDA HOPPER, "Looking at Hollywood," *Los Angeles Times*, October 6, 1945

REVIEW

"Working in cahoots, writer Clifford Odets and director Harold Clurman of New York's old Group Theatre have contrived what is practically a Group Theatre production on film, one that can almost be described as a whodunit told in parable form. I enjoyed *Deadline at Dawn*. Off-center though it may be, with its highfalutin double talk, like 'The logic is that there is no logic,' 'Happiness is no laughing matter,' and 'Time takes so long and it goes so fast,' the film does reintroduce a dimension which we could do with more of in more movies. Call it poetic, call it philosophic, this quality is unexpectedly ingratiating—whenever it doesn't sound like so much bushwa."

PHILIP K. SCHEUER, "Different Whodunit," *Los Angeles Times*, August 16, 1946

Top: "Aren't you dead yet?" Lola Lane asks her husband Marvin Miller in the opening scene of *Deadline at Dawn*. Photograph by Alex Kahle.

Bottom: *Deadline at Dawn* was written by Clifford Odets and directed by Harold Clurman, two alumni of the legendary Group Theatre. Susan Hayward, Joseph Calleia, and Jerome Cowan were three of the performers who contributed to its excellence.

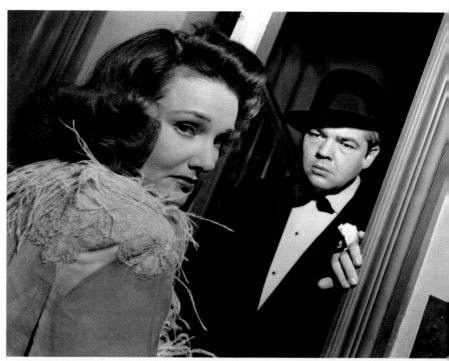

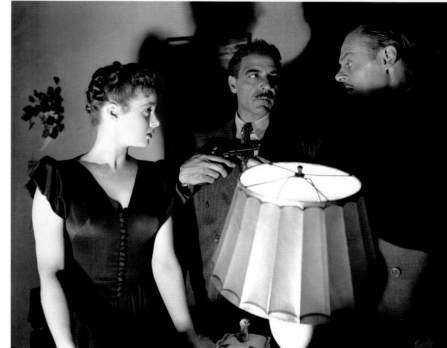

LETTER FROM REGIONAL THEATER OWNER

"We played this on our Cash Night to better than average business."

GEORGE E. CARAWAY, Joy Theatre, Dubach, Louisiana, *Motion Picture Herald*, January 4, 1947

ARTIST COMMENT

"A Hays Office functionary visited the set to complain that Susan Hayward was showing too much cleavage in the previous week's rushes. But Miss Hayward and I insisted that this was one of the more pleasing aspects of the picture."

HAROLD CLURMAN, *All People Are Famous*

THE BLUE DAHLIA

PARAMOUNT PICTURES
PREMIERED APRIL 18, 1946

Producer
JOHN HOUSEMAN

Director
GEORGE MARSHALL

Screenwriter
RAYMOND CHANDLER

Cinematographer
LIONEL LINDON

Stars
VERONICA LAKE
ALAN LADD • WILLIAM BENDIX

A VET RETURNING TO LOS ANGELES FINDS HIS WIFE INVOLVED WITH THE OWNER OF A SUNSET STRIP NIGHTCLUB.

PRODUCTION QUOTE

"Raymond Chandler's new original, tentatively called *The Blue Dahlia*, is a romance with murder, and it's being written for Alan Ladd."

HEDDA HOPPER, "Looking at Hollywood," *Los Angeles Times*, August 22, 1945

REVIEWS

"To the present expanding cycle of hard-boiled and cynical films, Paramount has contributed a honey of a rough-'em-up romance, for bones are being crushed with cold abandon, teeth are being callously kicked in, and shocks are being blandly detonated. An air of deepening mystery overhangs this tempestuous tale which shall render it none the less intriguing to those lovers of the brutal and bizarre."

BOSLEY CROWTHER, *The New York Times*, May 9, 1946

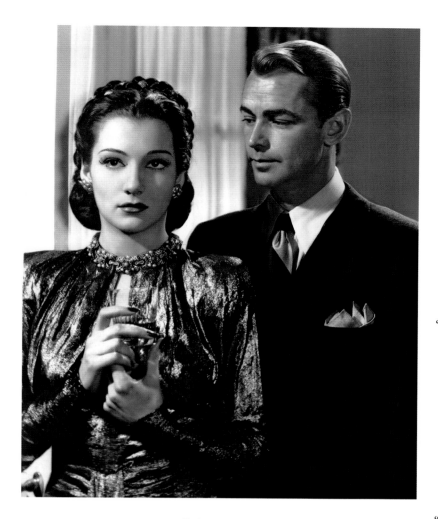

In George Marshall's *The Blue Dahlia*, Alan Ladd returns from the war to find his wife (Doris Dowling) behaving in an unwifely fashion.

"There are no letups—and no let-downs—in *The Blue Dahlia*, no 'breathers,' and even the humor is sardonic. A few of the more hysterical spectators supplied their own laughs at the Paramount yesterday, but I doubt if they broke the spell for the others. Nevertheless, 100 minutes of sustained intensity does impose a responsibility on the filmgoer. These etudes in suspense offer almost the only valid storytelling we are getting from the movies these days."

PHILIP K. SCHEUER, "Ace Shocker," *Los Angeles Times*, July 5, 1946

LETTER FROM REGIONAL THEATER OWNER

"One of the year's best mystery melodramas. Although not outstanding at the box office, this did a very unusual build on the second day of a two-day play."

W. F. SHELTON, Louisburg Theatre, Louisburg, North Carolina, *Motion Picture Herald*, October 26, 1946

ARTIST COMMENT

"Raymond Chandler was sort of a tin god to everybody. I remember Veronica Lake asking me, 'Who's this guy Chandler?' And I said, 'Why, Veronica, he's the greatest mystery writer around.' I told her all about him, and she listened and listened and listened. A couple of days later, I heard some newspaper reporter interviewing her, and she began telling him all about Chandler."

PUBLICIST TEET CARLE in Jeff Lenburg's *Peekaboo: The Story of Veronica Lake*

The Blue Dahlia cost $900,000, and grossed $2.75 million.

Right: A dynamically composed image of Alan Ladd and Don Costello from *The Blue Dahlia*.

Below: "Alan Ladd is his usual imperturbable self," wrote Bosley Crowther, "displaying a frigid economy in his movement of lips and limbs. As for Veronica Lake, her contribution is playing slightly starved for a good man's affection, to which she manifests an eagerness to respond."

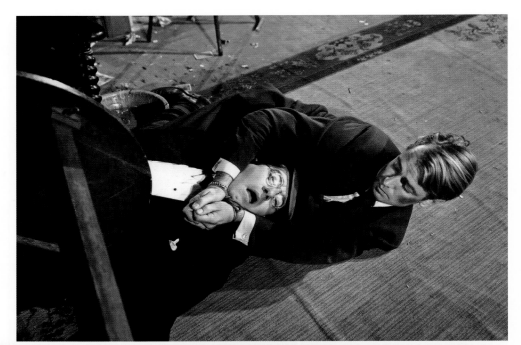

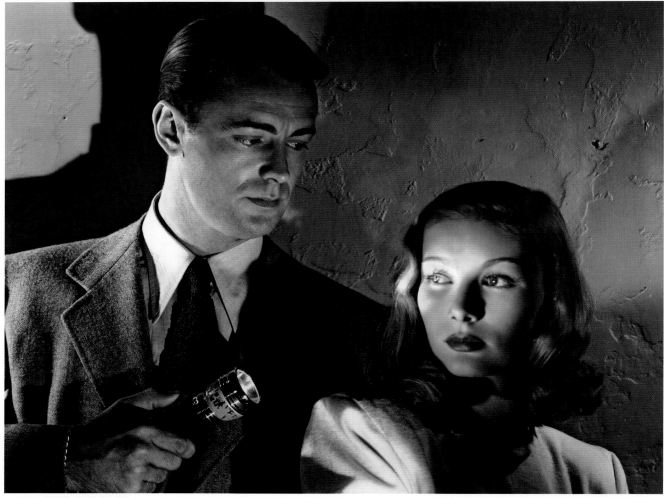

THE POSTMAN ALWAYS RINGS TWICE

METRO-GOLDWYN-MAYER
RELEASED MAY 2, 1946

Producer
CAREY WILSON

Director
TAY GARNETT

Screenwriters
HARRY RUSKIN • NIVEN BUSCH

Source
THE JAMES CAIN NOVEL

Cinematographer
SIDNEY WAGNER

Stars
LANA TURNER
JOHN GARFIELD
HUME CRONYN

A DRIFTER AND THE WIFE OF A LUNCH-STAND OPERATOR DECIDE TO KILL HER HUSBAND SO THEY CAN GO OFF TOGETHER.

PRODUCTION QUOTE

"When Metro picked Grant B. Cooper as technical director for *The Postman Always Rings Twice*, they got the Real McCoy. Cooper was assistant district attorney for Los Angeles County for eight years."

HEDDA HOPPER, "Looking at Hollywood," *Los Angeles Times*, August 23, 1945

REVIEW

"In its surface aspects, *The Postman Always Rings Twice* appears no more than a melodramatic tale, another involved demonstration that crime does not pay. But the artistry of writers and actors have made it much more than that; it is, indeed, a sincere comprehension of an American tragedy. For the yearning of weak and clumsy people for something better than the stagnant lives they live is revealed as the core of the dilemma, and sin is shown to be no way to happiness."

BOSLEY CROWTHER, *The New York Times*, May 3, 1946

The Postman Always Rings Twice was adapted from the James Cain novel that had been proscribed by the Production Code Administration in 1934. Despite censorship restrictions, Tay Garnett managed to retain the carnal desperation of the book, assisted in no small measure by Lana Turner's performance.

"With Hollywood's current fascinated interest in crimes of passion," wrote *Life* magazine, "studios are busy producing James Cain stories considered too hot for the censors in the 1930s. Being a reasonably complete catalog of the seven deadly sins, *The Postman Always Rings Twice* is not a movie for the fainthearted. But those who prefer romance with a snarl to romance with a sigh will like it very much." Lana Turner and John Garfield played the star-crossed criminals. Photograph by Clarence S. Bull.

LETTER FROM REGIONAL THEATER OWNER

"Some folks wondered why the title. The exhibitor who plays this will hear the cash register ring not twice but continuously."

HENRY SPARKS, Sparks Theatre, Cooper, Texas, *Motion Picture Herald*, June 29, 1946

ARTIST COMMENT

"Harry Ruskin, the guy who did the script, told me that Carey Wilson had Lana Turner dressed in white so that the public would understand that the girl is pure. She may be playing around with John Garfield, but she's not taking her pants off for him.

Ruskin had asked Wilson, 'Is this girl shacking this guy into bed? I know we don't put it on the screen, but I have to know.' Wilson couldn't make up his mind whether Lana was screwing Garfield. 'Jim,' Ruskin said to me, 'Wilson didn't know then, and he doesn't know now. That's why the central part of the thing is so fuzzy and shaky and squashy.'"

JAMES M. CAIN in Patrick McGilligan's *Backstory 1*

The Postman Always Rings Twice cost $1.68 million, and grossed $5.08 million.

THE DARK CORNER

**TWENTIETH CENTURY–FOX
RELEASED MAY 8, 1946**

Producer
FRED KOHLMAR

Director
HENRY HATHAWAY

Screenwriters
JAY DRATLER • BERNARD SCHOENFELD

Source
THE LEO ROSTEN SERIAL IN
GOOD HOUSEKEEPING MAGAZINE

Cinematographer
JOE MACDONALD

Stars
LUCILLE BALL
MARK STEVENS
CLIFTON WEBB • WILLIAM BENDIX

A PRIVATE INVESTIGATOR FRAMED FOR MURDER TRACKS THE PERPETRATORS TO THE WORLD OF FINE ART GALLERIES.

REVIEW

"When a talented director and a resourceful company of players meet up with a solid story, moviegoing becomes a particular pleasure. *The Dark Corner* is a tough-fibered, exciting entertainment revolving around a private detective who is marked as the fall guy in a cleverly contrived murder plot. Mark Stevens, a comparative newcomer looking and acting very much like Dana Andrews, is convincingly hard-boiled as the baffled gumshoe."

BOSLEY CROWTHER, *The New York Times*, May 9, 1946

LETTER FROM REGIONAL THEATER OWNER

"Its title kills it for the box office, but it is a very good picture."

GEORGE CLANTON, Daw Theatre, Tappahannock, Virginia, *Motion Picture Herald*, October 26, 1946

ARTIST COMMENT

"Clifton Webb was an angel, but he never really was a good actor. He was a character. He was marvelous because he was so elegant. *The Dark Corner* was not a successful film. It was dead. Mark Stevens never quite cut it. Too arrogant, cocksure."

HENRY HATHAWAY in Polly Platt and Rudy Behlmer's *Henry Hathaway*

Left: William Bendix in a scene from Henry Hathaway's *The Dark Corner*.

Below: Lucille Ball made her contribution to film noir in *The Dark Corner*.

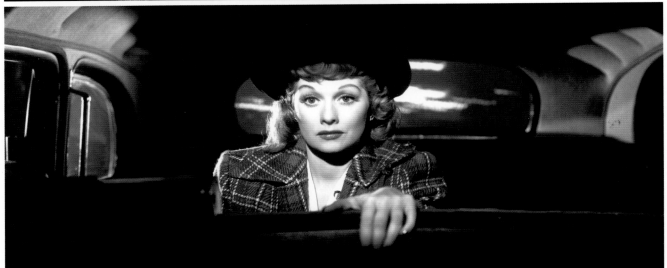

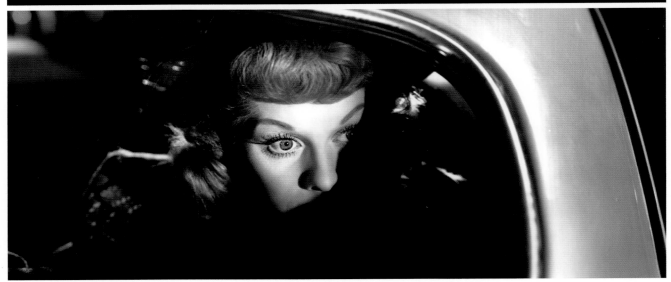

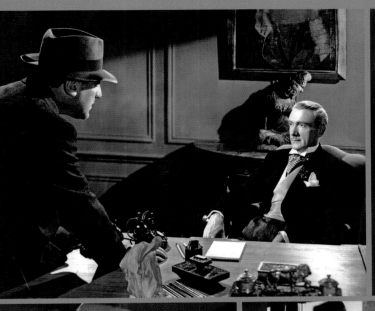
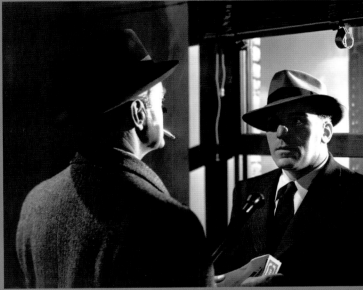
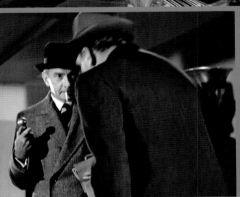
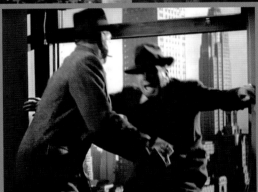

In *The Dark Corner*,
Clifton Webb does not
want to pay William Bendix
for his dirty work.

THE STRANGER

RKO RADIO PICTURES
AN INTERNATIONAL PICTURES PRODUCTION
RELEASED MAY 25, 1946

A POSTWAR NAZI HUNTER COMES TO A NEW ENGLAND UNIVERSITY TOWN IN SEARCH OF A HIGH-RANKING WAR CRIMINAL.

PRODUCTION QUOTE

"If Orson Welles and Eddie Robinson get through *The Stranger* with whole skins, it will be a miracle. Strange that two guys with such similar political viewpoints should be so far apart in their acting ideas. But it must be pretty tough for 'Little Caesar' to take direction from 'Little Genius.'"

HEDDA HOPPER, "Looking at Hollywood," *Los Angeles Times*, November 9, 1945

Producer
S. P. EAGLE (SAM SPIEGEL)

Director
ORSON WELLES

Screenwriter
ANTHONY VEILLER

Cinematographer
RUSSELL METTY

Stars
ORSON WELLES
LORETTA YOUNG
EDWARD G. ROBINSON

Five years after *Citizen Kane*, Orson Welles reluctantly agreed to direct and star in a film that he had not written, *The Stranger*. Though he disavowed the film for the next forty years, it is unique and fascinating.

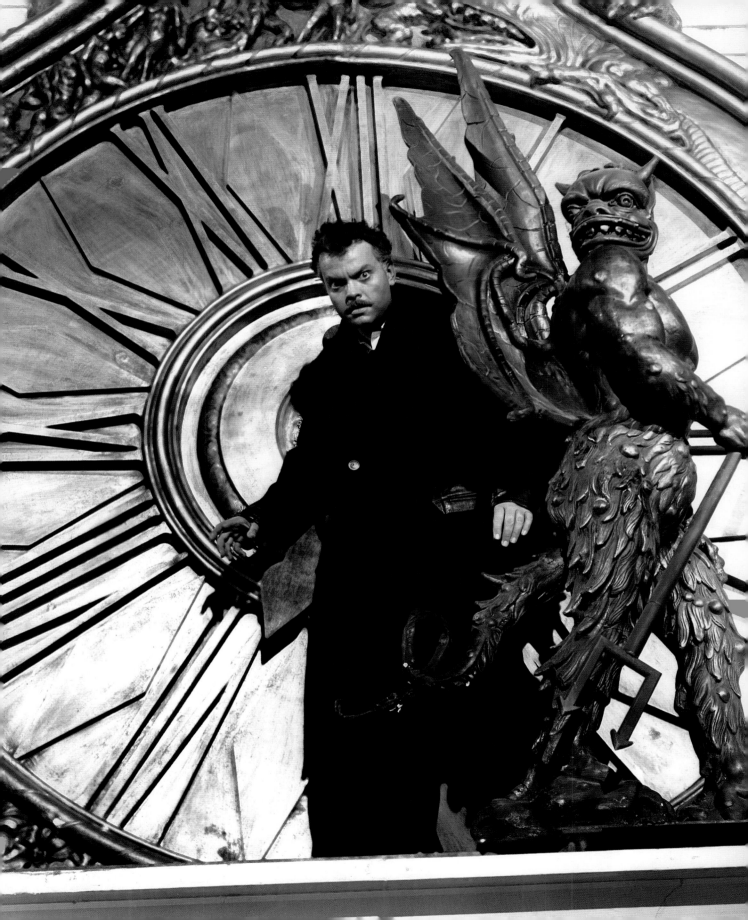

REVIEW

"Seen at the Pantages Hollywood, where the audience was audibly impressed, *The Stranger*, as directed by Orson Welles, is strongly reminiscent of Alfred Hitchcock; eerie, spine-chilling, macabre. Russell Metty's photography, which is superb, enhances the mood of mounting horror."

"The Stranger" *Motion Picture Herald*, May 25, 1946

"Orson Welles has directed his camera for some striking effects, with lighting and interesting angles much relied on in his technique. The fellow knows how to make a camera dynamic in telling a tale. And it is true, too, that Edward G. Robinson is restrained as the unrelenting sleuth and that Billy House does a superb job as a small-town clerk and gossip. But the whole film, produced by S. P. Eagle, comes off as a bloodless, manufactured show."

BOSLEY CROWTHER, *The New York Times*, July 11, 1946

Opposite: "That film had absolutely no interest for me," Welles said years later. "But I didn't do it with a completely cynical attitude; quite the contrary. I tried to do it as well as I could. But it's the one of my films of which I am least the author. I don't know if it's good or bad." (Orson Welles in Mark W. Estrin's *Orson Welles: Interviews*)

LETTERS FROM REGIONAL THEATER OWNERS

"A well done drama that was liked by the few who came to see what it was all about. It is the same old story. The market is crowded with these morose pictures. The folks stay away from them in droves whether the picture is good or not. On the other hand, down-to-earth, folksy pictures make the people stand in line. There never have been too many of them and there never will be. It is a queer business."

M. HULBERT, Gem Theatre, Cornell, Wisconsin, *Motion Picture Herald*, January 18, 1947

"Good show. No business. Very heavy and no child would like it. The women didn't like it."

CHARLES L. JONES, Elma Theatre, Elma, Iowa, *Motion Picture Herald*, February 15, 1947

ARTIST COMMENT

"*The Stranger* is the worst of my films. I did it to prove to the industry that I could make a picture on time and on budget, just like anyone else. There is nothing of me in that picture. It is absolutely of no interest to me. I did not make it with cynicism, however. I did my best with it."

ORSON WELLES in Joseph McBride's *Orson Welles*

The Stranger cost $1.03 million, and grossed $4.21 million.

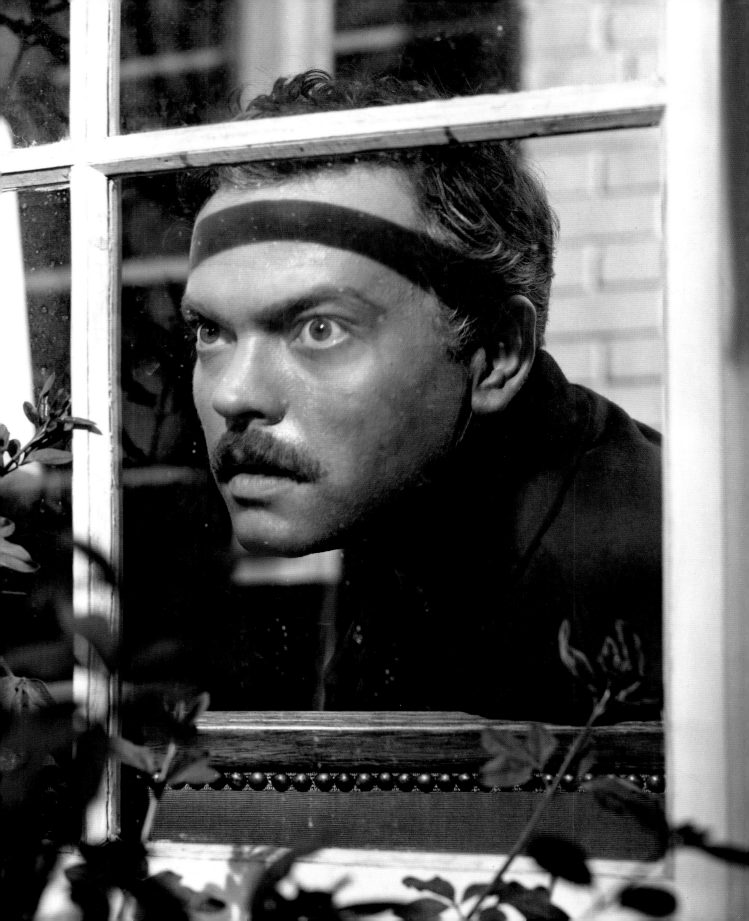

Left: "The only little things about the film I really like are the comments on the town, the drugstore man, the details of this kind," recalled Welles. Konstantin Shayne was creepy as a Nazi in hiding. Billy House was hilarious as the druggist who knows everybody's business. Edward G. Robinson was not happy when Welles made him and House improvise dialogue.

Opposite: Welles coached a powerful performance from Loretta Young, and Robinson was excellent, too. *The Stranger* was Orson Welles's most profitable film.

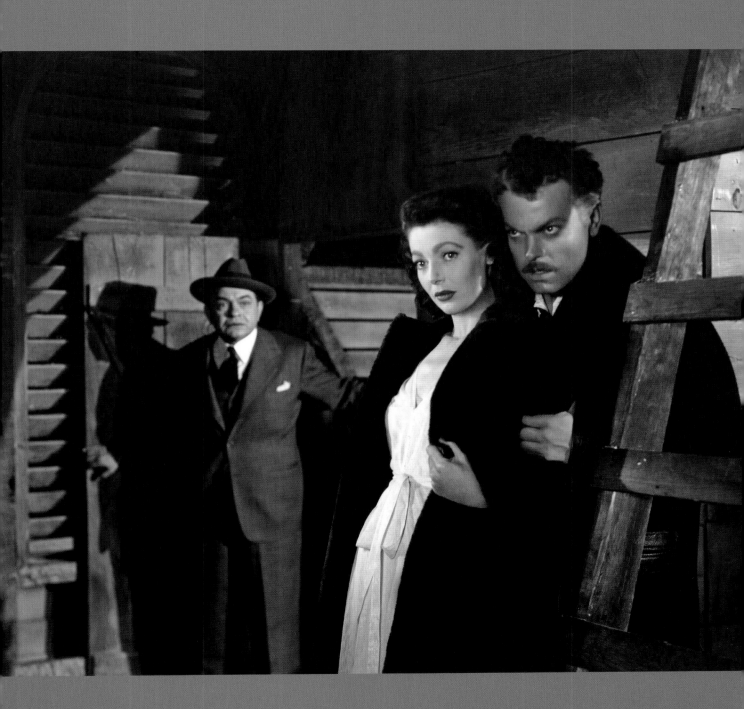

THE STRANGE LOVE OF MARTHA IVERS

PARAMOUNT PICTURES
HAL WALLIS PRODUCTIONS
RELEASED SEPTEMBER 13, 1946

Producer
HAL WALLIS

Director
LEWIS MILESTONE

Screenwriter
ROBERT ROSSEN

Source
THE JACK PATRICK STORY
LOVE LIES BLEEDING

Cinematographer
VICTOR MILNER

Stars
BARBARA STANWYCK
VAN HEFLIN • LIZABETH SCOTT
KIRK DOUGLAS

WORKING TITLE: *LOVE LIES BLEEDING*

A WEALTHY SMALL-TOWN WOMAN FINDS HER POSITION THREATENED WHEN A CHILDHOOD FRIEND APPEARS FROM NOWHERE.

PRODUCTION QUOTE

"When Barbara Stanwyck finished an emotional scene in *Love Lies Bleeding*, Van Heflin remarked, 'Gee, that was great!' She came back with, 'Haven't you heard? I'm the Bette Davis of Melrose Avenue.'"

HEDDA HOPPER, *Los Angeles Times*, November 9, 1945

REVIEWS

"The Paramount, where *Double Indemnity* once beguiled the customers, now presents another of the hard-boiled dramas. *The Strange Love of Martha Ivers* tells of tough people, some of them rich and aristocratic, some of them poor and adventurous, and all of them dangerous. The picture has its heart-stopping moments. It also has long stretches of exposition. Audiences are brighter than the moviemakers realize. They don't need so much spelling out."

EILEEN CREELMAN, "The New Movies," *New York Sun*, July 25, 1946

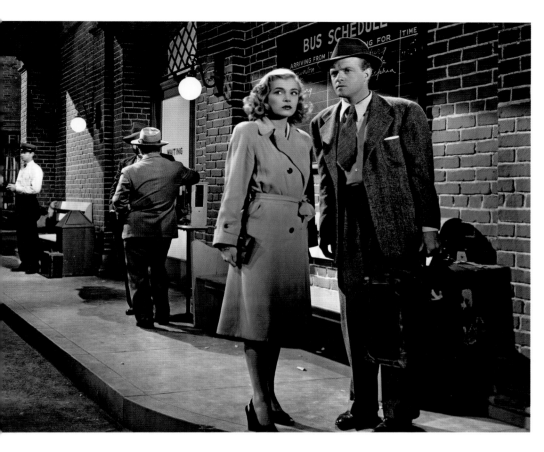

Lewis Milestone's *The Strange Love of Martha Ivers* was produced by Hal Wallis, who made his share of film noirs. "Very consciously, I made a series of melodramatic films with strong characters and situations," said Wallis. "The dark side of life was portrayed frankly and without compromise." This scene shows Van Heflin with Lizabeth Scott, a Wallis discovery.

"The James M. Cain influence is obviously responsible for this drama about horrible people, the kind that the law of Fate eventually overtakes. They seem strange on the screen because Hollywood passed them by until Mr. Cain proved that it was worthwhile not to. But they do exist, and they can be made to seem real, which is what Cain proved in *Double Indemnity*, *Mildred Pierce*, and *The Postman Always Rings Twice*."

HERBERT COHN, "The Sound Track," *The Brooklyn Eagle*, July 28, 1946

LETTERS FROM REGIONAL THEATER OWNERS

"A heavy melodrama with excellent values which pleased everyone. If it had been a trifle shorter, it would have been among the best pictures of the year."

T. DI LORENZO, New Paltz Theatre, New Paltz, New York, *Motion Picture Herald*, November 16, 1946

"The title whipped a mighty nice picture. Poor business. When will Hollywood learn?"

MORTON VINCENT, Ashland Theatre, Kansas City, Missouri, *Motion Picture Herald*, January 25, 1947

Above and opposite:
A fight scene between Van
Heflin and Barbara Stan-
wyck ends in a clinch.

Below: *The Strange Love of
Martha Ivers* showcased
another Wallis discovery,
Kirk Douglas. Wallis
recalled: "I knew I was
taking a risk pitting a new-
comer against that
powerhouse, Stanwyck, but
she was extraordinarily
considerate and played
unselfishly with him in
every scene."

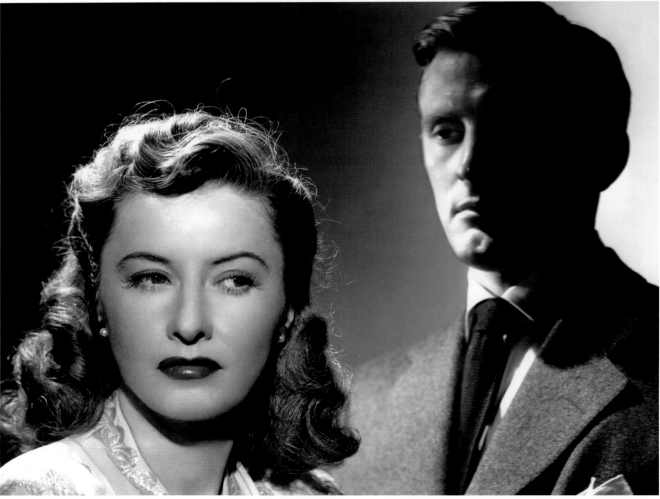

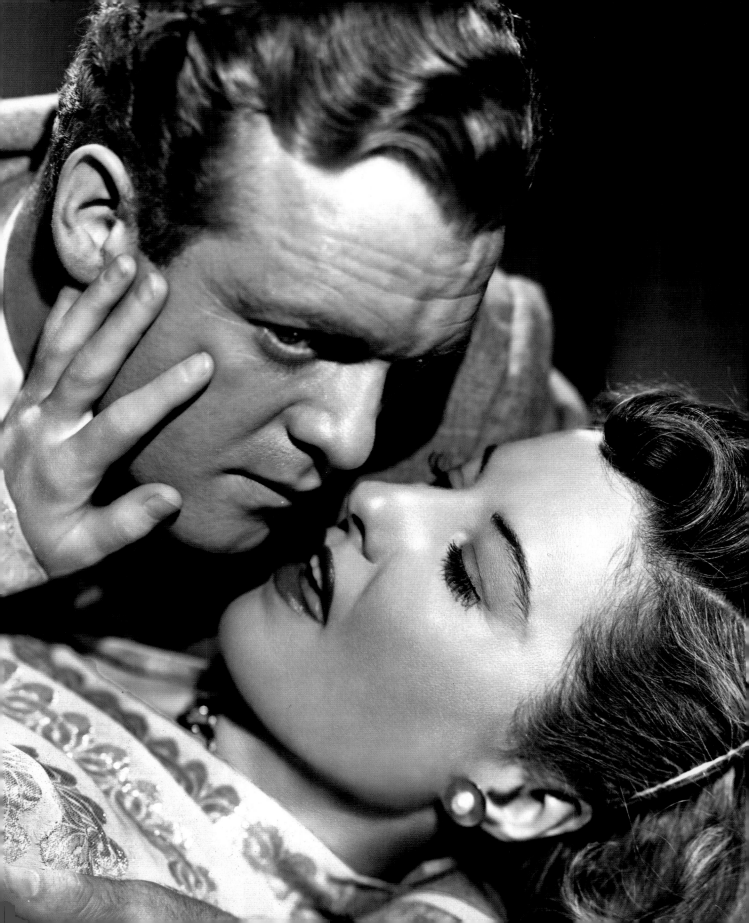

BLACK ANGEL

UNIVERSAL PICTURES
RELEASED AUGUST 2, 1946

Producers
TOM MCKNIGHT
ROY WILLIAM NEILL

Director
ROY WILLIAM NEILL

Screenwriter
ROY CHANSLOR

Source
THE CORNELL WOOLRICH NOVEL
THE BLACK ANGEL

Cinematographer
PAUL IVANO

Stars
CONSTANCE DOWLING
DAN DURYEA • PETER LORRE
JUNE VINCENT

WHEN A SONGWRITER'S WIFE IS FOUND MURDERED, HE FEELS THE POLICE HAVE ARRESTED THE WRONG MAN.

PRODUCTION QUOTES

"Universal has borrowed Ava Gardner from M-G-M for one of three stellar parts in the Cornell Woolrich subject *The Black Angel*. Dan Duryea, under contract to the U, is cast as a Bowery piano player, Miss Gardner as his wife, and Peter Lorre as a café proprietor suspected of murder."

EDWIN SCHALLERT, *Los Angeles Times*, April 1, 1946

"Sudden change of plans finds Ava Gardner out of the cast of *The Black Angel*, with June Vincent replacing her. Miss Gardner has decided to go east after all to see bandleader Artie Shaw, to whom she is married."

EDWIN SCHALLERT, *Los Angeles Times*, April 4, 1946

Roy William Neill directed Dan Duryea in *Black Angel*, another blackout parable based on a Cornell Woolrich book. Memory loss was a familiar motif of 1940s film noir, appearing in *Street of Chance* and, most famously, in *The Lost Weekend*. Portrait by Ray Jones.

The title was changed to *Black Angel*. Duryea was not a Bowery piano player; he was a Hollywood song-writer reduced to playing piano in a Los Angeles dive. Gardner was being cast, not as Duryea's wife, but as the wife of the unjustly convicted man, the heroine who is working with Duryea to clear her husband. Universal contract player June Vincent got the part. Constance Dowling had already been cast as Duryea's ill-fated wife. Gardner's departure had more to do with producer Mark Hellinger's project *The Killers* than with her failing marriage to Artie Shaw.

REVIEW

"Dan Duryea, who was presented as an unmitigated heel in *Scarlet Street* and *Woman in the Window*, enacts a combination hero-alcoholic in *Black Angel*. Universal has provided a liberal coat of whitewash and romantic trimmings. There's also a bit of *Lost Weekend* in the opus, with Duryea finally remembering, while in a drunken stupor, who committed the crime."

JOHN L. SCOTT, "Toughie Duryea Turns Noble," *Los Angeles Times*, August 14, 1946

LETTER FROM REGIONAL THEATER OWNER

"Played Thanksgiving on a double bill and this made quite a hit. Good suspense and fine acting."

J. C. BALKCOM, Gray Theatre, Gray, Georgia, *Motion Picture Herald*, May 26, 1945

ARTIST COMMENT

"In his two recent films, *Black Angel* and *White Tie and Tails*, Duryea is a nice guy. The reformation, to be sure, is gradual. He drinks too much in one and forges a check in the other. 'But I'm a nice guy in both,' he says. 'I'll take my boys to those pictures. It'll make a good impression.'"

LOUIS BERG, "Don't Shoot My Dad!" *Los Angeles Times*, November 10, 1946

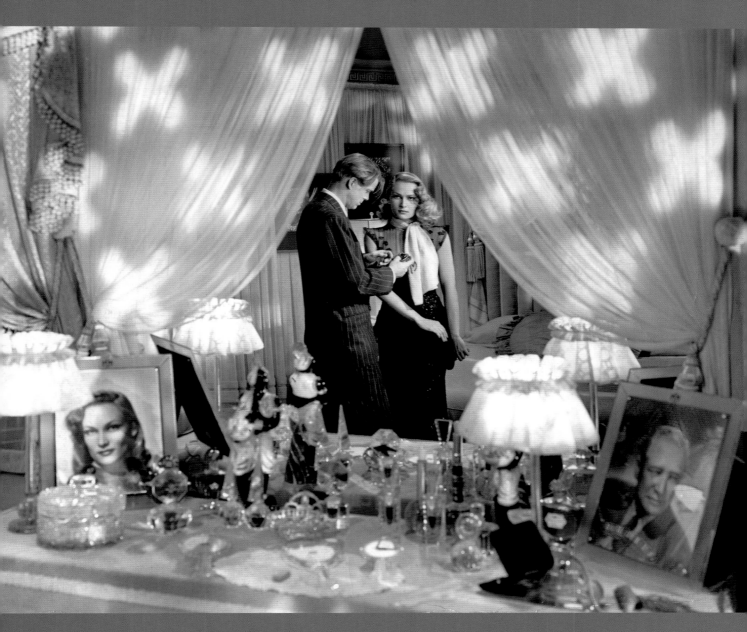

Constance Dowling was
the ill-fated femme fatale
in *Black Angel*.

THE BIG SLEEP

WARNER BROS. PICTURES
PREMIERED AUGUST 23, 1946

Producer-director
HOWARD HAWKS

Screenwriters
**JULES FURTHMAN • LEIGH BRACKETT
WILLIAM FAULKNER**

Source
THE RAYMOND CHANDLER NOVEL

Cinematographer
SID HICKOX

Stars
**HUMPHREY BOGART
LAUREN BACALL**

A HOLLYWOOD DETECTIVE IS HIRED BY AN AILING GENERAL TO SAVE HIS DAUGHTER FROM BEING BLACKMAILED.

PRODUCTION QUOTES

"After reading the write-ups about Lauren Bacall's performance in *Confidential Agent*, I urge you to give the girl at least three or four additional scenes with Bogart of the insolent and provocative nature that she had in *To Have and Have Not*. Bacall was more insolent than Bogart, and this very insolence endeared her to both the public and the critics. It was something startling and new. If this can be recaptured through these additional scenes, I feel that the girl will come through for you magnificently."

CHARLES K. FELDMAN, producer-packager and agent, to Jack L. Warner, November 16, 1945

The Big Sleep had been released in 1945 on a limited basis, primarily to Armed Forces bases overseas. It was pulled back for extensive retakes because Bacall got very bad reviews in *Confidential Agent*. Hawks removed and then reshot an equal number of her scenes in *The Big Sleep*. The 1946 version was slanted much more to Bacall than the 1945 version, but it made less sense; for whatever reason, a scene in which Bogart explains the various plot twists was deleted.

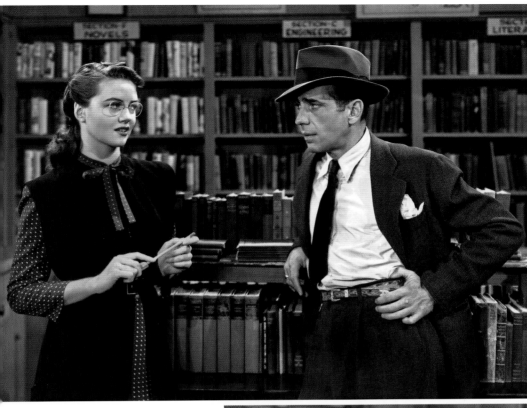

In *The Big Sleep*, Howard Hawks turned Humphrey Bogart into Philip Marlowe, the detective created by Raymond Chandler. Dorothy Malone and Martha Vickers were two of the women tossed in Bogart's path.

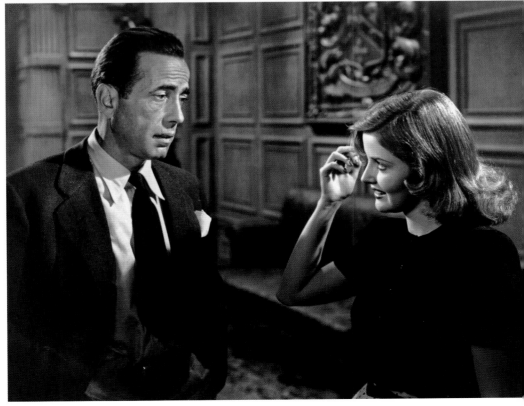

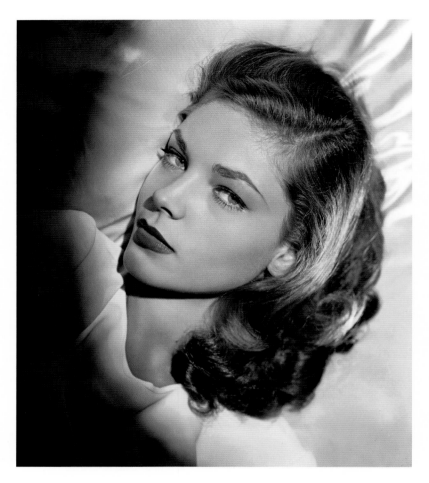

Above: A portrait of Lauren Bacall by Scotty Welbourne.

Opposite: Martha Vickers portrayed a precocious problem child in *The Big Sleep*.

REVIEW

"Except perhaps for the showgirls in a Metro musical, there has never been assembled for one movie a greater and more delightfully varied number of female knockouts. But whereas Metro showgirls at least look content, every woman in *The Big Sleep* is feverishly hungry for love. Though they appear ripe, inwardly they are starved, and so desperate for assuagement that, though every one of them would prefer Humphrey Bogart, they settle instantly for anybody."

CECILIA AGER, "Bogart, Bacall, Babes, and Bums," *PM*, August 25, 1946

LETTERS FROM REGIONAL THEATER OWNERS

"Did good business, but this Bogart-and-Bacall team has not done anything extra for us. The picture pleased most who saw it. I noticed that they all sat through it without noise or squirming."

ELSTUN DODGE, Elstun Theatre, Blaine, Washington, *Motion Picture Herald*, March 1, 1947

"Many good comments from my patrons. They don't like to see Humphrey Bogart play opposite anyone but Lauren Bacall."

CLEO MANRY, Buena Vista Theatre, Buena Vista, Georgia, *Motion Picture Herald*, March 18, 1947

ARTIST COMMENT

"Howard Hawks wanted me to be insolent, a woman who could do what Carole Lombard did. He wanted a woman who could trade dialogue with a guy on an equal level. He didn't want to have someone who would be cowed by a man. Insolence was really what he was looking for, and, of course that's easy to play. You say, 'Oh, *you're* going to tell *me*?' And then it becomes part of your personality."

LAUREN BACALL in Mark Cousins's *Scene by Scene: Film Actors and Directors Discuss Their Work*

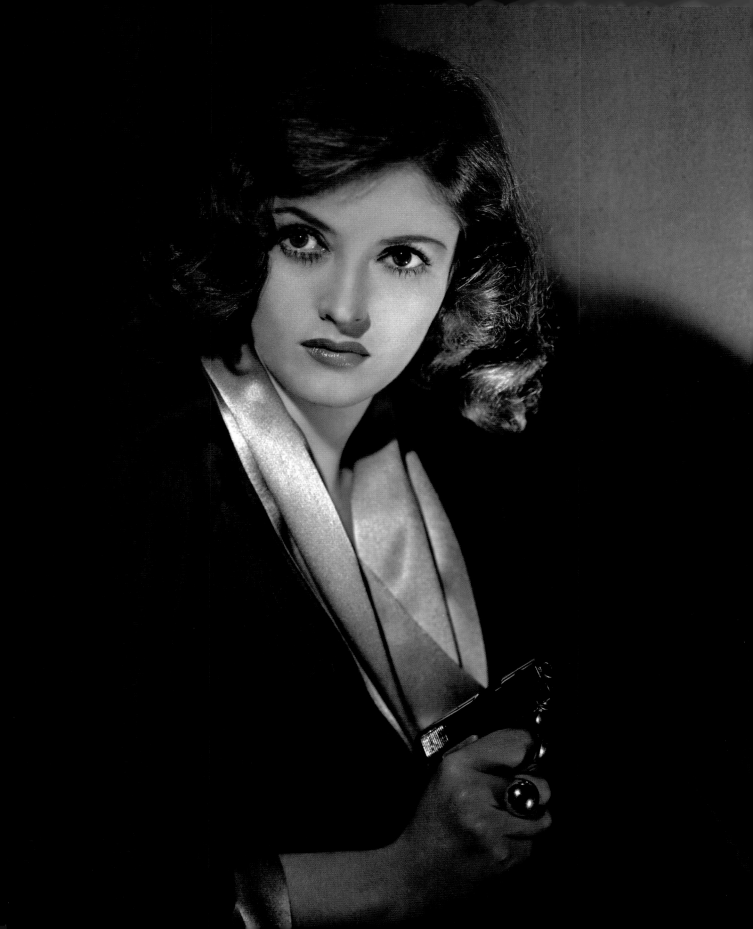

THE KILLERS

UNIVERSAL PICTURES
RELEASED AUGUST 28, 1946

Producer
MARK HELLINGER

Director
ROBERT SIODMAK

Screenwriter
ANTHONY VEILLER

Source
THE ERNEST HEMINGWAY SHORT STORY

Cinematographer
WOODY BREDELL

Stars
BURT LANCASTER
AVA GARDNER
EDMOND O'BRIEN

AN INSURANCE INVESTIGATOR RETRACES THE STEPS LEADING TO THE MURDER OF A FATALISTIC EX-BOXER.

PRODUCTION QUOTES

"Ava Gardner, one of Hollywood's ranking glamour girls and cinematic femme fatales, is taking extension courses from UCLA. 'Everyone else in Hollywood has read *Ivanhoe*, but I haven't,' says Miss Gardner, 'so I'm taking English literature. When I showed my report card on *The Killers* set and bragged about my B-pluses, the company didn't know whether to laugh or cry. I guess most picture people are satisfied with their education, whatever it is.'"

JOHN L. SCOTT, "Little Ava Goes Back to Learnin'," *Los Angeles Times*, June 30, 1946

"On the set of *The Killers* I found Burt Lancaster and Ava Gardner with director Robert Siodmak acting like Mother Gin Sling in *The Shanghai Gesture*. 'Hug her tighter!' he yelled at Burt. When the scene ended I said, 'I didn't hear a rib crack.' To which Siodmak replied, 'We'll dub that sound in later.'"

HEDDA HOPPER, "Looking at Hollywood," *Los Angeles Times*, May 31, 1946

Film noir traditionally tells the audience that the hero is doomed. Thus Burt Lancaster dies at the beginning of Robert Siodmak's *The Killers*, and his tragedy is recounted in flashback.

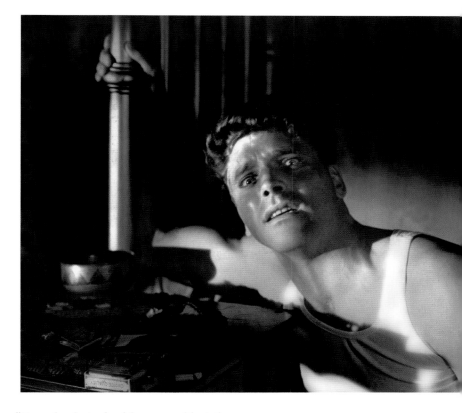

REVIEWS

"Back in the gangster-glutted Twenties, Ernest Hemingway wrote a morbid tale about two gunmen waiting in a lunchroom for a man they were hired to kill. And while they relentlessly waited, the victim lay sweating in his room, too weary and resigned to move. Now, in *The Killers*, Mark Hellinger and Anthony Veiller are cleverly explaining, through a flashback reconstruction of the life of that man, why the gunmen were after him. And although it may not be precisely what Hemingway had in mind, it makes for a taut and absorbing explanation."

BOSLEY CROWTHER, *The New York Times*, August 29, 1946

"Everybody is double crossed but the audience in *The Killers*, a picture which could be called a model of cinematic storytelling—if the matrix hadn't been set five years ago in another brilliant flashback job by the name of *Citizen Kane*. Robert Siodmak lets an insurance investigator ask the questions, and he gets kicked in the head and shot at. But what investigator isn't, these homicidal-movie days? Out front the spectator is crying for blood. Universal serves him his violence— vicariously. It hasn't had its trademark on a sweeter thriller in years."

PHILIP K. SCHEUER, "Hit Thriller," *Los Angeles Times*, October 12, 1946

 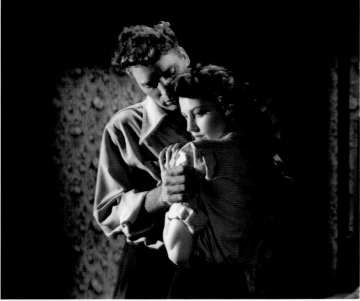

Above left: *The Killers* made Burt Lancaster a star. He was yet another Hal Wallis discovery, but Universal producer Mark Hellinger and director Robert Siodmak borrowed him from Wallis (and Paramount) for their adaptation of the Hemingway story. In this scene, he is a filling-station attendant grooming the automobile of a gangster (Albert Dekker).

Above right: Hellinger borrowed Ava Gardner from M-G-M to play the femme fatale of the piece. This film made her a star, too.

Opposite: A Ray Jones portrait of Burt Lancaster and Ava Gardner made in conjunction with *The Killers*.

LETTER FROM REGIONAL THEATER OWNER

"A marvelous picture. The acting is superb and there is never a dull moment. My patrons liked it but the title kept some away."

KEN GORHAM, Town Hall Theatre, Middlebury, Vermont, *Motion Picture Herald*, February 8, 1947

ARTIST COMMENTS

"Mark Hellinger trusted me from the beginning, so I trusted him. He saw me as an actress, not as a sexpot. He gave me a feeling of the responsibility of being a movie star, which I had never for a moment felt before. I knew he was a genius."

AVA GARDNER in Joe Hyams's "The Private Hell of Ava Gardner," *Look*, November 27, 1956

"Robert Siodmak taught us to convey emotion with the absolute minimum of facial expression. 'The camera is a magnifying glass,' he would say. He was so excited by Ava that he let her dominate every scene. In the scene in the Green Cat Café when I needle her, Siodmak told her to cut her expression in half and to move her mouth slightly as she moved her eyes. As a result she gave a convincing account of a deceiving woman about to be caught."

EDMOND O'BRIEN in Charles Higham's *Ava*

The Killers cost $875,000. It grossed $3 million.

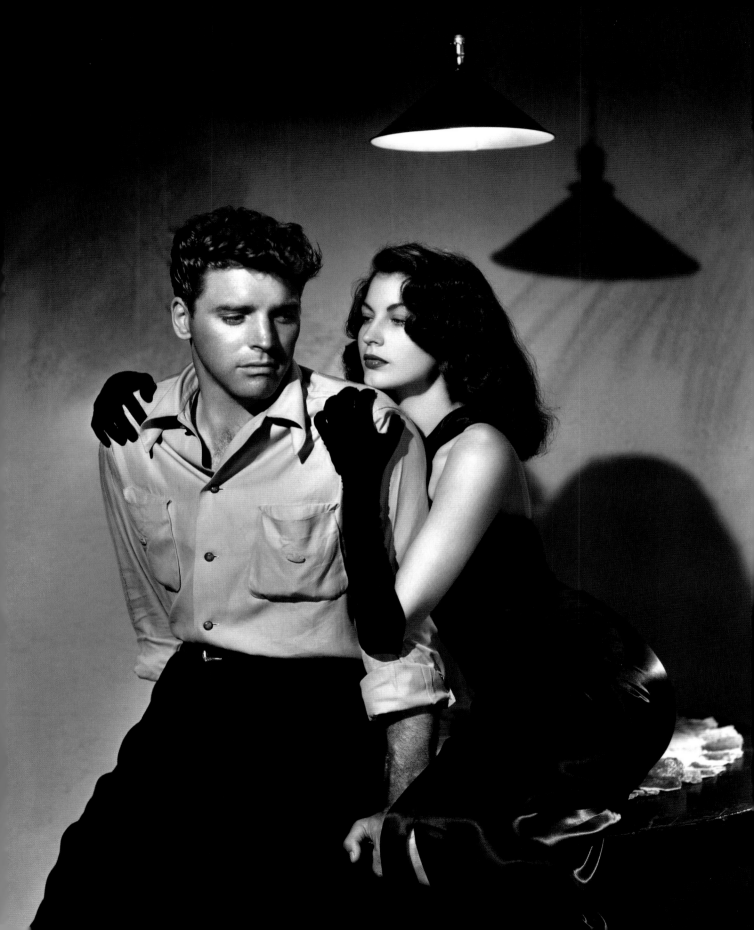

THE LOCKET

RKO RADIO PICTURES
RELEASED DECEMBER 20, 1946

Producer
BERT GRANET

Director
JOHN BRAHM

Screenwriter
SHERIDAN GIBNEY

Cinematographer
NICHOLAS MUSURACA

Stars
**LARAINE DAY
BRIAN AHERNE
ROBERT MITCHUM**

WORKING TITLE: WHAT NANCY WANTED

A WEDDING PARTY IS INTER-RUPTED WHEN A PSYCHIATRIST SHOWS UP TO SAY THAT THE BRIDE IS A THIEF AND MURDERER.

PRODUCTION QUOTE

"For a sequence in *What Nancy Wanted*, Laraine Day had to look haggard and worn. Instead of depending on makeup, she sat up all night and reported to the studio not only looking but also feeling the part."

Hedda Hopper, *Los Angeles Times*, May 8, 1946

REVIEW

"Sugar wouldn't melt in the mouth of Nancy, the heroine of *The Locket*. Yet if we are to believe the evidence, she is a first-class criminal. With this to go on, Nancy brings the wicked-lady-psychopathic parade up to date. Laraine Day gives what must be her most fascinating performance. As with so many of these wide-eyed innocents who are supposed to be baddies inside, the spectator may have difficulty in crediting her with such heartless villainies. However, there is just enough of a defiant something about Miss Day, more of the spirit than the actual behavior, to raise the shadow of a doubt. It is this question mark that holds one rapt."

PHILIP K. SCHEUER, "Laraine Day Psychopath," *Los Angeles Times*, May 27, 1947

LETTER FROM REGIONAL THEATER OWNER

"Here is a good picture—to keep away from. If your patrons are in the mood to untangle flashbacks within flashbacks, they might be moderately satisfied until the ending, when they get the feeling that nothing of importance has ever happened, and they go out scratching the backs of their heads. Business was below average the first night, but word of mouth soon knocked that down to mere insignificance. Skip it if you can."

GEORGE E. JANES, Ojai Theatre, Ojai, California, *Motion Picture Herald*, August 17, 1946

ARTIST COMMENTS

"The complexity of Sheridan Gibney's plot was what really enticed me to the material. It was an enigma within an enigma within an enigma. John Brahm had done a very good horror picture at Twentieth about Jack the Ripper called *The Lodger*. He was a German—but not too German—and I thought he would be good to direct this and give it some of the same atmosphere."

PRODUCER BERT GRANET in Lee Server's *Baby, I Don't Care*

Left: In John Brahm's *The Locket*, Mrs. Monks (Helene Thimig, real-life widow of Max Reinhardt) comforts Nancy (Sharyn Moffett) when she is denied the eponymous trinket. The lady of the house has decreed that a housekeeper's daughter does not deserve the gift of a jeweled artifact. "It's all right to want things," says Nancy's mother. "But you'll have to be patient. If you want things badly enough, someday you'll have them."

Right: The locket disappears and Mrs. Willis (Katherine Emery) suspects Nancy. The interview goes awry, terrifying the child. Sheridan Gibney's script conveys the power of a childhood trauma.

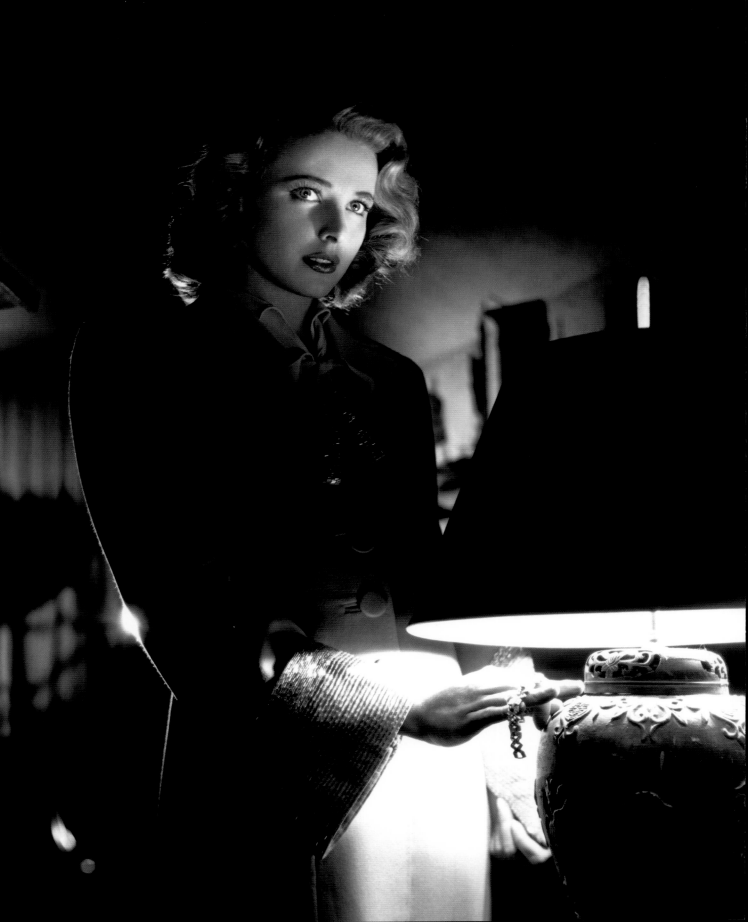

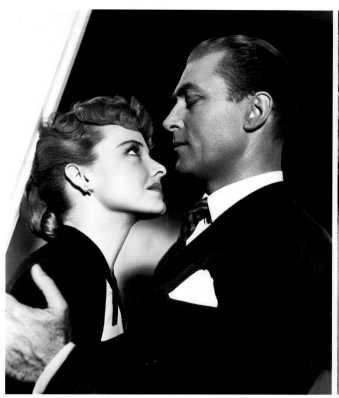

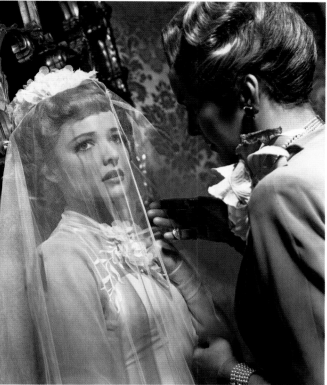

"I sold *The Locket* first as a treatment, about forty pages. Everybody in town—all the major studios and all the independent producers—turned it down, until it got to RKO, where Bill Dozier bought it for his wife, Joan Fontaine. Joan had another commitment, so we ended up with Laraine Day. John Brahm had a theater background; he respected the story about this man who is about to marry a girl who may be a paranoid kleptomaniac. The final scene is the wedding, where the groom has decided to go ahead. I ended the story with the bride approaching the altar and the groom waiting—this is where I wanted to fade out to a 'lady or the tiger' ending. The front office, because of censorship, wouldn't let me. They said, 'You can't do this. She's obviously guilty at the end. He can't marry her.' I said, 'Actually, I don't know that at all.' But they forced me to have her collapse during the ceremony and have the wedding called off. The picture would have been better with Joan Fontaine. She had more of a quality. Laraine Day gave a kind of weird performance, which wasn't necessary."

SHERIDAN GIBNEY in Patrick McGilligan's *Film Crazy*

Left: Nancy conveniently marries a psychiatrist (Brian Aherne), but even he fails to unlock Nancy's past. When she remarries, he tells her: "There can be no happiness for you. Ever."

Right: In a weird coincidence, Nancy finds herself engaged to Mrs. Willis's son. And what does Mrs. Willis give Nancy as a gift? Her obsession, the locket! *What Nancy Wanted* was Gibney's original title. He was not pleased with Laraine Day's performance, but it has stood the test of time, helping to make *The Locket* a genuinely disturbing film.

Opposite: The little girl grows up to be Nancy Monks (Laraine Day), who continues to attract missing jewelry.

HUMORESQUE

WARNER BROS. PICTURES
RELEASED DECEMBER 25, 1946

WHEN AN ASPIRING CONCERT VIOLINIST ACCEPTS A WEALTHY WOMAN'S PATRONAGE, HE BEGINS A DOOMED ROMANCE.

PRODUCTION QUOTE

"During this production, Joan Crawford often got to the set forty-five minutes before I did. I would find her rehearsing her part. No one had arrived yet, so she had an electrician reading John Garfield's lines. She's a perfectionist."

JEAN NEGULESCO in Arthur Millier's "Joan Crawford Makes Director Feel Humble," *Los Angeles Times*, December 15, 1946

Producer
JERRY WALD

Director
JEAN NEGULESCO

Screenwriters
ZACHARY GOLD
CLIFFORD ODETS

Source
THE FANNIE HURST SHORT STORY

Cinematographer
ERNEST HALLER

Unit stills photographers
EUGENE RICHEE • JACK WOODS

Stars
JOAN CRAWFORD
JOHN GARFIELD • OSCAR LEVANT

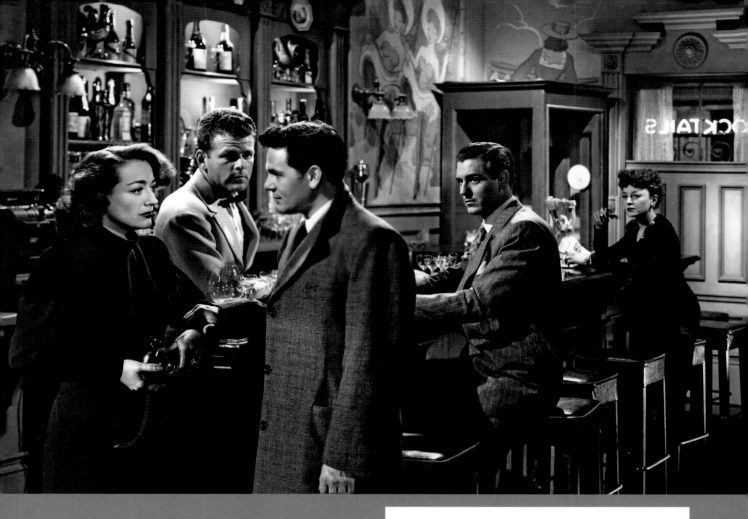

Above: Film noir is associated with urban locations, and even an elegant bar can turn dark if a doomed couple chooses it as a setting. Joan Crawford and John Garfield negotiate their misery in Jean Negulesco's *Humoresque*.

Right: Negulesco, who had come to Hollywood as a concept artist, drew a portrait in order to assuage the real-life anxiety of his star.

"This rags-to-penthouse fable in which a lower East Side boy makes good while an upper East Side girl makes trouble is mostly unadulterated 'schmaltz,' a word of obese connotation, introduced here by Oscar Levant. The Warner Brothers have wrapped this piteous affair in a blanket of soul-tearing music which is supposed to make it spiritually purgative. They have padded it with long passages from symphonic scores by Bizet, Rossini, and other masters, and, for the smashing, titanic climax, in which Joan Crawford wobbles out, soused to the ears, to cast herself tragically into the sea after a telephone conversation with John Garfield, who has told her that he loves his fiddle more, the music that cries and crashes is the *Liebestod* from *Tristan und Isolde*."

BOSLEY CROWTHER, *The New York Times*, December 26, 1946

"The point of *Humoresque* seems to be that parents whose children insist on playing the violin ought to take them, not to a music teacher, but to a psychiatrist. Previewed at the Academy Awards Theatre, where an all-press audience enjoyed Oscar Levant's comedy loudly and seemed depressed by the rest of the proceedings."

WILLIAM R. WEAVER, "Humoresque," *Motion Picture Herald*, December 28, 1946

LETTER FROM REGIONAL THEATER OWNER

"This is a picture for a big town but not suitable for a small town, where they don't like Miss Crawford. They expect to see John Garfield in an action picture instead of playing a fiddle."

E. M. FREIBURGER, Paramount Theatre, Dewey, Oklahoma, *Motion Picture Herald*, July 4, 1947

ARTIST COMMENT

"After we'd been making the picture for about a week, Jerry Wald came to me saying that Joan Crawford had entered his office weeping and complaining that I didn't want to talk to her. I asked him what he meant. 'Well,' he said, 'you don't explain any of the scenes to her.' I went home really quite worried. How could I get through to her? Then my wife Dusty said, 'Why don't you do a portrait?' And I did a wonderful portrait embodying what I thought the character should be. When I gave it to Crawford, I said, 'I'm sorry, but I'm not an eloquent man. This is what I think the character should be.'"

JEAN NEGULESCO in Charles Higham and Joel Greenberg's *The Celluloid Muse*

Opposite top: Indolent Paul Cavanagh watches as his self-destructive wife fixates on a selfish young musician. "Whether *Humoresque* will stand up after the first crowds have seen it will depend on whether the public has had enough of films in which none of the principal characters beget sympathy," wrote *Motion Picture Herald*.

Opposite bottom: Jean Negulesco pulled out all the stops to show the anguish of his heroine. And Joan Crawford held nothing back.

1947

REPORT ON THE "CRIME STORY" CYCLE

"The 'private eye,' that sometimes suave, sometimes tough, fictional money-minded detective who by fair means or foul solves murder mysteries too tough for the regular police, is expanding his tremendous following in the 25-cent paper books through motion pictures. Philip Marlowe, brain child of Raymond Chandler, a ranking writer of thrillers, is the latest sleuthing figure to hit the screen. In fact, he's currently being portrayed by not just one star but four. This sets a Hollywood record.

"Dick Powell's delineation of Marlowe, a shrewd but sometimes foolhardy character who receipts for many a beating before he washes up his cases, is in *Murder, My Sweet* (original title, *Farewell, My Lovely*). Humphrey Bogart enacts the role in *The Big Sleep*, Robert Montgomery in *Lady in the Lake*, and George Montgomery in *The Brasher Doubloon* (original title, *The High Window*.)

"Powell and Bogart grew beards for their characterizations, emphasizing the rougher nature of Marlowe. George Montgomery raised a mustache and enacts a combination suave-belligerent character. Robert Montgomery, on the other hand, is a more refined sleuth. This is the first time the same detective has been interpreted by four different actors. It also breaks Hollywood's tradition of allowing an appreciable time to elapse between presentations of the same character."

JOHN L. SCOTT, "Four Play Philip Marlowe," *Los Angeles Times*, August 11, 1946

LOOKING BACK AT FILM NOIR

"The French have a great penchant for this kind of categorizing, for putting names which are so ridiculous. I have a particular hatred for creating new vocabularies. This is what happens, that after a movement has taken place, without the people involved in it even knowing that it's a movement, along come these students, the critics, who can't do the thing at all, but they become the experts on it, as it were. They write books interpreting interpreters, and they create a special vocabulary."

EDWARD DMYTRYK in Alain Silver, James Ursini, and Robert Porfirio's *Film Noir Reader 3*

DEAD RECKONING

COLUMBIA PICTURES
RELEASED JANUARY 16, 1947

Producer
SIDNEY BIDDELL

Director
JOHN CROMWELL

Screenwriters
OLIVER H. P. GARRETT, STEVE FISHER,
FROM AN ADAPTATION
BY ALLEN RIVKIN

Source
A STORY BY SIDNEY BIDDELL
AND GERALD ADAMS

Cinematographer
LEO TOVER

Stars
HUMPHREY BOGART
LIZABETH SCOTT

WHEN A VETERAN ABOUT TO BE DECORATED FOR BRAVERY IS MURDERED, HIS BEST FRIEND VOWS TO FIND THE KILLER.

PRODUCTION QUOTES

"Lizabeth Scott is to be costarred with Humphrey Bogart in *Dead Reckoning*, one of the most striking bits of casting yet achieved in Hollywood. It is striking because Miss Scott was at one time compared with Lauren Bacall, who is reputed to have objected to playing in this film because she wants to attain her independent cinema destiny."

EDWIN SCHALLERT, *Los Angeles Times*,
June 7, 1946

"Humphrey Bogart's clothes in *Dead Reckoning* have looked so bad that the studio sent for his tailor. 'It's because of your lights,' the tailor told the cameraman. 'No,' chimed in Bogey. 'I always look this way.'"

HEDDA HOPPER, "Looking at Hollywood,"
Los Angeles Times, July 26, 1946

A Ned Scott photograph of Lizabeth Scott and Humphrey Bogart made to publicize John Cromwell's *Dead Reckoning*.

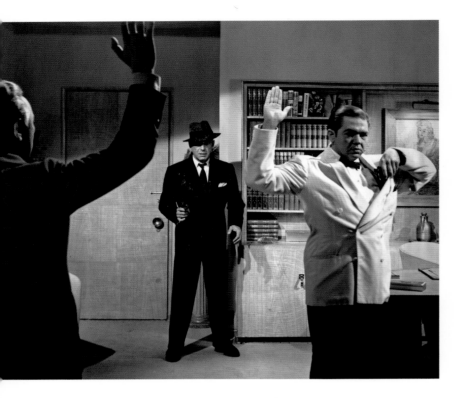

Above: Bogart gets the drop on Morris Carnovsky (left) and Marvin Miller in *Dead Reckoning*. Photograph by Joe Walters.

Opposite: A Ned Scott portrait of Humphrey Bogart in *Dead Reckoning*.

REVIEWS

"There are a lot of things about the script of *Dead Reckoning* that an attentive spectator might find disconcerting, but the cumulative effect of the new Humphrey Bogart slug 'em, love 'em, and leave 'em picture is all on the good side of entertainment. Old 'Bogey' takes the drubbing of his cinematic life from a tough, psychopathic character who delights in 'messing up' his victims to the strains of sweet music."

BOSLEY CROWTHER, *The New York Times*, January 23, 1947

"Humphrey Bogart continues his tough guy career with *Dead Reckoning*, a melodrama just arrived at the Criterion. Lizabeth Scott, husky-voiced and deliberately sinister, has the leading role, a part of the type usually assigned to Mrs. Bogart, Lauren Bacall of the movies. This film presents Bogart as neither gangster nor detective, but as an ex-soldier. That in itself is a relief."

EILEEN CREELMAN, "The New Movies," *New York Sun*, January 28, 1947

LETTER FROM REGIONAL THEATER OWNER

"A good Bogart melodrama which seemed to me to fall apart near the end. Business only fair. In this locality murder is slowly beginning to lose its appeal."

JOHN R. COONEY, Waldo Theatre, Waldoboro, Maine, *Motion Picture Herald*, April 26, 1947

ARTIST COMMENT

"Bogey would arrive in the morning, but he'd never know his lines. He'd come in, work on them for a couple of hours, and then Mr. John Cromwell, our director, would rehearse us a few times. Bogey always had two martinis while he ate his lunch, and he'd always keep his dressing room door open. After he was all put together again, we'd shoot, maybe a four- or five-page scene. We'd get it all in one take."

LIZABETH SCOTT in Alain Silver, James Ursini, and Robert Porfirio's *Film Noir Reader 3*

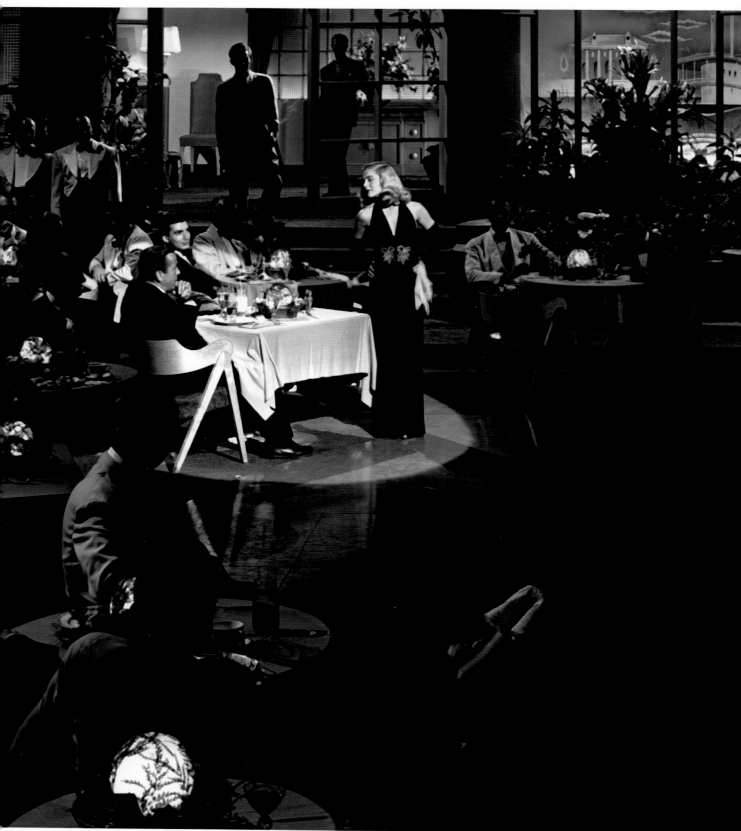

Left: Lizabeth Scott sings at Bogart's table in *Dead Reckoning*. Photograph by Joe Walters.

Below: If the film noir lexicon contained the word *spoiler*, this photo from *Dead Reckoning* would qualify. Yet 1940s film critics consistently gave away the endings of suspense films in their reviews. Photograph by Joe Walters.

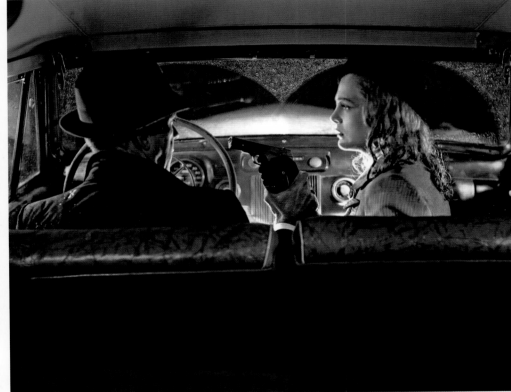

LADY IN THE LAKE

METRO–GOLDWYN–MAYER
RELEASED JANUARY 23, 1947

Producer
GEORGE HAIGHT

Director
ROBERT MONTGOMERY

Screenwriter
STEVE FISHER

Source
THE RAYMOND CHANDLER NOVEL
THE LADY IN THE LAKE

Cinematographer
PAUL C. VOGEL

Stars
ROBERT MONTGOMERY
AUDREY TOTTER • JAYNE MEADOWS

A DETECTIVE'S VISIT TO A CRIME-STORY PUBLISHER ENTANGLES HIM IN A MURDER CASE.

PRODUCTION QUOTES

"Robert Montgomery, I hear, has a yen to act in the film of Raymond Chandler's *The Lady in the Lake*, scripted by Steve Fisher."

EDWIN SCHALLERT, "Hervey Writing Indian Thriller," *Los Angeles Times*, February 28, 1946

"Robert Montgomery is directing *Lady in the Lake* from a wheelchair. Got his foot caught in a camera crane."

HEDDA HOPPER, "Looking at Hollywood," *Los Angeles Times*, June 20, 1946

"YOU will be Philip Marlowe (i.e.; the camera) throughout M-G-M's recently completed *Lady in the Lake*. Robert Montgomery reintroduces this revolutionary first- (or second-) person storytelling technique, an elaboration of that used in *Murder, My Sweet* and many other films, as far back as F. W. Murnau's *The Last Laugh* and Paul Fejos's *The Last Moment*, two decades ago."

PHILIP K. SCHEUER, "Call It Audience Participation, Please," *Los Angeles Times*, September 2, 1946

"We've never called Bob Montgomery a triple-threat man, but he is. He's got both feet on the ground and doesn't indulge in any Orson Welles shenanigans!"

HEDDA HOPPER, "Looking at Hollywood," *Los Angeles Times*, November 25, 1946

"All my romantic scenes were played with the camera instead of a real person. I doubt whether any other actress has had an experience just like that. I had to use a lot of imagination for any inspirational effect."

AUDREY TOTTER in Edwin Schallert's "Brilliant Career Dawning," *Los Angeles Times*, February 2, 1947

REVIEW

"Having seen *Lady in the Lake* yesterday at the Capitol, this corner now can confirm what the advertisements have been saying all along. The picture is definitely different and affords one a fresh and interesting perspective on a murder mystery. YOU do get into the story and see things pretty much the way the protagonist, Philip Marlowe, does, but YOU don't have to suffer the bruises he does. Of course, YOU don't get a chance to put your arms around Audrey Totter either. After all, the movie makers, for all their ingenuity, can go just so far in the quest for realism."

BOSLEY CROWTHER, *The New York Times*, January 24, 1947

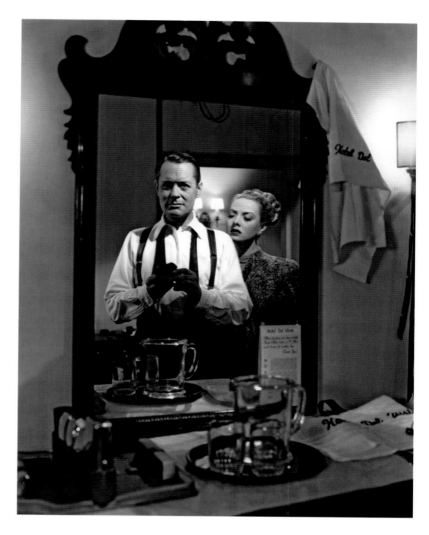

LETTER FROM REGIONAL THEATER OWNER

"We advertised the new technique, and as such we had a fair audience, but while the picture, as it developed, gripped them, the reaction of the audience was such that I don't think they will go for a steady diet of this."

A. E. HANCOCK, Columbia Theatre, Columbia City, Indiana, *Motion Picture Herald*, April 12, 1947

Robert Montgomery (here, with Audrey Totter) was both star and director of *Lady in the Lake*.

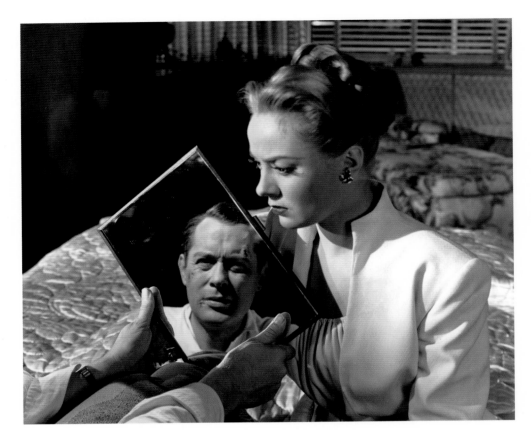

Montgomery was one of the biggest stars returning from distinguished service in World War II, and the prospect of his playing Philip Marlowe was intriguing, even to Bosley Crowther: "Mr. Montgomery's Philip Marlowe is somewhat more cynical

ARTIST COMMENTS

"Robert Montgomery has a vision that goes far beyond just the acting end of the films, because he seems to understand so well their technical possibilities. The unique treatment of the story employed in *Lady in the Lake* has been widely praised by the critics. He had the courage to do something utterly different."

AUDREY TOTTER in Edwin Schallert's "Brilliant Career Dawning," *Los Angeles Times*, February 2, 1947

"I had a little trouble making the picture—if you can call eight years of arguing 'a little trouble.' Nobody seems to want an actor to become a director. And the idea for this film wasn't exactly a pushover to sell. Our head cameraman Paul Vogel almost went daffy. He lived in constant fear of being sacked by the front office. But then, so did I."

ROBERT MONTGOMERY in Jack Sher's "How to Win an Argument," *Los Angeles Times*, March 2, 1947

Lady in the Lake cost $1.02 million. It grossed $2.65 million.

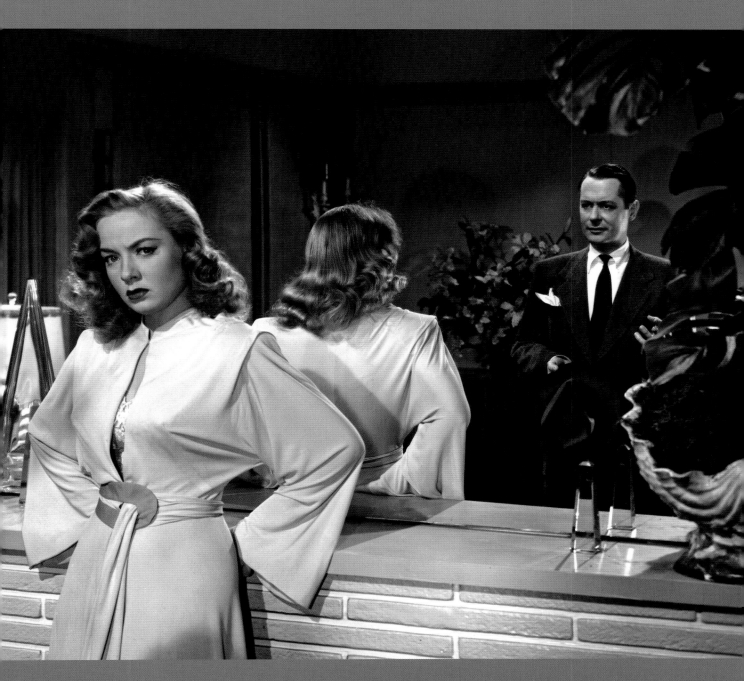

Lady in the Lake tells its story through Marlowe's eyes—the subjective camera—and Montgomery's face is only glimpsed occasionally, as in this mirror shot. The effect played to mixed reactions. "Our patrons were not much impressed," wrote exhibitor A. E. Hancock from Indiana. "They want to see the actor, not just hear an offscreen voice."

SMASH-UP— THE STORY OF A WOMAN

UNIVERSAL-INTERNATIONAL PICTURES
RELEASED MARCH 12, 1947

Producer
WALTER WANGER

Director
STUART HEISLER

Screenwriters
JOHN HOWARD LAWSON
LIONEL WIGGAM

Source
A STORY BY DOROTHY PARKER
AND FRANK CAVETT

Cinematographer
STANLEY CORTEZ

Stars
SUSAN HAYWARD
MARSHA HUNT • EDDIE ALBERT

WHEN A POPULAR NIGHTCLUB SINGER SEES HER HUSBAND BECOME A HUGE RADIO STAR, SHE TRIES TO QUELL HER INSECURITIES BY DRINKING.

PRODUCTION QUOTE

"The use of liquor in the scenes of drinking and drunkenness which crowd this picture are proper and necessary, but you would do well to dismiss this story from further consideration because showing a drunken woman moving about is both distasteful and repulsive; and the sound moral of your story will be forgotten in the reaction of disgust."

JOSEPH I. BREEN in Thomas Doherty's *Hollywood Censor: Joseph I. Breen and the Production Code Administration*

REVIEWS

"Dipsomania is again explored for screen purposes. In *Smash-Up*, Susan Hayward suffers from alcoholism in a but little milder form than Ray Milland in *The Lost Weekend*. The results are intensely insidious before the picture is fully unreeled. One does not witness the phenomenon of delirium tremens or view a psychopathic ward during this picture, but it is abundantly tragical as a study of the evils of drink when these assume a pathological aspect."

EDWIN SCHALLERT, "Feminine *Lost Weekend*," *Los Angeles Times*, March 13, 1947

"There isn't much doubt that *Smash-Up—The Story of a Woman* will be tagged as the *Lost Weekend* of a lady. But don't let this flattering parallel fool you. In its direction and performance, this film gives little evidence of sincerity of purpose toward depicting the realities of dipsomania. Susan Hayward performs the boozy heroine with a solemn fastidiousness which turns most of her scenes of drunken fumbling and heebie-jeebies into off-key burlesque. And it is notable that her appearance is never unflatteringly disarrayed. Except for the spectacle of much drinking by a lady and a lot of modern chic, this offering shows little more than any old-fashioned barroom tear-jerker."

BOSLEY CROWTHER, *The New York Times*, April 11, 1947

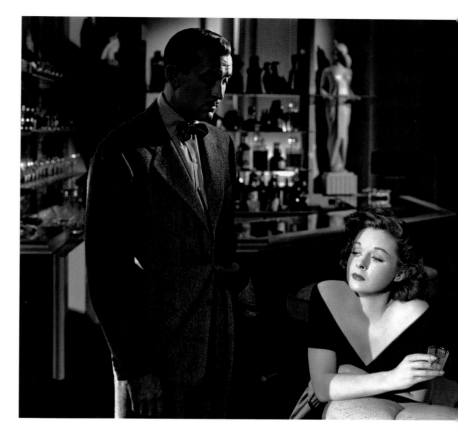

Lee Bowman cannot keep Susan Hayward from self-destruction in Stuart Heisler's *Smash-Up—The Story of a Woman*. "I saw customers walk away and never buy a ticket after they looked at the pictures in the lobby," wrote Vermont theater owner Ken Gorham. The pictures in question were not shocking. They captured the stylized photography of Stanley Cortez, which made the film outstanding, not to mention Miss Hayward's performance.

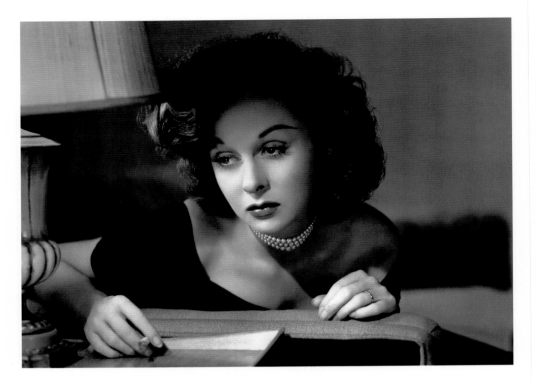

A publicity portrait of Susan Hayward made to publicize *Smash-Up—The Story of a Woman*.

LETTERS FROM REGIONAL THEATER OWNERS

"A powerful picture that caused a lot of discussion for the children. It drew fairly well."

A. N. MILES, Eminence Theatre, Eminence, Kentucky, *Motion Picture Herald*, November 1, 1947

"This does not come under our definition of entertainment. From the slim turnout a good many others must have thought the same thing. There is too much screaming and it is generally an unpleasant topic."

A. C. EDWARDS, Winema Cinema, Scotia, California, *Motion Picture Herald*, November 1, 1947

ARTIST COMMENTS

"*Smash-Up* was an interesting experiment. We had a scene in which the heroine is lying in bed and mumbling; she's having a nightmare. Susan Hayward helped by actually getting drunk to play the scene. It was fantastic."

STANLEY CORTEZ in Charles Higham's *Hollywood Cameramen*

"What an ordeal that picture was. I was limp as a rag every night."

SUSAN HAYWARD in Kim R. Holston's *Susan Hayward: Her Films and Life*

"I had a big fight scene with Susan Hayward in a powder room. We went right at it. No retakes. The bruises were showing."

MARSHA HUNT in Kim R. Holston's *Susan Hayward: Her Films and Life*

Smash-Up cost $1.36 million. It grossed $2.30 million.

BORN TO KILL

RKO RADIO PICTURES
RELEASED MAY 3, 1947

Producer
HERMAN SCHLOM

Director
ROBERT WISE

Screenwriters
EVE GREENE • RICHARD MACAULAY

Source
THE JAMES GUNN NOVEL
DEADLIER THAN THE MALE

Cinematographer
ROBERT DE GRASSE

Stars
LAWRENCE TIERNEY
CLAIRE TREVOR
ESTHER HOWARD

WORKING TITLE: *DEADLIER THAN THE MALE*

A CALCULATING WOMAN SCHEMES TO EXPLOIT A MURDERER'S PAST

PRODUCTION QUOTE

"Full-fledged recognition is coming to Claire Trevor at long last. RKO will star her under a new two-picture contract, the first being *Deadlier Than the Male*."

HEDDA HOPPER, *Los Angeles Times*, January 23, 1946

REVIEWS

"*Born to Kill* is a clear illustration of why the movies are sometimes held in low esteem by people who are thoughtful of their influence, which is also an apt demonstration of why critics sometimes go mad. For this crime-flaunting melodrama from the left hand of RKO is not only morally disgusting but also an offense to a normal intellect—and we say this with no more piety or conceit than is average, we feel sure."

BOSLEY CROWTHER, *The New York Times*, May 1, 1947

Opposite top: In Robert Wise's *Born to Kill*, Claire Trevor, Walter Slezak, and a cast of unsympathetic characters offended critics far and wide. "There is such a thing as being hard-boiled to the point where it turns into caricature," wrote Archer Winsten in *PM*. "The movie is so desperately loaded with sensation that you end up giggling. People who don't laugh are free to feel disgusted."

Opposite bottom: This scene of Lawrence Tierney, Elisha Cook Jr., and Esther Howard was one of many that incensed critics. "The whole detail of corruption," wrote Bosley Crowther, "is so indulgently displayed that it looks as though the aim of the producers was to include as much as possible within the limits of the Production Code."

"Lawrence Tierney, who has made himself a reputation on the screen as a killer and in court as a b-a-a-a-d boy, is now being elevated to the higher pinnacles of strength, corruption and depravity. First he kills a girl in Reno who has had the misfortune to make him slightly jealous. Next Tierney meets Claire Trevor, herself a fifteen-minute egg. No time is wasted hereabouts to make the plot less crudely sensational. Thrill-mongering of this kind can serve no useful purpose, except to reduce to ultimate absurdity the entire school of hard-boiled, chiller-killer-diller movies."

ARCHER WINSTEN, "*Born to Kill* Overworks Killer Instinct," *New York Post*, May 11, 1946

Lawrence Tierney served time for provoking violent or drunken incidents in July 1945, January 1946, February 1946, March 1946, and August 1946.

"*Born to Kill* is about as subtle as a poke in the eye with a sharp stick. There is no mystery, and Lawrence Tierney is a ruthless, deliberate killer who has a simple philosophy— if somebody gets in the way, eliminate him."

JOHN L. SCOTT, "Contrasting Movie Fare," *Los Angeles Times*, July 3, 1947

LETTER FROM REGIONAL THEATER OWNER

"Hardly any draw, although it is a good show."

RALPH RASPA, State Theatre, Rivesville, West Virginia, *Motion Picture Herald*, December 20, 1947

ARTIST COMMENT

"That was one of Robert Wise's first pictures and he was wonderful. I had not worked with a top director very often. I thought he was tops. He was very articulate and everything he said was pure gold, although the picture was not that complicated and didn't require a lot of explanation. Lawrence Tierney was my leading man and he was kind of kooky but entirely different from the killer he played. He was a creative, poetic kind of man."

CLAIRE TREVOR in William M. Drew's *At the Center of the Frame*

"The book was called *Deadlier Than the Male*, and anybody who's seen the film knows how meaningful that is. But having Lawrence Tierney, the studio thought it was important to get something more striking in the title. I was never happy about the change."

ROBERT WISE in Sergio Leeman's *Robert Wise on His Films*

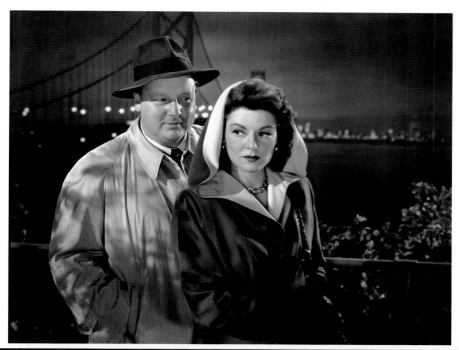

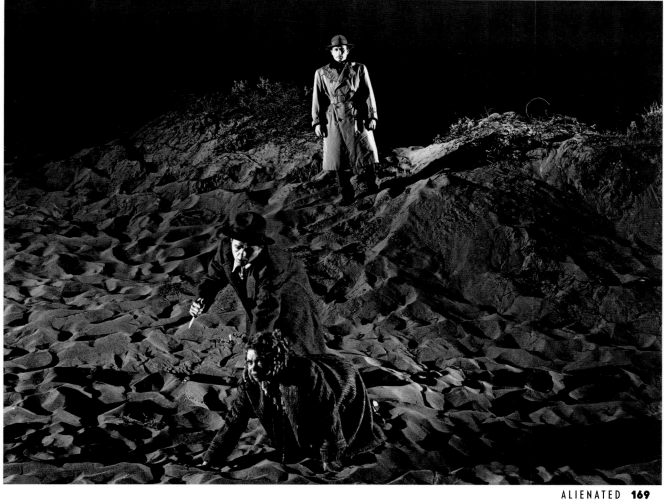

DESPERATE

RKO RADIO PICTURES
RELEASED MAY 9, 1947

Producer
MICHAEL KRAIKE

Director
ANTHONY MANN

Screenwriter
HARRY ESSEX, WITH ADDITIONAL
DIALOGUE BY MARTIN RACKIN

Source
A STORY BY ANTHONY MANN
AND DOROTHY ATLAS

Cinematographer
GEORGE E. DISKANT

Stars
STEVE BRODIE
RAYMOND BURR

WORKING TITLE: *FLIGHT*

A TRUCK DRIVER BECOMES
THE INNOCENT PAWN OF A BUR-
GLARY GANG

REVIEW

"Here is another gangster picture
with a slightly smaller-than-usual dose
of gunplay and violence and a propor-
tionately increased amount of heart
appeal. It is out to prove the old truth
that the wheels of justice grind slowly
but exceedingly fine, in some cases
to the point of extinction."

FRED HIFT, "*Desperate*," *Motion Picture Herald*,
May 17, 1947

LETTER FROM REGIONAL
THEATER OWNER

"A good action picture which failed
to draw even average business on
Friday and Saturday, due probably to
the lack of star power."

E. M. FREIBURGER, Paramount Theatre,
Dewey, Oklahoma, *Motion Picture Herald*,
September 13, 1947

Desperate cost $234,635.

Gang leader Walt Radak (Raymond Burr)
and his brother Al (Larry Nunn) plan a heist in
Anthony Mann's *Desperate*. Burr portrayed
Walt's love for his brother as more than
fraternal.

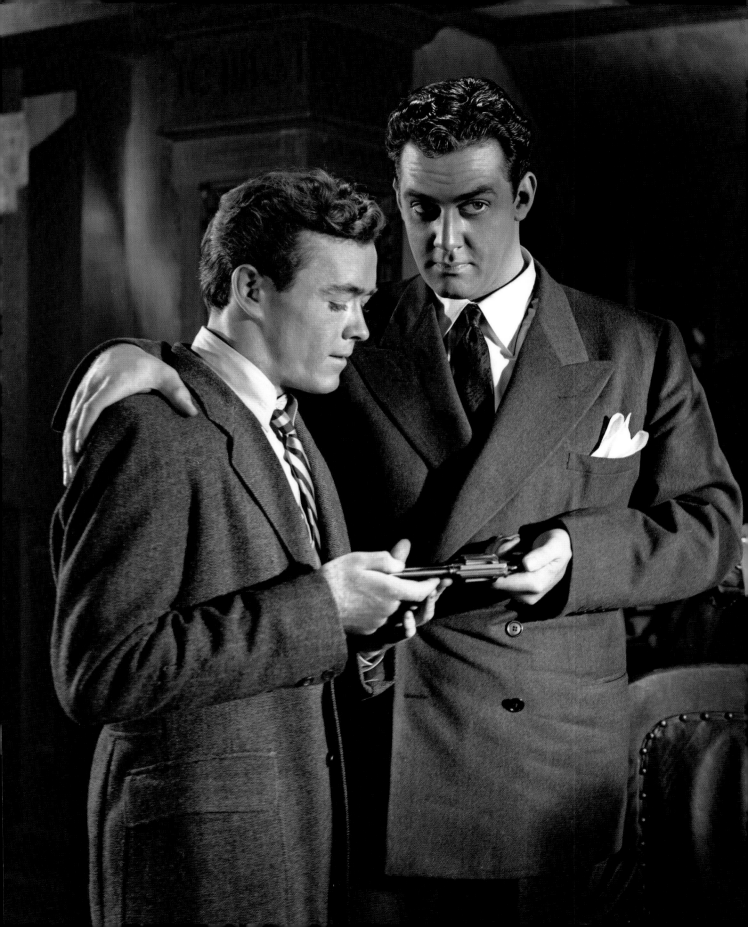

THE BRASHER DOUBLOON

TWENTIETH CENTURY-FOX
RELEASED MAY 21, 1947

A WEALTHY WOMAN HIRES A
DETECTIVE TO RECOVER A
VALUABLE COIN THAT BELONGED
TO HER LATE HUSBAND.

PRODUCTION QUOTE

"When I saw George Montgomery
working at his new picture at Twenti-
eth, he had all the assurance of a
veteran star. His picture is called *The
Brasher Doubloon*. In it he plays a
detective opposite Nancy Guild
(rhymes with 'wild'). Florence Bates
does the dirty work."

HEDDA HOPPER, "Influence of Dinah Shore,"
Los Angeles Times, November 9, 1945

Producer
ROBERT BASSLER

Director
JOHN BRAHM

Screenwriters
DOROTHY HANNAH
FROM AN ADAPTATION BY
LEONARD PRASKINS

Source
THE RAYMOND CHANDLER NOVEL
THE HIGH WINDOW

Cinematographer
LLOYD AHERN

Stars
GEORGE MONTGOMERY
FLORENCE BATES • NANCY GUILD

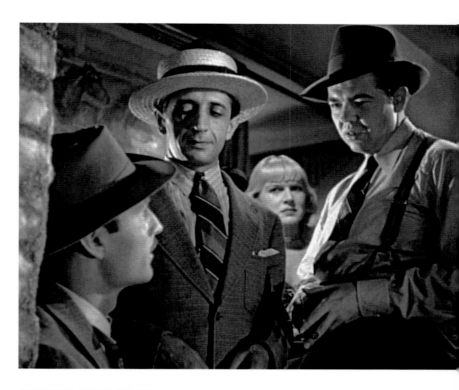

REVIEW

"Pull up a chair, friends of the mystery melodrama, and let's have a go at *The Brasher Doubloon*, latest escapade in the busy career of the indestructible Philip Marlowe. This is the fourth time around for Raymond Chandler's popular shamus and, we might add, the least of his exploits to date. Perhaps this is due to the lack of conviction in George Montgomery's interpretation. What's wrong with Mr. Montgomery? Well, he just doesn't look the part. Like his namesake, Robert, who played Marlowe in *Lady in the Lake*, George Montgomery just looks too respectable and intelligent, and he lacks the ruggedness and borderline honesty of the Marlowes created by Dick Powell and Humphrey Bogart."

BOSLEY CROWTHER, *The New York Times*, May 22, 1947

LETTER FROM REGIONAL THEATER OWNER

"A waste of film. The title means absolutely nothing in a small town. Did not even take in film rental. Why do we have to go on buying this kind of picture?"

E. M. FREIBURGER, Paramount Theatre, Dewey, Oklahoma, *Motion Picture Herald*, August 30, 1947

ARTIST COMMENT

"I had done a number of films by then, but this was the first of its kind for me. Mind you, I probably did everything the same. It was a case of being given a part and handed a script. In retrospect, I'd like to have played Marlowe when I was a little older. John Brahm was a marvelous guy but no great shakes as a director. As it stands, it was my own interpretation, and I didn't know a hell of a lot about interpretation."

GEORGE MONTGOMERY in Philip Kiszely's *Hollywood Through Private Eyes*

George Montgomery played Philip Marlowe in John Brahm's *The Brasher Doubloon*. He was surrounded by skilled character actors, including Alfred Linder and Marvin Miller.

THE WOMAN ON THE BEACH

RKO RADIO PICTURES
RELEASED JUNE 2, 1947

Producer
JACK J. GROSS

Director
JEAN RENOIR

Screenwriters
JEAN RENOIR, FRANK DAVIS, FROM AN
ADAPTATION BY MICHAEL HOGAN

Source
THE MITCHELL WILSON NOVEL
NONE SO BLIND

Cinematographer
LEO TOVER

Stars
JOAN BENNETT
ROBERT RYAN
CHARLES BICKFORD

WORKING TITLE: *DESIRABLE WOMAN*

A VETERAN HAUNTED BY A SINKING BECOMES ENTANGLED WITH A BLIND FORMER ARTIST AND HIS WIFE.

PRODUCTION QUOTE

"Joan Bennett, who plays the desirable woman, is amazing for her complete lack of vanity. She talks about her false eyelashes, about the gadgets she puts in her mouth to make her teeth look more regular and shiny, about her wig, even about her age with bemused irony and a complete lack of shame. She spends the whole day knitting, and I find it really funny to think that this homey person is considered by the American moral groups to be the most dangerous sexpot on the screen today."

JEAN RENOIR in Brian Kellow's *The Bennetts: An Acting Family*

REVIEWS

"There's a line midway in this turgid drama of hard-breathing passion on the Maine coast, where a character demands, 'What are we doing here?' That question will find a resentful echo in many a puzzled audience."

HOWARD BARNES, *New York Herald Tribune*

"Joan Bennett adds another portrait of a sullen and seductive dame to an ever-growing gallery," wrote critic Thomas M. Pryor, reviewing Jean Renoir's *The Woman on the Beach*. Photograph by John Miehle.

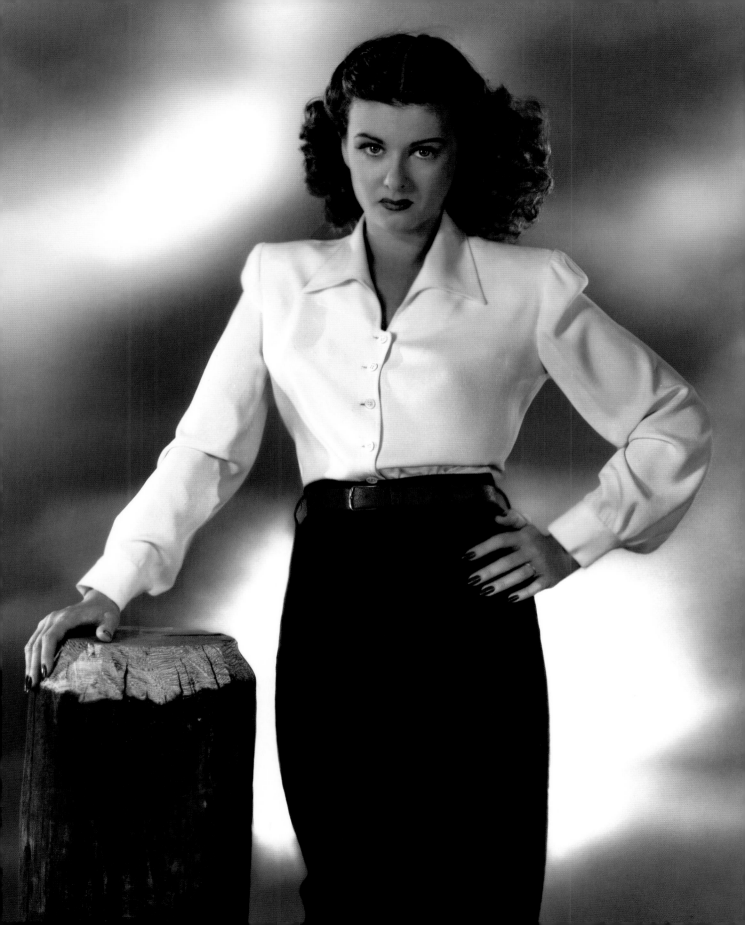

BRUTE FORCE

UNIVERSAL–INTERNATIONAL
RELEASED JUNE 30, 1947

Producer
MARK HELLINGER

Director
JULES DASSIN

Screenwriter
RICHARD BROOKS

Source
A STORY BY ROBERT PATTERSON

Cinematographer
WILLIAM DANIELS

Stars
**BURT LANCASTER
ANN BLYTH
HOWARD DUFF • HUME CRONYN**

A PRISON CAPTAIN'S BRUTALITY FORCES A GROUP OF INMATES TO PLAN A BREAKOUT.

PRODUCTION QUOTE

"When I walked on the set of *Brute Force*, Charlie Bickford was trying to crash through a prison gate in a burning truck. Hume Cronyn and Burt Lancaster were fighting on the prison wall tower. Hume fell off backward through the fire. It was a bloody, dramatic scene, with Jules Dassin, his hands black and burned, directing. Billy Daniels, who for fifteen years shot glamour gals at Metro-Goldwyn-Mayer, was lighting the plug-uglies for the cameras. Billy was Greta Garbo's favorite photographer, but styles in pictures have changed, just as the faces have. And—as in Mark Hellinger's phenomenally successful films—brute force is winning over beauty."

HEDDA HOPPER, *Los Angeles Times*, May 31, 1946

REVIEWS

"Well, assuming you have a fancy for violence and rough stuff on the screen, you will find a sufficiency of it in this deliberately brutal film. A stool pigeon is forced under a huge press; there is a suicide, a juicy third-degree and as riotous and bloody a prison break as ever we've seen portrayed. Hume Cronyn plays the captain with such noxious villainy that the triumphant moment of the picture is when he is hurled screaming from the high guard-tower. *Brute Force* is faithful to its title—even to taking law and order into its own hands. The moral is: don't go to prison; you meet such vile authorities there. And, as the doctor observes sadly, 'Nobody ever escapes.'"

BOSLEY CROWTHER, *The New York Times*, July 17, 1947

"Richard Brooks's gutty and cliché-filled writing is all mixed up ethically. The warden makes such an utter ass of himself in conferences with his henchmen that sympathy is thrown doubly to the prisoners, most of whom have been shown to be more sinned against than sinning. Then, at the end, the spectator is required to do a quick flip-flop. After all we have seen, we are sententiously reminded that a 'wrongie' is a 'wrongie' and crime still doesn't pay."

PHILIP K. SCHEUER, "Prison Life Violent," *Los Angeles Times*, July 9, 1947

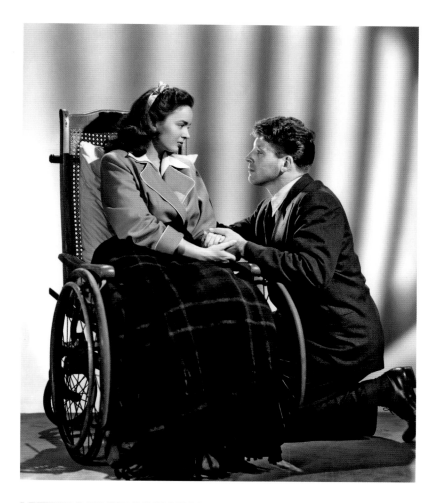

LETTERS FROM REGIONAL THEATER OWNERS

"This did much better than average but it is not the type of entertainment we approve. Too much violence and brutality. The criminals were glorified and the law put in the wrong light."

A. C. EDWARDS, Winema Cinema, Scotia, California, *Motion Picture Herald*, January 24, 1948

"These are the type of shows my Friday and Saturday payees eat up— and ask for more!"

WILLIAM EMKEY, Family Theatre, Glen Lyon, Florida, *Motion Picture Herald*, February 21, 1948

Jules Dassin's *Brute Force* was as powerful as its title suggested. This poster art of Ann Blyth and Burt Lancaster was made by Ray Jones.

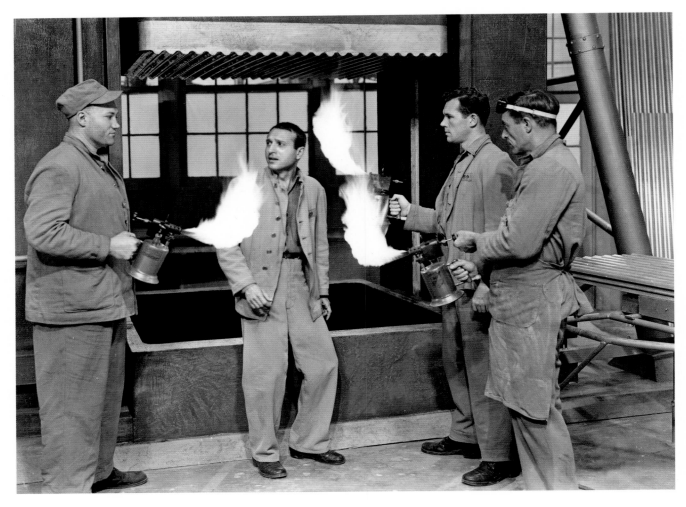

This scene from *Brute Force* shows the inmates attacking an informer; (l. to r.) Jack Overman, James O'Rear, Howard Duff, and John Hoyt.

ARTIST COMMENTS

"There was a scene when Burt Lancaster was going to be betrayed and realized who the betrayer was, so I got into this Stanislavskian monologue about what he should feel. At the end of my discourse, he said, 'You mean, then, that I give him the old snake eye?' That taught me much."

JULES DASSIN in Kate Buford's *Burt Lancaster: An American Life*

"*Brute Force* was very potent, and I think for those particular days it was a larger-than-life approach to things. The characters were all very strong and romantically written, as opposed to the usual documentary approach for that kind of film."

BURT LANCASTER in Douglas K. Daniel's *Richard Brooks: His Life and Films*

Brute Force grossed $2.2 million.

THEY WON'T BELIEVE ME

RKO RADIO PICTURES
RELEASED JULY 16, 1947

Producer
JOAN HARRISON

Director
IRVING PICHEL

Screenwriter
JONATHAN LATIMER

Source
A STORY BY GORDON MCDONELL

Cinematographer
HARRY J. WILD

Stars
ROBERT YOUNG
JANE GREER
SUSAN HAYWARD

WHEN A WEAK-WILLED MAN CHEATS ON HIS WEALTHY WIFE, HE SETS IN MOTION A SERIES OF DEADLY EVENTS.

PRODUCTION QUOTE

"Joan Harrison tested me first for *Nocturne*, but I didn't act in that. However, the meticulous care she used in making the test was responsible for the parts that have come my way since then. She also gave me my first opportunity in *They Won't Believe Me*."

JANE GREER in Edwin Schallert,
"Woman Puts Jane Greer on Ladder to Fame,"
Los Angeles Times, February 16, 1947

REVIEW

"This story of a handsome, weak-fibered gent, who becomes tragically enmeshed in the deaths of his wife and paramour, comes off as wholly edifying and exciting fare. Producer Joan Harrison, who seems to have profited from a long association with Alfred Hitchcock, and director Irving Pichel have created mounting suspense which comes to a distinctly surprising and explosive climax. Jonathan Latimer's pithy dialogue and Gordon McDonell's tale form a creditable and sturdy framework for this engrossing entertainment."

THOMAS M. PRYOR, *The New York Times*,
July 17, 1947

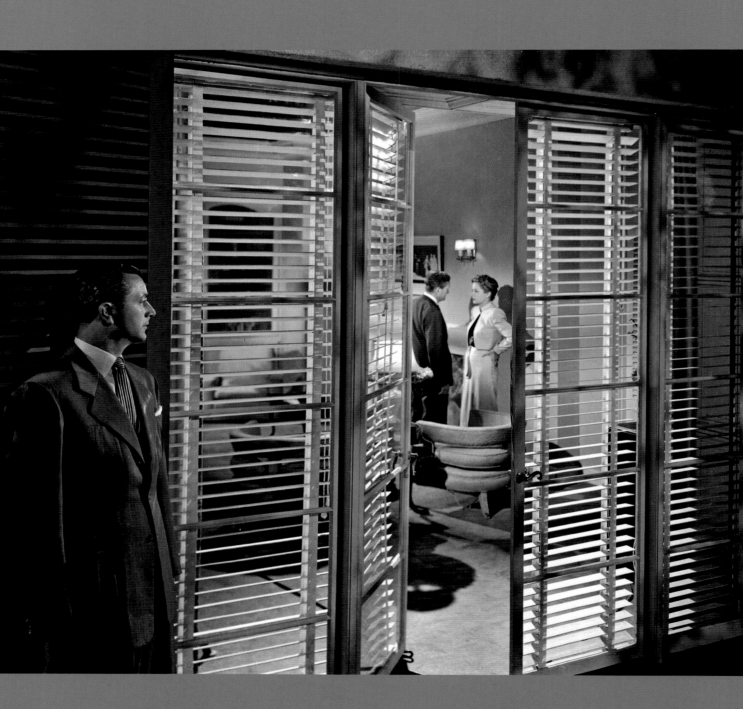

Opposite: Robert Young
plays a three-timing
Lothario in Irving Pichel's
They Won't Believe Me.

Right: A portrait of Jane
Greer by Ernest Bachrach.

LETTER FROM REGIONAL
THEATER OWNER

"RKO Radio won't believe me when
I tell them that this type of feature just
doesn't go and it is not worth half
the price they want for it."

RALPH RASPA, State Theatre, Rivesville,
West Virginia, *Motion Picture Herald*,
February 21, 1948

ARTIST COMMENT

"Robert Young didn't have a chance
with the audience. He played a heavy.
People didn't want to see this.
They hated it. And so it didn't do
well at all."

JANE GREER in Leo Verswijver's *Movies Were
Always Magical*

CROSSFIRE

RKO RADIO PICTURES
PREMIERED JULY 22, 1947

Producer
ADRIAN SCOTT

Director
EDWARD DMYTRYK

Screenwriter
JOHN PAXTON

Source
THE RICHARD BROOKS NOVEL
THE BRICK FOXHOLE

Cinematographer
J. ROY HUNT

Stars
ROBERT RYAN
ROBERT MITCHUM • GLORIA GRAHAME
ROBERT YOUNG

WORKING TITLE: CRADLE OF FEAR

A POLICE DETECTIVE IS PERPLEXED BY A MURDER THAT APPEARS TO HAVE NO MOTIVE.

PRODUCTION QUOTE

"In full swing already at RKO is *Crossfire*, which deals with racial intolerance. Can this be an early offset for Twentieth-Fox's *Gentleman's Agreement*, that is receiving so much advance ballyhoo? Dore Schary feels that *Crossfire* is supertopical, which is why it is being hastened. It is freely adapted from a book *The Brick Foxhole* by Richard Brooks."

EDWIN SCHALLERT, "Drama and Film," *Los Angeles Times*, March 6, 1947

REVIEWS

"*Crossfire* is a frank spotlight on anti-Semitism. Producer Dore Schary, in association with Adrian Scott, has pulled no punches. Here is a hard-hitting film with whodunit aspects incidental to the thesis of bigotry. There is no skirting with such folderol as intermarriage or clubs that exclude Jews."

"*Crossfire*," *Variety*, June 25, 1947

"Robert Ryan is frighteningly real as the hard, sinewy, loud-mouthed, intolerant and vicious murderer," wrote Bosley Crowther in his review of Edward Dmytryk's *Crossfire*. Photograph by Ernest Bachrach.

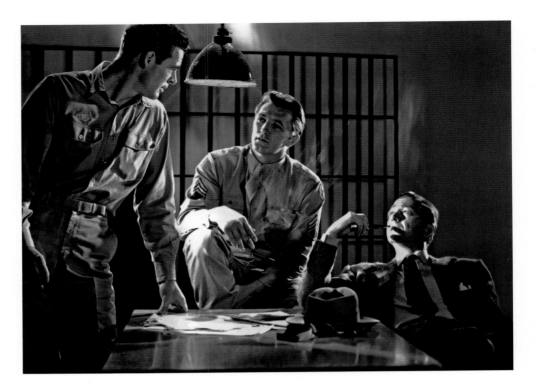

"*Crossfire* may backfire in its intent. I don't think that placing emphasis on race is the best way to fight intolerance. I believe the subtle and entertaining propaganda Leo McCarey and Bing Crosby put over in *Going My Way* is more effective. The same thing may be said of *The Jolson Story*. After seeing the latter picture you don't leave the theater saying, 'The film was about a Jewish family.' Rather, you say, 'What a wonderful family.' Christians won't love Jews—or Jews Christians—just because a film tells them to. You love people, regardless of race or creed, because they're fine American citizens and because of their contributions to our country and to humanity. And it is on these lines that I believe pictures should place emphasis."

HEDDA HOPPER, *Los Angeles Times*, June 27, 1947

On October 30, 1947, Hedda Hopper accused the British filmmaker of *So Well Remembered* of making a com- munist film. "I urge you to see it," she told her readers. "Then decide for yourself whether or not Hollywood is capable of inserting lefty propaganda in its films." Yet she had proposed exactly this technique in her June 27 column (quoted to the left). Within a few months she had become a ring- leader in the search for Hollywood communists by the House Un-Ameri- can Activities Committee. Dmytryk, Scott, and Paxton were among the ten who were jailed, and among hundreds who lost their careers.

"Much of the movie is as effective as a series of kicks to the solar plexus. Robert Ryan turns in the scariest performance of the season as the over-talkative, pathological Jew-hater. It is gruesome to watch such a character as Ryan."

Time, August 4, 1947

"An unqualified A for effort in bringing to the screen a frank and immediate demonstration of the brutality of religious bigotry as it festers in seemingly normal American minds is due to producers Dore Schary, Adrian Scott, and director Edward Dmytryk, who has employed a slow, aggravatingly set tempo and a heavily shaded pictorial style. He has worked for moods of ominous peril to carry the hot ferocity suggested in Richard Brooks's novel, *The Brick Foxhole*. Incidentally, the motive for murder which was brought out in the book has been changed for this present film version—and to remarkably advantageous effect."

BOSLEY CROWTHER, *The New York Times*, August 29, 1946

The motive for murder in *The Brick Foxhole* was homophobia. The book had been a groundbreaking achievement for describing the murder of a gay man, but the Production Code forbade portrayals of "sex perversion" on the screen, so the producers were made to bowdlerize the adaptation.

"The novel *The Brick Foxhole* had the unacceptable 'gimmick' of homosexuality motivating its action. Hollywood worships at the altar of the great god gimmick, the angle that draws the public. Ordinarily the plot motivation of money or normal sex lust would have replaced the homosexuality gimmick. Nonetheless, the use of anti-Semitism is no mere gimmick. *Crossfire* opens with the killing of a man. When it ends, something else has been killed—the idea that Hollywood is incapable of making a film that speaks out, clearly and unmistakably, against the disease known as anti-Semitism."

MARTIN FIELD, *"Crossfire," Cinema* magazine, August 1947

LETTER FROM REGIONAL THEATER OWNER

"It is quite apparent, in spite of the wide publicity, that this picture is not suited for our trade, that of a small lumber town."

A. C. EDWARDS, Winema Cinema, Scotia, California, *Motion Picture Herald*, May 22, 1948

ARTIST COMMENTS

"All the actors in *Crossfire* were so enthusiastic. They all worked like hell and really studied their parts. One told me that this was the first script he'd taken home and studied at night in three or four years. And when we got into scenes, I only had to make one or two takes. It all came so naturally, like rolling off a log. Robert Young's soliloquy on religious bigotry was filmed in only two takes. Ordinarily I wouldn't expect any actor to remember all that. Not because they can't, but because they're so disgusted with most scripts they don't want to bother."

EDWARD DMYTRYK in Ira Peck's "Crossfire," *PM*, August 1948

"There were cameramen working then, like Charlie Lang at Paramount, who took two days to light a single scene. Everything with its own keylight and back light. Two days. How do you light quickly? You light the actors and the background, just throw a dash of light on each and that's it. Shadows work for you. You don't have to worry about the things you can't see."

EDWARD DMYTRYK in Lee Server's *Baby, I Don't Care*

Dmytryk asserted repeatedly that *Crossfire* was completed in three weeks because of the simple lighting setups, yet study of the individual shots reveals that Roy Hunt used complex lighting schemes. The speed was more likely accomplished with long rehearsals, long takes, and wide-angle lenses.

"The changes in the script made *Crossfire* a more pertinent criticism of our society. Homosexuality at that time was not as public as it is today [1977]. If you mentioned homosexuality, everything suddenly had a different coloration. I felt we might get negative reactions, even lots of laughter. I also felt that the audience really wouldn't care. During the war much of the work that I was doing in Army Special Services related to anti-Semitism. One of the reasons that Jews went into the motion-picture business in great numbers is because of the overt anti-Semitism in the U.S."

DORE SCHARY in Alain Silver, James Ursini, and Robert Porfirio's *Film Noir Reader 3*

"At the time when we were putting *Crossfire* together, Dore Schary was not head of the studio. He was a producer there and a friend of ours. We used to go down and discuss the property with him. And he thought it was a very dangerous thing to make a picture about anti-Semitism."

EDWARD DMYTRYK in Alain Silver, James Ursini, and Robert Porfirio's *Film Noir Reader 3*

"Villainous roles pay off, though they're easier to play than straight characterizations. The one in *Crossfire* was a nasty, heelish part. But the picture is terrific. It has brought me more attention than the dozen roles I've played since 1940."

ROBERT RYAN in John L. Scott's "Good or Bad," *Los Angeles Times*, August 10, 1947

***Crossfire* cost $589,000. It grossed $1.27 million.**

POSSESSED

WARNER BROS. PICTURES
RELEASED JULY 26, 1947

Producer
JERRY WALD

Director
CURTIS BERNHARDT

Screenwriters
SILVIA RICHARDS
RANALD MacDOUGALL

Source
THE RITA WEIMAN NOVEL
ONE MAN'S SECRET

Cinematographer
JOSEPH VALENTINE

Stars
JOAN CRAWFORD
RAYMOND MASSEY • VAN HEFLIN

A WOMAN IS FOUND DAZED AND WANDERING THE STREETS OF DOWNTOWN LOS ANGELES.

PRODUCTION QUOTES

"The fellow I play in *Possessed* is a sort of dastard. Joan Crawford wants to possess him."

VAN HEFLIN in Philip K. Scheuer's "Van Heflin Plays Varied Roles," *Los Angeles Times*, January 5, 1947

"There was no invasion of the right of privacy involved when Joan Crawford, film actress, watched a mental patient undergo shock treatment at the Pasadena Sanitarium, it was contended with the filing of an answer in a $200,000 damage suit pending in Superior Court."

"Los Angeles Briefs," *Los Angeles Times*, January 25, 1947

The suit was settled out of court by Crawford for $5,000. It is not known if this was a nuisance suit or if Crawford was indeed present at the therapy.

REVIEWS

"The last time we saw Joan Crawford (in *Humoresque*), she was walking out into the ocean with the intention of drowning herself because John Garfield didn't love her as much as he loved music. Apparently she succeeded, and this is her spirit which we now see. For not only does Miss Crawford resemble nothing so much as a waterlogged cadaver, but her attitude is that of a desperate woman's ghost wailing for a demon lover beneath a waning moon."

BOSLEY CROWTHER, *The New York Times*, May 30, 1947

"*Possessed* comes as near to 'psychological thriller' as any picture ever made. It can, however, be better described as a 'psychosis melodrama,' since the central feminine character becomes by degrees the victim of insanity. The picture, when you sum it up, amounts to a super exhibition of high-tension acting by Joan Crawford."

EDWIN SCHALLERT, "Power Marks *Possessed*," *Los Angeles Times*, October 25, 1947

LETTER FROM REGIONAL THEATER OWNER

"This one was a miss for us, although Miss Crawford was good in her role. What's wrong? They used to make good pictures, pictures that remained in the public's mind overnight.
We used to get a pat on the back from our patrons, but no more. They just file into the lobby with a deadpan expression."

A. E. HANCOCK, Columbia Theatre, Columbia City, Indiana, *Motion Picture Herald*, December 6, 1947

ARTIST COMMENT

"I went on to an even more difficult part in *Possessed*, the part of a schizophrenic, a woman going insane from unrequited love. The role of Louise was violent and fearful and required medical accuracy. I spent six weeks in hospitals watching schizophrenics, seeing how sodium pentothal and sodium Amytal restores them to memory for a few brief moments—six weeks at L.A. General Hospital, and many sanatoriums."

JOAN CRAWFORD, *A Portrait of Joan*, 1959

Possessed cost $2.59 million. It grossed $3.07 million.

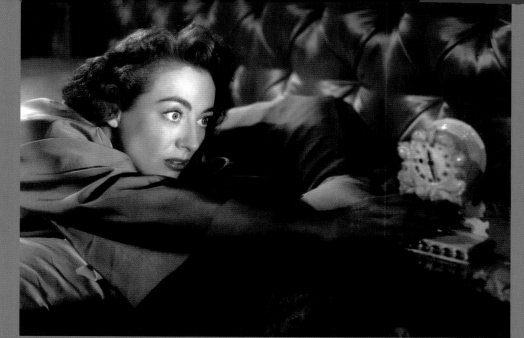

Above: In Curtis Bernhardt's *Possessed*, Joan Crawford is alienated from her household fixtures by incipient madness. "Joan Crawford cops all thesping honors in this production," wrote *Variety* on June 4, 1947. "Actress has a self-assurance that permits her to completely dominate the screen even vis-à-vis such accomplished players as Van Heflin and Raymond Massey."

Right: *Possessed* was a critical (and financial) success, and it brought Crawford an Academy Award nomination for Best Actress.

DESERT FURY

PARAMOUNT PICTURES
RELEASED AUGUST 15, 1947

Producer
HAL WALLIS

Director
LEWIS ALLEN

Screenwriter
ROBERT ROSSEN, FROM AN
ADAPTATION BY A. I. BEZZERIDES AND
RAMONA STEWART

Source
THE RAMONA STEWART NOVEL
BITTER HARVEST

Cinematographers
CHARLES LANG • EDWARD CRONJAGER

Stars
BURT LANCASTER
LIZABETH SCOTT
JOHN HODIAK • WENDELL COREY

WHEN A YOUNG WOMAN TAKES UP WITH A GANGSTER, SHE INFLAMES THE JEALOUSY OF HIS POSSESSIVE FRIEND.

PRODUCTION QUOTES

"At present John Hodiak is doing *Desert Fury*. John plays a villain of the deepest dye. He's contented with it, and well he should be, as Burt Lancaster would have given a lot for this part. 'However,' says John, 'this is my third heavy in a row. I've got to look for a change in character.'"

HEDDA HOPPER, "John Hodiak Captivates," *Los Angeles Times*, January 12, 1947

"I left New York to escape gangster and detective roles, but here I'm doing them again. Now don't get me wrong. I'm not beefing. What's good enough for the other boys is good enough for me—for the time being."

WENDELL COREY in John Berg's "Heavy Roles Winning Star Rating," *Los Angeles Times*, October 19, 1947

Desert Fury was one of the few films noirs made in Technicolor, but it showed that color could accommodate low-key lighting. Like many films of this genre, it was derided by critics, dismissed by audiences, and then discovered by students and cineastes years later.

REVIEWS

"*Desert Fury* is a beaut—a beaut of a Technicolored mistake from beginning to end. The story is an impossible conglomeration of seething human passions involving a headstrong daughter of a gambling town czarina who falls in love with a truculent big-time gambler against the violent opposition of her mother, who, it develops, was once infatuated with the fellow herself. Robert Rossen, who wrote the screenplay from a story by Ramona Stewart, should go stand in a corner and hang his head in shame. He ought to be joined, too, by Lewis Allen, the director, who has let the story wander all over the desert like grains of sand in the wind. *Desert Fury* is indeed a strangely incompetent motion-picture to bear the imprimatur of Hal B. Wallis."

THOMAS M. PRYOR, *The New York Times,*
September 25, 1947

"*Desert Fury* makes you think of a magnificently decorated package inside which someone has forgotten to place the gift."

ARCHER WINSTEN, *New York Post*

DARK PASSAGE

WARNER BROS. PICTURES
RELEASED SEPTEMBER 20, 1947

Producer
JERRY WALD

Director
DELMER DAVES

Screenwriter
DELMER DAVES

Cinematographer
SID HICKOX

Stars
HUMPHREY BOGART
LAUREN BACALL
AGNES MOOREHEAD

A CONVICT ESCAPES FROM ALCATRAZ AND UNDERGOES PLASTIC SURGERY IN ORDER TO FIND HIS WIFE'S ACTUAL MURDERER.

PRODUCTION QUOTE

"One of the fastest purchases on record was put over this week by Warner Bros. Humphrey Bogart read the story *Dark Passage*, a *Saturday Evening Post* serial by David Goodis, and immediately pictured himself in the part of Vincent Parry, a chap unjustly sentenced for murdering his wife. Bogart got in touch with producer Jerry Wald, who agreed. The whole thing was dumped in the lap of the front office. A deal was made at once. The price is said to have been $35,000."

PHILIP K. SCHEUER, *"Dark Passage* Bought," *Los Angeles Times*, August 24, 1946

REVIEWS

"Director Delmer Daves has confused things by using a subjective camera, so that it sees things as through the eyes of a fugitive. This technique withholds Mr. Bogart from the audience's observation for some time. When he finally does come before the camera, he seems uncommonly chastened and reserved, a state in which Mr. Bogart does not appear at his theatrical best. However, the mood of his performance is compensated by that of Lauren Bacall, who generates quite a lot of pressure as a sharp-eyed, knows-what-she-wants girl. Agnes Moorehead is electric as a meddlesome shrew. Indeed, it is in the bizarre contacts of Mr. Bogart with shady characters such as those played by these well-directed actors that *Dark Passage* achieves tension and drive. Perhaps he should be given more time with them. No reflection upon Miss Bacall, of course."

BOSLEY CROWTHER, *The New York Times*, September 6, 1947

"Truth is stranger than fiction. Fiction has to be convincing. Truth doesn't. Why, then, is Agnes Moorehead, the villainess of the piece, described as the sort of savage, jealous, vindictive creature who might be capable of murdering the wife of a man she couldn't have so he could take the rap? She is not capable. She is a silly, rather stupid woman who, in fact, amused the customers yesterday. And brother, once your menace gets a laugh, you're done."

JOHN BRIGGS, *The New York Post*, September 12, 1947

LETTER FROM REGIONAL THEATER OWNER

"I hope Bogart's next picture is something really good and different, because he really needs a boost."

RALPH RASPA, State Theatre, Rivesville, West Virginia, *Motion Picture Herald*, December 27, 1947

ARTIST COMMENT

"Despite the fact that you haven't too many sides [pages of script] in this film, the scenes you do are without doubt the finest job of acting I've seen on the stage or screen in years. You're truly a great artist."

JERRY WALD to Agnes Moorehead in Axel Nissen's *Film of Agnes Moorehead*

Delmer Daves directed the Bacall-and-Bogart team in *Dark Passage*, another tale of an unjustly convicted man seeking justice.

THE UNSUSPECTED

WARNER BROS. PICTURES
RELEASED OCTOBER 3, 1947

Producer
CHARLES HOFFMAN

Director
MICHAEL CURTIZ

Screenwriters
BESS MEREDYTH
RANALD MACDOUGALL

Source
THE CHARLOTTE ARMSTRONG NOVEL

Cinematographer
WOODY BREDELL

Stars
CLAUDE RAINS
AUDREY TOTTER

A RADIO STAR WHO BROADCASTS CLEVER MURDER STORIES USES THE SAME TECHNIQUES TO DISPOSE OF HIS INTIMATES.

PRODUCTION QUOTES

"Charles Hoffman, the gent who is going to produce *The Unsuspected*, fixed me seriously with his eye and said, 'We've had to change the character of Grandy a little. We made him more the Alexander Woollcott type.' I burst into laughter."

CHARLOTTE ARMSTRONG in Rick Cypert's *The Virtue of Suspense: The Life and Works of Charlotte Armstrong*

Charlotte Armstrong had, of course, based her character of the wicked radio star Luther ("Grandy") Grandison on the flamboyant radio star Alexander Woollcott.

"The character I play in *The Unsuspected* is usually described with a five-letter word, with an unpleasant meaning. But you don't discover what she's like until she reveals this in a big dramatic scene. Simultaneously she explains why she is that way, and becomes to a certain extent sympathetic. It is the sort of role that actresses dream about."

AUDREY TOTTER in Edwin Schallert's "Brilliant Career Dawning," *Los Angeles Times*, February 2, 1947

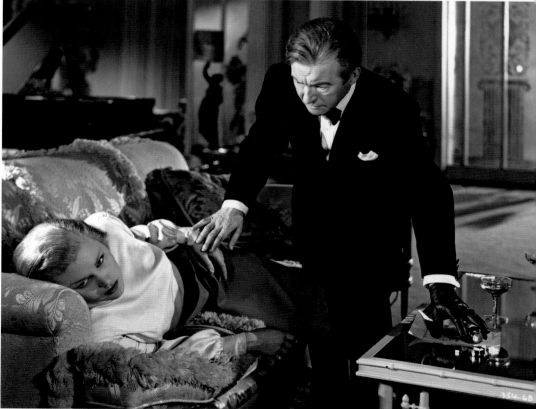

Above: In Michael Curtiz's *The Unsuspected*, bibulous Hurd Hatfield and acidulous Audrey Totter are beholden to her celebrated uncle, Claude Rains.

Right: Claude Rains disposes of his other niece, Joan Caulfield, with a mixture of pills and champagne.

REVIEW

"There is reasonable ground for suspicion that the people who made *The Unsuspected* thought that they were fashioning another *Laura*. For this Michael Curtiz whodunit is set amid surroundings of worldliness and elegance. Furthermore, it is centered on a character of literary suavity and it lays much stress on the portrait of a girl, believed dead. But, beyond a brisk flurry of excitement and wickedness, it bears little showmanly resemblance to that previous top-drawer effort. To be sure, Claude Rains is intriguing as the fashionable radio ghoul, but the rest of the performers are as patly artificial as the plot."

BOSLEY CROWTHER, *The New York Times*, October 4, 1947

LETTER FROM REGIONAL THEATER OWNER

"Took a nose dive on this unpleasant story of murder and crime."

N. W. HUSTON, Liberty Theatre, Columbus, Kansas, *Motion Picture Herald*, June 12, 1948

ARTIST COMMENTS

"It looks as though I tried to make a great picture out of a story that wasn't a great story."

MICHAEL CURTIZ in John T. Soister and JoAnna Wioskowski's *Claude Rains*

"Claude Rains was such a darling man. I adored him. He made doing that film a really enjoyable experience. Another unusual thing was that part of it was set in a radio studio. Claude Rains had a radio show, and they made it out to be such a huge production, not at all like radio was really done. And the art of black-and-white photography was never better than in these pictures."

AUDREY TOTTER in Charles and Roberta Mitchell's "Versatile Queen of Noir," *Classic Images*

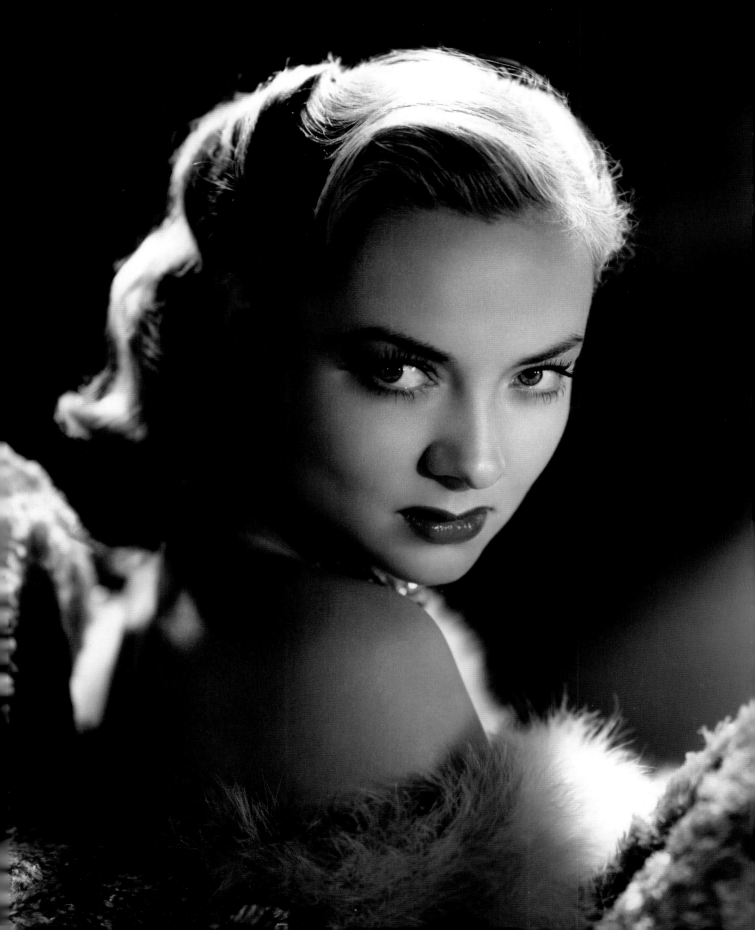

RIDE THE PINK HORSE

**UNIVERSAL-INTERNATIONAL
RELEASED JUNE 30, 1947**

Producer
JOAN HARRISON

Director
ROBERT MONTGOMERY

Screenwriters
BEN HECHT
CHARLES LEDERER

Source
THE DOROTHY B. HUGHES NOVEL

Cinematographers
RUSSELL METTY
MAURY GERTSMAN

Stars
ROBERT MONTGOMERY
WANDA HENDRIX

A VETERAN TRAVELS TO THE SOUTHWEST TO CONFRONT THE GANG LORD WHO KILLED HIS WARTIME FRIEND.

PRODUCTION QUOTES

"Bob Montgomery's war record preceded him to Santa Fe, New Mexico, where he is shooting backgrounds for *Ride the Pink Horse*. A special motorcade came down from Los Alamos to escort him on an inspection tour of the government's huge atomic bomb project—which left Bob limp."

HEDDA HOPPER, "Looking at Hollywood,"
Los Angeles Times, May 15, 1947

Robert Montgomery served five years of active duty in World War II, including a tour as a PT boat commander. His decorations included a Bronze Star and the European Theater Ribbon with Battle Stars.

"No, I'm not giving this story the subjective treatment. The camera isn't you or me or anybody else. If anything, it's the third person singular—just 'it.' The characters are picked up casually, without any explanation as to who they are or what they're doing—other, of course, than what we can see and hear. They are developed and their backgrounds filled in, as we go along. We hope to make them interesting anyway."

ROBERT MONTGOMERY in Philip K. Scheuer's
"*Tio Vivo* Sparks New Montgomery Picture,"
Los Angeles Times, June 1, 1947

REVIEW

"Nobody writing for movies likes to muse on the dizzy and eccentric rotations of the merry-go-round of life more than ironic Ben Hecht. And that is what he is doing, in a hard-boiled and often violent way, in the script which he and Charles Lederer have written for *Ride the Pink Horse*. That is likewise what Robert Montgomery has intriguingly captured on the screen in this taut and macabre melodrama. Nothing is proved, particularly, in this grimly humored tale of an amateur blackmailer's adventures in a noisy New Mexican resort town—nothing except that life is a fateful a nd fickle experience."

BOSLEY CROWTHER, *The New York Times*, July 17, 1947

LETTER FROM REGIONAL THEATER OWNER

"Quite a satisfactory crime thriller. It has a quality about it that places it in the something different category. Holds interest throughout and patrons seemed quite pleased."

W. D. RASMUSSEN, Star Theatre, Anthon, Iowa, *Motion Picture Herald*, June 19, 1948

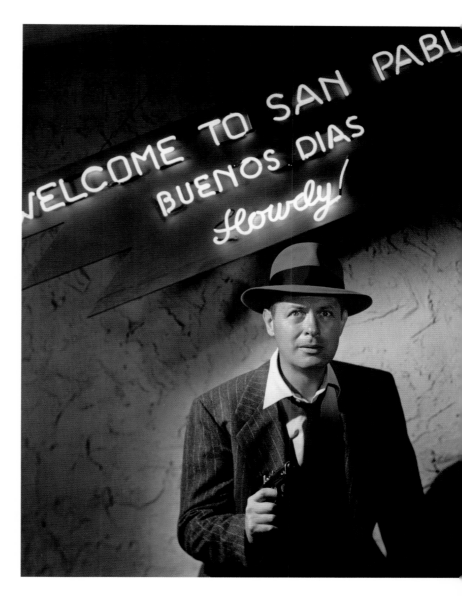

Robert Montgomery directed and starred in a drama of vengeance called *Ride the Pink Horse*. Portrait by Ray Jones.

NIGHTMARE ALLEY

TWENTIETH CENTURY–FOX
RELEASED OCTOBER 9, 1947

Producer
GEORGE JESSEL

Director
EDMUND GOULDING

Screenwriter
JULES FURTHMAN

Source
THE WILLIAM LINDSAY GRESHAM NOVEL

Cinematographer
LEE GARMES

Stars
TYRONE POWER
JOAN BLONDELL • COLEEN GRAY
HELEN WALKER

A CARNIVAL ROUSTABOUT MANIPULATES A PSYCHIC AND HER ALCOHOLIC HUSBAND TO MOVE UP IN THE WORLD.

PRODUCTION QUOTES

"Anne Baxter and Mark Stevens are set for *Nightmare Alley*, which Georgie Jessel will produce, with Bill Keighley directing."

HEDDA HOPPER, "Looking at Hollywood," *Los Angeles Times*, November 23, 1946

Lloyd Bacon replaced William Keighley in early 1947, and Tyrone Power kept after Darryl F. Zanuck for the lead role. By March, Power was in, Mark Stevens was out, and Edmund Goulding had replaced Bacon.

"This is an unconventional story, but it must be told in terms that will make it a popular story, the story of a man who has some good traits, however deep they may be buried; a man who, if he had applied himself with the same zeal could have amounted to something worthwhile. While we want to keep him a man who has this insatiable appetite for money and success, there must be a point where we feel sympathy for him. Otherwise it becomes a story of frustration, and there is no audience for that."

DARRYL F. ZANUCK, transcription of story conference, January 29, 1947, in Rudy Behlmer's *Memo from Darryl F. Zanuck*

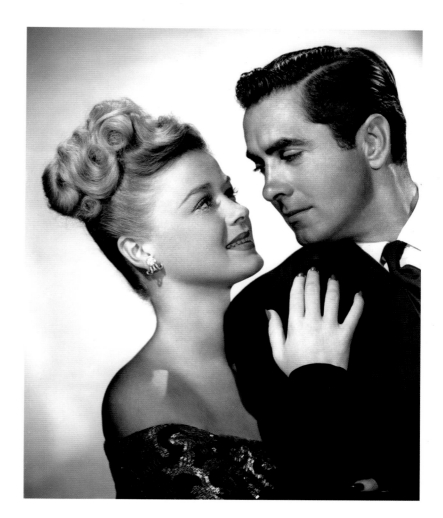

"When I walk onto a set, I never have the slightest idea what I'm going to shoot. Then I sit in a chair for a few minutes and I see it all before me."

EDMUND GOULDING in Philip K. Scheuer's "Versatile Goulding," May 18, 1947

REVIEWS

"Tyrone Power is playing an utterly reprehensible charlatan out to bilk gullible rich folk with artfully contrived manifestations of metaphysical powers. There is, in fact, little in the way of human wickedness that Mr. Power doesn't do as the slick-tongued carnival spieler. He has a juicy role and sinks his teeth into it, performing with considerable versatility and persuasiveness. Helen Walker, as a phony psychologist, is cool and poised as the role demands."

Thomas M. Pryor, *The New York Times*, October 10, 1947

This poster art photo for Edmund Goulding's *Nightmare Alley* conveys none of the perversity that Helen Walker and Tyrone Power brought to the film.

"*Nightmare Alley* is a harsh, brutal story told with the sharp clarity of an etching. The film deals with the roughest phases of carnival life and showmanship. Tyrone Power is Stan Carlisle, who works his way from carney roustabout to big-time mentalist and finally to would-be swindler in the spook racket. Helen Walker comes through as the calculating femme who topples Power from the heights."

Variety, October 15, 1947

"*Nightmare Alley* makes *The Lost Weekend* almost pleasant by comparison. It's strong meat, and not recommended for children. Ty Power was never better. Ian Keith, as the husband of Joan Blondell, and Helen Walker, as a phony psychiatrist, give lots of help in their supporting roles."

HEDDA HOPPER, *Los Angeles Times*, October 27, 1947

LETTER FROM REGIONAL THEATER OWNER

"Full of booze and carnival bunco. Sorry we played it. We took in film rental but very little more. For such a star as Tyrone Power, what a pity to waste his talents in a shower bath of whiskey and champagne."

N. W. HUSTON, Liberty Theatre, Columbus, Kansas, *Motion Picture Herald*, June 12, 1948

ARTIST COMMENTS

"I liked working with Edmund Goulding. He was like so many of those great directors of the 1940s. He was always patient enough to break things down for you, so you understood the characters and their motivations."

MIKE MAZURKI in William Hare's *Early Film Noir: Greed, Lust, and Murder Hollywood Style*

"Edmund Goulding had a brilliant mind. But he was strange. He'd say something that suggested genius, and ten minutes later he'd forget what he had in mind. Luckily he had someone around always to take notes of what he said, and he'd look them up. He was utterly spontaneous. He had no idea of camera. He concentrated on the actors."

LEE GARMES in Charles Higham's *Hollywood Cameramen*

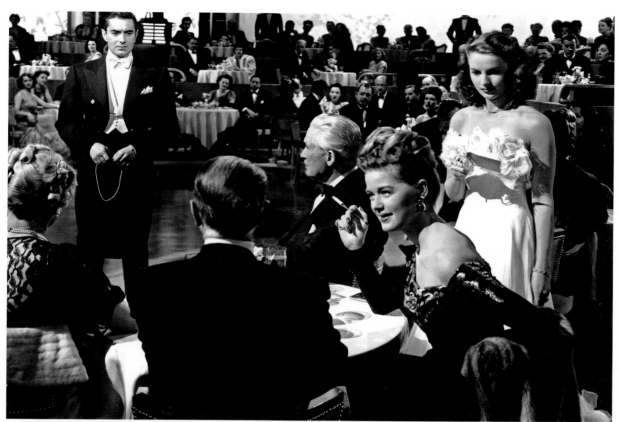

OUT OF THE PAST

RKO RADIO PICTURES
RELEASED NOVEMBER 13, 1947

Producer
WARREN DUFF

Director
JACQUES TOURNEUR

Screenwriter
GEOFFREY HOMES
(DANIEL MAINWARING), WITH
ADDITIONAL DIALOGUE BY JAMES M.
CAIN AND FRANK FENTON

Source
THE GEOFFREY HOMES
NOVEL *BUILD MY GALLOWS HIGH*

Cinematographer
NICHOLAS MUSURACA

Stars
ROBERT MITCHUM
JANE GREER • KIRK DOUGLAS

WHEN A PRIVATE DETECTIVE SEARCHES FOR A GAMBLER'S MISSING GIRLFRIEND, SHE TURNS OUT TO BE DEADLY.

PRODUCTION QUOTES

"Jane Greer will be the costar with Robert Mitchum in *Build My Gallows High*, per proclamation of RKO. 'A definite step up,' is the way this choice is described. Her role in this Warren Duff production will be dramatic, and thus test the talents of Miss Greer in a new way."

EDWIN SCHALLERT, "Jane Greer Attains Dramatic Highroad," *Los Angeles Times*, September 16, 1946

"*Out of the Past* will be the title of Warren Duff's production for RKO of the Geoffrey Homes novel, *Build My Gallows High*."

"New Title," *Los Angeles Times*, December 6, 1946

"After Jane wound up in *Out of the Past*, her performance was recognized as so good that RKO executives decided retroactively, as it were, to change her billing to a costar in *They Won't Believe Me*."

EDWIN SCHALLERT, "Woman Puts Jane Greer on Ladder to Fame," *Los Angeles Times*, February 16, 1947

This had occurred before the January 1947 arrival of Dore Schary, who decided to undersell both films so as not to compete with his new slate of productions.

REVIEWS

"There have been double- and triple-crosses in many of these tough detective films, and in one or two Humphrey Bogart specials they have run even higher. But the sum of deceitful complications that occur in *Out of the Past* must be reckoned by logarithmic tables, so numerous and involved do they become. The consequence is that the action is likely to leave the napping or unmathematical customer far behind. Frankly, that's where it left us. The style is sharp and realistic, the dialogue crackles with verbal sparks and the action is still crisp and muscular, not to mention slightly wanton in spots. But the pattern and purpose of it is beyond our pedestrian ken. People get killed, the tough guys browbeat, the hero hurries—but we can't tell you why.

"However, as we say, it's very snappy and quite intriguingly played by a cast that has been well and smartly directed by Jacques Tourneur. Robert Mitchum is magnificently cheeky and self-assured as the tangled private eye, consuming an astronomical number of cigarettes in displaying his nonchalance. And Jane Greer is very sleek as his Delilah, Kirk Douglas is crisp as a big crook. If only we had some way of knowing what's going on in the last half of this film, we might get more pleasure from it. As it is, the challenge is worth a try."

BOSLEY CROWTHER, *The New York Times*, November 26, 1947

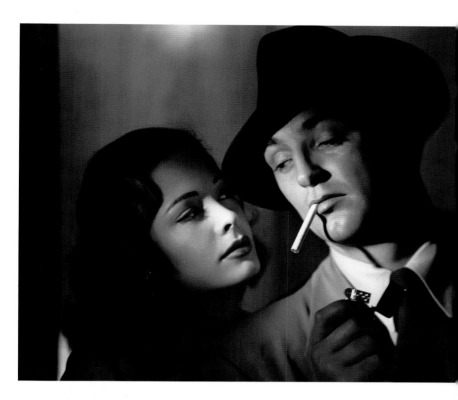

"One of the main reasons for the obstinate fascination of *Out of the Past* is that you can't bring yourself to believe that Kathie Moffat, played by Jane Greer, is as bad as she is. Geoffrey Homes, who wrote the screenplay from his novel *Build My Gallows High*, has really thrown the book at her: lies, promiscuity, grand larceny, the double-double-cross, murder, and the most serious offense of all, a variation of backseat driving. (Well, it wrecks a good-looking car.) Maybe Homes just doesn't like women. More probably, he knows what sells novels—and movies."

PHILIP K. SCHEUER, *Los Angeles Times*, December 12, 1947

Ernest Bachrach made this portrait of Jane Greer and Robert Mitchum to publicize Jacques Tourneur's *Out of the Past*.

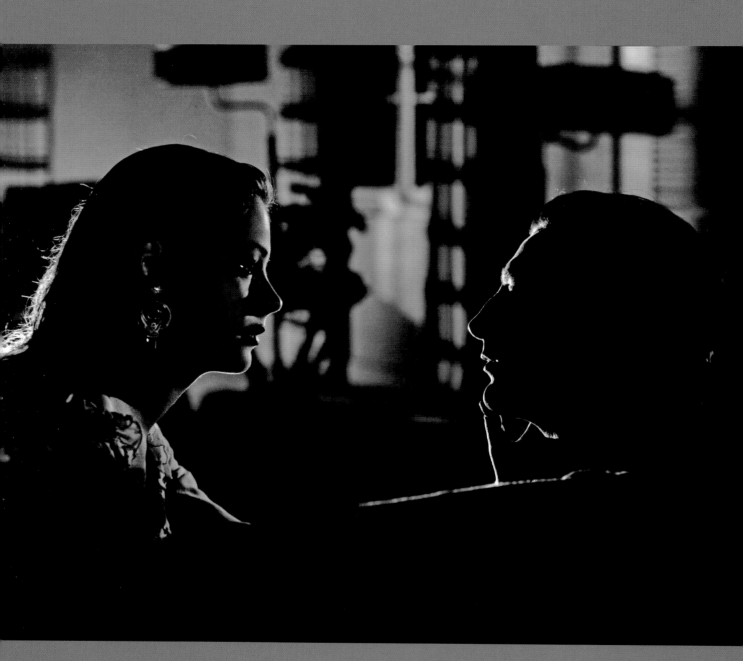

LETTERS FROM REGIONAL THEATER OWNER

"A good show that failed to bring in any business. I don't know when business will get back to normal."

RALPH RASPA, State Theatre, Rivesville, West Virginia, *Motion Picture Herald*, June 12, 1948

"Played late but did excellent business. RKO has a fine lineup of pictures this season."

ANDREW D. MURPHY, Broad Brook Theatre, Broad Brook, Connecticut, *Motion Picture Herald*, August 14, 1948

"This picture held the interest every minute, and, on the whole, it registered with my patrons to a much higher degree than pictures of this type usually do."

M. R. HARRINGTON, Avalon Theatre, Clatskanie, Oregon, *Motion Picture Herald*, September 11, 1948

A review of trade papers for 1947 reveals that *Out of the Past* had an uninspired, misleading ad campaign.

ARTIST COMMENTS

"Well, I started *Build My Gallows High*, the novel. And my agent wouldn't look for a job for me until I finished it. The novels I wrote I did just like James Cain and Raymond Chandler. But we all rewrote Dashiell Hammett. Cain later did a draft of *Out of the Past*. He didn't know how to write screenplays. He hadn't the slightest idea. Chandler wasn't much better. *The Blue Dahlia* was lousy. Chandler was not a good screenwriter. He was a much better novelist, and over dinner,

he was a great raconteur. But that doesn't make a script."

DANIEL MAINWARING in Alain Silver, James Ursini, and Robert Porfirio's *Film Noir Reader 3*

"Kathie Moffat was a great, great part. Anybody would die for a part like that. The way they build her up before you even see her. It was like that Alan Ladd thing, *Whispering Smith*. The whole first half is all 'Who is Whispering Smith?' and 'Boy, you never met anyone like Whispering Smith!' And by the time little Alan Ladd shows up, five foot four or something, he looks six foot nine. In my story it was 'She shot me. She took my money. But don't hurt her. I just want her back.' And then the guy sees her and falls instantly in love with her. This is some kind of woman. How can you go wrong? It was a part made in heaven."

JANE GREER in Lee Server's *Baby, I Don't Care*

"Jane, do you know the word *impassible*? Yes. 'Impassive.' That's what I want. No big eyes. No expressive. In the beginning you act like a nice girl. But then, after you kill the man you meet in the little house, you become a bad girl. Yes? First half, good girl. Second half, bad girl. At first you wear light colors. After you kill the man, darker colors. And no big eyes, please."

JACQUES TOURNEUR, quoted by Jane Greer, in *Hollywood, the Golden Years: The RKO Story*, BBC documentary, 1987

Opposite: *Out of the Past* unfolds like an Aesop's fable as detective Jeff Markham (Robert Mitchum) is hired by racketeer Whit Sterling (Kirk Douglas) to find Kathie Moffat (Jane Greer), the girl who shot Sterling and ran off with his money. When Jeff finds Kathie, the hunter becomes the prey.

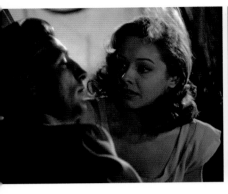

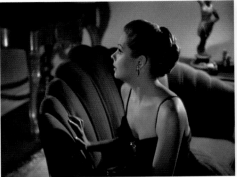

Above: Nicholas Musuraca's closeups of Jane Greer made her a film noir icon.

Opposite: Sterling lays down the law, but he too is doomed.

"People sometimes write things that we supposedly did. They find all kinds of things in your performance that aren't there at all. I've had people say, 'Oh, that scene when you're watching them fighting and you shoot him—that look on your face, that joy when you're gonna kill him!' I said, 'Joy?! As a matter of fact, I could hardly see him. The camera was off to the right and all I saw was this bright light from the floor. I couldn't see anything!'"

JANE GREER in Leo Verswijver's *Movies Were Always Magical*

"*Out of the Past* was a film I enjoyed making. The script was very hard to follow, and very involved. Often in this type of film the audience should be deliberately confused, because if your story becomes too pat then it's often dull."

JACQUES TOURNEUR in Charles Higham and Joel Greenberg's *The Celluloid Muse*

"Jacques Tourneur didn't talk about performance at all. He did have to keep Paul Valentine, who plays Joe, on track, because Paul thought the whole thing was just silly. 'We're just kidding, right? We're just making believe?' That sort of thing. In a moment of horror, he'd be giggling. That took up a little of Jacques's time. We had just seen Kirk Douglas in *The Strange Love of Martha Ivers*, and he was very good, so we were pleased that he was working with us."

ROBERT MITCHUM in Charles Champlin and Jerry Roberts's *Robert Mitchum in His Own Words*

"Dore Schary didn't like *Out of the Past* because the novel had been bought and produced before he came to run RKO [in January 1947]. He didn't like any of the things that were in progress when he got there. He tried to get rid of them, and mostly just threw them out there without any publicity."

DANIEL MAINWARING in Lee Server's *Baby, I Don't Care*

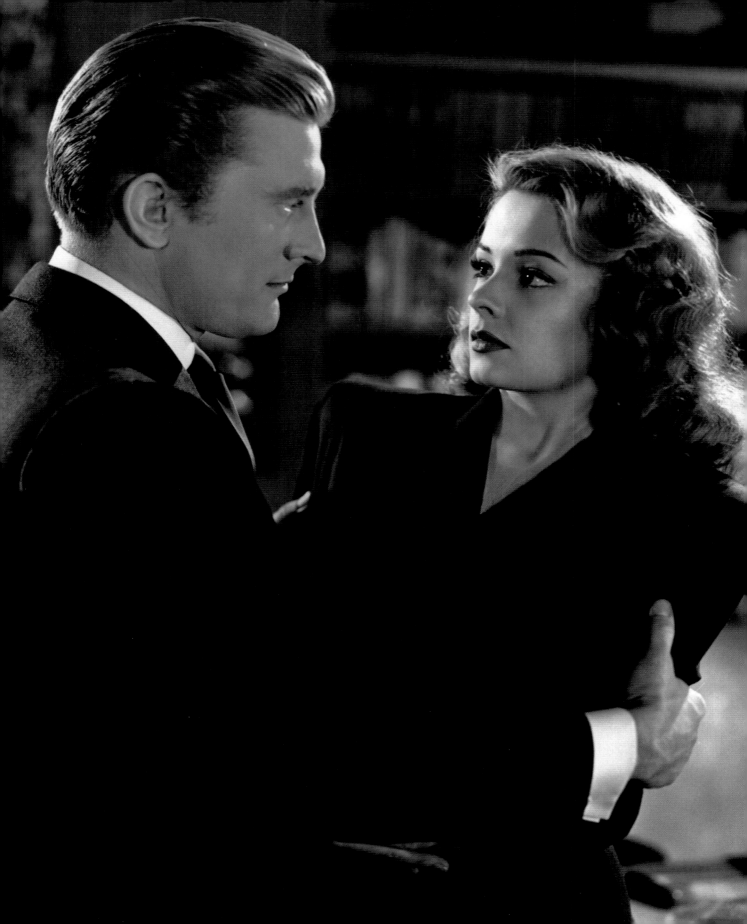

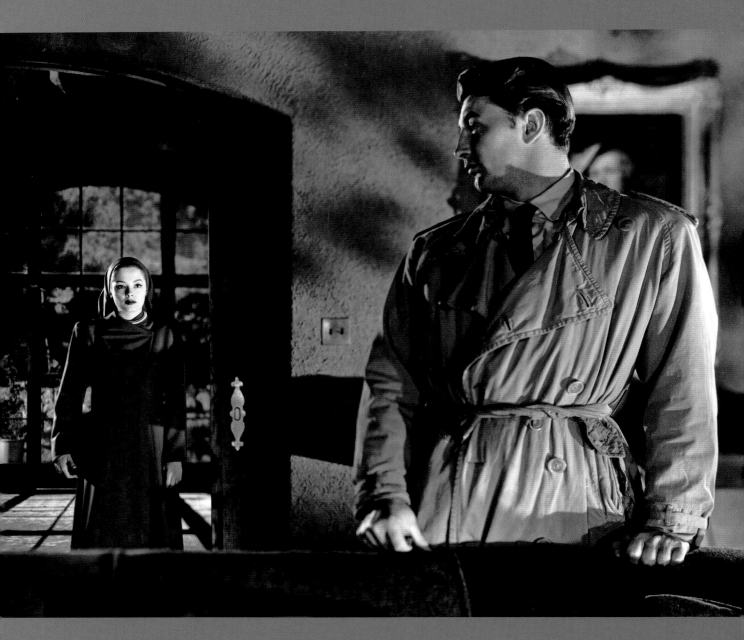

Above: Jane Greer
plays Kathie Moffat as
a slinky enigma, an
unknowable creature who
lives only to cross and
double-cross.

Opposite:
A Bachrach portrait of
Robert Mitchum as
Jeff Markham.

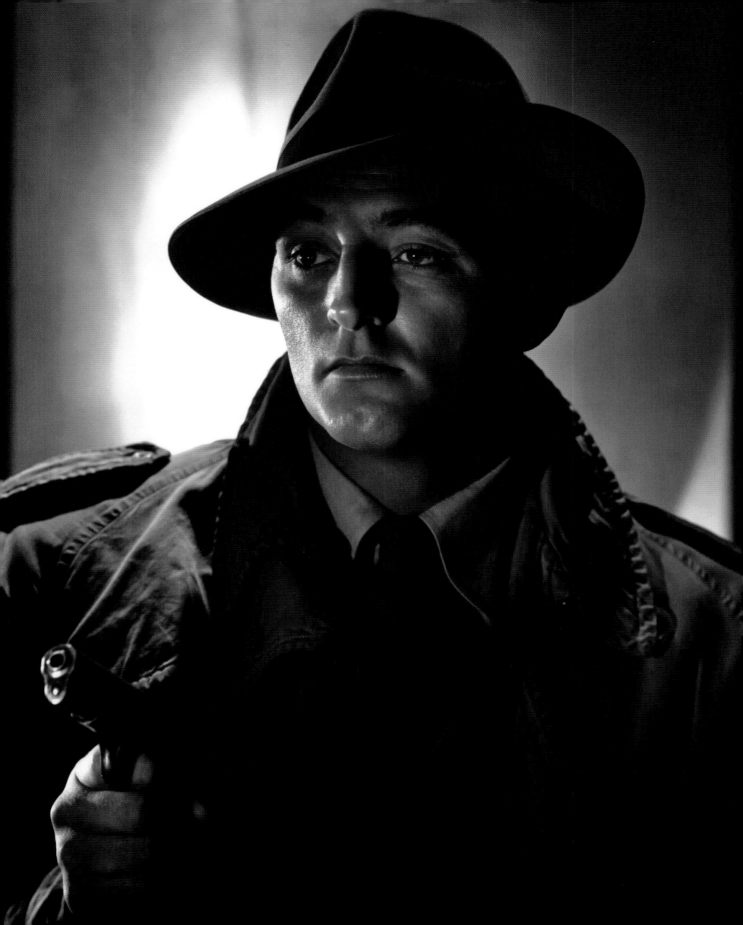

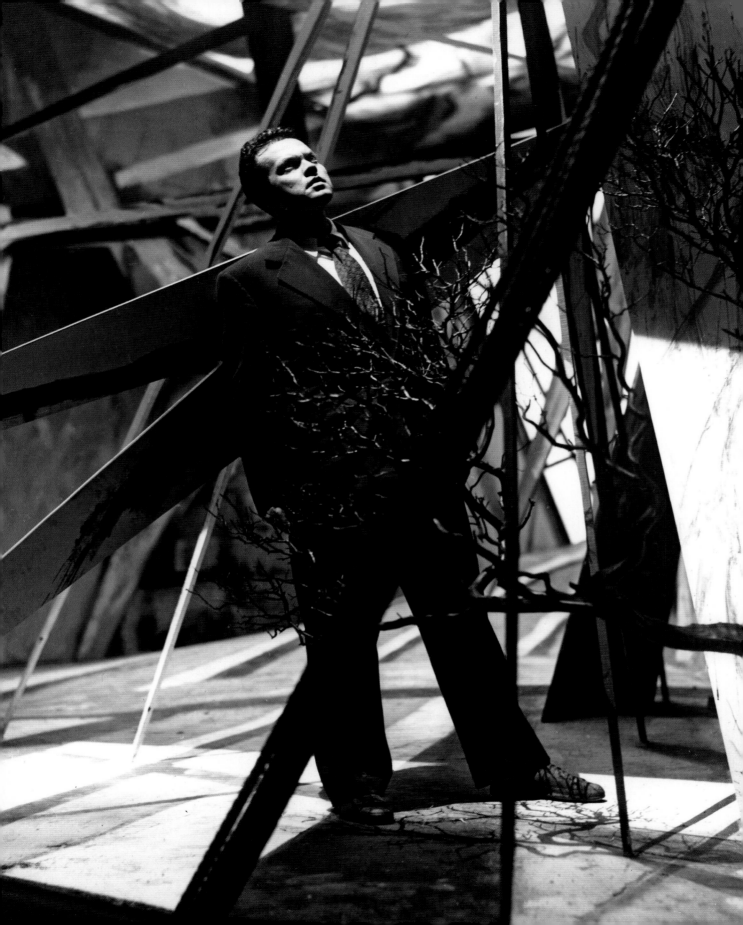

Obsessed

(1948–1949)

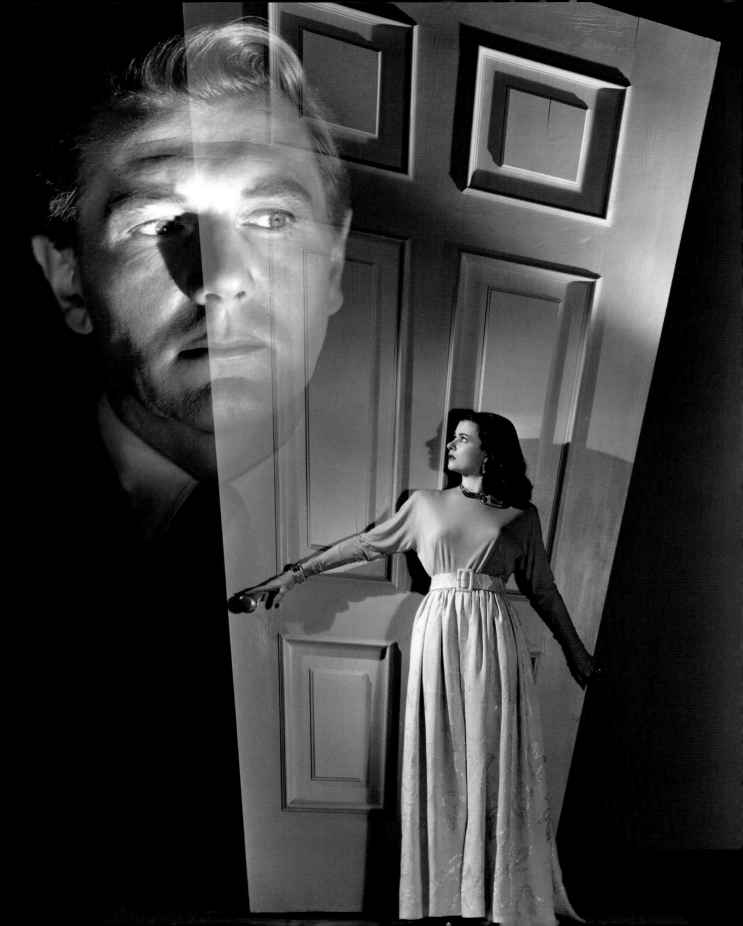

1948

p. 212: Orson Welles wrote, directed, and costarred in *The Lady from Shanghai*.

Opposite: In Fritz Lang's *Secret Beyond the Door*, Michael Redgrave is obsessed with a locked room and Joan Bennett must discover why.

REPORTS ON THE "CRIME STORY" CYCLE

"A 'new look' is beginning to assert itself in the motion-picture industry. What may be termed the postwar renaissance is starting to take shape and form. America's loss of British revenue and a decline in receipts at home are not interfering with significant long-range planning. Technical revolutions may be anticipated, notably through television, which this year will be coming into its own."

EDWIN SCHALLERT, "Films Ready to Conquer New Worlds," *Los Angeles Times*, January 2, 1948

"Hollywood has been going through one of its worst years. It was hit with a series of body blows in fairly quick succession. Adjustment on account of antitrust litigation are disturbing, plus the loss of practically the entire foreign market, notably the British, which was excellent during the war. General conditions in this country—particularly high prices for food—hit the box office. During the war and immediately thereafter, practically any film that remotely suggested amusement could score a hit. Those days of easy money are over. What Hollywood produces for audiences today must be shaped with intelligence and skill. One independent producer ventures the opinion that television is beginning to take a toll. A large portion of the public is investing in sets for this visual entertainment the money that it would formerly have spent on regular moviegoing. This public goes only to the picture that is notably worthwhile."

EDWIN SCHALLERT, "Clouds Now Lowering Over Movie Studios," *Los Angeles Times*, November 28, 1948

LOOKING BACK AT FILM NOIR

"Moviegoing audiences had matured during the war and no longer required false and sentimental portraits of human nature. I dealt again and again with the psychology of murderers. I showed, and encouraged my writers to show, how frustration, poverty, and a desperate need for money could drive people to psychotic extremes. In every case, the motive for destruction was greed, a theme with which millions could identify. We made no attempt to glamorize, excuse, or deify villains. We explained them; that was all. The dark side of life was portrayed frankly and without compromise."

HAL WALLIS, *Starmaker*

"It's very funny that some writers about pictures discovered film noir. I must tell you, I never heard of it until years later. Nobody knew then what that was. I didn't want to make a 'film noir.' I didn't want to make a 'film blanc.' I wanted to make a truthful picture, an honest slice of life, the way I saw it. That was all."

ANDRE DE TOTH in Alain Silver, James Ursini, and Robert Porfirio's *Film Noir Reader 3*

SECRET BEYOND THE DOOR

UNIVERSAL–INTERNATIONAL
RELEASED JANUARY 5, 1948

Producers
WALTER WANGER • FRITZ LANG

Director
FRITZ LANG

Screenwriter
SILVIA RICHARDS

Source
THE RUFUS KING NOVEL
MUSEUM PIECE NO. THIRTEEN

Cinematographer
STANLEY CORTEZ

Stars
JOAN BENNETT
MICHAEL REDGRAVE

AFTER A WOMAN IMPULSIVELY MARRIES A MAN WHILE ON VACATION, SHE BEGINS TO FEAR FOR HER LIFE.

PRODUCTION QUOTES

"Fritz Lang tried out a preview of *Secret Beyond the Door* for men only in San Bernardino and now will have one for women only to obtain separate reactions. Women protested the male exclusiveness."

"Studio Briefs," *Los Angeles Times*, September 24, 1947

"Bill Goetz [head of Universal-International] may think he can increase the value of the picture by cutting it, but it seems to me that such extensive cutting is damaging the picture. The value of the film lies in the things which are new and different; if these are cut out according to Bill's personal taste, the picture will be just another typical U-I release, and our aim to avoid making run-of-the-mill product will not only have been completely defeated but the box-office value definitely lessened."

FRITZ LANG, letter to Walter Wanger, in Matthew Bernstein's *Walter Wanger*

The heads of the newly merged entities of International Pictures and Universal Pictures did allow Fritz Lang to partially restore *Secret Beyond the Door* from William Goetz's heavily reshot version to the original version, but the combination of production overruns (both Stanley Cortez and Lang worked very slowly) and a slump in cinema attendance made the film a disastrous failure.

REVIEWS

"Film carries the Diana Productions label, a combo of Walter Wanger, Fritz Lang and Joan Bennett, who have been responsible for several other Diana thrillers. It is arty, with almost surrealistic treatment in camera angles, story-telling mood and suspense, as producer-director Lang hammers over his thrill points."

"Secret Beyond the Door," *Variety*, December 28, 1947

Joan Bennett's assured, inventive performances qualify as some of the best in the film noir canon. This scene is from *Secret Beyond the Door*.

"If the young lady played by Joan Bennett in *Secret Beyond the Door* were a little less itchy for romance and a little more rational in the head she would know at the start that the gentleman played by Michael Redgrave is a bad one for her to wed. For he's a moody sort of bar-fly who gives her the eye in a Mexican crowd and thereby causes strange sensations to occur at the back of her neck. He's also one of those fellows who says such arresting things as, 'There's something in your face that I saw once—in South Dakota. Wheat country. Cyclone weather, it was.' But she goes right ahead and marries him, along about the end of Reel 1. And before she has done much more than tickle the nose of her spouse a couple of times, she knows she is in for a session with a very queer duck, indeed."

BOSLEY CROWTHER, *The New York Times*, January 16, 1948

LETTER FROM REGIONAL THEATER OWNER

"Business scarcely sufficient to meet film rental and nothing else. Several of the few who attended left for home or elsewhere early in the evening. Maybe there are enough people in the cities who like this type, but our customers do not."

A. C. EDWARDS, Winema Theatre, Scotia, California, *Motion Picture Herald*, June 5, 1948

ARTIST COMMENTS

"I remember typing up the pages as they were handed to me and I thought it was just awful. And I thought, 'Well, if I can see it, why can't they?'"

LANG'S SECRETARY HILDA ROLFE in Brian Kellow's *The Bennetts: An Acting Family*

"Fritz Lang wouldn't use doubles for me or Michael Redgrave in the sequence in the burning house. We fled, terrified, through scorching flames, time and again. It wasn't a fire for toasting marshmallows."

JOAN BENNETT, *The Bennett Playbill*

"I was on the set quite a bit. Fritz Lang was being very naughty. He was diabolical and cruel. Michael Redgrave was a mess. He was nervous and uptight. Maybe Fritz thought that he was going to get a performance that way."

DIANA ANDERSON (Joan Bennett's daughter) in Brian Kellow's *The Bennetts: An Acting Family*

"*Secret Beyond the Door* was another of those psychological melodramas, the second and last film made with Walter Wanger for my own Diana Productions. But this one was destined to go wrong from the start. You see, I do believe in destiny. The script was cold, the cameraman could not do what I wanted, and I compromised on some ideas about how to let the audience hear the subconscious thoughts. I should never have done a picture that I did not want to do."

FRITZ LANG in Alain Silver, James Ursini, and Robert Porfirio's *Film Noir Reader 3*

Joan Bennett stealthily
borrows a key—but not
stealthily enough.

I WALK ALONE

PARAMOUNT PICTURES
RELEASED JANUARY 16, 1948

Producer
HAL WALLIS

Director
BYRON HASKIN

Screenwriter
**CHARLES SCHNEE, FROM AN
ADAPTATION BY ROBERT SMITH AND
JOHN BRIGHT**

Source
**THE THEODORE REEVES
PLAY *BEGGARS ARE COMING TO TOWN***

Cinematographer
LEO TOVER

Stars
**BURT LANCASTER • LIZABETH SCOTT
KIRK DOUGLAS • WENDELL COREY**

WORKING TITLE: *DEADLOCK*

A BOOTLEGGER RELEASED FROM JAIL AFTER FOURTEEN YEARS FINDS THAT OLD CRIME METHODS NO LONGER WORK.

PRODUCTION QUOTES

"Hal Wallis isn't passing up any bets. When Paramount's East Coast sales department urged him to reteam Lizabeth Scott and Burt Lancaster, whom they designated a natural combo, it was no sooner said than done. Wallis's next production, *Deadlock*, is a melodrama in which the smoky-voiced actress, as a nightclub entertainer, will have an excuse to test out a couple of ballads."

PHILIP K. SCHEUER, "Scott-Lancaster Act Due for Repeat," *Los Angeles Times*, December 16, 1946

Top: Former cameraman Byron Haskin directed *I Walk Alone* for Hal Wallis. He made it elegant and stirring. In this scene are Lizabeth Scott and Burt Lancaster, whom Paramount execs designated a "natural combo."

Bottom: Mike Mazurki chokes Burt Lancaster to keep him from bothering Wendell Corey and Kirk Douglas. George Rigaud is at far right.

REVIEWS

"It's a mighty low class of people that you will meet in *I Walk Alone*—and a mighty low grade of melodrama, if you want the honest truth—in spite of a very swanky setting and an air of great elegance. For the people are mostly ex-gangsters, nightclub peddlers or social black sheep, and the drama is of the vintage of gangster fiction from twenty years ago. It is notable that the slant of sympathy is very strong toward the mug who did the 'stretch,' as though he were some kind of martyr. Nice thing! Producer Hal Wallis should read the Production Code."

BOSLEY CROWTHER, *The New York Times*, January 22, 1948

"All I can say at the outset about *I Walk Alone* is that Burt Lancaster looks very fit for a fellow who is supposed to have spent fourteen years in prison. This film plows through a melodramatic morass that is no more counterfeit (pardon the mixed metaphor) than most situations in movies nowadays. In fact, a regular filmgoer has become so accustomed to phony narratives during the past year that this is less difficult to accept than most."

EDWIN SCHALLERT, "Lancaster Gypped," *Los Angeles Times*, January 30, 1948

LETTER FROM REGIONAL THEATER OWNER

"A sample of a feature that doesn't do any business and which is in the higher bracket. Burt Lancaster should smile at least. Average business. No complaints and no praises."

WILLIAM EMKEY, Family Theatre, Glen Lyon, Pennsylvania, *Motion Picture Herald*, April 24, 1948

ARTIST COMMENT

"I cast Kirk Douglas as a bootlegger, a shameless double-crosser in *I Walk Alone*. He was as powerfully convincing as a gangster as he was in the part of the drink-sodden husband of Martha Ivers. Kirk's only problem was that he occasionally went overboard in dramatic scenes. Once it was explained to him that his power was greater if contained, he listened carefully, absorbed thoroughly, and learned. Warm and grateful for his chance in Hollywood, he never gave me any trouble, nor was there a hint in his personal life of the savage quality that gave such color to his performances on film."

HAL WALLIS, *Starmaker*

THE BIG CLOCK

**PARAMOUNT PICTURES
RELEASED APRIL 9, 1948**

Producer
RICHARD MAIBAUM

Director
JOHN FARROW

Screenwriter
**JONATHAN LATIMER, WITH ADDITIONAL
DIALOGUE BY HAROLD GOLDMAN**

Source
THE KENNETH FEARING NOVEL

Cinematographer
JOHN F. SEITZ

Unit stills photographer
JACK KOFFMAN

Stars
**RAY MILLAND • CHARLES LAUGHTON
ELSA LANCHESTER
MAUREEN O'SULLIVAN**

WORKING TITLE: *THE JUDAS PICTURE*

A CRIME MAGAZINE EDITOR BECOMES THE MYSTERY WITNESS TO A MURDER COMMITTED BY HIS BOSS.

PRODUCTION QUOTE

"With his *Lost Weekend* Oscar safely tucked away, Milland's ambition is a role that would make people forget that unforgettable one. His latest picture, *The Big Clock*, is hardly the one to do that, though. It has a monumental drunk sequence with an evening he can't remember afterwards."

LOUIS BERG, "Ginger Ale, Please," *Los Angeles Times*, April 11, 1948

REVIEWS

"There are weaknesses lurking in this pic, namely a too-patly tailored yarn and some spotty acting. Ray Milland turns in a workmanlike job, polished to groove to the unrelenting speed of the plot. Charles Laughton overplays his hand so that his tycoon-sans-heart takes on the quality of parodying the real article."

Variety, February 18, 1948

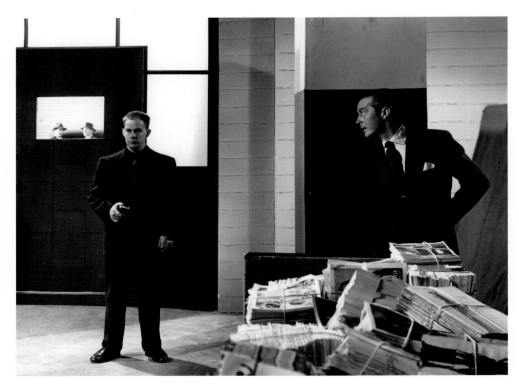

Ray Milland spends much of *The Big Clock* eluding Charles Laughton and his henchman, Henry Morgan.

"Charles Laughton does some fine acting in *The Big Clock*. It's a smooth, slick, sadistic production, with Ray Milland giving his best performance since *The Lost Weekend*. Director Johnny Farrow put his wife, Maureen O'Sullivan, in as leading lady, and she's charming. Elsa Lanchester is a riot. I don't know why we don't give her bigger parts. *The Big Clock* will tick millions into the till of Paramount without their having to rewind it."

HEDDA HOPPER, "Perfect Time," *Los Angeles Times*, April 13, 1948

"When you hear the musical chime at the end of this ticking review of *The Big Clock*, it will be exactly the time for all devotees of detective films to make a mental memorandum to see it without possible fail. Note well, we make the stipulation that you should be a devotee of detective films and that you should have in your mind the mechanisms of precision peculiar to the cult. For this is a dandy clue-chaser of the modern chromium-plated type, but it is also an entertainment which requires close attention from the start. Actually, in the manner of the best detective fiction these days, it isn't a stiff and stark whodunit activated around some stalking cop. Nary a wise-guy policeman clutters up the death room or the clues. As a matter of fact, the policemen are not called in until the end. And the fellow who does the murder is known by the audience all along."

BOSLEY CROWTHER, *The New York Times*, April 22, 1948

LETTER FROM REGIONAL THEATER OWNER

"A big title, but not such a big show. Anyway, business wasn't so big. Just fair. Not enough action and a very poor story. A very good cast which will draw the patrons."

THURSTON COOPER, Myers Theatre, Nashville, North Carolina, *Motion Picture Herald*, May 8, 1948

ARTIST COMMENTS

"Since we had so many people talking at once and so much camera movement, I did practically the whole picture by reflected light, reflected from the ceiling and sometimes the floor. It was quite an innovation. We had lights above the cloth and we had mikes from the ceiling too, so you couldn't see them and they wouldn't get in the way of the moving camera and would not cast shadows. Charlie Laughton remarked, 'It's so different working this way.' We'd do a take as soon as he got the words the way John Farrow wanted. We did a lot of them in one take."

JOHN SEITZ in Alain Silver, James Ursini, and Robert Porfirio's *Film Noir Reader 3*

John Seitz uses the word "reflected" in place of the word "diffused," which would more accurately describe the practice of stretching muslin across the top of a set and then lighting it from above so that the entire set is evenly illuminated. This is not the shadowy lighting style associated with film noir, but there are scenes in *The Big Clock* that are lit dramatically.

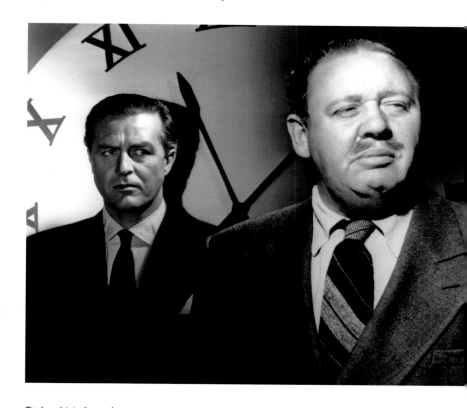

Richard Maibaum's production of John Farrow's *The Big Clock* featured a highly watchable contest between editor Ray Milland and publisher Charles Laughton.

RAW DEAL

EAGLE-LION FILMS
RELEASED MAY 26, 1948

WHEN A MAN ESCAPES FROM
PRISON TO PROVE HIS INNOCENCE,
TWO WOMEN JOIN HIS QUEST.

PRODUCTION QUOTE

"Marsha Hunt will play the lead once
set for Phyllis Thaxter in *Corkscrew
Alley*. Phyllis couldn't undertake the
role following the loss of her baby
because her scenes had to be pho-
tographed more or less immediately.
So Miss Hunt and Claire Trevor will
share feminine honors opposite
Dennis O'Keefe in the Eagle-Lion
production."

EDWIN SCHALLERT, "Marsha Hunt Plays
Corkscrew Alley Lead," *Los Angeles Times*,
November 21, 1947

Producer
EDWARD SMALL

Director
ANTHONY MANN

Screenwriters
LEOPOLD ATLAS • JOHN C. HIGGINS

Source
A STORY BY ARNOLD B. ARMSTRONG
AND AUDREY ASHLEY

Cinematographer
JOHN ALTON

Stars
DENNIS O'KEEFE
MARSHA HUNT
CLAIRE TREVOR

WORKING TITLE: CORKSCREW ALLEY

REVIEW

"The end of a fascinating friendship between a fugitive jailbird and the girl who has loyally aided his activities, even down to his desperate prison break, is cheerlessly documented in *Raw Deal*, a pistol-powered crime melodrama. And the reason for this annulment is that the fugitive meets another girl—a beautiful, law-respecting citizen—while taking it on the lam. Claire Trevor plays the girl whom Mr. O'Keefe gives the raw deal in favor of Marsha Hunt. And anyone watching these two ladies and their behavior in this film might not be inclined to wonder at the change in the gentleman's choice. But this, of course, is a movie, and a pretty low-grade one at that. Sensations of fright and excitement are more diligently pursued than common sense."

BOSLEY CROWTHER, *The New York Times*, July 9, 1948

LETTER FROM REGIONAL THEATER OWNER

"This is better than *T-Men*, and a picture that the people will like to see. Some didn't like the ending but it wouldn't do to have all the pictures end rosy. This picture is well acted with lots of suspense."

L. BRAZIL JR., New Theatre, Bearden, Arkansas, *Motion Picture Herald*, September 25, 1948

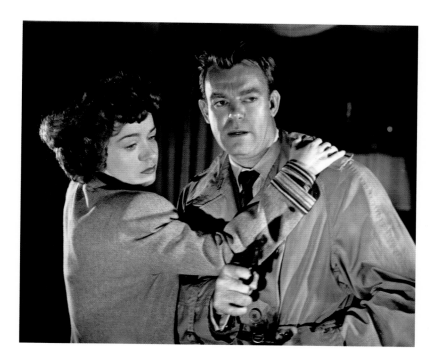

ARTIST COMMENTS

"I found a director in Tony Mann who thought like I did. He not only accepted what I did, he demanded it. The other cameramen illuminated for exposure. They'd put a lot of light in it so the audience could see everything. I used light for mood. All my pictures looked different. That's what made my name, what set me apart. People asked for me. I gambled. In most cases, the studios objected. They had the idea that the audience should be able to see everything. But when I started making dark pictures, the audience saw there was a purpose to it."

JOHN ALTON in Todd McCarthy's "Deep Focus," *Variety*, March 11, 1993

"Dennis O'Keefe was a joy to work with, a first-rate actor, and a wonderful, congenial compatriot."

MARSHA HUNT, interviewed at the Turner Classic Movies Film Festival, 2012

In Anthony Mann's *Raw Deal*, Marsha Hunt is on the run with escaped convict Dennis O'Keefe.

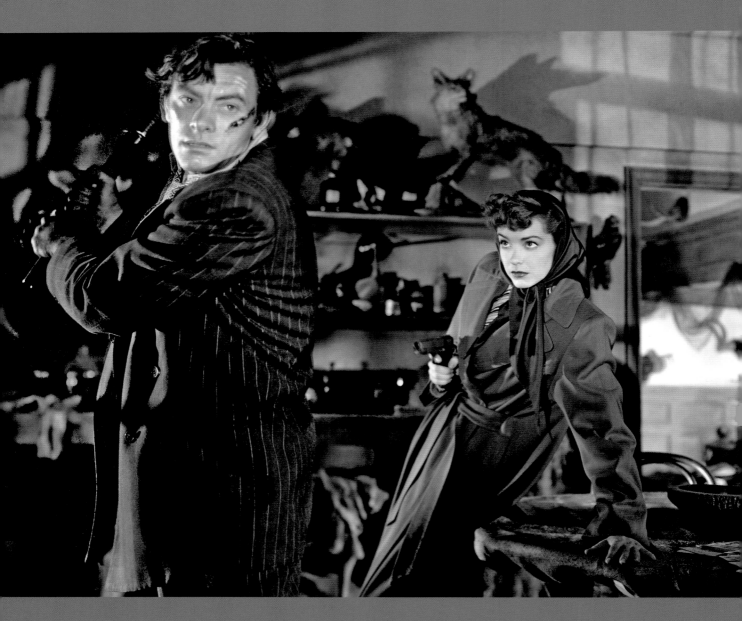

Above: When John Ireland
threatens O'Keefe, good
girl Marsha Hunt adapts to
the environment.

Opposite: Like Alan Ladd,
Dennis O'Keefe had spent
a decade as an extra and
bit player before becoming
a star.

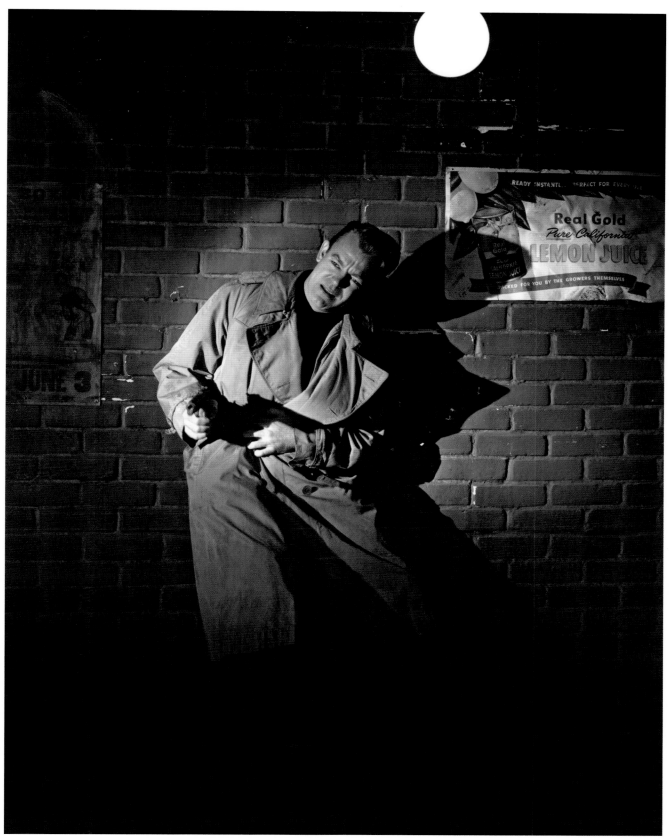

THE LADY FROM SHANGHAI

COLUMBIA PICTURES
RELEASED JUNE 9, 1948

Producer-director
ORSON WELLES

Screenwriters
ORSON WELLES • WILLIAM CASTLE
FLETCHER MARKLE • CHARLES LEDERER

Source
THE SHERWOOD KING NOVEL
IF I DIE BEFORE I WAKE

Cinematographer
CHARLES LAWTON JR.

Unit stills photographers
NED SCOTT • EDWARD CRONENWETH

Stars
RITA HAYWORTH
ORSON WELLES • EVERETT SLOANE

A SAILOR'S GOOD DEED FOR A WOMAN IN DISTRESS LEADS HIM INTO ADULTERY AND ENDS WITH A FIGHT FOR HIS LIFE.

PRODUCTION QUOTES

"Orson Welles is up to his old methods in making *The Lady From Shanghai*. He's recorded all the dialogue first—at a cost of $100,000—and is shooting the picture silently. The film will then be matched with the sound track. I watched Orson and Rita Hayworth do a very dramatic death scene. It was the first time I'd ever seen a Svengali in actual operation. Orson's influence on Rita was hypnotic and exciting. She loved it. I must say he's getting a dramatic performance out of her that will surprise you."

HEDDA HOPPER, "Looking at Hollywood," *Los Angeles Times*, February 27, 1947

"With this picture I had to be particularly careful, because Rita was starring in it. She's Columbia's bread, butter, and cake, and everything about her performance had to be just right."

ORSON WELLES in Hedda Hopper's "Orson Welles Sets Own Schedule," *Los Angeles Times*, July 27, 1947

Harry Cohn, the head of Columbia Pictures, disliked *The Lady from Shanghai* and had it recut. Fantastic scenes made on sets like this were thrown away, never to be viewed. Photograph by Ned Scott.

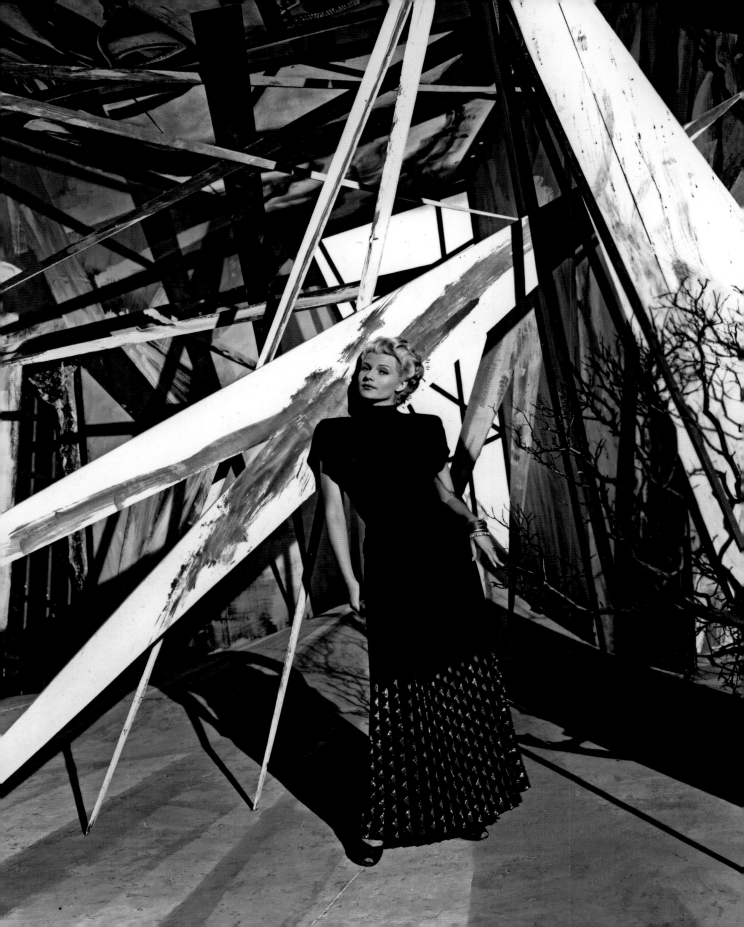

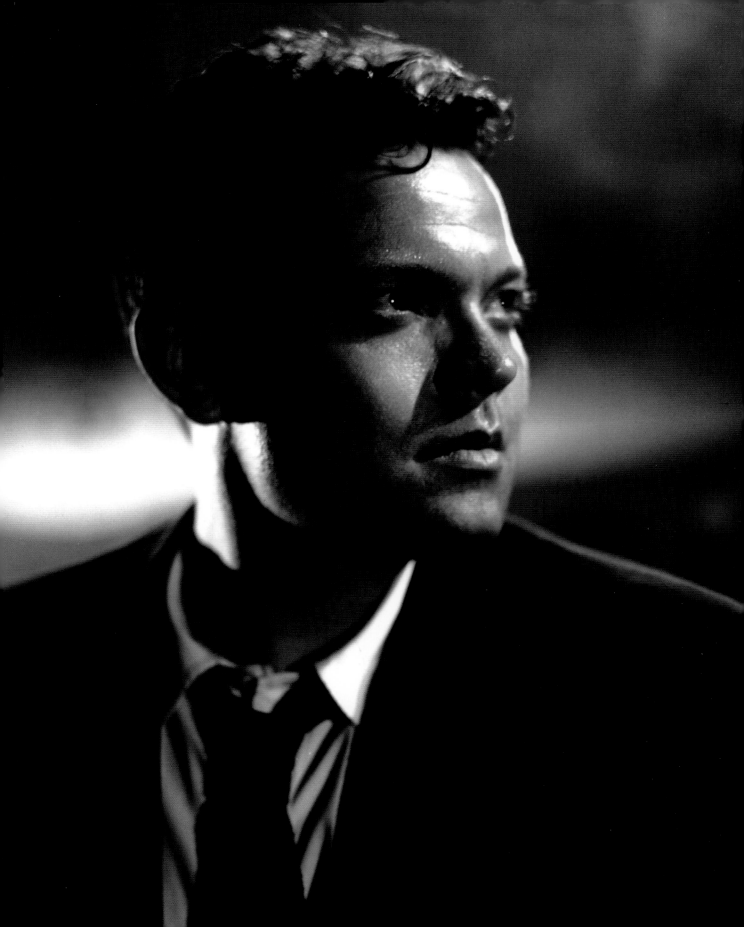

REVIEWS

"*The Lady from Shanghai* is okay box office. It's exploitable and has Rita Hayworth's name for the marquees. Entertainment value suffers from the striving for effect of Orson Welles' production, direction, and scripting. Script is wordy and full of holes which need the plug of taut story telling. Rambling style used by Orson Welles has occasional flashes of imagination, particularly in the tricky backgrounds he uses to unfold the yarn, but effects, while good on their own, are distracting to the murder plot."

WILLIAM BROGDON, *Variety*, April 14, 1948

"*The Lady From Shanghai* could have been a terrific piece of melodramatic romance. For the idea, at least, is a corker and the Wellesian ability to direct a good cast against fascinating backgrounds has never been better displayed. And for its sheer visual modeling of burning passions in faces, forms and attitudes, galvanized within picturesque surroundings, it might almost match *Citizen Kane*. But the protean gentleman's arrangement of a triple-cross murder plot is thoroughly confused and baffling. Tension is recklessly permitted to drain off in a sieve of tangled plot. As producer of the picture, Mr. Welles might better have fired himself—as author, that is—and hired somebody to give Mr. Welles, director, a better script. And he certainly could have done much better than use himself in the key role, for no matter how much you dress him in rakish yachting caps and open shirts, Mr. Welles simply hasn't the capacity to cut a romantic swath. And when he adorns his characterization with a poetic air and an Irish brogue, which is painfully artificial, he makes himself—and the film—ridiculous."

BOSLEY CROWTHER, *The New York Times*, June 10, 1948

LETTER FROM REGIONAL THEATER OWNER

"This was a box office flop. Didn't take at all."

HARLAND RANKIN, Erie Theatre, Wheatley, Ontario, Canada, *Motion Picture Herald*, July 10, 1948

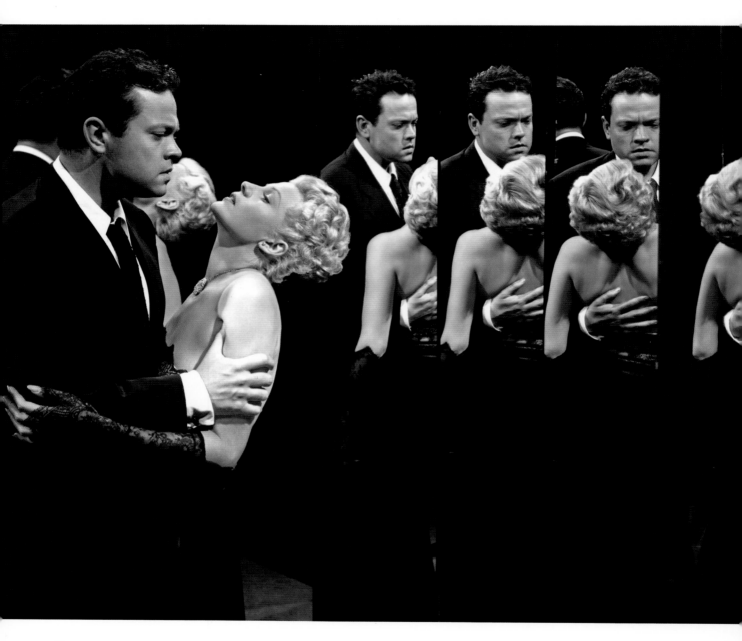

The end of *The
Lady from Shanghai.*
Photograph by Ned Scott.

A Robert Coburn portrait
of Rita Hayworth.

ARTIST COMMENTS

"Orson was the best director I ever
worked with and I'm not saying that
just because I was married to him.
Actually, he is a better director than
he is an actor, though he'd kill me if he
heard me say it."

RITA HAYWORTH in John Parkyn's
"Rita Hayworth Is Alive and Filming," *Chicago
Tribune*, August 21, 1969

"Orson was trying something new
with me, but Harry Cohn wanted 'The
Image,' that image he was going to
make me use until I was ninety. *The
Lady from Shanghai* was a very good
picture. So what does Harry Cohn say
when he sees it: 'He's cut your hair off!
He's ruined you!'"

RITA HAYWORTH in John Hallowell's
"Don't Put the Blame on Me, Boys," *The New
York Times*, October 25, 1970

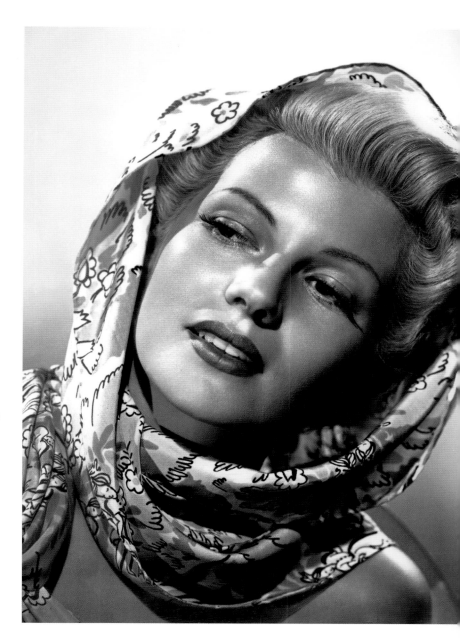

KEY LARGO

WARNER BROS. PICTURES
RELEASED JULY 31, 1948

Producer
JERRY WALD

Director
JOHN HUSTON

Screenwriters
RICHARD BROOKS • JOHN HUSTON

Source
THE MAXWELL ANDERSON PLAY

Cinematographer
KARL FREUND

Unit stills photographer
MAC JULIAN

Stars
**HUMPHREY BOGART • LAUREN BACALL
EDWARD G. ROBINSON
LIONEL BARRYMORE
CLAIRE TREVOR**

A HURRICANE TRAPS A DISILLUSIONED VETERAN IN A HOTEL WITH GANGSTERS.

PRODUCTION QUOTES

"Richard Brooks, who has been writing *Key Largo* with director John Huston as story consultant, will return Monday from Florida with the completed script. He and Huston gathered material in the story's locale."

EDWIN SCHALLERT, "Drama and Film," *Los Angeles Times*, November 18, 1947

"Steve Jackson and the Breen office mention in their notes that Murillo [changed to Johnny Rocco in the film] is definitely 'a gangster surrounded by his henchmen and his kept woman.' Apparently the Breen office has not seen *Brute Force, Desert Fury, The Strange Love of Martha Ivers, Ride the Pink Horse*, etc. They go on to say in their note that the public reaction to gangster stories is extremely violent and vociferous. Again, I call your attention to *The Killers* and pictures of that type. To my way of thinking, the Breen office is narrowing our range of properties down to where we can either make a musical or a comedy. The office is good in many ways, but it goes by the Code that was written in 1930. This piling up of continuous censorship is making all our pictures empty. No wonder the industry is continually being ridiculed. No wonder it has to continually apologize for itself."

JERRY WALD, inter-office memo, in Rudy Behlmer's *Inside Warner Bros.*

"Humphrey Bogart returned to Warners to do four days of closeups for *Key Largo*, just so Eddie Robinson wouldn't steal the picture."

HEDDA HOPPER, "Looking at Hollywood," *Los Angeles Times*, April 13, 1948

"I have such a wonderful part in *Key Largo*. Let me be hammy enough to tell you about just one scene. I'm a girl that Eddie Robinson, a gangster, has lifted out of the chorus as a singer. He comes back from Europe after ten years, and I've turned into a horrible dipso. I'm cringing and crawling and shaking, begging him for a shot of whisky. But he makes me try to sing a song in front of everybody first. Then he refuses to give me the drink. It's the toughest scene I ever tried to play."

CLAIRE TREVOR in Hedda Hopper's "Trevor and Ever," *Los Angeles Times*, April 24, 1948

"You're the kind of drunken dame whose elbows are always a little too big. Your voice is a little too loud and you're a little too polite. You're very sad, very resigned."

JOHN HUSTON to Claire Trevor, in William F. Nolan's *John Huston: King Rebel*

"If a guy points a gun at you, the audience knows you're afraid. You don't have to make faces."

HUMPHREY BOGART in Lawrence Grobel's *The Hustons*

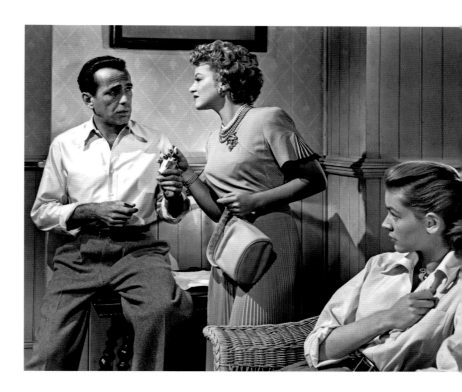

John Huston's *Key Largo* was both harrowing and satisfying, a gangster rally in a nightmare landscape. In this scene are Humphrey Bogart, Claire Trevor, and Lauren Bacall.

REVIEWS

"A tense film thriller has been developed from Maxwell Anderson's play. The excitement generated is quiet, seldom rambunctious or slambang, although there are moments of high action. There are overtones of soapboxing on a better world but this is never permitted to interfere with basic plot."

Variety, July 7, 1948

"It is whimsical that the Warners, who had a great deal to do with the rise of the gangster in the movies, should subject him to the final irony: they have him enacted again by no less a one than Edward G. Robinson and then they let a reformed Humphrey Bogart bump him off. This, to the old gangster-film fan, will smack distinctly of race suicide—or, at least, of deliberate self-destruction of a type through internecine strife. And this was, no doubt, an intention of those who arranged to bring two such notorious veterans of the old days together in this film. For a great deal of pertinent suggestion is unquestionably conveyed by the spectacle of one classic film thug putting the quietus on another one. Unfortunately, the staggering impact of the image itself is somewhat lost in an excess of prefatory talking, much of it along philosophical lines. Talk—endless talk—about courage and the way the world goes and gums it up. And the presentation of old-time gangsterism in this light shows up its obsolescence. The Warners were sentimental, perhaps."

BOSLEY CROWTHER, *The New York Times,* July 17, 1948

LETTER FROM REGIONAL THEATER OWNER

"Average show that should have done much better business. One of the old-time Warner dramas."

S. W. BOOTH, Booth Theatre, Rich Hill, Missouri, *Motion Picture Herald,* November 8, 1948

ARTIST COMMENTS

"I used to serve tea in my dressing room every afternoon, and the whole cast would come in—Eddie Robinson, Bogey, Claire Trevor. Lionel Barrymore had to sit outside the door in his wheelchair, but he looked forward to those tea parties, always came, and really enjoyed himself."

LAUREN BACALL in Margot Peters's *The House of Barrymore*

"Let me tell you something about Bogie. I got the star treatment because he insisted upon it. When he was asked to come on the set, he would first ask: 'Is Mr. Robinson ready?' And then he'd come to my trailer dressing room to get me."

EDWARD G. ROBINSON, *All My Yesterdays*

PITFALL

UNITED ARTISTS
RELEASED AUGUST 24, 1948

Producer
SAMUEL BISCHOFF

Director
ANDRÉ DE TOTH

Screenwriters
KARL KAMB • BILL BOWERS

Source
THE JAY DRATLER NOVEL *THE PITFALL*

Cinematographer
HARRY WILD

Unit stills photographer
FRANK TANNER

Stars
DICK POWELL
LIZABETH SCOTT
RAYMOND BURR • JANE WYATT

A HAPPILY MARRIED INSURANCE MAN ANGERS AN INVESTIGATOR BY DATING A WOMAN INVOLVED IN A CASE.

PRODUCTION QUOTES

"I heard that Susan Hayward has been borrowed from Walter Wanger to star in *Pitfall*, Dick Powell's current movie. Veronica Lake was scheduled for this. She wanted to do it because her husband André de Toth is the director."

LOUELLA PARSONS, "Hollywood," *Philadelphia Inquirer*, November 29, 1947

"Dick Powell, who has a hunk of moola tied up in *The Pitfall*, is patting André de Toth on the back for bringing in the picture ten days ahead of schedule."

HEDDA HOPPER, "Looking at Hollywood," *Los Angeles Times*, February 14, 1948

Lizabeth Scott and Dick Powell are menaced by Raymond Burr in poster art for André de Toth's *Pitfall*. Photograph by Frank Tanner.

REVIEW

"*Pitfall* is a neatly constructed film that builds suspense as it goes along and reaches a sensible conclusion without frittering away its climactic interest and tension. Moreover, it is a surprisingly moral entertainment, as palatable and effective a sample of cinematic sermonizing on marital mores as the screen has presented in some time. There is nothing especially novel about *Pitfall*. A family man slips momentarily from the path of propriety and pays a stiff penalty. It's the type of story the screen has presented time and again, but seldom as sensibly. In its handling of the problems that disturb the marriage of Dick Powell and Jane Wyatt, *Pitfall* mercifully eschews divorce as the one and only solution. Indeed there isn't even the final traditional embrace that connotes—and they lived happily ever after. In these and other small yet important details, such as the design of the sets and the way the principals dress, this picture has a realistic look which enhances its narrative values. Here is a sample of the realism that has been asked for in pictures in place of the extravagance in costume and production qualities which have thrown many a potentially good film off key. But the meat of the drama lies in the man's desperate struggle with his conscience, his overwhelming sense of guilt and striving to spare his wife and son the shameful consequences of his indiscretion."

BOSLEY CROWTHER, *The New York Times*, August 20, 1948

LETTER FROM REGIONAL THEATER OWNER

"Did fair business both days. Was booked up with *Wild Horse Valley* with Bob Steele. Would have done better if booked with Bill Elliott or Sunset Carson feature."

SAMUEL G. WAITSMAN, Radio Theatre, Baltimore, Maryland, *Motion Picture Herald*, November 1, 1948

ARTIST COMMENT

"*Pitfall* was the most amazing film to make, because they had the book, but they didn't have a script. I read the book and I said, 'That's great. Okay. I'd love to do it.' Every day they'd give us a few pages that we were to shoot the following day. You'd come in prepared to do it in the morning, but sometimes they'd say, 'No. We don't like that scene any longer,' and they'd give us another. So we'd learn the other scene. That was why I was so excited doing that film."

LIZABETH SCOTT in Alain Silver, James Ursini, and Robert Porfirio's *Film Noir Reader 3*

SORRY, WRONG NUMBER

PARAMOUNT PICTURES
RELEASED SEPTEMBER 1, 1948

Producers
HAL WALLIS • ANATOLE LITVAK

Director
ANATOLE LITVAK

Screenwriter
LUCILLE FLETCHER

Source
THE LUCILLE FLETCHER RADIO PLAY

Cinematographer
SOL POLITO

Stars
BARBARA STANWYCK
BURT LANCASTER • ED BEGLEY SR.
WENDELL COREY

AN INVALID OVERHEARS A TELEPHONE CONVERSATION BETWEEN TWO HIRED KILLERS.

PRODUCTION QUOTE

"Claudette Colbert's next picture will be *Sorry, Wrong Number* for Hal Wallis, under Anatole Litvak's direction."

HEDDA HOPPER, "Looking at Hollywood,"
Los Angeles Times, October 15, 1947

Claudette Colbert did not make the film, but the reason is not known. It may have been that she required a five o'clock quitting time and camera angles only from her left side. Wallis was not known for catering to stars.

REVIEWS

"*Sorry, Wrong Number* is a real chiller. Plot deals with an invalid femme who overhears a murder scheme through crossed telephone lines. Alone in her home, the invalid gradually comes to realize that it is her own death that is planned. Barbara Stanwyck plays her role of the invalid almost entirely in bed. Her reading is sock, the actress giving an interpretation that makes the neurotic, selfish woman understandable."

Variety, July 24, 1948

Hal Wallis's production of Anatole Litvak's *Sorry, Wrong Number* gave Barbara Stanwyck the role of a lifetime. "I had twelve days of the terror scenes in bed," recalled Stanwyck.

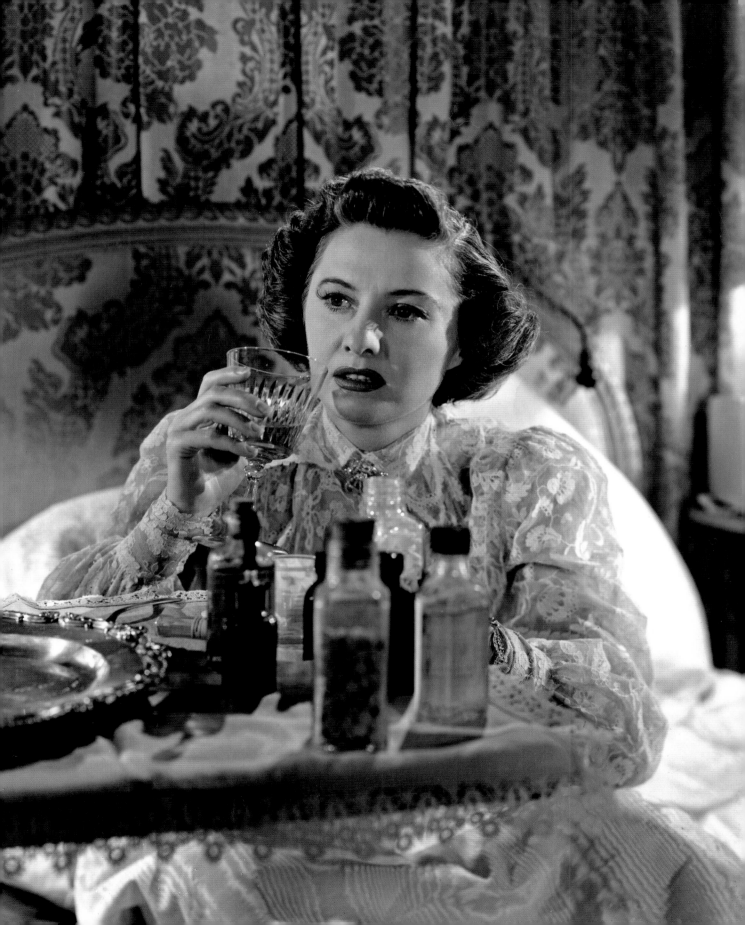

"The moral of *Sorry, Wrong Number* is that you should never leave a woman alone in a house with a telephone, for, according to this demonstration, she can drive herself stark staring mad by an excessive utilization of that innocent little machine. The gimmick, of course, is the telephone, which has long been the playwright's best friend—but never, to our recollection, as exploited as it is here. As the ear-bending lady, Miss Stanwyck does a quite elaborate job of working herself into a frenzy, as well as playing a nasty dame in the previous and self-aggrandizing phases of her life. Perhaps if you have a special interest in foul folks and morbidities, you will thrill to this picture. Frankly, we squirmed—and not from dread."

BOSLEY CROWTHER, *The New York Times*, September 2, 1948

LETTER FROM REGIONAL THEATER OWNER

"A real thriller which, because of its morbid plot, has somewhat limited appeal. Those of our patrons who like this type of show thought it excellent."

ROWELL BROS., Idle Hour Theatre, Hardwick, Vermont, *Motion Picture Herald*, December 11, 1948.

ARTIST COMMENTS

"I regarded the writer as king. *Sorry, Wrong Number* had been a one-woman radio drama, so Lucille Fletcher had to flesh out several new characters for the film."

HAL WALLIS, *Starmaker*

"There was a scene in the last part of the picture just before she was to be murdered by hired killers. I remember, being an incorrigible perfectionist, asking her to do the scene over and over again. At a certain moment I decided to stop to give Barbara a little time to recover as it was a highly emotional and difficult scene. When I left the stage to get a drink she was told by the crew that it was ridiculous of me to ask her to do this scene again—that what she did was good enough. But instead of agreeing with them, she gave them hell, saying that it was not for them to judge but for the director—that 'good' was not enough."

ANATOLE LITVAK in Ella Smith's *Starring Miss Barbara Stanwyck*

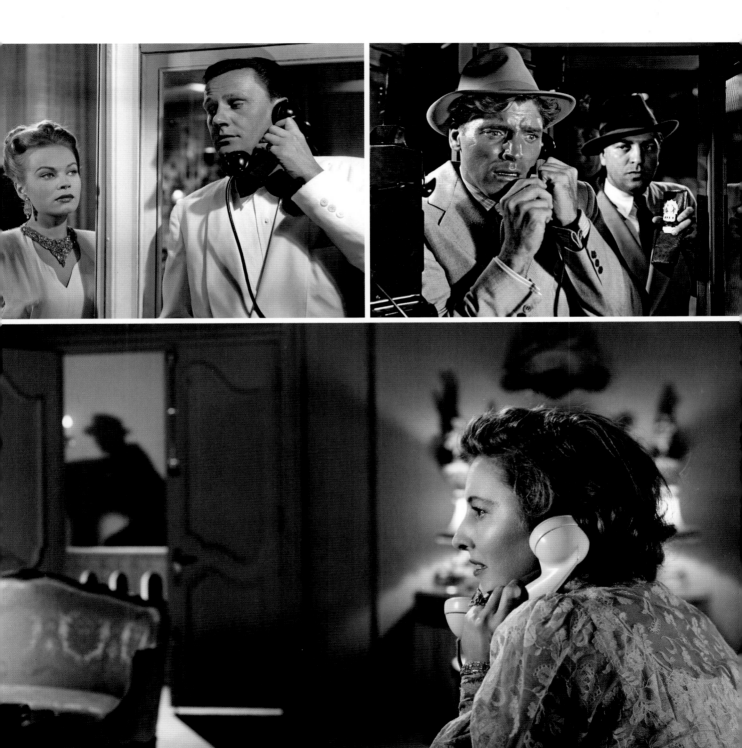

MOONRISE

**REPUBLIC PICTURES
RELEASED OCTOBER 1, 1948**

A YOUNG MAN WHO HAS BEEN BULLIED SINCE CHILDHOOD BECAUSE HIS FATHER WAS HANGED FOR MURDER ACCIDENTALLY KILLS HIS TORMENTOR.

PRODUCTION QUOTE

"Guy Madison has been visiting Gail Russell on the set of *Moonrise*, despite the fact that they are no longer supposed to be in love."

HEDDA HOPPER, *Los Angeles Times*, January 13, 1948

REVIEW

"The ancient argument as to which medium tells a story best, written words or pictorial images, is again brought into focus by *Moonrise*. And, using this adaptation of Theodore Strauss's novel as a case in point, the book towers above the picture. Not because the filmmakers have tampered with their source material. Rather, it is because the author, snugly fitting each word and idea into an intricate mosaic, developed three-dimensional people experiencing genuine mounting tensions, hates and passions in a genuine, if cruel, society. But the terrible weight of persecution, guilt, and loneliness felt by Danny Hawkins, the hunted hero, is indicated obliquely in the film, and, except for a few characters, the cast is only a shadowy society moving lethargically towards an inexorable climax."

BOSLEY CROWTHER, *The New York Times*, March 7, 1949

Producer
CHARLES HAAS

Director
FRANK BORZAGE

Screenwriter
CHARLES HAAS

Source
THE THEODORE STRAUSS NOVEL

Cinematographer
JOHN L. RUSSELL

Unit stills photographer
DON KEYES

Stars
DANE CLARK • GAIL RUSSELL
ETHEL BARRYMORE
REX INGRAM

LETTER FROM REGIONAL THEATER OWNER

"A very good show and a very good cast. Dane Clark is a good draw here. Played with Chapter V of *Superman* serial. Box office okay. This picture should hold up well for two days."

THURSTON COOPER, Myers Theatre, Nashville, North Carolina, *Motion Picture Herald*, January 22, 1949

Gail Russell falls in love with Dane Clark while he is on the run from the police in Frank Borzage's *Moonrise*. This was a masterly film noir version of the poignant romances, such as *7th Heaven*, that Borzage had made at Fox Film in the '20s.

FORCE OF EVIL

ENTERPRISE STUDIOS
DISTRIBUTED BY METRO-GOLDWYN-MAYER
RELEASED DECEMBER 25, 1948

Producer
BOB ROBERTS

Director
ABRAHAM POLONSKY

Screenwriters
IRA WOLFERT • ABRAHAM POLONSKY

Source
THE IRA WOLFERT NOVEL
TUCKER'S PEOPLE

Cinematographer
GEORGE BARNES

Stars
JOHN GARFIELD
THOMAS GOMEZ • MARIE WINDSOR

AN AMBITIOUS LAWYER PLOTS TO WIN CONTROL OF THE NEW YORK NUMBERS RACKET.

PRODUCTION QUOTE

"I felt that Ira Wolfert's novel *Tucker's People* [published in 1943] was essentially cynical and defeatist. Wolfert felt that, too. The war had changed his view. So our picture will show Joe Morse [John Garfield] as a corporation lawyer who rediscovers not only his responsibility in life but also his soul. At the close he pulls down the world of evil he has helped create. It is a visible act of regeneration. This is not a gangster picture but a psychological study of men's business relations to a racket. Morse, Tucker and the others would have liked to see lotteries legalized. Meanwhile they succumbed to corruption."

ABRAHAM POLONSKY in Philip K. Scheuer's "Polonsky Meteoric Writer," *Los Angeles Times*, June 13, 1948

REVIEWS

"*Force of Evil* is a dynamic crime-and-punishment drama, brilliantly and broadly realized. It gathers suspense and dread, a genuine feeling of the bleakness of crime and a terrible sense of doom. And it catches in eloquent tatters of on-the-wing dialogue moving intimations of the pathos of hopeful lives gone wrong. But the main thing about this picture is that it shows, in plausible terms, the disintegration of a character under the too-heavy pressure of his sense of wrong. Abraham Polonsky and Ira Wolfert do it in startling situations and in graphic dialogue, in shattering cinematic glimpses and in great, dramatic sweeps of New York background. New to the business of directing, Mr. Polonsky here establishes himself as a man of imagination and unquestioned craftsmanship. In this particular picture, produced by Bob Roberts for Enterprise, we have a real new talent in the medium, as well as a sizzling piece of work."

BOSLEY CROWTHER, *The New York Times*, December 27, 1948

Abraham Polonsky's *Force of Evil* was by turns stylized and stark, one of the best written, best directed, best acted, and best photographed of the genre.

"*Force of Evil* fails to develop the excitement hinted at in the title. Makers apparently couldn't decide on the best way to present an exposé of the numbers racket, winding up with neither fish nor fowl as far as hard-hitting racketeer meller is concerned. A poetic, almost allegorical, interpretation keeps intruding on the tougher elements of the plot. This factor adds no distinction and only makes the going tougher."

Variety, December 29, 1948

LETTER FROM REGIONAL THEATER OWNER

"No good for my situation. Business below average. No favorable comments."

O. FOMBY, Paula Theatre, Homer, Louisiana, *Motion Picture Herald*, May 23, 1949

ARTIST COMMENT

"I was too inexperienced to invent novel visual images or evoke great performances. And certainly there was nothing in my literary record to suggest a New Voice. All I tried to do was use the succession of visual images, the appearances of human personality in the actors, and the rhythm of words in unison or counterpoint. I varied the speed, intensity, congruence, and conflict for design, emotion, and goal, sometimes separating the three elements, sometimes using two or three together. As for the language, I merely freed it of the burden of literary psychology and the role of crutch to the visual image. Blank verse? No. But the babble of the unconscious, yes, as much as I could, granted the premise that I was committed to a representational film."

ABRAHAM POLONSKY in Andrew Dickos's *Abraham Polonsky: Interviews*

Opposite: Marie Windsor played a racketeer's wife in *Force of Evil*.

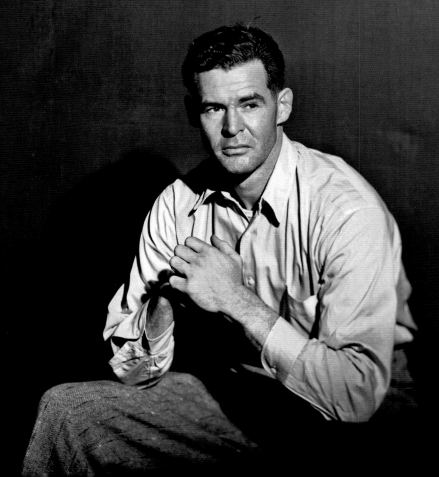

1949

REPORTS ON THE CRIME STORY CYCLE

Robert Ryan played a fading boxer in Robert Wise's *The Set-Up*. Photograph by Ernest Bachrach.

"Despite growing—and, in some quarters, vociferous—reaction against it, 1948 was, like the twelvemonth preceding it, realism's year. We live in a terrifying age, and art follows life, although the reformers would have us believe it's the other way around. It would be well to remember, too, that the late war swept aside sham (in personal if not international relations) and taught us to respect direct action and plain speaking. In short, we got tough. The story of man against society, the villain pursued and punished—the 'gangster,' as a generalization—remains basic A No. 1 cinema stuff. When it's done well—and it usually is—you can't beat it for suspense, vicarious thrills, and at the end, the smug satisfaction ('There, but for the grace of God, go I!') of watching justice vindicated. And, in a long-brewing reaction against phony sets and actors, we have found a new, newsreel, newspaper reality in the semidocumentary technique—actual locations, peopled by men and women whose glamour comes from within, not without."

PHILIP K. SCHEUER, "Movie Realism at Peak," *Los Angeles Times*, December 26, 1948

"In three months I've seen nineteen gangster pictures. Since I left, seven years ago, Hollywood has not made one movie about babies; all they're about is lust, terror, murder, and rape. Is it any wonder that many doctors prescribe 'no movies' because of their possible prenatal influence? Or didn't you know that? The world looks to Hollywood for two hours' relief from its cares. The big guys in the studios have a terrific obligation to all humanity. Yet what do I find? The spirit has gone out of the place. Dry rot is setting in. You are all looking for something on which to blame bad business at the box office—the election, British tax, Italy, inflation, television, even home movies. Anything will do!"

AUTHOR BETH BROWN in Philip K. Scheuer's "Woo Women to Solve Those Box-Office Blues," *Los Angeles Times*, December 12, 1948

"The trouble is that this is a man's age in pictures. There are wonderful stories today dealing powerfully with live topics and issues, and in the most realistic manner, but practically all of them revolve about male characters. Writers seem to follow the trend industriously, turning out spontaneous and even inspired subjects. Yet when they start a script for a feminine star, they face a high barrier of 'don'ts,' mostly linked with sex."

BETTE DAVIS in Edwin Schallert's "Bette Deplores This Man's Age," *Los Angeles Times*, May 22, 1949

"The rugged type of male movie actor is taking over again. He can be homely, play a heel, policeman, stevedore, or prizefighter—and before he knows it, he has become a romantic star. Survey the newer crop of male personalities and you'll find most of them started as rough-and-ready villains. Now they're still rugged but they're winning the girls in their pictures, too. Some examples are Burt Lancaster, Kirk Douglas, Robert Ryan, Paul Douglas, David Brian, Macdonald Carey, Robert Mitchum, and Wendell Corey."

JOHN L. SCOTT, "Tough Guy Finds Romance Tougher," *Los Angeles Times*, December 25, 1949

LOOKING BACK AT FILM NOIR

"I have done many pictures which I suppose are film noir. And I can see the roots of that in *Citizen Kane* and in the lot of the work that many of us did at RKO. But I couldn't have defined it for you, then or now."

ROBERT WISE in Alain Silver, James Ursini, and Robert Porfirio's *Film Noir Reader 3*

CRISS CROSS

UNIVERSAL–INTERNATIONAL PICTURES
RELEASED JANUARY 11, 1949

Producer
MICHAEL KRAIKE

Director
ROBERT SIODMAK

Screenwriter
DANIEL FUCHS

Source
THE DON TRACY NOVEL

Cinematographer
FRANK PLANER

Unit stills photographer
BERT ANDERSON

Stars
BURT LANCASTER • YVONNE DE CARLO
DAN DURYEA

A MAN IS DRAWN TO HIS EX-WIFE, DEFYING HER NEW HUSBAND AND HIS VENGEFUL GANG.

PRODUCTION QUOTE

"Yvonne de Carlo has reached what she considers the high point in her career in *Criss Cross*, the realistic romance prepared by the late Mark Hellinger. She has been pretty smart about promoting her career from a Vancouver dancing class pupil to the actress selected by Mr. Hellinger himself to play the lead in his dramatic film. The strange thing is that Yvonne, anxious to do the picture, questioned Mark repeatedly about when it would be made. He reassured her as often as she asked, but it was not until Mark died that she was called to do the film."

E. J. STRONG, "Yvonne de Carlo May Brave Suspension," *Los Angeles Times*, October 3, 1948

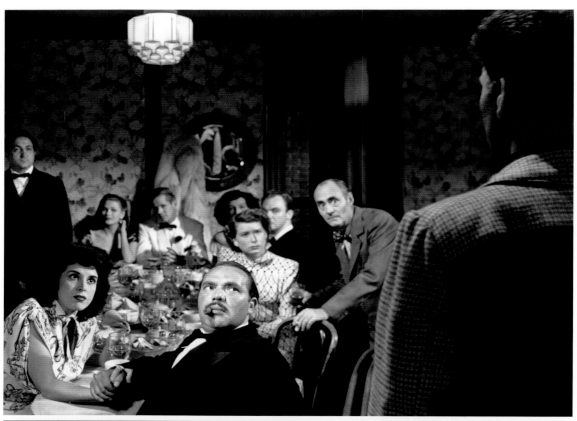

REVIEW

"A tough, mildly exciting melodrama about gangsters and a dame named Anna who 'gets into the blood' of a guy named Steve and causes him no end of trouble, *Criss Cross* is a suspenseful action picture, due to the resourceful directing of Robert Siodmak. But it also is tedious and plodding at times, due partly to Mr. Siodmak's indulgence of a script that is verbose, redundant and imitative. Even though Burt Lancaster starts out as a normal fellow carrying a torch, he eventually gets around to being the same old tough guy of yore. It should not be surprising that his performance is competent, for he has been working at the same type of role for some time. The same may be said of Dan Duryea's interpretation of Slim Dundee."

THOMAS M. PRYOR, *The New York Times*, March 12, 1949

LETTER FROM REGIONAL THEATER OWNER

"If you don't have to play this, then skip it. This certainly is not the kind of entertainment for small-town theatres. Both of the principal stars get killed at the end of the picture."

P. B. WILLIAMS, Gretna Theatre, Gretna, Virginia, *Motion Picture Herald*, March 26, 1949

ARTIST COMMENT

"About a week before shooting was to begin I'd go to the producer and say, 'Look, this is a wonderful script, but there is just one little point,' and I'd then suggest a small but vital alteration. This would be accepted, if only to keep the peace, and then, of course, other things would have to be altered to fit in with it, and gradually the thing would start to come apart at the seams. By the time we started shooting, everything would be so confused that I could begin with no set script at all and could do as I liked, which was the way I wanted it."

ROBERT SIODMAK in John Russell Taylor's "Encounter with Siodmak," *Sight and Sound*, Summer-Autumn, 1959

Opposite top: There is no room at the table for Burt Lancaster in Robert Siodmak's *Criss Cross*.

Opposite bottom: "In *Criss Cross* Yvonne de Carlo is trying something different," wrote Thomas Pryor. "She is Anna, a dangerous dish who wants to have her cake and eat it, too."

Below: A portrait of Yvonne de Carlo and Burt Lancaster made for *Criss Cross* by unit stills photographer Bert Anderson.

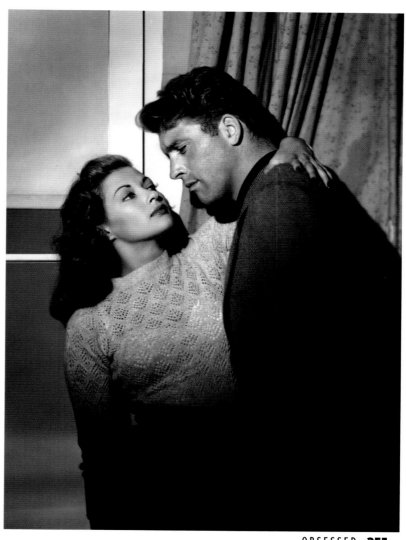

ACT OF VIOLENCE

METRO-GOLDWYN-MAYER
RELEASED JANUARY 22, 1949

Producer
WILLIAM H. WRIGHT

Director
FRED ZINNEMANN

Screenwriter
ROBERT L. RICHARDS

Source
A STORY BY COLLIER YOUNG

Cinematographer
ROBERT SURTEES

Stars
JANET LEIGH
ROBERT RYAN • VAN HEFLIN

A PEACEFUL, HAPPILY MARRIED VET SUDDENLY FINDS HIMSELF HUNTED BY A WAR BUDDY.

PRODUCTION QUOTE

"A year ago, Jerry Wald wanted to make *Act of Violence* but it was sold to Mark Hellinger. Now Metro-Goldwyn-Mayer has bought the story from Hellinger's widow, Gladys Glad, and the Hellinger estate, and has scheduled it for an important production. Bob Ryan has been borrowed from RKO. That's news, what with all the male stars on the Metro lot. Bob plays a flier whose one aim in life is to kill his best friend, after learning the guy has betrayed him."

HEDDA HOPPER, "Looking at Hollywood," *Los Angeles Times*, April 17, 1948

REVIEWS

"*Act of Violence* is strong meat for the heavy drama addicts, tellingly produced and played to develop tight excitement. Heflin and Ryan deliver punchy performances that give substance to the menacing terror. A standout is the brassy, blowzy femme created by Mary Astor, a woman of the streets who gives Heflin shelter during his wild flight from fate."

Variety, December 22, 1948

"*Act of Violence* is sharpened up with extra-special direction and performances by Robert Ryan as the hunter and Van Heflin as the hunted. Ryan's inexorable nemesis and Heflin's remorseful weakling are effective and make one wish they had played a scene together."

OTIS L. GUERNSEY, *New York Herald-Tribune*, January 17, 1949

LETTER FROM REGIONAL THEATER OWNER

"A different type of film which holds interest throughout. Although slow moving in a few spots, it builds to a good climax. Heflin is very popular with the high-school and college students. Old-timer Mary Astor almost steals the picture in a small role. Average business for this type of film. Comments good."

FRANK AYDELETTE, Trail Theatre, Fort Collins, Colorado, *Motion Picture Herald*, April 16, 1949

ARTIST COMMENT

"For two weeks or so I was with the Fred Zinnemann company playing a sleazy, aging whore. I worked out the way this poor alley cat should look, and insisted firmly that the one dress in the picture would not be made at the M-G-M wardrobe, but be found on a rack at the cheapest department store. We made the hem uneven, put a few cigarette burns and some stains on the front. I wore stiletto-heeled slippers with the heels sanded off at the edges to make walking uncom-

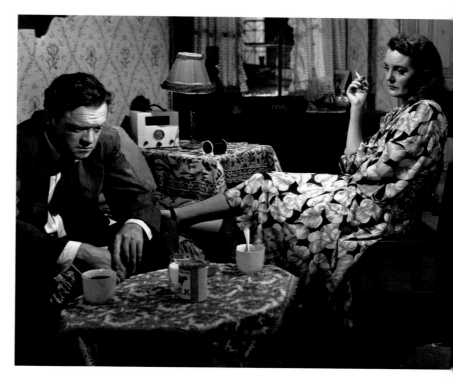

fortable. I wore a fall, a long unbecoming hairpiece that came to my shoulder. I used no foundation makeup, just too much lipstick and too much mascara—both 'bled,' that is, smeared, just a little. And camera helped with bad lighting."

MARY ASTOR, *A Life on Film*

Act of Violence cost $1.29 million. It grossed $1.12 million.

"Where would anybody be if they couldn't get their kicks?" Mary Astor asks Van Heflin in Fred Zinnemann's *Act of Violence*.

CAUGHT

ENTERPRISE STUDIOS
DISTRIBUTED BY METRO-GOLDWYN-MAYER
RELEASED FEBRUARY 17, 1949

Producers
DAVID L. LOEW
WOLFGANG REINHARDT

Director
MAX OPHÜLS (AS MAX OPULS)

Screenwriter
ARTHUR LAURENTS

Source
THE LIBBIE BLOCK NOVEL
WILD CALENDAR

Cinematographer
LEE GARMES

Stars
ROBERT RYAN
BARBARA BEL GEDDES
JAMES MASON

WHEN A MATERIALISTIC WORKING GIRL MARRIES A RECLUSIVE MILLIONAIRE, SHE FINDS HERSELF TRAPPED.

PRODUCTION QUOTES

"Barbara Bel Geddes will play the feminine lead, regarded as a plum role, in *The Luckiest Girl in the World*, which Enterprise Pictures previously called *Wild Calendar*."

"Bel Geddes Deal Settled," *Los Angeles Times*, June 29, 1948

"I'm not going to make a picture from that lousy book *Wild Calendar*. I'm going to make a picture about Howard Hughes. Make him an idiot. An egomaniac. Terrible to women. Also to men. Make him die. Kill him off!"

MAX OPHÜLS in Arthur Laurents's *Original Story By: A Memoir of Broadway and Hollywood*

REVIEWS

"This picture, produced by defunct Enterprise, is a very low-grade dime-store romance, expensively rendered on film. The girl in the case is a cut-out of the most obviously fictitious sort—a car-hop who takes a charm-school brush-up and snags a handsome millionaire. Miss Geddes is just about as touching as the poor little rich girl, torn between a millionaire hubby and a White Knight, as her ilk on the radio. And although Robert Ryan is dynamic as her arrogant, neurotic spouse, he cannot make this

isolated character believable in his gauzy realms. As for James Mason, the popular British actor who makes his Hollywood debut in this film, a more menial job of supporting could not have been wished on him. Now he should know that the females get the plums in Hollywood."

BOSLEY CROWTHER, *The New York Times*, February 18, 1949

"*Caught* is an out-and-out soap opera on film. The performances are top-notch and consistent. The millionaire is better developed than usual in this kind of story. He's a tall, dark man of many business interests, odd hours, playboy tendencies, and a reluctance to wedlock. Robert Ryan plays him to the hilt."

Variety, February 23, 1949

LETTER FROM REGIONAL THEATER OWNER

"I didn't realize my Wednesday-and-Thursday business could get so bad. I knew this type of picture was no good for my type of patronage, but they kept away from it like scarlet fever. Leo, please don't do things like this to us again."

FRED G. WEPPLER, Colonial Theatre, Colfax, Illinois, *Motion Picture Herald*, November 5, 1949

ARTIST COMMENT

"Max Ophüls was very fond of Robert Ryan. He thought that he was a natural human being in front of the camera. And that's what Max wanted in that particular part."

ASSISTANT DIRECTOR ALBERT VAN SCHMUS in Lutz Bacher's *Max Ophuls in the Hollywood Studios*

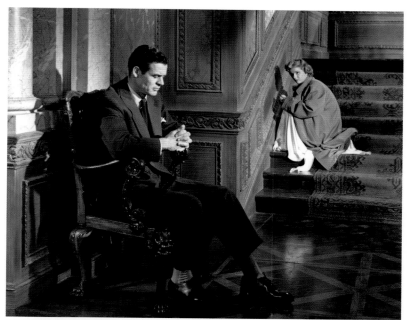

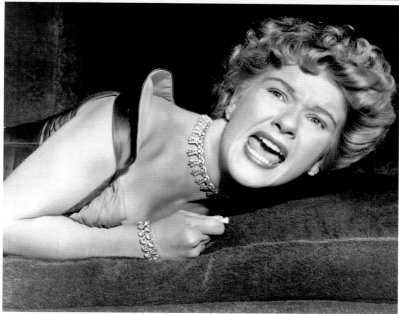

Top: "Although Robert Ryan and Barbara Bel Geddes dominate Max Opuls's *Caught*," wrote Howard Barnes in the *New York Herald-Tribune*, "Ryan is the central character in these proceedings and he knows it. His portrait of a spoiled tycoon is terrifying."

Bottom: Barbara Bel Geddes suffers the torments of marriage to a psychotic millionaire.

IMPACT

CARDINAL PICTURES
DISTRIBUTED BY UNITED ARTISTS
RELEASED MARCH 19, 1949

Producer
LEO C. POPKIN

Director
ARTHUR LUBIN

Screenwriters
JAY DRATLER • DOROTHY REID

Source
A STORY BY JAY DRATLER

Cinematographer
ERNEST LASZLO

Stars
HELEN WALKER
BRIAN DONLEVY • ELLA RAINES

WHEN A MAN IS NEARLY MURDERED BY HIS WIFE AND HER LOVER, HE HIDES OUT WITH A KINDLY FAMILY.

PRODUCTION QUOTE

"I talked to Ella Raines in her dressing room on the set of Cardinal Pictures' *Impact*, which a jokester said should be called *Infirmary*. Miss Raines is working in spite of an illness called mononucleosis, or, in simpler words, gland fever. Brian Donlevy is also ill, suffering from a cold that keeps him in the hospital some nights."

EDWIN SCHALLERT, "Ella Raines Will Sail to Join Mate," *Los Angeles Times*, November 21, 1947

REVIEWS

"To be noted is the fact that advertising plugs are worked into scenes for such products as Pabst Blue Ribbon Beer, Raleigh cigarettes, Coca-Cola, Gruen watches, and Rexall."

"Impact," *Harrison's Reports*, March 20, 1949

"Frankly, your correspondent is past giving credence to yarns about fellows who go through mental torments because their mean wives have tried to bump them off. This fable about one such agonized gent is as lifeless and wretched in its playing as it certainly must have been in the script. As the fellow whose wife has betrayed him and who thereafter moons for quite a spell, Brian Donlevy has all the animation and charm of an automaton. Helen Walker is just about as handsome and just about as blank as an electric refrigerator in the role of his coldly villainous wife. And Ella Raines' performance as the Idaho small-town girl who makes him believe again in women reminds one of that state's most famous crop. The melodramatics in this picture are tediously uninspired."

BOSLEY CROWTHER, *The New York Times*, March 21, 1949

LETTER FROM REGIONAL THEATER OWNER

"This indeed is a very good picture. You should especially invite them and give them passes."

MRS. DENZIL HILDEBRAND, Algerian Theatre, Risco Missouri, *Motion Picture Herald*, May 13, 1950

Helen Walker played a wicked San Franciscan in Arthur Lubin's *Impact*.

THE SET-UP

RKO RADIO PICTURES
RELEASED APRIL 4, 1949

Producer
RICHARD GOLDSTONE

Director
ROBERT WISE

Screenwriter
ART COHN

Source
THE JOSEPH MONCURE MARCH POEM

Cinematographer
MILTON KRASNER

Stars
**ROBERT RYAN • AUDREY TOTTER
JAMES EDWARDS**

AN AGING BOXER RESISTS HIS WIFE'S PLEAS THAT HE RETIRE.

PRODUCTION QUOTE

"Robert Ryan will be coached by former welterweight champion Johnny Indrisano for prizefight scenes in *The Set-Up*, which will go into work in July at RKO."

"Filmland Briefs," *Los Angeles Times*, June 18, 1948

REVIEWS

"The sweaty, stale-smoke atmosphere of an ill-ventilated small-time arena and the ringside types who work themselves into a savage frenzy have been put on the screen in harsh, realistic terms. And the great expectations and shattered hopes which are the drama of the dressing room also have been brought to vivid, throbbing life in the shrewd direction of Robert Wise and the understanding, colloquial dialogue of Art Cohn. The human animal has not changed much from the days of the Roman arena. The squared ring is an area where blood is to be spilled and when it is not the crowd yells its displeasure. There is, we hear, a sporting as well as a seamy side to prize-fighting. It is with these ugly aspects that *The Set-Up* is concerned.

THOMAS M. PRYOR, *The New York Times*, March 30, 1949

Robert Ryan fights Hal Fieberling in *The Set-Up*. Photograph by Ernest Bachrach.

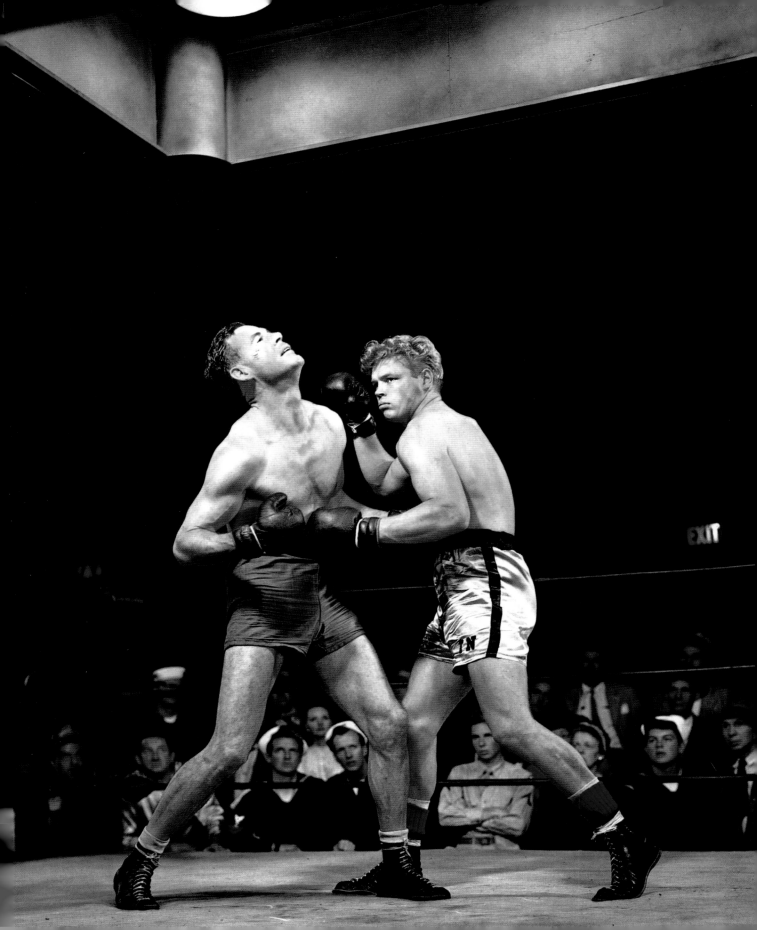

"As a detailed and unrelenting description of small-time prize fighting, *The Set-Up* is an almost perfect job. Robert Ryan, in one of his best performances, plays a shabby, discouraged pug who has made a miserable living in the ring for 20 years. The film is reassurance that there are still craftsmen around the studios."

ROBERT HATCH, "The Set-Up," *New Republic*, April 25, 1949

LETTER FROM REGIONAL THEATER OWNER

"Everybody really liked this one. At first they were bored with too much talk, but liked the fighting. Worthwhile playing anywhere. Business poor because it was not advertised until the day of showing."

JUSTUS BEAL, Memorial Theatre, Wilmington, Alabama, *Motion Picture Herald*, September 10, 1949

ARTIST COMMENTS

"The only interest Howard Hughes had at all in [*The Set-Up*] was who was to play the leading lady. We had originally thought of Joan Blondell. She had done a film called *Nightmare Alley* in which she played Tyrone Power's wife, and she was a little blowzy and very earthy. We had always seen Stoker's wife as wife and mother to him, so we thought that Blondell would be just right. With some trepidation, we threw this idea to Sid Rogell. The next day he called us back and said, 'Here's Hughes's answer to that suggestion: "What's

wrong with those guys? Blondell looks like she was shot out of the wrong end of a cannon."

ROBERT WISE in Sergio Leeman's *Robert Wise on His Films*

"When shooting a fight, the movements are in a sense choreographed. I used three cameras: one covering the whole ring, another covering the two of them, and a handheld camera. I told the operator of the latter, 'Get all the little closeup bits and pieces that you can.' He got some marvelous close shots of gloves hitting and sweat flying off. We spent about a week on it. When it came to editing that sequence, we had so much film that the editor, Roland Gross, couldn't come up with a cut that satisfied me, so I did it myself."

ROBERT WISE in Sergio Leeman's *Robert Wise on His Films*

"Bob Ryan had a real character part as this washed up fighter—and he ran with it. We thought we had a winner [in *The Set-Up*], but Howard Hughes heard there was another boxing picture, *Champion*, going to open. He was determined to beat it, so we opened with no press publicity, and we just died."

AUDREY TOTTER in Charles and Roberta Mitchell's "Versatile Queen of Noir," *Classic Images*

CHAMPION

UNITED ARTISTS
RELEASED APRIL 9, 1949

Producer
STANLEY KRAMER

Director
MARK ROBSON

Screenwriter
CARL FOREMAN

Source
THE RING LARDNER SHORT STORY

Cinematographer
FRANZ PLANER

Unit stills photographer
SCOTTY WELBOURNE

Stars
KIRK DOUGLAS • ARTHUR KENNEDY
MARILYN MAXWELL
RUTH ROMAN

A BOXER USES PEOPLE AND
THEN DISCARDS THEM IN ORDER
TO ACHIEVE THE CHAMPIONSHIP.

PRODUCTION QUOTE

"The subject matter of a picture is everything. I believe that there is a lost tribe of motion-picturegoers, formerly habitual attendees who don't go any more because of the patterns in use today—the costarring teams, the cops and robbers, the lush musicals. They've seen it all. This doesn't mean they want messages. They want stories off the beaten track. To give them such pictures, I intend to use as many of the 'brittle' kind of creative artists as I can—and by 'brittle' I mean sensitive to the type of subject they will handle. I run a great deal to younger people because they don't appear to worry so much about the status quo, the 'past performance' idea."

STANLEY KRAMER in Philip K. Scheuer's "Stanley Kramer's Smash Hits Prove His Fitness to Survive," *Los Angeles Times*, July 17, 1949

REVIEWS

"Fight scenes, under Franz Planer's camera, have realism and impact. Unrelenting pace is set by the opening sequence. Cast, under Mark Robson's tight direction, is fine. Kirk Douglas is the boxer and he makes the character live. Where the Lardner story made the boxer a no-good from the start, Foreman's screenplay casts him as an appealing Joe in the earlier reels. Already stuck with a persecution complex because of his boyhood poverty, it doesn't take long for him to become a real heel."

Variety, March 16, 1949

"*Champion* tells the story of an up-from-the-gutter kid who pushes himself into the prize ring and rises by stepping on heads. He has no compunctions about deceiving the various females he encounters en route, and he eventually double-crosses the mellow manager who helped him on his way. But, at that, he's a mere opportunist in an obviously dog-eat-dog game, and some of his generosities are remarkably noble and correct. He gives his old mother plenty of money, he keeps his crippled brother in fine style—until the latter assaults him in a little conflict over l'amour—and he has the grit and gumption to defy a gang of gamblers and cross them up on a fixed fight. Indeed, he is such a forthright fellow in so many little ways that the intended irony in the title is much thinner than it should be."

BOSLEY CROWTHER, *The New York Times*, April 11, 1949

LETTER FROM REGIONAL THEATER OWNER

"Not as good a picture as the original story, but full of good performances and some excellent shots of action in the ring. Our audiences liked it."

L. F. ADAMS, Tapline Theatre, Vacaville, Colorado, *Motion Picture Herald*, February 11, 1950

ARTIST COMMENT

"Film was a producer's medium at that time. It was not a director's. The producer hired the director to do his vision. He was always on the set, telling the director exactly how he expected everything to be directed. He hired the actors, supervised the editing, the scoring, etc, and he made all the decisions. The producer had the first cut and the final say. But I never financed the entire film myself. They were backed by retired oil men and so forth. I even went to a lettuce grower in Salinas, California, to raise money for *Champion*. While telling him the story, I played all the parts. I played Kirk the boxer. I played Arthur Kennedy his brother. I literally played the picture to convince him. And he invested the money."

STANLEY KRAMER in Leo Verswijver's *Movies Were Always Magical*

Champion cost $568,000, and it grossed $2.5 million.

Opposite: Poster art of Kirk Douglas and Marilyn Maxwell for Mark Robson's *Champion*.

FLAMINGO ROAD

WARNER BROS. PICTURES
RELEASED APRIL 30, 1949

Producer
JERRY WALD

Director
MICHAEL CURTIZ

Screenwriter
ROBERT WILDER, WITH ADDITIONAL
DIALOGUE BY EDMUND H. NORTH

Source
THE SALLY AND ROBERT WILDER
PLAY *FLAMINGO ROAD*

Cinematographer
TED McCORD

Stars
JOAN CRAWFORD
SYDNEY GREENSTREET
ZACHARY SCOTT • DAVID BRIAN

A CARNIVAL GIRL STRANDED IN A SMALL TOWN MAKES AN ENEMY OF A CORRUPT POLITICAL BOSS.

PRODUCTION QUOTE

"Ann Sheridan has talked Jack Warner into buying Robert Wilder's play *Flamingo Road*, the story of a modern clansman who's 'agin' the K.K.K."

HEDDA HOPPER, "Looking at Hollywood," *Los Angeles Times*, October 23, 1946

The Klan element did not appear in the final version of *Flamingo Road*. And Joan Crawford exerted her influence to take the property away from Ann Sheridan.

REVIEWS

"*Flamingo Road* is a class vehicle for Joan Crawford, loaded with heartbreak, romance and stinging violence. Crawford imparts personality shadings ranging from strength to tenderness with a continuous and convincing style. As the heavy, Greenstreet delivers a suavely powerful performance that surmounts an overdrawn role."

Variety, April 6, 1949

"It is fair to state that Joan Crawford has a somewhat unsettled career in *Flamingo Road*. Miss Crawford is a carnival girl, a waitress in a cheap cafe, an inmate of the workhouse, an employee of a sporting resort, the mistress and wife of a political chieftain and, eventually, a jailbird again. Miss Crawford runs this gamut in ninety-four minutes flat, and she isn't even winded. From one dramatic crisis to the next she moves like a sleek automaton. Her face, deeply plastered with makeup, is an ageless, emotionless mask. Adversity only registers now and then in her glycerin-moistened eyes. Hers is a Spartan demonstration of bearing-up-under-it-well."

BOSLEY CROWTHER, *The New York Times*, May 7, 1949

LETTER FROM REGIONAL THEATER OWNER

"Joan Crawford is no Box Office Queen in this small town, but we had nothing but good comments on this one. Business unfortunately was off."

S. W. BOOTH, Booth Theatre, Rich Hill, Missouri, *Motion Picture Herald*, September 3, 1949

Flamingo Road cost $1.52 million. It grossed $2.89 million. Some film histories describe *Humoresque*, *Possessed*, and *Flamingo Road* as "flops." According to studio records, they were among the top-grossing Warner Bros. films in their respective years of release.

In Michael Curtiz's *Flamingo Road*, Joan Crawford essayed the role of a carnival girl who moves up in the world through an alliance with a powerful contractor, David Brian. "Miss Crawford's speech is perhaps too cultured for a 'cooch-wiggler,' wrote Christopher Vane, 'but the minute she slings a mink across her back, you're with the Crawford you know and understand.'"

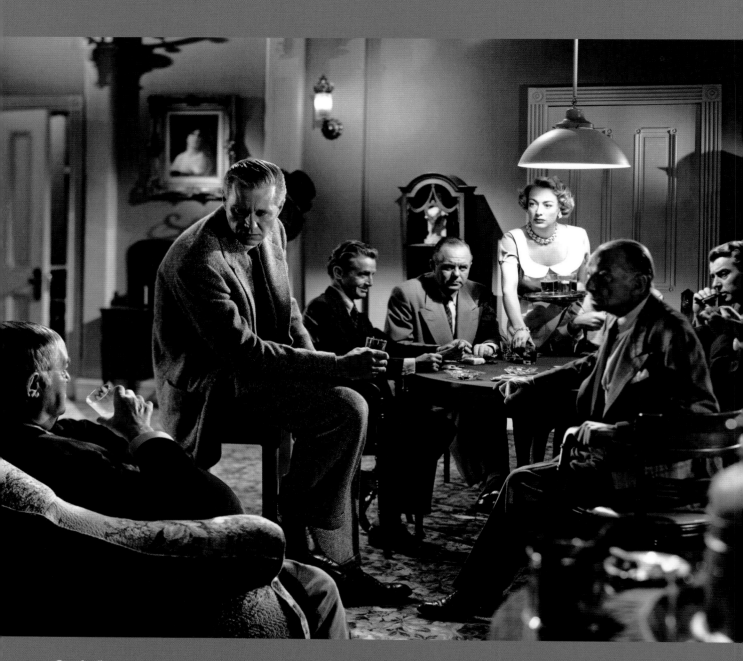

Crawford's nemesis is a corrupt—and corrupting—political boss played by Sydney Greenstreet. Ted McCord's lighting brings a Rembrandt touch to a film noir subject.

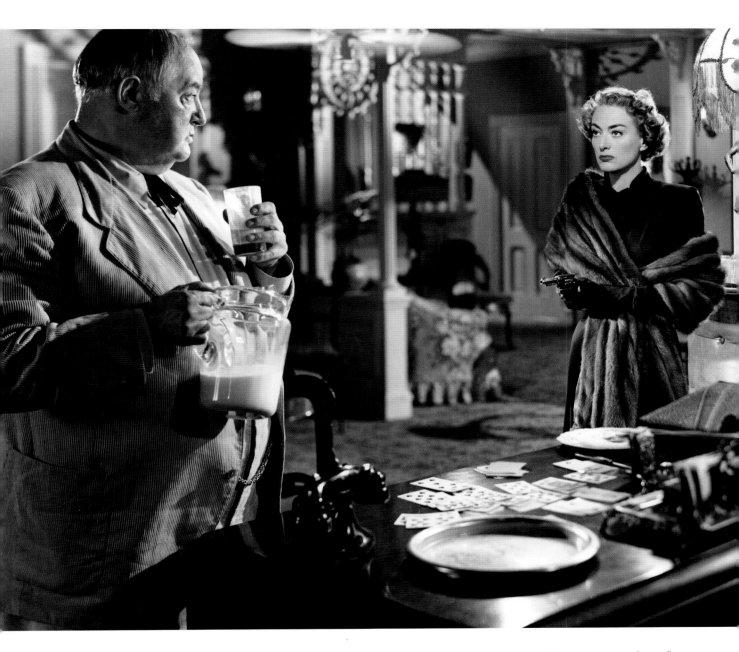

"I'm going to crucify you," says the milk-swilling villain, so the outsider has no choice but to defend herself.

THE WINDOW

RKO RADIO PICTURES
RELEASED MAY 17, 1949

WHEN A BOY WHO HABITUALLY MAKES UP STORIES ACTUALLY WITNESSES A MURDER, NO ONE WILL BELIEVE HIM.

PRODUCTION QUOTE

"My only intention was to make as interesting and believable a picture as possible with the background we had. People don't want 'pretty' pictures any more. They want natural, realistic ones."

TED TETZLAFF in Philip K. Scheuer's "Tetzlaff Scores as Director," *Los Angeles Times*, October 24, 1948

Producer
FREDERIC ULLMAN JR.

Director
TED TETZLAFF

Screenwriter
MEL DINELLI

Source
THE CORNELL WOOLRICH SHORT STORY
"THE BOY CRIED MURDER"

Cinematographers
WILLIAM STEINER • ROBERT DE GRASSE

Unit stills photographer
OLLIE SIGURDSON

Stars
BOBBY DRISCOLL
RUTH ROMAN • PAUL STEWART
BARBARA HALE • ARTHUR KENNEDY

REVIEW

"The mounting terror of a young boy who lives in mortal fear of his life is projected with remarkable verisimilitude by 12-year-old Bobby Driscoll in *The Window*. The striking force and terrifying impact of this melodrama is chiefly due to Bobby's brilliant acting, for the whole effect would have been lost were there any suspicion of doubt about the credibility of this pivotal character. Although Ted Tetzlaff's direction is not always as restrained as might be desired, he has not permitted any of several increasingly harrowing incidents to spoil the full, crushing force of the picture's climax, when the boy is trapped on a high beam in an abandoned house on the verge of collapse. There is such an acute expression of peril etched on the boy's face that one experiences an overwhelming anxiety for his safety."

THOMAS M. PRYOR, *The New York Times*, August 8, 1949

LETTER FROM REGIONAL THEATER OWNER

"Here is a sleeper that might be sold for some extra business. It is one of the most suspenseful pictures we've seen in a long time. It puts you out on the edge of your seat and never lets you sit back. Small children were scared too much—even though we advertised it as not recommended for small children."

W. FRANK AYDELOTTE, Trail Theatre, Fort Collins, Colorado, *Motion Picture Herald*, September 17, 1949

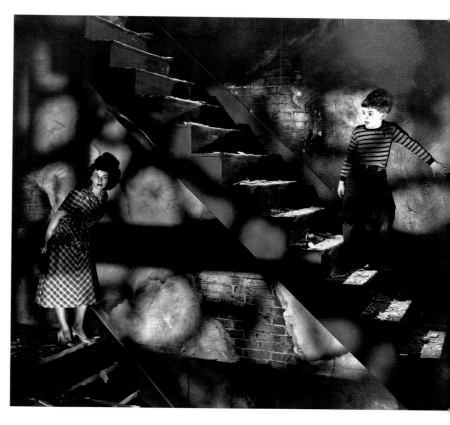

ARTIST COMMENT

"We had to wear long underwear and take quick breaths so that the vaporous mists didn't show up on the screen. During the part where they were running on the rooftops, the water would accumulate and form icy patches. They had to do many takes at this point because people kept slipping and falling."

BARBARA HALE in Jim Foster's "The Window," *Classic Images*, December 2014

In this scene from *The Window*, murderess Ruth Roman tracks witness Bobby Driscoll to an abandoned tenement. The film was adapted from a Cornell Woolrich novel and directed by Ted Tetzlaff, a former cinematographer, partly on location in New York. Thanks to him and to its young star, the film was a hit and later gained a reputation as a noir masterpiece.

WHITE HEAT

WARNER BROS. PICTURES
RELEASED SEPTEMBER 3, 1949

Producer
LOUIS F. EDELMAN

Director
RAOUL WALSH

Screenwriters
IVAN GOFF • BEN ROBERTS

Source
A STORY BY VIRGINIA KELLOGG

Cinematographer
SID HICKOX

Stars
JAMES CAGNEY
EDMOND O'BRIEN • STEVE COCHRAN
VIRGINIA MAYO

AN INSANE KILLER AND HIS MOTHER RUN A GANG OF ROBBERS ON A COLLISION COURSE WITH THE LAW.

PRODUCTION QUOTE

"The Warners executives wanted to do a gangster story. So we thought about it and we synthesized Ma Barker down to having the one son instead of four, and we put the evil of all four into one man. Then we went back and said, 'We'd like to do Ma Barker and have the gangster with a mother complex and play it against Freudian implications that she's driving him to do these things, and he's driving himself to self-destruction. Play it like a Greek tragedy.' They said, 'Fellas . . . ?' We said, 'Believe us, it will work. And there's only one man who can play this and make the rafters rock. That is Jimmy Cagney.'"

BEN ROBERTS in Patrick McGilligan's
White Heat

REVIEWS

"The tight-lipped scowl, the hunched shoulders that rear themselves for the kill, the gargoyle speech, the belching gunfire of a trigger-happy paranoiac—one with a mother complex, no less—these are the standard and still-popular ingredients that constitute the James Cagney of *White Heat*. All that is missing is the grapefruit in a dame's physiog."

Variety, August 31, 1949

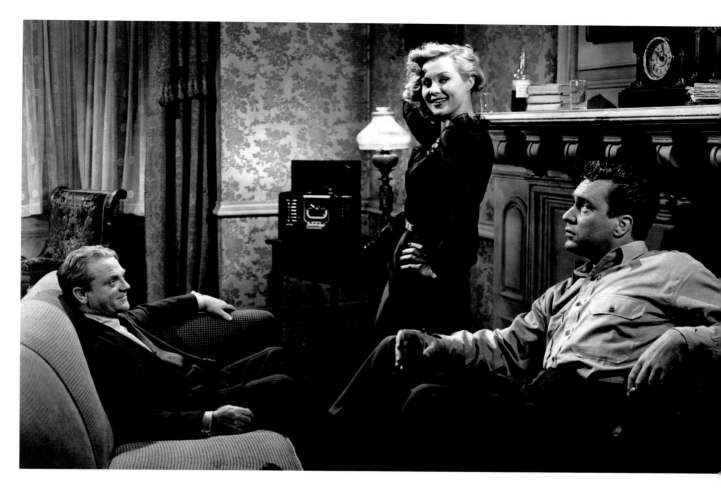

"If you think Mr. Cagney looked brutal when he punched Mae Clark in the face with a ripe grapefruit in *Public Enemy*, you should see the sweet and loving things he does to handsome Virginia Mayo, who plays his low-grade wife in *White Heat*," so wrote Bosley Crowther; this scene includes Edmond O'Brien.

"Warner Brothers weren't kidding when they put the title *White Heat* on the new James Cagney picture. They might have gone several points higher in the verbal caloric scale and still have understated the thermal intensity of this film. For the simple fact is that Mr. Cagney has made his return to a gangster role in one of the most explosive pictures that he or anyone has ever played. If that is inviting information to the cohorts of thriller fans, let us soberly warn that *White Heat* is also a cruelly vicious film and that its impact upon the emotions of the unstable or impressionable is incalculable. Indeed, as

the ruthless gang leader in this furious and frightening account of train-robbery, prison-break, gang war, and gun fighting with the police, Mr. Cagney achieves the fascination of a brilliant bullfighter at work, deftly engaged in the business of doing violence with economy and grace. His movements are supple and electric, his words are as swift and sharp as swords, and his whole manner carries the conviction of confidence, courage, and power."

BOSLEY CROWTHER, *The New York Times*, September 3, 1949

"Any review of *White Heat* should properly be written in 'scareheads and exclamation points.' This picture is what they call in the trade an exploitation film, for it exploits the return of Jimmy Cagney to: (1) gangsterism; and (2) Warner Bros. For additional exploitation he is costarred with Virginia Mayo. Together they spell box office. Cagney plays Cody Jarrett, who is described with singular understatement as a 'gang leader, a braggart, and a homicidal paranoiac with a mother fixation.' Yes, sirreee, Cody is some guy. He kicks chairs out from under his gal, shoots people down in cold blood, and kicks a corpse downstairs with a merry 'Catch!' to his buddies. That's our boy, and there is no moral justification for him—and no viewpoint more profound than that of the customers sitting more or less bug-eyed in theater seats at the Warners Hollywood, the Downtown, and the Wiltern."

PHILIP K. SCHEUER, "James Cagney Comes Back," *Los Angeles Times*, September 3, 1949

LETTER FROM REGIONAL THEATER OWNER

"This one certainly smells. Don't they have any censorship of pictures anymore? It should never have been passed. Average at the box office."

Valley Theatre, El Paso, Texas, *Motion Picture Herald*, January 7, 1950

ARTIST COMMENT

"I didn't have to psych myself up for the scene in which I go berserk on learning of my mother's death. You don't psych yourself up for those things. You do them. I knew what deranged people sounded like. As a youngster I had visited Ward's Island. A pal's uncle was in the hospital for the insane. My God, what an education that was. The shrieks. The screams of those people under restraint. I remembered those cries. I saw that they fit the scene. I called on my memory to do as required. No need to 'psych up.'"

JAMES CAGNEY, *Cagney by Cagney*

THIEVES' HIGHWAY

TWENTIETH CENTURY–FOX
RELEASED SEPTEMBER 20, 1949

Producer
ROBERT BASSLER

Director
JULES DASSIN

Screenwriter
A. I. BEZZERIDES

Source
THE A. I. BEZZERIDES NOVEL
THIEVES' MARKET

Cinematographer
NORBERT BRODINE

Stars
RICHARD CONTE • LEE J. COBB
VALENTINA CORTESA

WHEN A MAN FINDS HIS FATHER MAIMED BY A CORRUPT PRODUCE DEALER, HE VOWS TO AVENGE HIM.

REVIEWS

"Script stresses realism and Jules Dassin's direction carries out that emphasis in no-holds-barred love sequences between Richard Conte and Hollywood newcomer Valentina Cortesa."

Variety, September 7, 1949

"The Golden Apples of Hesperides have nothing on two loads of Fresno Golden Delicious when it comes to stirring up trouble. The loads are being trucked to San Francisco by Richard Conte and Millard Mitchell. These men drive by night and by day, too. Conte makes it; Mitchell does not. And like most movies that move in more or less of a straight line, this one comes through with flying colors. It's tough, cruel, and plenty rugged; a bit overcrowded with coincidence, perhaps, but told with a camera that pushes right in there where it will do the most good and held to an on-the-spot intensity when it reaches an unbearable pitch in the depiction of a careening truck in which the brakes have gone out."

PHILIP K. SCHEUER, "Brakes Off for Conte in Careening Saga," *Los Angeles Times*, September 21, 1949

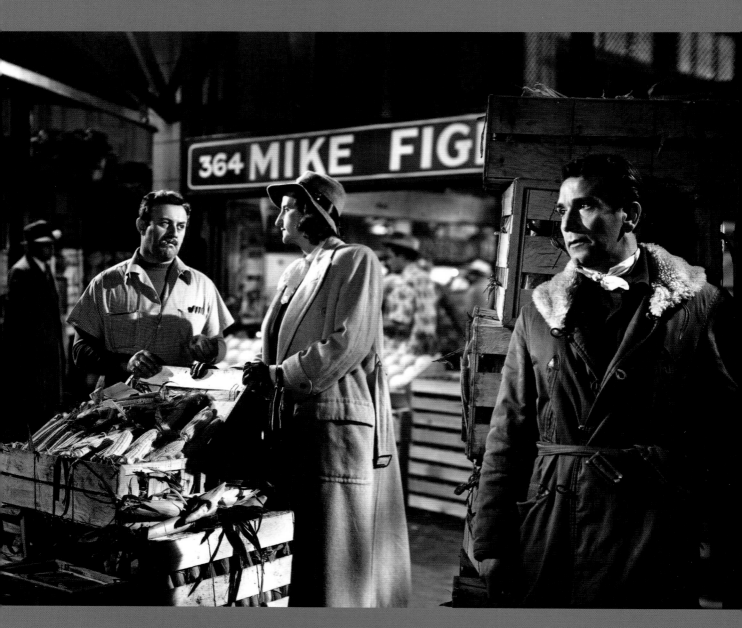

Lee J. Cobb, Hope Emerson, and Richard Conte in one of the many tense scenes in Anthony Mann's *Thieves' Highway*, a film noir that was as polished photographically as it was realistic.

"You'd never imagine what a fellow has to go through to earn a buck in the supposedly mundane business of trucking fruits and vegetables—not, that is, until you've witnessed the pounding an honest truckman gets in this vigorous dramatization of one full day in a truck driver's life. Mr. Dassin has got the look and 'feel' of people and places in the produce world. You can almost sense the strain of trucking and smell the crated fruit. More than that, he has got the excitement and the tension of commerce today."

BOSLEY CROWTHER, *The New York Times*, September 24, 1949

LETTER FROM REGIONAL THEATER OWNER

"Good action film with Lee J. Cobb and Valentina Cortesa in supporting roles. The scenes of the San Francisco locale were enjoyed, especially by our California customers."

L. F. ADAMS, Tapline Theatre, Ras el Misha'ah, Saudi Arabia, *Motion Picture Herald*, December 9, 1950

ARTIST COMMENT

"Fox bought a novel of mine, *Thieves' Market*. They didn't want to use the original title because San Francisco objected to it. So, it became *Thieves' Highway*. I said okay. Then the director, Julie Dassin, says, 'For the prostitute, I want Valentina Cortesa, so rewrite it for her.' He was going with her. We were going to have Shelley Winters, who would have been perfect. But I rewrote it. And we go to the meeting with Zanuck. The first thing Zanuck says is, 'I want a new beginning. I want the father still alive. He's crippled. That's why the kid's trucking.' Now in my story the father is dead at the beginning. The kid starts trucking because he's trying to make his father's life valid. I only knew that story from my life. But that didn't matter. I said, 'Yes, Mr. Zanuck.' I wrote another beginning. So the picture didn't do real well. Oh, I tell you, once you give in a little bit, you're finished."

A. I. BEZZERIDES in Lee Server's *Screenwriter: Words Become Pictures*

BEYOND THE FOREST

WARNER BROS. PICTURES
RELEASED OCTOBER 21, 1949

Producer
HENRY BLANKE

Director
KING VIDOR

Screenwriter
LENORE COFFEE

Source
THE STUART ENGSTRAND NOVEL

Cinematographer
ROBERT BURKS

Unit stills photographer
EUGENE RICHEE

Stars
**BETTE DAVIS • JOSEPH COTTEN
DAVID BRIAN • RUTH ROMAN
DONA DRAKE**

WORKING TITLE: ROSE MOLINE

A WOMAN PLOTS TO ESCAPE
HER SMALL-TOWN LIFE AND
BECOME THE MISTRESS OF A RICH
MAN IN A BIG CITY.

PRODUCTION QUOTES

"This morning I told Lew Wasserman, Bette Davis's agent, over the telephone that she said she will not do *Rose Moline*. In view of this situation, I told Wasserman to give me the maximum settlement she would make on her contract, which she could pay us over two years."

JACK L. WARNER, memo to legal counsel Roy Obringer, May 3, 1949, in Rudy Behlmer's *Inside Warner Bros.*

"Following a meeting yesterday between Jack L. Warner and Bette Davis, it was announced that the filming of *Rose Moline* will begin on May 16. Miss Davis will report to the studio for wardrobe tests tomorrow. King Vidor is now directing location scenes at Loyalton, California. Joseph Cotten is leaving for Loyalton tonight."

"Movieland Briefs," *Los Angeles Times*, May 5, 1949

"Bette Davis didn't want to do *Beyond the Forest* but was talked into it against her will—and that's a strong will to talk against. She realizes now she should have kept refusing. Bette Davis has been the fall guy for *Beyond the Forest*."

HEDDA HOPPER, "Think It Over," *Los Angeles Times*, November 4, 1949

REVIEWS

"Of all the no-good women that Bette Davis has portrayed in her numerous elaborate demonstrations of the deadliness of the female sex, she has never done any more unpleasant nor more grotesque than the creature she plays in *Beyond the Forest*. This time she's not only a mean one: she's a callous and calculated fiend whose flamboyant selfishness and cruelties are on a virtually extra-human plane. As a matter of fact, she is so monstrous— so ghoulishly picturesque—that her representation often slips off into laughable caricature. We cannot imagine that King Vidor, her director, desired this, but we strongly suspect that he was working to make her look just as vicious as he could. He has harshened and uglified Miss Davis so that she's as repulsive as a witch in a cartoon."

BOSLEY CROWTHER, *The New York Times*, October 22, 1949

"King Vidor's having his onscreen lovers quickly change from hate to passion got a laugh from the audience, just as it did in *The Fountainhead*. It's ticklish stuff even at its best—which this is not."

PHILIP K. SCHEUER, "*Beyond the Forest* Dissects Life of Vicious Woman," *Los Angeles Times*, November 10, 1949

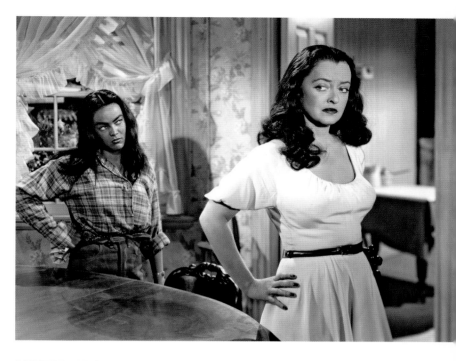

LETTER FROM REGIONAL THEATER OWNER

"I did see *Beyond the Forest*. For only the third time in my entire career as a picture exhibitor, I walked out. In my belief, the picture's box-office poison."

H. A. COLE, Allied Theatre Owners, Dallas Texas, *Independent Exhibitors Film Bulletin*, January 2, 1950

"Bette Davis, in a long black wig for *Beyond the Forest*, is trying to get away from herself," wrote Hedda Hopper. "I scarcely recognized her. 'No matter how long you're an actress, says Bette, 'you never really feel like one until you get that pancake on.'" Here is Bette, feeling like an actress as she plays a small-town housewife obsessed with escape. Dona Drake plays her ill-mannered maid.

ARTIST COMMENTS

"Warner Brothers wouldn't cooperate with us on the Code cuts we wanted in *Beyond the Forest*. They said it was too late to rescore and remix the music behind the dialogue and the shots we wanted them to cut out. We had to threaten them with the $25,000 fine. Well, it turned out that it *was* too late. So we came up with a plan so that the cuts could be made and the film be printed in time for the metropolitan exhibitors.

"We first had the editor cut the shots that implied that the woman was seeking an abortion. They replaced the shot of the doctor's office with a shot of the door in a legal office, to show that she was seeking a divorce, not an abortion.

"Then we made them reshoot a closeup of Bette Davis where she says 'I hope I die.' We made them add: 'And burn.' So that the character admits that she's doing wrong and will pay for it. (I heard later that she had abrogated her contract with the studio and this retake was the last thing she ever did there.)

"Finally we got a small commercial outfit to shoot a preface—which as I recall, Geoff Shurlock wrote. This was to tell them that the woman was immoral, since there was no voice for morality in the film as it stood. Warners reluctantly made these changes and released the film, jump cuts and all. You can see them and hear them. This was, to my best recollection, the only real crisis we had in what you call the 'film noir' period."

Retired Production Code administrator Jack Vizzard to the author, January 27, 1998

"King Vidor, who directed *Beyond the Forest*, told me that he could not remember a less rewarding moment in his long and historic life behind the camera. The picture was a low point in Bette Davis's career, which she has acknowledged with her usual candor. As for me, I will admit to having stumbled into several trash bins, but never such an important trash bin."

JOSEPH COTTEN, *Vanity Will Get You Somewhere*

"Billy Wilder liked *Beyond the Forest*. He told me that he'd seen it three or four times. He talked a lot about the symbolism for the last scene."

KING VIDOR in Nancy Dowd and David Shepard's *King Vidor*

"The line 'What a dump' is the only claim to fame that *Beyond the Forest* has or ever will have."

BETTE DAVIS in Whitney Stine's *Mother Goddam*

This 1974 prophecy proved to be inaccurate. *Beyond the Forest* has been recognized as an important film noir.

This is the story of evil. Evil is headstrong — is puffed up. For our soul's sake, it is salutary for us to view it in all its naked ugliness once in a while. Thus may we know how those who deliver themselves over to it, end up like the Scorpion, in a mad fury stinging themselves to eternal death.

Left: Revival audiences have long been mystified by the jump cuts in *Beyond the Forest*. In 1998, the author interviewed a retired PCA censor named Jack Vizzard, and he explained them (see Artist Comments).

Right: *Beyond the Forest* was reviled and derided upon its release. Nonetheless, its place in the film noir pantheon is secure. There is no other film like it. Photograph by Eugene Richee.

BORDER INCIDENT

METRO-GOLDWYN-MAYER
RELEASED OCTOBER 28, 1949

Producer
NICHOLAS NAYFACK

Director
ANTHONY MANN

Screenwriter
JOHN C. HIGGINS

Source
THE STORY BY GEORGE ZUCKERMAN
AND JOHN C. HIGGINS

Cinematographer
JOHN ALTON

Stars
RICARDO MONTALBAN
GEORGE MURPHY • CHARLES McGRAW
HOWARD DA SILVA

WORKING TITLE: WETBACKS

A MEXICAN AGENT AND AN
AMERICAN AGENT ROOT OUT
THE CRIMINALS WHO EXPLOIT
BRACEROS CROSSING THE BORDER.

PRODUCTION QUOTE

"Bryan Foy, of Eagle-Lion, is following
up his successful *T-Men* with another
picture connected with the treasury
department. It's called *Wetbacks* and
deals with the smuggling of aliens
across the Mexican border. Title
comes from the fact that the aliens
often have to swim the Rio Grande."

HEDDA HOPPER, "Looking at Hollywood," *Los
Angeles Times*, January 14, 1948

REVIEWS

"Unlikely as it may seem at first glance,
Border Incident bears the M-G-M
imprimatur. Anthony Mann, John
Alton, and John C. Higgins have
wisely refrained from giving it the
well-known Metro glamour treatment.
Far from being prettied up, this is as
ugly, brutal, and compelling stuff as
Leo ever roared and shook his
uncomprehending mane at."

PHILIP K. SCHEUER, "*Incident* Top-Notch
Thriller," *Los Angeles Times*, October 29, 1949

Ricardo Montalban played a Mexican Federal
agent in Anthony Mann's *Border Incident*.

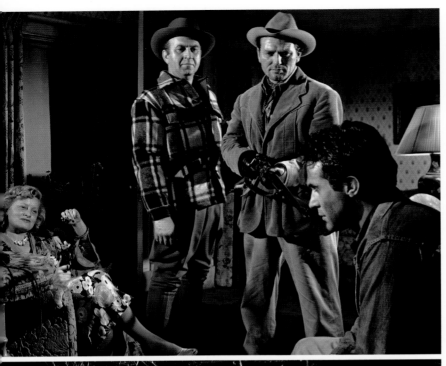

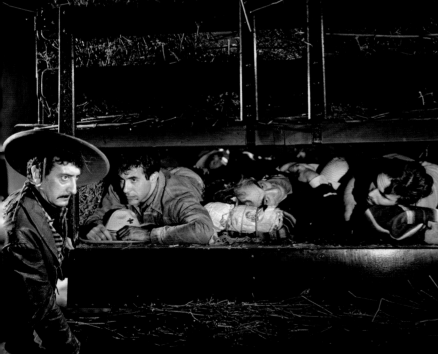

Top: *Border Incident* pits undercover agent Ricardo Montalban against border criminals who are exploiting and killing immigrants. In this scene he is trapped by Lynn Whitney, Howard da Silva, and Charles McGraw.

Bottom: Arnold Moss hides Ricardo Montalban in a truck carrying *braceros*.

"Produced on a modest budget, pic wraps a conventional yarn within a semi-documentary casing. *Border Incident* opens strongly with a depiction of the plight of Mexican laborers who annually migrate north for work on U.S. farms. Filmed on location, this section has an authentic quality and impact. When the plot, however, switches to tracking down a ring of border-running racketeers, the film unfortunately takes on the unconvincing flavor of an old-fashioned melodrama."

Variety, November 30, 1949

ARTIST COMMENT

"I had more freedom on *Border Incident* at Metro because they didn't know what kind of animal I was."

ANTHONY MANN in Max Alvarez's *The Crime Films of Anthony Mann*

Border Incident cost $741,000.

THEY LIVE BY NIGHT

RKO RADIO PICTURES
RELEASED NOVEMBER 3, 1949

Producer
JOHN HOUSEMAN

Director
NICHOLAS RAY

Screenwriter
CHARLES SCHNEE, FROM
AN ADAPTATION BY NICHOLAS RAY

Source
THE EDWARD ANDERSON NOVEL
THIEVES LIKE US

Cinematographer
GEORGE E. DISKANT

Unit stills photographer
OLLIE SIGURDSON

Stars
FARLEY GRANGER • CATHY O'DONNELL
HOWARD DA SILVA

WORKING TITLE: *YOUR RED WAGON*

TWO YOUNG OUTCASTS FALL IN LOVE WHILE THE POLICE CLOSE IN.

PRODUCTION QUOTE

"When Sam Goldwyn saw his two players, Cathy O'Donnell and Farley Granger, in *Your Red Wagon*, he said, 'I wouldn't sell their contracts for $1 million. No! Not for $2 million! They are the greatest romantic team since Vilma Banky and Ronald Colman!'"

HEDDA HOPPER, "The Song's the Thing," *Los Angeles Times*, October 28, 1947

Both actors would later describe Goldwyn's management of their careers as ruinous.

REVIEW

"A commonplace little story about a young escaped convict on the lam and his romance with a nice girl whom he picks up and marries is told with pictorial sincerity and uncommon emotional thrust in *They Live by Night*. Although it—like others—is misguided in its sympathies for a youthful crook, this crime-and-compassion melodrama has the virtues of vigor and restraint. As the young bandit, Farley Granger gives a genuine sense of nervous strain and is wistful and appealing in his brave approach to a piteous romance. Cathy O'Donnell is sincerely affecting as his drab but intense little bride, and Ian Wolfe is disturbingly shifty as a marrying parson in a Texas town."

BOSLEY CROWTHER, *The New York Times*, November 4, 1949

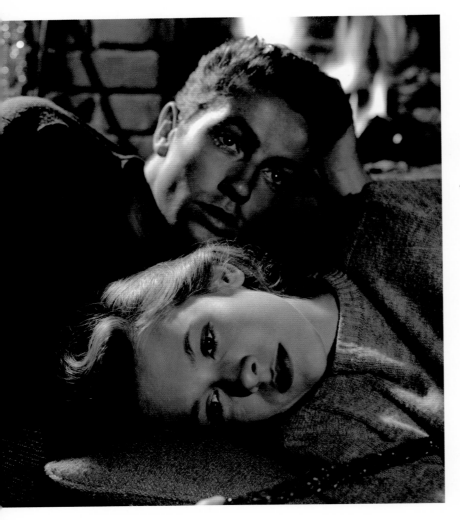

Farley Granger and Cathy O'Donnell are newlyweds on the run in Nicholas Ray's *They Live by Night*. Like many films of the 1940s, *They Live by Night* sat on a shelf for a year before it was released and was then acclaimed for its darkly poetic vision. Portrait by Ernest Bachrach.

LETTER FROM REGIONAL THEATER OWNER

"Quite a few bobbysoxers turned out to squeal over Farley Granger, who shows considerable promise, but at the moment is beyond his depth and unconvincing as a pathetically wronged gangster. The picture is beautifully produced but drags along at a deadly slow pace to an ending which could have come in less than ninety-five minutes."

WILLIAM HAYDEN, Vacaville Theatre, Vacaville, California, *Motion Picture Herald*, April 22, 1950

ARTIST COMMENT

"We were almost through shooting *Your Red Wagon* when we learned that Howard Hughes was taking over RKO and Dore Schary was going to M-G-M. I don't think anyone was terribly surprised to open *Daily Variety* and read that Hughes had shelved our film. Two years later it opened as *They Live by Night* in a small London art house. The English critics loved it. Soon after, RKO released it in the States, where it received excellent reviews."

FARLEY GRANGER, *Include Me Out*

WHIRLPOOL

TWENTIETH CENTURY–FOX
RELEASED NOVEMBER 28, 1949

Producer-director
OTTO PREMINGER

Screenwriters
BEN HECHT • ANDREW SOLT

Source
**THE GUY ENDORE NOVEL
METHINKS THE LADY**

Cinematographer
ARTHUR MILLER

Stars
**GENE TIERNEY • JOSE FERRER
RICHARD CONTE
BARBARA O'NEIL**

A SELF-PROCLAIMED MASTER OF HYPNOSIS PROPOSES TO CURE A PROMINENT WOMAN OF KLEPTOMANIA.

PRODUCTION QUOTE

"Charles Bickford gets a costarring role in *Whirlpool*. He plays a cop who studies psychology. Looks to me like the picture's going to be *The Snake Pit* with murder. Gene Tierney plays a psycho; Richard Conte, her psychiatrist husband; and Jose Ferrer, a hypnotist."

HEDDA HOPPER, "Widmark Mature Star," *Los Angeles Times*, May 28, 1949

REVIEWS

"*Whirlpool* is a highly entertaining, exciting melodrama that combines the authentic features of hypnosis. Ben Hecht and Andrew Solt have tightly woven a screenplay about the effects of hypnosis on the subconscious, but they, and Otto Preminger in his direction, have eliminated the phoney characteristics that might easily have allowed the picture to slither into becoming just another eerie melodrama."

Variety, November 23, 1949

Gene Tierney is a
disturbed socialite in Otto
Preminger's *Whirlpool*.

"There is no doubt that people will do strange things under hypnotic spell and that the techniques of hypnotism may be villainously employed. But you don't catch this fairly rational corner accepting this obvious attempt to pull the wool over the eyes of an unsuspecting audience with a thoroughly fabricated tale written by Ben Hecht and Andrew Solt. Jose Ferrer, the Broadway champion, is the smooth and piercing villain of the piece who mouths Mr. Hecht's silken phrases with acid savor and burns folks with his eyes. Furthermore, haughty Gene Tierney plays the lady who is slightly off the track. All together, with several others, they labor to cast a spell. But their efforts are bleakly artificial. You'd better see this one in a state of trance."

BOSLEY CROWTHER, *The New York Times*, January 14, 1950

LETTER FROM REGIONAL THEATER OWNER

"No good for rural or small communities. Acting splendid, especially Jose Ferrer. Why do they continue making those psycho pictures? They really don't go over. Didn't make expenses."

E. J. BUNNELL, Crist Theatre, Loveland, Ohio, *Motion Picture Herald*, April 8, 1950

ARTIST COMMENTS

"Otto Preminger and Darryl Zanuck hoped that *Whirlpool*, which is like a sequel to *Laura*—it had the same star, the same mood and atmosphere—would have the same success."

JOSE FERRER in Foster Hirsch's *Otto Preminger: The Man Who Would Be King*

THE RECKLESS MOMENT

COLUMBIA PICTURES
RELEASED DECEMBER 29, 1949

Producer
WALTER WANGER

Director
MAX OPHÜLS (AS MAX OPULS)

Screenwriters
HENRY GARSON, ROBERT W. SODERBERG, FROM AN ADAPTATION BY MEL DINELLI AND ROBERT E. KENT

Source
THE ELISABETH SANXAY HOLDING SHORT STORY "THE BLANK WALL"

Cinematographer
BURNETT GUFFEY

Stars
JOAN BENNETT • JAMES MASON

WHEN A WOMAN COVERS UP A MURDER SHE THINKS HER DAUGHTER COMMITTED, SHE FALLS PREY TO A SUAVE BLACKMAILER.

PRODUCTION QUOTE

"A shot that does not call for tracks
Is agony for poor, dear Max.
Once, when they took away his crane,
I thought he'd never smile again."

JAMES MASON on-the-set poem, in Wheeler Winston Dixon and Gwendolyn Audrey Foster's *A Short History of Film*

REVIEWS

"James Mason seems perversely attracted to pictures in which he can make delayed entrances and to roles that are morbid but partially redeemed by a touch of the poetic vagabond."

PHILIP K. SCHEUER, "Odd Man Role Falls to Mason," *Los Angeles Times*, December 2, 1949

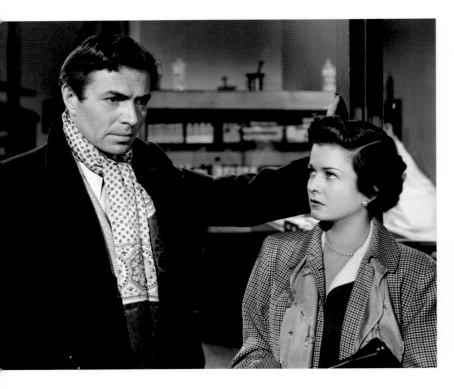

Above: James Mason sympathizes with blackmail victim Joan Bennett in Walter Wanger's production of *The Reckless Moment*, which was directed by Max Ophüls.

Opposite: *The Reckless Moment* was Joan Bennett's last film noir outing, but it was a memorable swan song.

"The heroine of *The Reckless Moment* is a Balboa, Calif., lady who gets herself into a slight jam while her husband, a footloose bridge builder, is away in Germany. It seems that among her many problems of running a comfortable home is one of removing the body of a no-good fellow whom she thinks her daughter has killed. She doesn't like dead men lying around. So she casually loads the body into a motor boat and lugs it off to an island where she hopes it will not be found. This, of course, is her indiscretion—her reckless moment—for not only is the body found by the police, but a blackmailer who, deeply touched by the lady, her beauty and her plight, falls in love, makes a sacrificial gesture and takes the blame for the supposed murder ere he dies. Thus Miss Bennett is able to phone her husband on Christmas Eve and tell him not to worry, that everything is all right at home. Maybe it is with that lady. Maybe she doesn't mind having done a completely stupid and plainly unprincipled thing. But it isn't all right with this picture. The heroine gets away with folly. We don't think this picture will."

BOSLEY CROWTHER, *The New York Times*, December 30, 1949

ARTIST COMMENT

"Walter Wanger was a man who always wanted to be European. He didn't know how to be European, but he wanted to be, so *The Reckless Moment* was rather the kind of film—like *Brief Encounter*, I suppose—that he would try to make. But it wasn't very good."

JAMES MASON in Rui Nogueira's "James Mason," *Focus on Film 2* (March–April 1970)

The Reckless Moment cost $882,653. It grossed $717,188. The film was very poorly marketed by Columbia, which resulted in its being seen by almost no one in this country. After a period of years it was adopted by art and revival houses because of Max Ophüls's growing reputation and was acknowledged as a superior film noir.

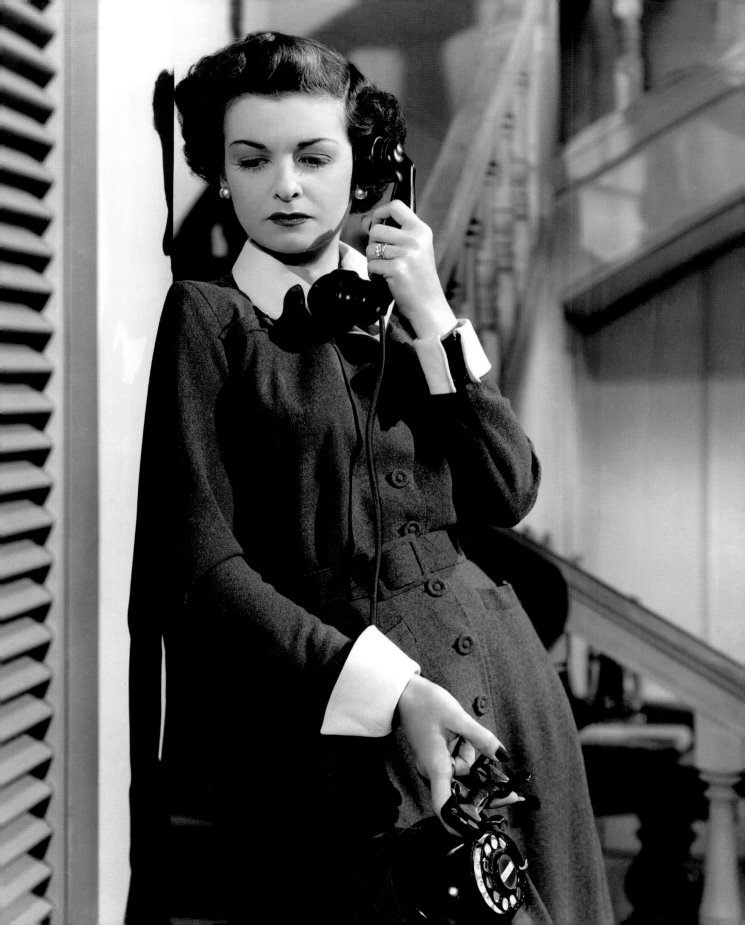

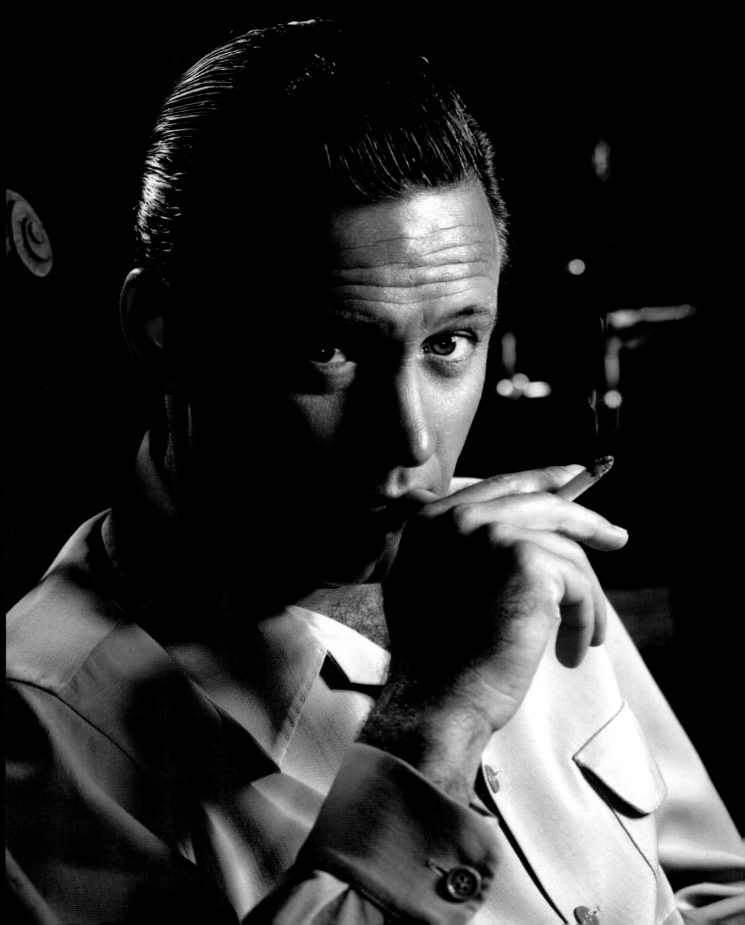

CHAPTER 5

———

Doomed

———

(1950)

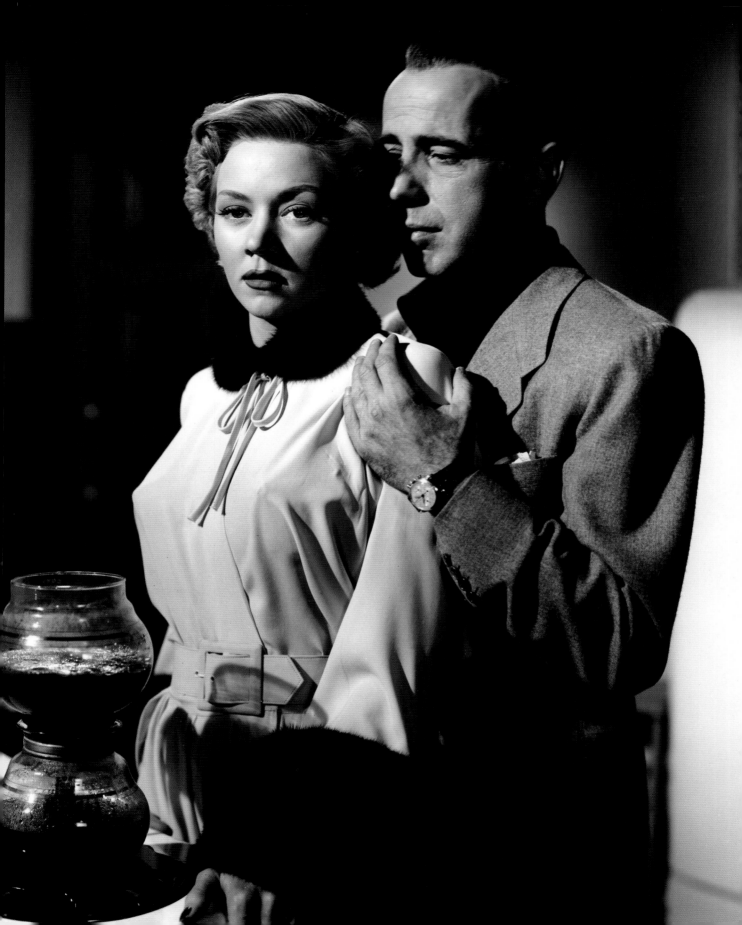

1950

REPORT ON THE BOX-OFFICE CYCLE

"It's a man's world—on the screen. In the *Motion Picture Herald's* annual poll of exhibitors, Bob Hope edged out Bing Crosby as the top money-making star for 1949. Crosby had held the place for five successive years. Abbott and Costello held third place as they did in 1948. John Wayne, Gary Cooper, and Cary Grant were next. Whether you look at the girls as box-office or artistic favorites, those girls have been slipping: only four femmes make the first 25 'Money-Making Stars.' Two—Betty Grable and Esther Williams—are among the Top 10, in seventh and eighth places, respectively. The other two are Loretta Young, No. 15, and June Allyson, No. 16. During the war, women succeeded in holding nearly half the *Herald*'s list. Weekly *Variety* was able to muster only seven frails for its roster of 25—and these only after slapping on a precautionary heading: 'Subject Matter Again Prime Factor in Pix Stars Achieving Top Rating.' Who is to say, for instance, how much Jeanne Crain contributed to the $4.2-million gross of *Pinky*—or whether it was purely subject matter—and to what degree Elia Kazan's direction and Darryl F. Zanuck's production counted?

"In an attempt to get at the 'why' of this deplorable condition, I consulted with three directors. The question I put to each went something like this: Today's screen is a masculine screen. To what do you attribute it? War, the aftermath of war, the influence of documentaries, the hard-boiled cycle, lack of training or of opportunity for actresses—or what?"

CLARENCE BROWN:

"During the war, there was a dearth of males; there has been a superabundance ever since. Producers choose stories with them in mind. The girls just have to fall in behind. At one time everything had to give way in order to keep them beautiful. They even died beautifully. Now they die with rings under their eyes and no makeup!"

GEORGE CUKOR:

"It's economics. The slattern is up for awards because she reflects the times. Chivalry is dead. We have a different kind of 'tortured' girl. Instead of inhabiting a boudoir, she hangs on bars—cocktail or prison. There are no kept women any more, at least in the old gay-life sense. And there are no mysterious vampires who wreck homes. They are all Freudian now!

"In Arthurian times, woman was worshipped. She was the queen and the man was on his knees. In the Victorian era, she was the protected one. Now she works and demands absolute equality. The kind of woman we saw around us in years past does not exist

p. 298: A Bud Fraker portrait of William Holden, costar of Billy Wilder's Sunset Boulevard.

A scene still of Humphrey Bogart and Gloria Grahame in Nicholas Ray's film, In a Lonely Place.

in life, so she cannot exist on the screen. It would be fraudulent to put a woman on the screen as a character we don't know.

"However, we lose sight of the fact that the very serious actresses—Garbo, Hepburn, Lillian Gish—were not top box office. Shearer and Crawford were, yes, but they were exceptions. Box office only indicates who has a successful picture, not who is a really great star. Anyway, these things run in cycles. I think the romantic love story is trying to come back."

EDMUND GOULDING:

"Blame the producer's fear of costly flops. He is disinclined to invest his money in an actress's performance. He no longer seems to have the time or patience to give the woman story the added work and care it requires. It has been easier to set several strong men at each other's throats and throw a little girl in there for seasoning.

"The successful subjects in the past were contrived for specific actresses, embracing their special ability to dress, weep, lure, commit, confess, come home to die or disappear into the crowd. In the last few years writing costs have made producers wary of such speculation, so they wait for books and plays of proven success, yet there are not enough to supply female star talent; hence the lack of performances by women. Too, the producer fears to trust a big emotional role to a newcomer; a bad guess is too costly. And the older and standard girls too often turn down roles because they think that, by the attempt to seem younger, they will only emphasize their age on the screen!

"As for the writers, they're tired of submitting original woman stories because the femme fatale cliché is grounds for comedy today to the younger audience. The female in the tabloids gives a better performance. Soon, however, the producer must get back to his women, as Irving Thalberg did in his series with Shearer, Garbo, and Crawford; as Paramount did years ago with Swanson, Dietrich, and Carole Lombard; as Warners did with Bette Davis—*All This and Heaven Too* still holds the record for his firm—and as Hal Wallis and Anatole Litvak did with *Sorry, Wrong Number*—and cleaned up!"

PHILIP K. SCHEUER, "Will Feminine Stars Regain Film Favor?" *Los Angeles Times*, January 22, 1950

The trend to male stars, whether as cause or effect, can be seen in the film noir genre, although major successes with female stars—Gloria Swanson, Joan Crawford, Jane Russell, and Barbara Stanwyck—reflected the momentary comeback that could be seen in other genres; e.g., Bette Davis in *All About Eve*, Katharine Hepburn in *Adam's Rib*, and Vivien Leigh in *A Streetcar Named Desire*. By the end of 1950, though, it was obvious that the era of the big-budget crime-and-detective melodrama—what we call film noir—was ending.

LOOKING BACK AT FILM NOIR

"Any director who says he didn't gain something from *Citizen Kane* is either a damn fool or is not telling the truth. I ran that film fifty times, a hundred times, and if you want to call that stealing, fine. If you want to call it absorbing, fine. Maybe I took nothing from it, only the thought."

JOSEPH H. LEWIS in Alain Silver, James Ursini, and Robert Porfirio's *Film Noir Reader 3*

GUN CRAZY

A KING BROS. PRODUCTION
DISTRIBUTED BY UNITED ARTISTS
RELEASED JANUARY 20, 1950

Producers
MAURICE KING • FRANK KING

Director
JOSEPH H. LEWIS

Screenwriters
**MACKINLAY KANTOR • DALTON TRUMBO
MILLARD KAUFMAN**

Source
THE MACKINLAY KANTOR SHORT STORY

Cinematographer
RUSSELL HARLAN

Unit stills photographer
EDDIE JONES

Stars
JOHN DALL • PEGGY CUMMINS

WORKING TITLE: *DEADLY IS THE FEMALE*

A YOUNG MAN WHO IS OBSESSED WITH FIREARMS MEETS A YOUNG WOMAN WHO IS TRIGGER HAPPY.

REVIEWS

"*Gun Crazy* is not a pleasant story, but John Dall builds some sympathy as the male. Opposite him is Peggy Cummins, a sideshow Annie Oakley without morals. She is not too convincing. Script points up the physical attraction between Dall and Cummins but, despite the emphasis, it is curiously cold and lacking in genuine emotions. Fault is in the writing and direction, both staying on the surface and never getting underneath the characters."

Variety, November 2, 1949

"Even with some adroit camouflaging, *Gun Crazy* is basically on a par with the most humdrum pulp fiction. The main drawbacks are the stars them-selves, who look more like fugitives from a 4-H Club than from the law. Just why two such clean-cut young-sters as Peggy Cummins and John Dall should be so cast is something for the Sphinx, but they certainly give it the works. . . . At the risk of being drilled between the eyes by one of these sureshots, we must say that it takes more than crime and the King Brothers to make sows' ears out of silk purses."

BOSLEY CROWTHER, *The New York Times*, August 25, 1950

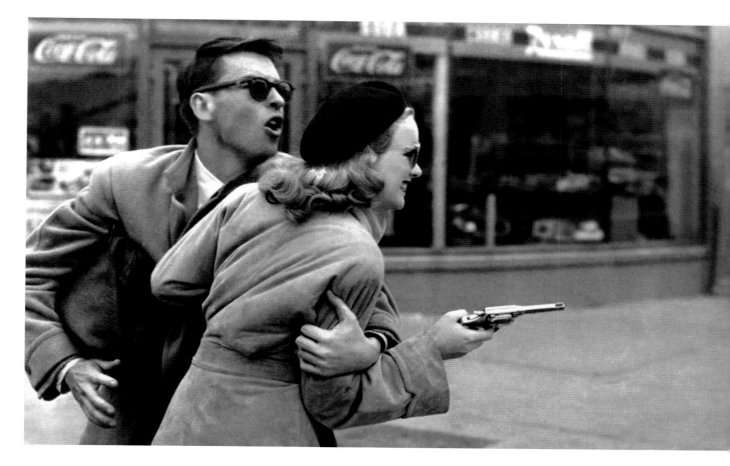

LETTER FROM REGIONAL THEATER OWNER

"A very outstanding program for a little picture. Play it."

MRS. DENZIL HILDEBRAND, Algerian Theatre, Risco, Missouri, *Motion Picture Herald*, July 22, 1950

ARTIST COMMENT

"I wanted to build a genuine love story of two criminals who couldn't possibly lead a proper life. And who could judge them at the end as criminals who should die? The audience. But I wanted the audience to root for them, right from the beginning. And I believe that this possibility was captured beautifully by the performances of Peggy Cummins and John Dall."

JOSEPH H. LEWIS in Alain Silver, James Ursini, and Robert Porfirio's *Film Noir Reader 3*

In this image, the unit stills photographer caught the essence of the film.

THE FILE ON THELMA JORDON

**PARAMOUNT PICTURES
RELEASED JANUARY 18, 1950**

Producer
HAL WALLIS

Director
ROBERT SIODMAK

Screenwriter
KETTI FRINGS

Source
THE MARTY HOLLAND SHORT STORY

Cinematographer
GEORGE BARNES

Stars
**BARBARA STANWYCK
WENDELL COREY**

AS A MARRIED DISTRICT ATTORNEY GETS INVOLVED WITH A WOMAN, HE IS PULLED INTO HER MURDEROUS PLOT.

PRODUCTION QUOTE

"Marty Holland, who wrote *Fallen Angel* and *Glass Heart*, has sold her newest novel to Hal Wallis. *The File on Thelma Jordon* is a story of crime in Los Angeles and a prosecuting attorney who falls in love with a girl accused of murdering her wealthy aunt. Barbara Stanwyck should star in the picture."

HEDDA HOPPER, "Looking at Hollywood," *Los Angeles Times*, September 1, 1948

REVIEWS

"*Thelma Jordon* unfolds as an interesting, femme-slanted melodrama, told with a lot of restrained excitement."

"The File on Thelma Jordon," *Variety*, November 2, 1949

"Centering around the mad infatuation of a misguided assistant district attorney, married and a father, for a beautiful but wicked woman, this melodrama shapes up as a spottily suspenseful film of limited appeal. The theme is distasteful and the characters are unsympathetic, and some of the sequences are so long-drawn-out that they will cause the audience to squirm in their seats."

Harrison's Reports, November 5, 1949

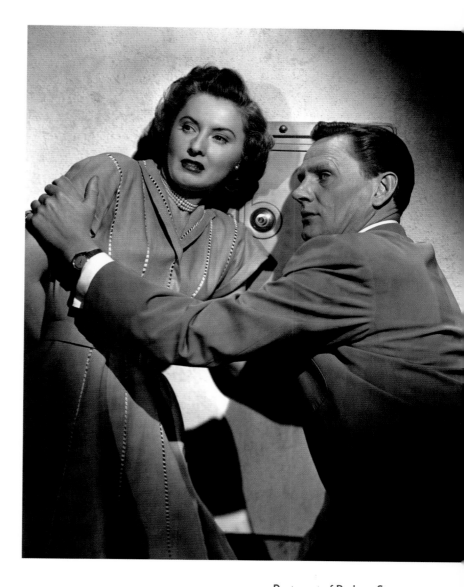

LETTER FROM REGIONAL THEATER OWNER

"The suds flew thick and fast. The women wept and loved it. A heavy-handed 'psycho' murder drama with emphasis on sex. It turned in a very satisfactory two days midweek, so I'd be a fool to complain even though I've seen Stanwyck 'pant' through similar roles several times before."

WILLIAM HAYDEN, Vacaville Theatre, Vacaville, California, *Motion Picture Herald*, May 27, 1950

ARTIST COMMENT

"Barbara always had the character completely worked out. She would be sitting in her chair, her eyes closed, and her concentration on the scene she was to play. She never even looked in the mirror. Completely absorbed in her work, she would go without a word in front of the camera."

ROBERT SIODMAK in Ella Smith's *Starring Miss Barbara Stanwyck*

Poster art of Barbara Stanwyck and Wendell Corey from Robert Siodmak's *The File on Thelma Jordon*.

D.O.A.

CARDINAL PICTURES
DISTRIBUTED BY UNITED ARTISTS
RELEASED APRIL 21, 1950

Producer
LEO C. POPKIN

Director
RUDOLPH MATÉ

Screenwriters
CLARENCE GREENE • RUSSELL ROUSE

Cinematographer
ERNEST LASZLO

Unit stills photographer
FRANK TANNER

Stars
**EDMOND O'BRIEN • PAMELA BRITTON
LUTHER ADLER**

A MAN WHO HAS BEEN POISONED HAS TO FIND THE CRIMINAL WHO DID IT BEFORE THE TOXIN TAKES FULL EFFECT.

REVIEWS

"*D.O.A.* poses the novel twist of having a man looking for his own murderer. That off-beat idea and a strong performance by Edmond O'Brien do a lot to hold it together. But script is difficult to follow and doesn't get into its real meat until about 35 minutes of footage have passed. Rudolph Maté's direction of the first portion of the story lingers too long over it, spreading the expectancy very thin, but when he does launch his suspense-building, it comes over with a solid wallop."

Variety, December 28, 1949

"For all practical purposes, Frank Bigelow is as good as dead when he stumbles into Los Angeles Police Headquarters to unfold a fantastic tale about his own murder. Bigelow is a victim of 'luminous poison,' for which there is no antidote, and hence the producers of the film took as their title *D.O.A.*, this being an abbreviation of a police term meaning 'dead on arrival.' It is perhaps entirely natural for a man to want to know why he has been poisoned, so in the few days left to him on earth Bigelow undertakes some remarkable sleuthing to discover the reasons for his impending demise. Edmond O'Brien puts a good deal of drive into his performance as the unfortunate Mr. Bigelow. Pamela Britton, as his secretary-fiancée, adds a pleasant touch of blonde attractiveness, but the way she keeps hounding the poor fellow to express his affection is disconcerting. For all their efforts, however, *D.O.A.* adds up to only a mild divertissement."

BOSLEY CROWTHER, "Melodrama Opens at Criterion," *The New York Times*, May 1, 1950

LETTER FROM REGIONAL THEATER OWNER

"Good picture for a double bill. It is different. Average business. Small town patronage."

TOM POULOS, Paonia Theatre, Paonia, Colorado, *Motion Picture Herald*, June 16, 1951

In Rudolph Maté's *D.O.A.*, Edmond O'Brien's diagnosis sets the plot in motion.

THE DAMNED DON'T CRY

WARNER BROS. PICTURES
RELEASED MAY 13, 1950

A WOMAN USES UNDERWORLD FIGURES TO CLIMB FROM LOWER-CLASS MISERY TO A LIFE OF WEALTH.

PRODUCTION QUOTE

"Frank and Nancy Sinatra's home in Palm Springs will be in *The Victim*, and Joan Crawford will live in it while shooting there."

HEDDA HOPPER, "Wellman Discovers John Pershing III," *Los Angeles Times*, October 10, 1949

Producer
JERRY WALD

Director
VINCENT SHERMAN

Screenwriters
HAROLD MEDFORD • JEROME WEIDMAN

Source
THE GERTRUDE WALKER STORY
"CASE HISTORY"

Cinematographer
TED MCCORD

Stars
JOAN CRAWFORD
STEVE COCHRAN
DAVID BRIAN • KENT SMITH
RICHARD EGAN

WORKING TITLE: *THE VICTIM*

REVIEW

"Take the old true-confession formula, slick it up with some synthetic 'class,' top it with gangster-film violence, and you have yourself a notion of this show. Joan Crawford runs the routine of cheap motion-picture dramatics in her latter-day hard-boiled, deadpan style. As a laborer's wife, she plays it without makeup and with her face heavily greased (although fake eyelashes are still retained as a customary embellishment of a laborer's wife). As a clothes model, she speaks the tough guy's line and looks the mere men squarely and coldly in the face. And as the ultimately cultivated 'lady,' she gives it the lofty dignity that goes with champagne buckets and Palm Springs pools. A more artificial lot of acting could hardly be achieved. However, the men who support her run her a very close race. When David Brian comes to a line such as, 'I like a woman who has brains, but when she also has spirit, that excites me,' he virtually ends it with a lecherous 'Hey-hey!' Vincent Sherman's direction is as specious as the script."

BOSLEY CROWTHER, *The New York Times*, April 8, 1950

In Vincent Sherman's *The Damned Don't* Cry, Joan Crawford gives her mentor (Jacqueline de Wit) a lesson in arithmetic.

LETTER FROM REGIONAL THEATER OWNER

"In spite of intense heat and a pre-holiday weekend, this held up very well. The title is both intriguing and misleading; the trailer and advertising definitely sell the picture short. It is a very good gangster story that really packs a wallop and is especially timely with the current craze for underworld investigations."

WILLIAM HAYDEN, Vacaville Theatre, Vacaville, California, *Motion Picture Herald*, July 22, 1950

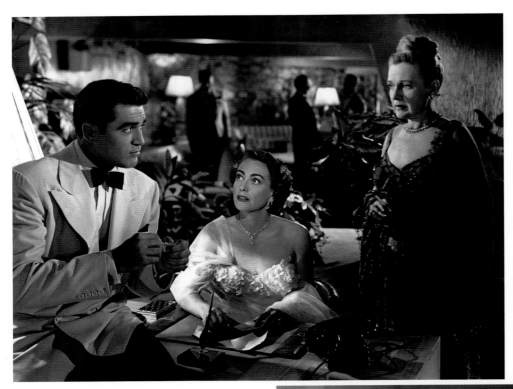

Left: Selena Royle has transformed Joan Crawford from low-class Ethel Whitehead to classy Lorna Hansen Forbes, but gangster Steve Cochran is suspicious.

Below: Steve Cochran and Joan Crawford strike black-and-white sparks in *The Damned Don't Cry*.

Opposite: *The Damned Don't Cry* combines the Joan Crawford formula with the film noir formula, so her glamorous ascendance has to be paid for.

ARTIST COMMENT

"*The Damned Don't Cry* captured the drive of an ambitious woman to improve her life while she is still young enough to attract men, but she ignores the cost and finally comes to grief. It also explored the gangster element in our society, being the first film to touch on the Virginia Hill-Bugsy Siegel romance and tragedy."

VINCENT SHERMAN, *Studio Affairs*

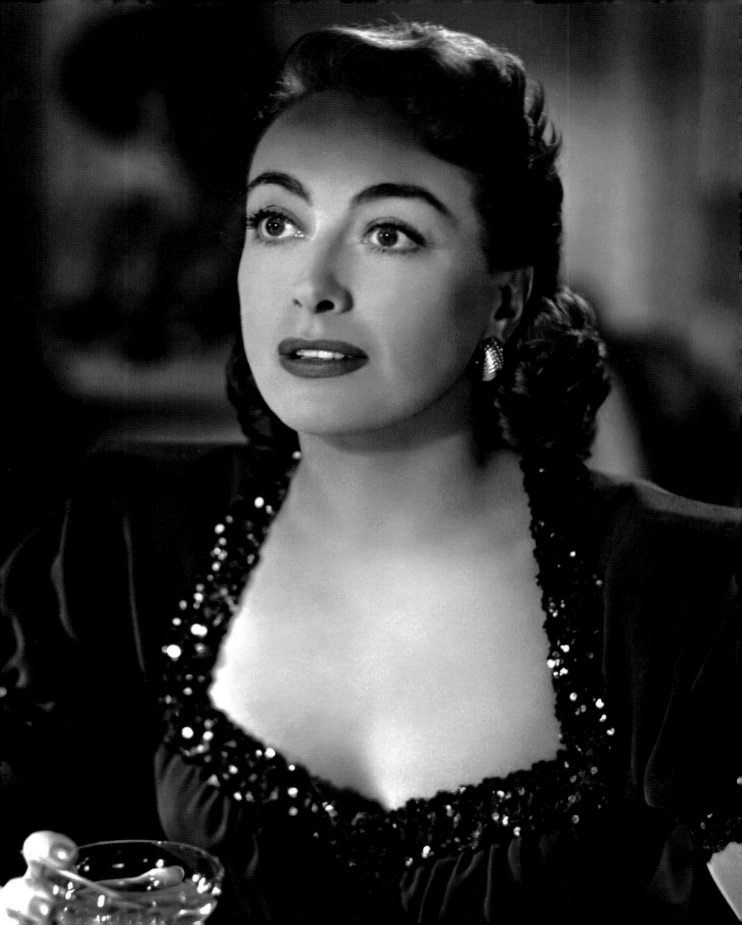

IN A LONELY PLACE

SANTANA PICTURES PRODUCTION
COLUMBIA PICTURES
RELEASED MAY 17, 1950

Producer
ROBERT LORD

Director
NICHOLAS RAY

Screenwriters
DOROTHY B. HUGHES
ANDREW SOLT • EDMUND NORTH

Source
THE DOROTHY B. HUGHES NOVEL

Cinematographer
BURNETT GUFFEY

Stars
HUMPHREY BOGART
GLORIA GRAHAME • FRANK LOVEJOY

WORKING TITLE: *BEHIND THIS MASK*

A TROUBLED SCREENWRITER BECOMES INVOLVED WITH A TRUSTING GIRL WHILE SUSPECTED OF MURDER.

PRODUCTION QUOTE

"I believe in daring things. That is what really makes show business, what insures showmanship. I don't believe in wasting an 'A' effort on a 'C' story. You must have a solid, and if possible, a provocative subject, one that is off the beaten track. I feel that this picture, which we started as *In a Lonely Place* but which is now *Behind This Mask*, provides a fine opportunity, and Bogart is a wonderful star to work with. I directed Gloria Grahame before we were married, in *A Woman's Secret*, so this is not an altogether new experience."

NICHOLAS RAY in Edwin Schallert's "Special Agreement," *Los Angeles Times*, December 4, 1949

"Humphrey Bogart has a sympathetic role, though cast as one always ready to mix it with his dukes. As the screenplay scrivener who detests the potboilers, Bogart is excellent. He favors the underdog; in one instance he virtually has a veteran, brandy-soaking character actor (out of work) on his very limited payroll. Director Nicholas Ray maintains nice suspense. Gloria Grahame, as his romance, also rates kudos."

Variety, December 28, 1949

"Humphrey Bogart is in top form in his latest independently made production, and the picture itself is a superior cut of melodrama. Playing a violent, quick-tempered Hollywood movie writer suspected of murder, Mr. Bogart looms large on the screen and moves flawlessly through a script which is almost as flinty as the actor himself. Andrew Solt, who fashioned the screenplay, makes no attempt to psychoanalyze Steele and neither does Mr. Bogart, but the actor plays with such terrific drive that one is content not to pick apart the characterization. Thus Dixon Steele remains as much of an enigma, an explosive, contradictory force at loose ends when the film ends as when it starts. *In a Lonely Place* comes off a dandy film."

BOSLEY CROWTHER, *The New York Times*, May 18, 1950

Nicholas Ray's *In a Lonely Place* presents Hollywood as a place where insiders become outsiders without warning. Faded star Robert Warwick can hold court because alienated screenwriter Humphrey Bogart is buying his drinks. Agent Art Smith and actress Gloria Grahame innocently enjoy the scene.

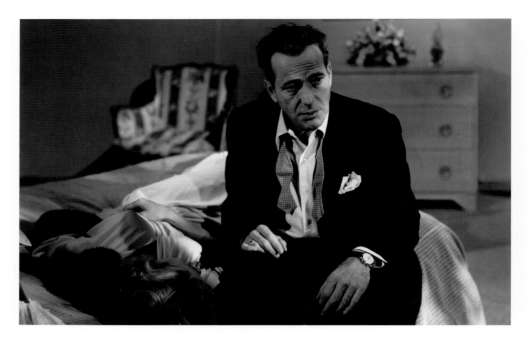

Because Humphrey Bogart was producing his own vehicles, he could try complex, unpleasant roles.

Opposite: The troubled writer spoils a pleasant outing; (l. to r.) Frank Lovejoy, Jeff Donnell, Humphrey Bogart, Gloria Grahame.

LETTER FROM REGIONAL THEATER OWNER

"The surprise ending was certainly a disappointment, and as a result it certainly fell off after the first night. One of the few movies I've played that people actually walked out on after seeing less than half of the picture. Stilted corn! Can't seem to get anything decent from Columbia that pays off at the box office."

LESTER E. SIEGEL, Jamestown Theatre, Jamestown, Rhode Island, *Motion Picture Herald*, October 21, 1950

ARTIST COMMENT

"*In a Lonely Place* was a very personal film for me. I tried to treat Hollywood the way I would a Pennsylvania cattle town. In Beaver, Pennsylvania, the same things happen as in Hollywood. In the first draft of the screenplay that I wrote with Bundy Solt, the end of the film was more clearly stated. Dixon kills Laurel and the detective arrests him. But I didn't like that ending. So I kicked everyone off the set, except for the actors, and we improvised the ending. We don't know exactly what it means. It's the end of their love, of course. But Dixon could also drive his car off a cliff, stop over in a bar and get drunk, or else go home to his old mother. Anything is possible. It's left to the imagination of the audience."

NICHOLAS RAY in Kathryn Bigelow and Sarah Fatima Parsons's "The Last Interview," nicholasrayfoundation.org

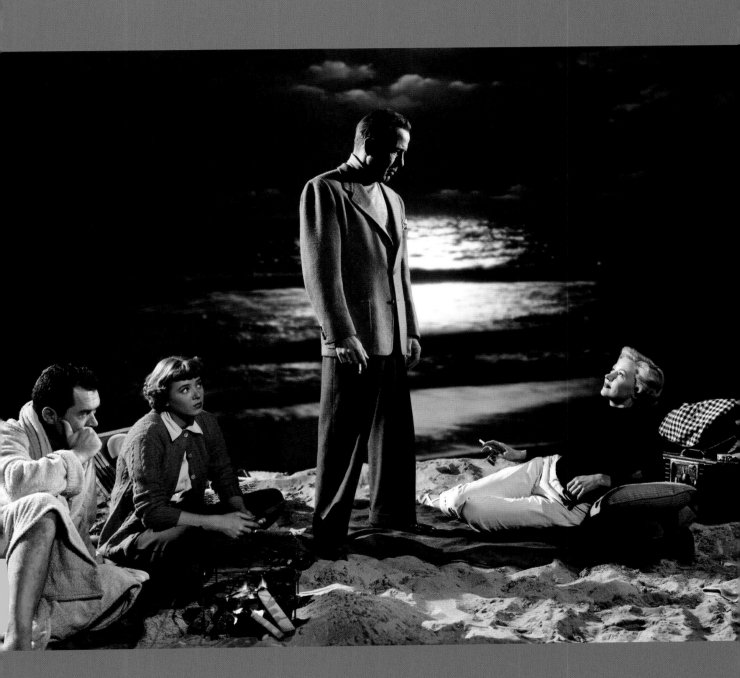

THE ASPHALT JUNGLE

METRO-GOLDWYN-MAYER
RELEASED MAY 23, 1950

FIVE MEN PLAN A MAJOR ROBBERY IN THE HOPES OF ESCAPING UNFULFILLED LIVES.

PRODUCTION QUOTE

"Johnny Huston tells me that Sterling Hayden's performance in *Asphalt Jungle* is just that—sterling. This will put him on top, where he belongs."

HEDDA HOPPER, "Riviera Story," *Los Angeles Times*, November 16, 1949

REVIEWS

"*The Asphalt Jungle* is a study in crime, hard-hitting in its exposé of the underworld. Ironic realism is striven for and achieved in the writing, production and direction. An audience will quite easily pull for the crooks in their execution of the million-dollar jewelry theft around which the plot is built."

Variety, May 10, 1950

Producer
ARTHUR HORNBLOW JR.

Director
JOHN HUSTON

Screenwriters
BEN MADDOW • JOHN HUSTON

Source
THE W. R. BURNETT NOVEL

Cinematographer
HAROLD ROSSON

Unit stills photographer
SAM C. MANATT

Stars
STERLING HAYDEN
SAM JAFFE • LOUIS CALHERN
JEAN HAGEN • MARILYN MONROE

"This film gives such an electrifying picture of the whole vicious circle of a crime—such an absorbing illustration of the various characters involved, their loyalties and duplicities, and of the minutiae of crime techniques—that one finds it hard to tag the item of exhibition repulsive in itself. For the plain truth is that this picture enjoins the hypnotized audience to hobnob with a bunch of crooks, participate with them in their plunderings, and sympathize with their personal griefs. Mr. Huston has filmed a straight crime story about as cleverly and graphically as it could be filmed. From the very first shot, in which the camera picks up a prowling thug, sliding along between buildings to avoid a police car in the gray and liquid dawn, there is ruthless authority in this picture, the hardness and clarity of steel, and remarkably subtle suggestion that conveys a whole involvement of distorted personality and inveterate crime. Mr. Huston's *The Maltese Falcon*, which brought him to the fore as a sure and incisive director, had nothing in the way of toughness on this film."

BOSLEY CROWTHER, *The New York Times*, June 9, 1950

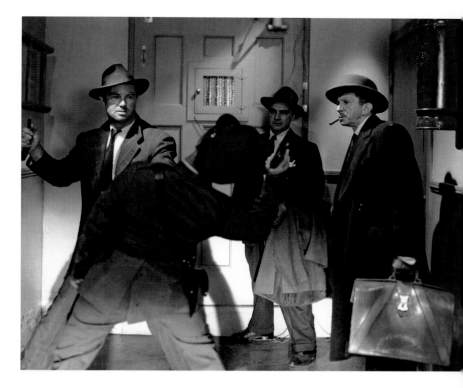

LETTER FROM REGIONAL THEATER OWNER

"The show suited me, but not many came. This one cost us all the profits we made on *Father of the Bride*."

A. E. MASSMAN, Park Theatre, Columbia Falls, Montana, *Motion Picture Herald*, January 27, 1951

ARTIST COMMENT

"I thought *The Asphalt Jungle* was a hell of a picture, with beautiful performances. It was easy to make because the people were so good. Everything was fine tuned."

JOHN HUSTON in Lawrence Grobel's *The Hustons*

Sterling Hayden, Anthony Caruso, and Sam Jaffe in a scene from John Huston's *The Asphalt Jungle*. Photograph by Sam Manatt.

THE UNDERWORLD STORY

FILMCRAFT TRADING CORP.
DISTRIBUTED BY UNITED ARTISTS
RELEASED JULY 21, 1950

Producer
HAL E. CHESTER

Director
CYRIL ENDFIELD

Screenwriters
HENRY BLANKFORT • CYRIL ENDFIELD

Source
THE CRAIG RICE NOVEL
THE BIG STORY

Cinematographer
STANLEY CORTEZ

Stars
DAN DURYEA • GALE STORM
HERBERT MARSHALL
HOWARD DA SILVA

WORKING TITLE: *WHIPPED*

WHEN A PHILADELPHIA REPORTER LOSES HIS JOB OVER A LEAKED STORY ABOUT A MOBSTER, HE GOES TO A SUBURBAN PAPER, AND THEN ENCOUNTERS THE SAME MAN.

PRODUCTION QUOTE

"Plenty of stirring action is promised picturegoers in *The Underworld Story*, a Jack Dietz presentation starring Dan Duryea, Gale Storm, and Herbert Marshall, which will screen Thursday at the Pantages and Hillstreet theaters."

"Action Stressed as Selling Point," *Los Angeles Times*, August 1, 1950

REVIEW

"An alarmingly low opinion of newspaper publishers and newspaper men is apparently held by the people who got together to make *The Underworld Story*, for journalism is presented as a wicked, corrupt and shameless trade. However, with Dan Duryea playing the reporter in his customary nasty, loud-mouthed way, one need not trouble too much about the damage which this film is likely to do. It is so poorly made, so haphazard, and so full of detectable holes that it carries no impact or conviction, regardless of credibility. Mr. Chester and his associates are free to proclaim, if they wish, that newspaper men are no good. We think the same of his film."

BOSLEY CROWTHER, *The New York Times*, July 29, 1950

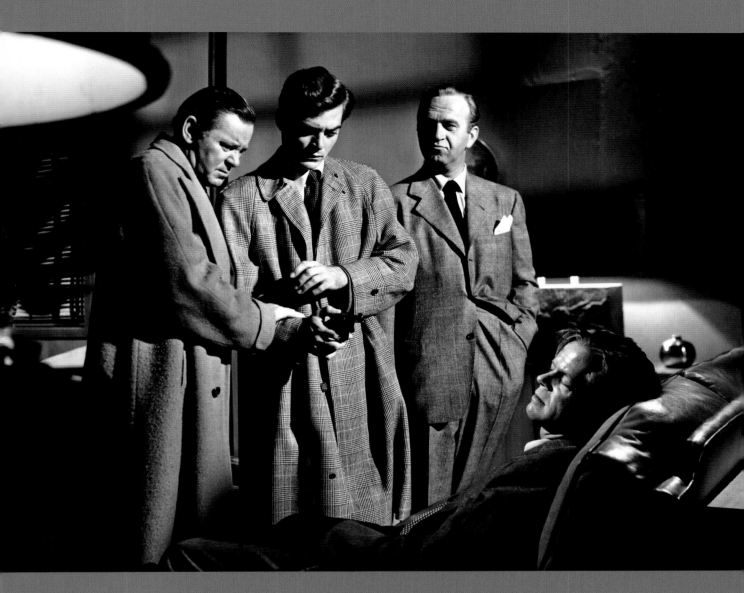

In Cyril Endfield's *The Underworld Story*, Herbert Marshall is a publisher with an errant son (Gar Moore). In this scene they are about to silence reporter Dan Duryea, with the blessing of mobster Howard da Silva. Stanley Cortez's cinematography distinguishes the well-written film.

SUNSET BOULEVARD

PARAMOUNT PICTURES
PREMIERED AUGUST 10, 1950

Producer
CHARLES BRACKETT

Director
BILLY WILDER

Screenwriters
**CHARLES BRACKETT • BILLY WILDER
D. M. MARSHMAN JR.**

Cinematographer
JOHN F. SEITZ

Unit stills photographer
GLEN E. RICHARDSON

Stars
**GLORIA SWANSON
WILLIAM HOLDEN
ERICH VON STROHEIM
NANCY OLSON • JACK WEBB**

AN OUT-OF-WORK SCENARIST IS FORCED TO ADAPT A WORTHLESS SCENARIO FOR A RECLUSIVE FORMER STAR.

PRODUCTION QUOTES

"It was mighty grim on the *Sunset Boulevard* set after Gloria Swanson shot and killed Bill Holden. The scene was a morgue, with Bill doing a relaxing scene—with thirty-six actors covered with sheets, lying on marble slabs. Billy Wilder has wanted to do a scene like this for a long time. He was crazy about Evelyn Waugh's book *The Loved One* and wanted the studio to buy it. He thought it would make another *Lost Weekend*. That's the tale about Forest Lawn and a dog crematory that raised eyebrows. Waugh wrote it while he was here as a guest of Metro-Goldwyn-Mayer and studio officials were trying to make up their minds if his book *Brideshead Revisited* could be filmed."

HEDDA HOPPER, "Montgomery Clift Air Lift Star," *Los Angeles Times*, June 13, 1949

"Recently, at a special showing of *Sunset Boulevard* for movie bigwigs, many of them sat there and wept. Each saw in it a bit of his own life. During the film, and at the end of it, Gloria got applause from the men who really know this business."

HEDDA HOPPER, "Career Trail Blazed by Gloria Swanson," *Los Angeles Times*, April 16, 1950

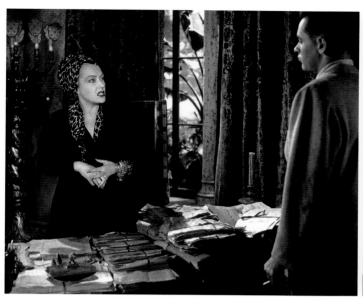

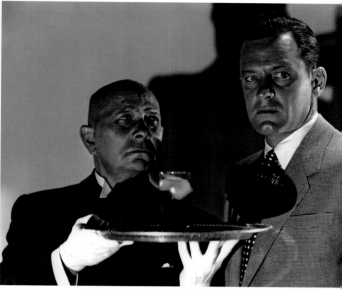

REVIEWS

"*Sunset Boulevard* is a backstage melo-drama using a filmland, instead of a legit, locale. Because it is tied in with a pseudo-exposé of Hollywood, the peek behind the scenes undoubtedly will fascinate a considerable slice of the public. Charles Brackett and director Billy Wilder, along with co-scripter D. M. Marshman Jr., have used an iconoclastic approach that will help shatter the public's illusions and which does much to perpetuate filmland myths and idiosyncrasies. On this count they rate a nod for daring, as well as credit for an all-around film-making job that, disregarding the unpleasant subject matter, is a standout.

"The industry family circle will appreciate the exposure of studio foibles. Picture bares with consider-able sting a lot of half-truths that are generally accepted as fact, plus adding quite a few glib cracks of its own. William Holden's stock within the industry should mount after his standout job as the young writer enmeshed with an old woman.

"Miss Swanson, returning to the screen after a very long absence, socks hard with a silent-day technique to put over the decaying star she is called upon to portray. Erich von Stroheim, as the butler and original discoverer, delivers with excellent restraint. Only two other members have a chance at more than a few lines but they come over with a wallop. Nancy Olson, comparative newcomer, more than holds her own in trouping with the more experienced performers. Her work as the studio reader who falls for Holden is splendid. The other per-former rating more than a mention is Cecil B. DeMille. He plays himself with complete assurance in one of the few sympathetic roles."

WILLIAM BROGDON, *Variety*, April 19, 1950

Left: In Billy Wilder's *Sunset Boulevard*, silent star Norma Desmond (Gloria Swanson) explains screenwriting to screen-writer Joe Gillis (William Holden).

Right: This is poster art of William Holden, and of Erich von Stroheim, who was a retired silent-film director called back to Hol-lywood to play a retired silent-film director.

"A segment of life in Hollywood is being spread across the screen in *Sunset Boulevard*. Using as the basis of their frank, caustic drama a scandalous situation involving a faded, aging silent-screen star and a penniless, cynical young scriptwriter, Charles Brackett and Billy Wilder (with an assist from D. M. Marshman, Jr.) have written a powerful story of the ambitions and frustrations that combine to make life in the cardboard city so fascinating to the outside world. *Sunset Boulevard* is by no means a rounded story of Hollywood, past or present. But it is such a clever compound of truth and legend—and is so richly redolent of the past, yet so contemporaneous—that it seemingly speaks with great authority. *Sunset Boulevard* is that rare blend of pungent writing, expert acting, masterly direction, and unobtrusively artistic photography which quickly casts a spell over an audience and holds it enthralled to a shattering climax.

"Gloria Swanson was coaxed out of long retirement to portray the pathetic, forgotten film queen, Norma Desmond, and now it can be said that it is inconceivable that anyone else might have been considered for the role. Even when she is not on the screen, her presence is felt like the heavy scent of tuberoses which hangs over the gloomy, musty splendor of her memento-cluttered mansion. The fantastic, Babylonian atmosphere of an incredible past is reflected sharply in the gaudy elegance of the decaying mansion in which she lives.

"Playing the part of Joe Gillis, the scriptwriter, William Holden is doing the finest acting of his career. His range and control of emotions never falters and he engenders a full measure of compassion for a character who is somewhat less than admirable. Hounded by collectors from the auto-finance company, the struggling, disillusioned writer grabs an opportunity to make some money by helping Norma Desmond to fashion a screenplay. He is indignant when Norma insists that he live in her house, but gradually his self-respect is corroded by easy comforts and he does nothing strenuous to thwart her unsubtle romantic blandishments. But while all the acting is memorable, one always thinks first and mostly of Miss Swanson, of her manifestation of consuming pride, her forlorn despair, and a truly magnificent impersonation of Charlie Chaplin.

"This is a great motion picture, marred only slightly by the fact that the authors permit Joe Gillis to take us into the story of his life after his bullet-ridden body is lifted out of Norma Desmond's swimming pool. That is a device completely unworthy of Brackett and Wilder, but happily it does not interfere with the success of *Sunset Boulevard*."

THOMAS M. PRYOR, *The New York Times*, August 11, 1950

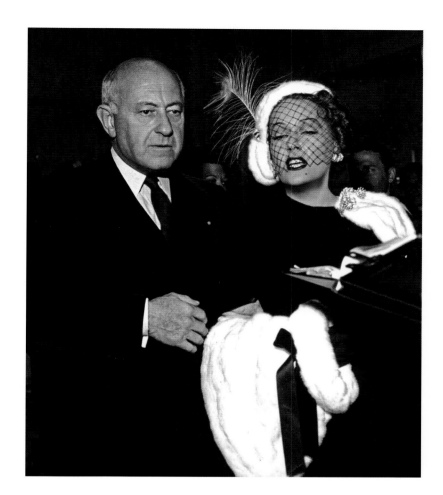

In *Sunset Boulevard*, Cecil B. DeMille played himself as he really was, authoritative, wry, and considerate. Norma Desmond played a combination of two silent-film veterans: Mae Murray and Nita Naldi.

LETTER FROM REGIONAL THEATER OWNER

"Superior attraction but not too suitable for small towns. We failed to do average business on same after an intensive campaign. The busy harvest season accounts partially for a poor gross."

LEE BREWERTON, Capitol Theatre, Raymond, Alberta, Canada, *Motion Picture Herald*, October 21, 1950

ARTIST COMMENT

"A director-writer like Billy Wilder is a creator. He and Charles Brackett made it all so effortless for me with their brilliant dialogue. It came so easily. It didn't even seem like work. It was the first time I've been happy since *Golden Boy* [1939]. I was even—this is a trite word, I know—*inspired*."

WILLIAM HOLDEN, in Philip K. Scheuer's "Bill Holden Laughs Last," *Los Angeles Times*, February 25, 1951

Sunset Boulevard cost $1.75 million. It grossed $5 million.

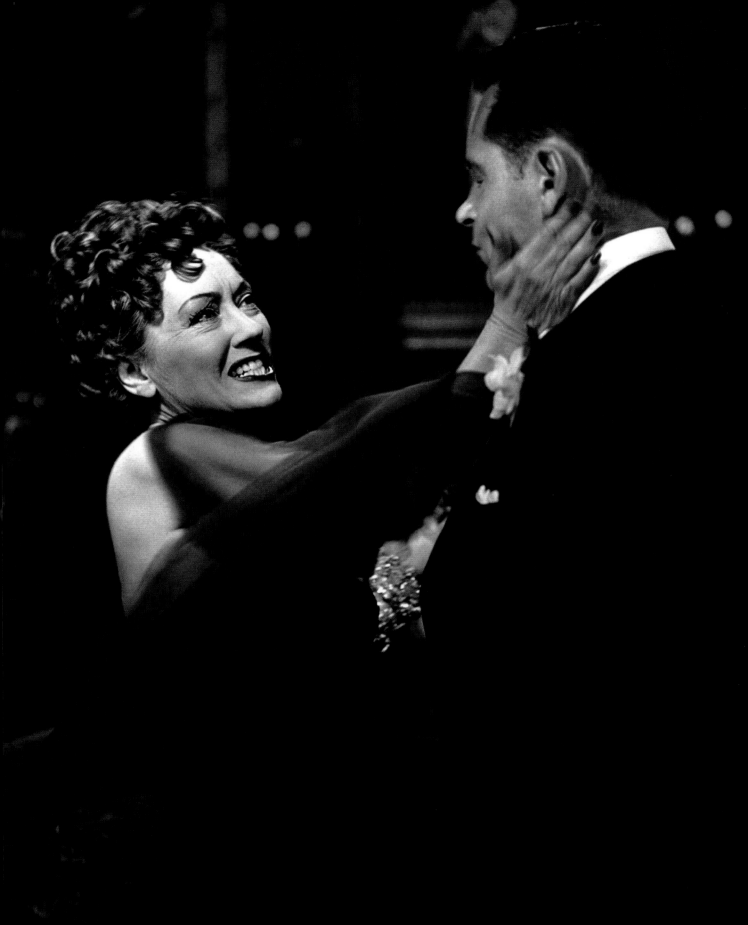

Opposite: In film noir, obsessed characters have unrealistic expectations.

Right: At the conclusion of *Sunset Boulevard*, Norma Desmond turns alienation into sanctuary.

Next page: Norma Desmond uses a projector arc as a spotlight in *Sunset Boulevard*.

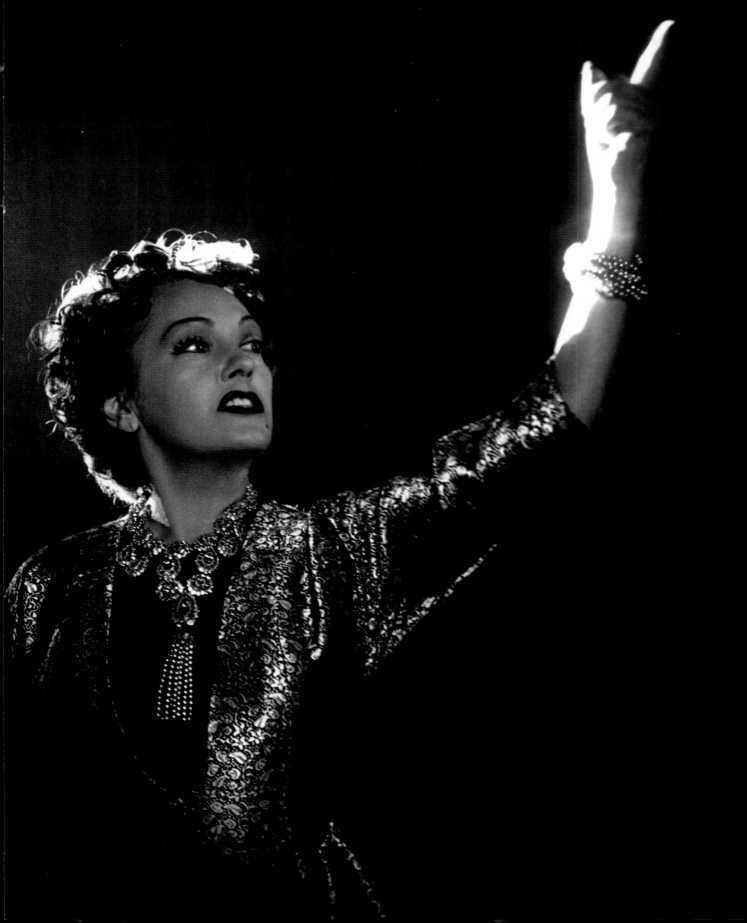

SELECTED BIBLIOGRAPHY

BOOKS

Alvarez, Max. *The Crime Films of Anthony Mann*. Jackson, Mississippi: University Press of Mississippi, 2013.

Astor, Mary. *A Life on Film*. New York: Delacorte Press, 1971.

Bacher, Lutz. *Max Ophuls in the Hollywood Studios*. Chapel Hill, North Carolina: Rutgers University Press, 1996.

Behlmer, Rudy. *Henry Hathaway*. Metuchen, New Jersey: The Scarecrow Press, 2001.

_____. *Inside Warner Bros.* New York: Viking Penguin, 1985.

_____. *Memo from Darryl F. Zanuck: The Golden Years at Twentieth Century-Fox*. New York: Grove Press, 1993.

Bennett, Joan. *The Bennett Playbill*. New York: Holt McDougal, 1970.

Bernstein, Matthew. *Walter Wanger: Hollywood Independent*. Berkeley: University of California Press, 1994.

Bigelow, Kathryn, and Peter Keough. *Kathryn Bigelow: Interviews*. Jackson, Mississippi: University Press of Mississippi, 2013.

Buford, Kate. *Burt Lancaster: An American Life*. New York: Alfred A. Knopf, 2013.

Cagney, James. *Cagney by Cagney*. New York: Doubleday, 1976.

Cardullo, Bert. *Jean Renoir: Interviews*. Jackson, Mississippi: University Press of Mississippi, 2005.

Champlin, Charles, and Jerry Roberts. *Robert Mitchum in His Own Words*. New York: Limelight Editions, 2000.

Clurman, Harold. *All People Are Famous*. New York: Harcourt, Brace, Jovanovich, 1974.

Cocteau, Jean. *Professional Secrets*. New York: Colophon, 1970.

Cotten, Joseph. *Vanity Will Get You Somewhere*. San Francisco: Mercury House, 1987.

Cousins, Mark. *Scene by Scene: Film Actors and Directors Discuss Their Work*. London: Laurence King Publishing, 2002.

Crawford, Joan, with Jane Kesner Ardmore. *A Portrait of Joan*. Garden City, New York: Doubleday, 1962.

Cypert, Rick. *The Virtue of Suspense: The Life and Works of Charlotte Armstrong*. Selinsgrove, Pennsylvania: Susquehanna University Press, 2008.

Daniel, Douglas K. *Tough as Nails: The Life and Films of Richard Brooks*. Madison, Wisconsin: University of Wisconsin Press, 2011.

Davis, Bette, and Whitney Stine. *Mother Goddam: The Story of the Career of Bette Davis*. New York: Hawthorn Books, 1974.

Dickos, Andrew. *Abraham Polonsky: Interviews*. Jackson, Mississippi: University Press of Mississippi, 2012.

Winston-Dixon, Wheeler, and Gwendolyn Audrey Foster. *A Short History of Film*. Chapel Hill, North Carolina: Rutgers University Press, 2013.

Doherty, Thomas. *Hollywood Censor: Joseph I. Breen and the Production Code Administration*. New York: Columbia University Press, 2007.

Dowd, Nancy, and David Shepard. *King Vidor: A Directors Guild of America Oral History*. Metuchen, New Jersey: The Scarecrow Press, 1988.

Drew, William M. *At the Center of the Frame: Leading Ladies of the Twenties and Thirties*. New York: Vestal Press, 1999.

Estrin, Mark W. *Orson Welles: Interviews*. Jackson, Mississippi: University Press of Mississippi, 2002.

Hirsch, Foster. *Otto Preminger: The Man Who Would Be King*. New York: Alfred A. Knopf, 2010.

Granger, Farley. *Include Me Out*. New York: St. Martin's Griffin, 2008.

Grant, Barry Keith. *Fritz Lang: Interviews*. Jackson, Mississippi: University Press of Mississippi, 2003.

Greco, Joseph. *The File on Robert Siodmak, 1941–1951*. Dissertation.com, 1999.

Greenberg, Joel, and Charles Higham. *The Celluloid Muse*. Chicago, Illinois: Henry Regnery, 1969.

Grobel, Lawrence. *The Hustons*. New York: Charles Scribner's Sons, 1989.

Hare, William. *Early Film Noir: Greed, Lust, and Murder Hollywood Style*. Jefferson, North Carolina: McFarland, 2003.

Heston, Charlton: *In the Arena: An Autobiography*. New York: Simon & Schuster, 1995.

Higham, Charles. *Ava: A Life Story*. New York: Delacorte Press, 1974.

_____. *Hollywood Cameramen: Sources of Light*. Bloomington, Indiana: Indiana University Press, 1970.

Holston, Kim R. *Susan Hayward: Her Films and Life*. Jefferson, North Carolina: McFarland, 2009.

Isenberg, Noah. *Edgar G. Ulmer: A Filmmaker at the Margins*. Berkeley: University of California Press, 2014.

Jarlett, Franklin. *Robert Ryan: A Biography and Critical Filmography*. Jefferson, North Carolina: McFarland, 1990.

Jones, J. R. *The Lives of Robert Ryan*. Middletown, Connecticut: Wesleyan University Press, 2015.

Kellow, Brian. *The Bennetts: An Acting Family*. Lexington, Kentucky: University of Kentucky Press, 2004.

Kiszely, Philip. *Hollywood Through Private Eyes*. New York: Peter Lang Publishing, 2006.

Kobal, John. *People Will Talk*. New York: Alfred A. Knopf, 1986.

Leaming, Barbara. *Orson Welles: A Biography*. New York: Limelight Editions, 1995.

Leeman, Sergio. *Robert Wise on His Films: From Editing Room to Director's Chair*. Los Angeles: Silman-James Press, 1995.

Lenburg, Jeff. *Peekaboo: The Story of Veronica Lake*. New York: St. Martin's Griffin, 2008.

Mank, Gregory. *Women in Horror Films, 1940s*. Jefferson, North Carolina: McFarland, 2005.

McBride, Joseph. *Orson Welles*. New York: The Viking Press, 1972.

McGilligan, Patrick. *Backstory 1: Interviews with Screenwriters of Hollywood's Golden Age*. Berkeley, University of California Press, 1986.

_____. *Film Crazy: Interviews With Hollywood Legends*. New York: St. Martin's Press, 2000.

_____. *White Heat: Warner Bros. Screenplays Series*. Madison, Wisconsin: University of Wisconsin Press, 1984.

Milland, Ray. *Wide-Eyed in Babylon*. New York: William Morrow, 1974.

Muller, Eddie. *Dark City Dames: The Women of Film Noir*. New York: Harper, 2001.

_____. *Dark City: The Lost World of Film Noir*. New York: St. Martin's Griffin, 1998.

Negulesco, Jean. *Things I Did and Things I Think I Did*. New York: Linden Press-Simon & Schuster, 1984.

Nelson, Nancy. *Evenings with Cary Grant*. New York: William Morrow, 1991.

Nissen, Axel. *The Films of Agnes Moorehead*. Metuchen, New Jersey: The Scarecrow Press, 2013.

Nolan, William F. *John Huston: King Rebel*. West Hollywood, California: Sherbourne Press, 1965.

Nugent, Elliott. *The Events Leading Up to the Comedy*. New York: Trident Press, 1965.

Peters, Margot. *The House of Barrymore*. New York: Alfred A. Knopf, 1990.

Phillips, Gene D. *Creatures of Darkness: Raymond Chandler, Detective Fiction, and Film Noir*. Lexington, Kentucky: University of Kentucky Press, 2003.

Porfirio, Robert, and Alain Silver, James Ursini. *Film Noir Reader 3: Interviews With Filmmakers of the Classic Noir Period*. New York: Limelight Editions, 2002.

Porfirio, Robert, and Alain Silver, James Ursini, Elizabeth Ward. *Film Noir: The Encyclopedia*. New York: Overlook Duckworth, 2010.

Price, Victoria. *Vincent Price: A Daughter's Biography*. New York: St. Martin's Press, 1999.

Reid, John Howard. *Films Famous, Fanciful, Frolicsome, and Fantastic*. Lulu, 2010.

Robinson, Edward G. *All My Yesterdays: An Autobiography*. New York: Hawthorn Books, 1973.

Server, Lee. *Robert Mitchum: Baby, I Don't Care*. New York: St. Martin's Press, 2001.

_____. *Screenwriter: Words Become Pictures*. Pittstown, New Jersey: The Main Street Press, 1987.

Sherman, Vincent. *Studio Affairs: My Life as a Film Director*. Lexington, Kentucky: University of Kentucky Press, 1996.

Smith, Ella. *Starring Miss Barbara Stanwyck*. New York: Crown Publishers, 1974.

Soister, John T., and JoAnna Wioskowski. *Claude Rains: A Comprehensive Illustrated Reference to His Work in Film, Stage, Radio, Television, and Recordings*. Jefferson, North Carolina: McFarland, 1999.

Tierney, Gene. *Self-Portrait*. New York: Wyden Books, 1979.

Verswijver, Leo. *Movies Were Always Magical*. Jefferson, North Carolina: McFarland, 2003.

Wallis, Hal. *Starmaker*. New York: Macmillan, 1980.

Young, Jordan R. *Reel Characters: Great Movie Character Actors*. Beverly Hills, California: Moonstone Press, 1975.

INDEX

Page numbers in italics refer
to photographs and their captions.

ACKNOWLEDGMENTS

Thirty years ago when I watched nitrate prints of *Murder, My Sweet* and *Out of the Past* at the York Theatre in San Francisco, I never thought I would be writing a book on film noir. Here is my chance to express my gratitude.

For access to photographs in the Cinematic Arts Library at the University of Southern California, I thank Ned Comstock, Senior Library Assistant; Sandra Garcia-Myers, Director of the Archives of the Cinematic Arts; and Steve Hanson, Head Cinematic Arts Librarian. I thank Alan K. Rode of the film Noir Foundation. I thank Ken Blaustein and the Digital Imaging Specialists at Iron Mountain in Hollywood for excellent scans. I thank Damon Devine for digital color correction. For access to photographs at Turner Brand, I thank Turner Classic Movies and in particular, Christian Pierce.

I thank Eddie Muller of the Film Noir Foundation for his support of this project. His work to restore and share lost film noirs is exemplary and commendable.

I thank these individuals for photographs: Chester M. Carey; Alfred B. Chico; David Chierichetti; Norm Scott of the Ned Scott Archives; Jack Allen of Dream City; Jamie Vuignier of the Kobal Collection at Art Resource; the David Wills Collection; John McElwee of Greenbriar Picture Shows; and Cindy De La Hoz.

For expert archival research, I thank Mary Mallory. I thank Angel Cortez for preventing a third computer crash. For Photoshop and marketing tutelage, I thank Frank Coiro. For sustenance during writing and editing sessions, I thank my friends at Casita del Campo Restaurant: Florentino Martinez; Omar Sandoval; Baldomero Mendoza; Jay Richards; and Rigoberto Benitez; and a special thank-you to Andrew Montealegre. For assistance in the Granada Buildings, I thank Rudy Aguilar and Daniel Mesones. I thank Horalia and Leonel Way. I especially thank Antonio Marroquin

Guarchaj for a smoothly functioning studio and for keeping the mascots content.

I thank Betty Lasky for encouragement. For guidance and counsel, I thank Helen Cohen; Suzanne McCormick; Jann Hoffman; William Martin; Bryan Potok, L.C.O.; Ruben Alvarez, M.D.; Rev. Shanna Steitz; Rev. Ryan Steitz; and the Rev. Dr. R. Scott Colglazier, First Congregational Church of Los Angeles.

For generous assistance and support, I am deeply grateful to: Connie Parker; George Wagner; Kenton Bymaster; Katherine Orrison; Vincent Estrada; David Chierichetti; Jon Davison; Kim Hill; Robert L. Hillmann; Andrew Montealegre; Bruce Paddock; Howard Mandelbaum; Ben Carbonetto; Jonathan G. Quiej; Peter Koch; Karie Bible; Mary Mallory; Felix Pfeifle; Marguerite Topping; Leonel and Horalia Way; Damon Devine; and P. R. Tooke.

I thank Cecilia de Mille Presley for her patronage.

I thank Deborah Warren of East-West Literary for her steadfastly resourceful work on my behalf.

I thank Running Press for this project, especially Christopher Navratil, Susan Weinberg, Allison Devlin, Kristin Kiser, and book designer Jason Kayser. I thank my editor, Cindy De La Hoz, for shepherding the project and for bringing it to a happy conclusion. And working with Turner Classic Movies again means a great deal to me. No company has done more to preserve America's film heritage, and to make it available. The Blu-Ray of *Out of the Past* is sensational.

I dedicate this book to my parents, with whom I saw my first film noir—and one of my first movies—on TV in October 1957. It was *The Locket*. I hope this book expresses my gratitude. For ongoing encouragement, I thank my family: Joan Semas; Barry Gutfeld; Beverly Ferreira Rivera; Sue Costa; Dorothy Chambless; Michael Chambless; Lenore Griego; Matthew Griffiths; John and Julie Vieira; Guy and Shannon Vieira; and Steve and Janine Faelz.